Annals of
KIRSTENBOSCH
Botanic Gardens

Volume 14

J N ELOFF DSc
Editor
Director, National Botanic Gardens

51.

M. elliotii.

THE MORAEAS
OF SOUTHERN AFRICA

A Systematic Monograph of the Genus in South Africa,
Lesotho, Swaziland, Transkei, Botswana, Namibia and Zimbabwe

PETER GOLDBLATT

B. A. Krukoff Curator of African Botany,
Missouri Botanical Garden, St. Louis, USA

Watercolours by
FAY ANDERSON
and line drawings by Margo L. Branch and Janet E. Klein

National Botanic Gardens
in association with the
Missouri Botanical Garden, USA

© Text: Peter Goldblatt
Watercolour Artwork: Fay Anderson
1986

ISBN 0 620 09974 7

Printed by CTP Book Printers, Cape
BD4711

Foreword

The aims of the National Botanic Gardens, according to the Forestry Act of 1984, are to promote the conservation of and research in connection with southern African Plants. Publication or research results in the form of monographs and longer works, started in 1944 and since then, 13 such works known as Supplementary volumes to the Journal of South African Botany, have been published at regular intervals. In 1984, the Journal of South African Botany amalgamated with the South African Journal of Botany which is produced for the National Botanic Gardens and the South African Association of Botanists. The numbering of volumes followed that of the Journal of South African Botany.

With an increase in the research and educational activities of the National Botanic Gardens the need for publication of longer works increased and it was decided that the title of this new serial publication should be "Annals of Kirstenbosch Botanic Gardens." This series will still be devoted to the publication of monographs and major works on southern African flora and the numbering will follow on that of the now defunct supplementary volumes.

This volume reflects all four of the functional areas in which the National Botanic Gardens is involved. In the first place, this is a scientific document which represents a distinct advance in our scientific knowledge. Secondly, it is horticulturally important and it is also very valuable for the plant utilisation function because of the potential economic value of the Moraeas. Lastly, the educational and conservation value of *Moraea* is important especially because a beautiful plant such as *Moraea loubseri* is apparently now extinct in nature.

This first volume of Annals of Kirstenbosch Botanic Gardens, has been co-sponsored by the Missouri Botanical Garden, where Peter Goldblatt is the B A Krukoff Curator of African Botany. The Director, Dr Peter Raven, is thanked for this very welcome co-operation. The scientific and artistic value of this first volume is so great that it will be extremely difficult for subsequent volumes to surpass it.

J N ELOFF
EXECUTIVE DIRECTOR
NATIONAL BOTANIC GARDENS
KIRSTENBOSCH

Contents

Foreword v
Contents vii
Acknowledgements ix
Abstract xi
Introduction 1
Taxonomic History 2
Morphological Characters 8
Cytology 11
Floral Biology and Pollination 11
Conservation 14
Cultivation 15
Distribution and Evolution 16
Relationships 18
Subgeneric Classification 19
Systematic Treatment 20
 Key 21
 Species Descriptions 28
 Excluded Species 219
Bibliography 221
Index 223

Acknowledgements

This work is dedicated to the late T. T. Barnard, for sharing his wide knowledge of *Moraea*, and of early botany in South Africa.

I want to express my grateful appreciation to the following people for their assistance in the field or in providing me with material for study or illustration: Dierdre Snijman, Compton Herbarium, Kirstenbosch; Ion Williams, Vogelklip, Hermanus; J. H. J. Vlok, Department of Forestry, George; Mike Viviers, Department of Forestry, Cedarberg; Neil MacGregor, Glenlyon, Nieuwoudtville; Rhoda and Hendrik van Zijl, Rust en Vrede, Constantia; Margaret Thomas, Kirstenbosch; Georges Delpierre, Durbanville; Chris Burgers, Cape Department of Nature and Environmental Conservation; Lynette Davidson, Johannesburg; Olive Hilliard, University of Natal; Bill Burtt, Royal Botanic Garden, Edinburgh; Jim Holmes, Rustenberg Estates, Stellenbosch; Bobby and Chris van Vuuren, Rosh Pinah, Namibia; Johan Loubser, Welgemoed, Cape; Dale Parker, Zonnestraal, Constantia; and especially Elsie Esterhuysen, Bolus Herbarium, University of Cape Town, who helped me with many of the rare mountain species. Graham Duncan of Kirstenbosch, has been particularly helpful in growing many species and providing ample material for illustration. The support and hospitality provided by John Rourke and his staff, Compton Herbarium, Kirstenbosch, Cape Town in the course of field work is acknowledged here with gratitude. I also wish to extend a special thanks to Fay Anderson and Margo Branch for the many excellent illustrations made for this monograph, often under difficult circumstances.

This work is the product of over fifteen years of reasearch during which time many people and several institutions have assisted and supported me in this study. Financial support has largely been provided by the United States Science Foundation, from which grants BMS 74–18905, DEB 78–10655 and DEB 81–19292 are gratefully acknowledged. The Missouri Botanical Garden has supported and partially funded my studies research and Kirstenbosch has provided assistance and workspace in my many field trips to South Africa. I also wish to acknowledge the South African Department of Forestry and the Cape Department of Nature and Environmental Conservation for their support of this project and for collecting permits issued to further my research in the field.

Abstract

Moraea is a large genus of Iridaceae native to Africa south of the Sahara but concentrated in the south-western Cape and the Drakensberg Mountains. Of the 119 species currently recognized, 103 are found south of the Zambezi–Cunene rivers, and more than 65 of these are restricted to the winter rainfall area of the south and west coasts and immediate interior of South Africa. *Moraea* comprises small to large corm-bearing plants with channelled bifacial leaves and *Iris*-like flowers with flattened petaloid style branches topped by large paired crests. It is closely related to the predominantly Cape genus *Homeria*, with which several species may be confused, owing to convergent evolution for the same type of flower in which the style branches are reduced in size, the crests are vestigial and the filaments completely united in a slender column. *Moraea* comprises five subgenera *Visciramosa* (5 spp.); *Monocepahalae* (4 spp.); *Moraea* (51 spp.); *Vieusseuxia* (31 spp.); and *Grandiflora* (28 spp.). Sugenus *Moraea*, the largest, is divided into six sections, each with a distinctive vegetative morphology but with generally similar unspecialized flowers. Four of the species in this work are new to science and were only discovered or adequately documented in the past few years; one, *M. brevistyla*, is raised from subspecific rank; and one, *M. venenata* is raised from synonymy in *M. polystachya*.

Moraea is seen as a late Tertiary genus that probably differentiated from ancestors much like the present-day woodland genus *Dietes*, in central and south-western Africa when much of southern and east Africa including the Cape Region was still heavily forested. The drying and progressive seasonality of the African climate after the end of the Oligocene and the establishment in the Pliocene and Pleistocene of a mediterranean climate in the south-western Cape probably gave the impetus to the extensive radiation of *Moraea* in dry parts of southern Africa, especially in the south-western Cape and Namaqualand, where today all of the more primitive species and many of the most specialized members of the genus occur.

The major trends in the evolution of *Moraea* include: the reduction in the number of leaves from several to one, and solitary leaves together with other features characterize the two specialized subgenera *Vieusseuxia* and *Grandiflora*; the reduction in the number of branches on the stem; the development of long-lasting flowers (subgenera *Vieusseuxia* and *Grandiflora*) from the basic fugacious flower that lasts less than a single day; the reduction of the inner tepals to tricuspidate, filiform or ciliate structures (subgenus *Vieusseuxia*); the development of the acaulescent habit in section *Acaules*; and the evolution of a perianth tube in section *Tubiflora*. Basic chromosome number for *Moraea* is $x = 10$. Aneuploid reduction has occurred in several lines in subgenus *Moraea*, with $n = 10-5$ in section *Subracemosae*, $n = 10-8$ in section *Moraea* and $n = 6$ in section *Polyanthes*. Subgenera *Vieusseuxia* and *Grandiflora* both have a derived base number of $x = 6$. Polyploidy is rare in *Moraea*, and has been found in only seven species, in all but two of which there are also diploid races.

Introduction

Moraea is a large genus, of the monocot family Iridaceae, native to Africa south of the Sahara, and concentrated in southern Africa, where it is widespread. Known in different parts of the subcontinent as tulps, or more specifically *flappies, uintjies* or *uiltjies*, or sometimes as *wild irises*, species of *Moraea* can be found in almost all parts of the several countries that comprise southern Africa. In many places they are small and inconspicuous, with tiny *Iris*-like flowers, but in the western Cape, Namaqualand and in the Drakensberg and eastern Escarpment, species are sometimes common and have large conspicuous flowers so that they are among the loveliest, although perhaps least well-known of the beautiful wild flowers of the veld.

Moraeas can be recognized by their flowers which are almost exactly like those of *Iris*, a related genus restricted to the Northern Hemisphere. Thus the *Moraea* flower (Figure 1) has three large outer tepals, usually with spreading to reflexed limbs, each marked near the base with a bright nectar guide; smaller inner tepals, either spreading or erect; and distinctive flattenned style branches that resemble petals, and have paired terminal appendages, the crests. The anthers are appressed to the style branches and concealed between them and the lower part of the outer tepals. The tepals are free to the base in *Moraea*, in contrast to *Iris* in which they are united in a tube. The underground organ is a corm and the leaves are bifacial and usually grooved or channelled, unlike most Iridaceae which have unifacial sword-like leaves.

Since its treatment in *Flora Capensis* (Baker, 1896) in which 45 species of *Moraea* were recognized (two now regarded as species of *Dietes*), the genus has been revised completely for the summer and winter rainfall parts of southern Africa (Goldblatt, 1973; Goldblatt, 1976b) and for tropical Africa (Goldblatt, 1977). Since the completion of this series of revisions, new species of *Moraea* have been discovered at a surprising rate, while additional evidence has accumulated confirming that several more are distinct from species in which they had been included. This monograph thus includes 101 species in southern Africa, of which no less than 25 were unknown or not included in the revisions published only 10–12 years ago, comparatively recently for botanical publications. Four new species are described here for the first time; one, *M. brevistyla*, is raised from subspecific rank; one, *M. venenata* is raised from synonymy in *M. polystachya*; and three species included in *Homeria* until 1980, are now placed in *Moraea*. Most of the new species described since 1976 are local endemics of very restricted distribution, and given the frequency of very localized species in southern Africa, especially in the western Cape, it seems almost certain that new species of *Moraea* will continue to be discovered in the coming years, although at a decreasing rate as the flora is by and large well known.

History of *Moraea*

THE BEGINNING 1758–1778: THE LINNAEAN PERIOD

1758. The history of *Moraea* begins in 1758 with Philip Miller's publication of the genus *MOREA*, in which he included three 'species' described polynomially (*Figures of Plants* tab. 238, fig. 1–2, and tab. 239, fig. 1). The first two of these are conspecific and represent the type species of the genus, *M. vegeta* Linnaeus; the third is now regarded as belonging to the genus *Dietes*. Prior to this time *Moraea* was known only through various unpublished illustrated works, the most notable of which is the *Codex Witsenii*, a collection of approximately 1 500 paintings of South African plants, amongst them several species of *Moraea*. Similar volumes possibly containing the originals of the paintings in the *Codex Witsenii* are known to be located in various libraries in Europe and South Africa (Barnard, 1947; Jessop, 1966; Macnae & Davidson, 1969). The original paintings were made during the late seventeenth century at the Cape, under the patronage of the Governor, Simon van der Stel and perhaps of his son Willem Adriaan, who was also Governor for some time. The paintings were copied repeatedly, and a few were published in the early eighteenth century (Breyne, 1739; Burman, 1738–1739). However, none of the several paintings of species of *Moraea* was published and no species were described, even polynomially. Thus relatively few people were aware of the existence of what we now call *Moraea* prior to 1758.

1762. Miller's new genus was immediately adopted by the great Swedish botanist Carl Linnaeus in the second edition of his *Species Plantarum* (1762). Linnaeus altered the spelling to *MORAEA* (this form now conserved against Miller's *Morea*), possibly because he wished to commemorate his wife's father and their family name Moraeus. In the *Species Plantarum* two species, *M. vegeta* and *M. juncea*, are described following the binomial system of plant names introduced by Linnaeus. Miller is referred to in the diagnostic descriptions, but without citation of page or plate.

1766. The publication of Daniel de la Roche's doctoral dissertation, *Descriptiones Plantarum Aliquot Novarum* in 1766 is the third important milestone in the history of *Moraea*. De la Roche, a student of David van Royen, the eminent, eighteenth century Dutch botanist, described 21 new species of South African Iridaceae, including the new genus *Vieusseuxia* (= *Moraea* subgenus *Vieusseuxia*) with three species, all of which were in cultivation in Holland. Although aware of Linnaeus' genus *Moraea*, he considered his three species of *Vieusseuxia* generically distinct. The three species that De la Roche described, now *M. fugax*, *M. aristata*, and *M. bellendenii* are all somewhat different from the type species of *Moraea*, *M. vegeta*, being slender, solitary-leafed, and in the two latter species, in having tricuspidate inner tepals.

De la Roche's first species, *Vieusseuxia spiralis*, illustrated beautifully in the text, is *Moraea bellendenii* (Sweet) N.E. Brown. The epithet *spiralis* cannot be transferred to *Moraea* because the name had already been used in this genus (Linnaeus fil., 1782) for a species of *Aristea*. The second is the common Cape species *M. fugax*, long known by a later name *M. edulis* (Goldblatt & Barnard, 1970). The third is the rare *M. aristata*, better known in Europe as *M. glaucopis*. Owing to a printing error, the epithets of the second and third species of *Vieusseuxia* were transposed, and this led to confusion over their interpretation. Several authors automatically corrected the obvious error, like Nicholas Jacquin (1776), Martin Houttuyn (1780); others did not realize the mistake, but Lewis (1948) rejected both species on the grounds of confusion. The *Botanical Code of Nomenclature* allows for automatic correction of a printing error of this type and the intended application of these De la Roche epithets was therefore revived by Goldblatt & Barnard (1970) (see also discussion under *M. aristata*).

While I was studying the specimens associated

with De la Roche's species in the Rijksherbarium, Leiden, several manuscripts containing draft descriptions of the published species came to light. The descriptions of *Vieusseuxia aristata*, progressively revised, apparently with considerable help from Van Royen, reveal quite surprisingly that De la Roche began by describing the white form of *Moraea gigandra*. Van Royen obviously had a similar plant in cultivation and assumed it was De la Roche's species, so that by the time the description was published, it was so modified as to apply to what we must now call *M. aristata*, the Cape Peninsula endemic.

Thus, by 1767 at least four species of *Moraea* are known to have been in cultivation in Holland and at least one more, *M. vegeta*, in England.

1767. No sooner had De la Roche published *Vieusseuxia*, than Linnaeus (in 1767) described a third species, *M. iridioides*, clearly referring this species to Miller's *Figures of Plants* tab. 239, fig. 1, the rhizomatous *Dietes iridioides*. Later the same year, Linnaeus, in the 12th edition of the *Systema Naturae*, amplified *Moraea*, now with *M. vegeta* referred to Miller, *Figures of Plants* tab. 238, fig. 1 & 2, but *M. juncea* remained without a reference. From both Linnaeus' and Miller's treatments, it is clear that *Moraea* is a southern African genus of *Iris*-like plants with both inner and outer tepals spreading and lacking a perianth tube. Both cormous, bifacial-leafed and rhizomatous, unifacial-leafed forms are included in this early circumscription.

The first two species which Linnaeus published, *M. vegeta* and *M. juncea*, have been the subjects of endless confusion (Barnard & Goldblatt, 1975). The complex situation is extensively dealt with elsewhere, and it is sufficient here to explain that Miller, in the eighth edition of *The Gardeners Dictionary*, misapplies the Linnaean epithets; thus, the name and description of *M. vegeta* is applied to the *Dietes*, while *M. juncea* is applied to the second illustration on this plate, *Tritonia crocata*. There is no doubt that this was incorrect in view of Linnaeus, clear referrals of *M. vegeta* to tab. 238 and of *M. iridioides* to tab. 239, and in fact, in the abridged edition of the *Dictionary*, published in 1771, the error is partly corrected, with *M. vegeta* applied to tab. 238, fig. 1, but with the previously untypified *M. juncea* to tab. 238, fig. 2. Nevertheless, the English botanist N. E. Brown (1928) found reason to follow *The Gardeners Dictionary*, ed. 8, in making the combination *Dietes vegeta* (of which *M. iridioides* is a synonym). Brown also revived *M. juncea* for what is correctly *M. vegeta* (but which was at that time known by a later synonym, *M. tristis* (Linnaeus fil.) Ker). Brown's treatment was followed and as a result the *nomen nudum*, *M. juncea*, came to be regarded as the type species of *Moraea* and was for a time conserved as such. This situation has now been corrected (Voss, 1983).

Linnaeus published no further species of *Moraea*, although he did receive specimens of undescribed species from Anders Sparrman and from Carl Peter Thunberg, both of whom arrived in the Cape in 1772. Entries in Linnaeus' manuscript *Mantissa* no. 3 (T. T. Barnard, pers. comm.), indicate that he then intended to apply the name *M. juncea* (until that time untypified) to one of the plants which Sparrman sent him – namely what is now *M. gawleri* Spreng. After his father's death, the younger Linnaeus applied the epithet *iriopetala* to the specimen in question, and published this description in a confusing and illegitimate way under the name *M. iriopetala* var. *juncea* (for the typical variety) in the *Supplementum Plantarum*.

EARLY EXPLORATION 1778–1830: CLIMAX OF THE CAPE PERIOD IN HORTICULTURE

1778. After Linnaeus's death in 1778, his son continued to work on the Mantissa 3, Linnaeus's unfinished manuscript which was published in 1782 as the *Supplementum Plantarum*. The younger Linnaeus added greatly to the work by borrowing from the manuscripts of Carl Peter Thunberg, and he incorporated descriptions of most of the Iridaceous plants collected by Thunberg at the Cape during a very productive 3-year period there. Thunberg's exploration at the Cape is extremely significant for he was an energetic collector and travelled widely, making trips to the Roggeveld (Sutherland district) and the southern and eastern Cape. Thunberg travelled first with the German, J. A. Auge, and on his second and third trips with the

The illustration in Philip Miller's *Figures of Plants*, published in 1758, that is the type of the genus *Moraea*, *M. vegeta* L.

English gardener, Francis Masson who was interested particularly in obtaining live material for cultivation in Britain. Masson's plant collections did not have the impact that Thunberg's enjoyed, but many of the lovely Cape species that were grown and flowered in Britain over the next thirty years and illustrated in *Curtis's Botanical Magazine* and Andrew' *Botanists' Repository* were introduced by him.

The younger Linnaeus was strongly influenced by Thunberg's ideas, for he altered drastically the concept of *Moraea*, adopting Thunberg's circumscription of *Moraea* for plants that did not have *Iris*-like petaloid style branches. However, Linnaeus fil. obviously did not completely understand the situation and his treatment is inconsistent. He placed under *Moraea* his father's manuscript description of *M. juncea* (now *M. gawleri* Sprengel) using the ephithet *iriopetala* including as the only varieties, *M. juncea* and *M. vegeta*. At the same time, he included under *Iris* several species taken from Thunberg's manuscripts including *I. crispa* (= *M. gawleri*) and *I. tristis* (=*M. vegeta* L.), the former conspecific with his *M. iriopetala* var. *juncea*.

Thunberg's concept of *Moraea* was quite different from that of Miller and Linnaeus, and he considered what we now regard as *Moraea* to be South African species of *Iris*. Thunberg's own manuscript treatment of *Iris* was published in December 1782.

In this work, all of the 15 South African species included by the younger Linnaeus are described in detail, while 3 more are added. The form of three specific epithets differs as follows: *Iris tricuspis* Thunberg is *I. tricuspidata* Linnaeus fil.; *I. spathacea* Thunberg is *I. spathulata* Linneaus fil.; and *I. setacea* Thunberg is *I. setifolia* Linnaeus fil. Most, if not all, of the younger Linnaeus's species of South African *Iris* cannot be identified from his descriptions nor from a specimen in the Linnaean herbarium. The types remained in Thunberg's collection and identification is possible only by consulting Thunberg's very detailed descriptions, as well as his herbarium specimens. Strictly speaking, because of the adoption of Thunberg's specific epithets, and of the reliance on Thunberg's published work, species which the younger Linnaeus described from Thunberg's manuscript should be cited as Thunberg ex Linnaeus fil. This practice has traditionally not been followed, and for simplicity perhaps should not be adopted.

1787. When Thunberg published his *Dissertatio de Moraea*, he included in the genus species occurring in Asia, Africa, and the New World, having in common simple style branches, fugaceous flowers and subequal spreading tepals. These are now considered to comprise several different genera, including *Homeria*, *Aristea*, *Bobartia*, *Ferraria*, *Belamcanda*, *Sisyrinchium*, and *Hexaglottis* as well as two still included in *Moraea*, *M. crispa* and *M. polyanthos*, both of which have unusually reduced style branches.

Thunberg maintained his incorrect application of *Moraea* until his death, and in all his works true species of *Moraea* are treated as *Iris*. Other botanists given the lead by Nicholas Jacquin (*M. fugax* (de la Roche) Jacquin, 1776) soon abandoned Thunberg's view. A dichotomy in the interpretation of *Moraea* developed from Thunberg's example and lasted until 1823. The German school as successor to the Linnaean tradition (Willdenow, Sprengel, Roemer & Schultes, etc.) used *Iris* and occasionally *Vieusseuxia* as well for species of *Moraea*, while the English school, following Ker (1803), consistently used *Moraea* in the Linnaean sense, although the genus *Vieusseuxia* was often recognized for the species with tricuspidate inner tepals (Sweet, 1830).

The post-Linnaean period is one of intense interest in Cape plants and during this time several well-known plant collectors visited the Cape, continually bringing back novelties. Among these were Francis Masson, mentioned above, Martin Lichtenstein, the famous explorer William Burchell, Franz Boos and Georg Scholl, who collected for Jacquin, and somewhat later in the 1820s J. F. Drège, C. F. Ecklon and C. L. Zeyher. Jacquin illustrated several species of *Moraea*, some for the first time, but he described no new species.

In England, however, a significant contribution was made by John Bellenden Ker (who changed his name early in his career from John Gawler). Ker systematically revised the Iridaceae (Ker, 1805, 1827) describing several new genera and changing the circumscriptions of several others. At first, Ker

CAROLO PETRO THUNBERG,

Cape Town as it appeared to late eighteenth century travellers. From Francois Le Vaillant's *Voyage dans l'Interieur de l'Afrique* (1790).

included South African species of *Moraea* in *Iris*, but he soon reverted to the Linnaean circumscription of the genus, transferring the younger Linnaeus' and Thunberg's South African species of *Iris* to *Moraea*. Ker added five species to the genus over a 25-year period, *M. villosa*, *M. lurida*, *M. longiflora*, *M. unguiculata* and *M. tenuis* (now included in *M. unguiculata*).

1808. The French naturalist Louis Ventenat published two new genera, *Homeria* and *Hexaglottis*, both based on species previously regarded as *Moraea*. This contribution was not immediately accepted, for Ker continued to regard both as synonyms of *Moraea*. Sweet (1830), however, recognized both, and subsequent treatments accepted these segregated genera.

1812. The English botanist, R. A. Salisbury was the first to suggest that *Moraea iridioides* might belong to a different genus, for which he proposed the name *Dietes*, neglecting, however, to provide a generic description. He is also the first to suggest that what is today recognized as *Gynandriris* might be distinct from *Iris* and from *Moraea*, to which Ker had referred the well-known Mediterranean species, *Iris sisyrinchium*. Salisbury's *Diaphane* is, however, also without a proper description. A third invalid genus of Salisbury's, *Helixyra*, was based on *Moraea longiflora*. *Helixyra* was subsequently used by F. W. Klatt and J. G. Baker for species of *Gynandriris*, although at the subgeneric level. Salisbury's studies on the Iridaceae are noteworthy, but the eccentric way in which he published his work makes much of it nomenclaturally invalid. He did however, provide a valid new name for the species often misnamed *M. iriopetala*, referring it to *Ferraria* as *F. lugubris*.

1827. The Danish plant collector C. F. Ecklon's *Topographisches Verzeichniss der Pflanzensammlung*, in which most of the monocotyledons collected by Ecklon and his colleague C. L. Zeyher are presented, is of little taxonomic significance since it is primarily a list of plant species. Several new names are used, some for new species, but all the species of *Vieusseuxia* (Ecklon used *Moraea* for species of *Homeria* and *Gynandriris*) are synonyms or *nomina nuda*.

Publication of Ker's *Iridearum Generum* (1827) closes this period. In this essentially modern treatment of the family, *Moraea* is treated with *Vieusseuxia* as synonymous and including *Hexaglottis*, *Homeria*, and *Gynandriris*, but not *Dietes*. Ker included 30 species in *Moraea*, and 24 of these are still recognized in the genus. This publication established the foundation for the work on *Moraea*, and in fact for the whole Iridaceae, by J. G. Baker and F. W. Klatt in the latter half of the nineteenth century.

EXPANDING HORIZONS 1830–1896: THE PERIOD OF AFRICAN EXPLORATION

The intense interest in Cape plants declined after 1830 as other newly explored regions provided exciting subjects for horticulture. However, settlement in South Africa proceeded towards the interior, while exploration into tropical Africa began and inevitably the flora of the newly explored areas was collected and studied. It soon became evident that *Moraea* was more widespread than had until then been believed.

1844. Two species of *Moraea*, collected by the German explorer Wilhelm Schimper in Ethiopia, were described by C. F. Hochstetter in a new genus *Hymenostigma*. Hochstetter's species were ultimately found to be conspecific and to belong to *Moraea*. His *H. schimperi*, the earliest name for

what was for many years known as *M. zambeziaca*, was only transferred to *Moraea* in 1950.

1853. Friedrich Welwitch's exploration of the Portuguese territory of Angola began in 1853, and during a long period of exploration in this vast area, he discovered several species of *Moraea* in the interior highlands. It was, however, only much later in 1878 that Welwitch's specimens were described by J. G. Baker.

1863. The German botanist F. W. Klatt's treatments of *Moraea*, published from 1863 onwards, are notable for the recognition of *Homeria*, *Hexaglottis* and *Dietes* as distinct genera. In miscellaneous papers published over a 30-year period, Klatt described several new species of *Moraea*, based on collections made by Drège and by Ecklon and Zeyher in the 1820s. Most are now regarded as synonyms of earlier names, but Klatt is to be credited with *M. falcifolia*, its synonym *M. fasciculata*, and *M. fimbriata*, the latter a later homonym, is now *M. fergusoniae* L. Bolus. Klatt was, however, at variance with modern treatments in recognizing *Vieusseuxia* for the tricuspidate species (subgenus *Vieusseuxia* here).

1896. The nineteenth century ended with the production of major floristic works and the English botanist J. G. Baker's revisions of *Moraea* in the *Handbook of the Irideae* (1892), *Flora Capensis* (1896), and *Flora of Tropical Africa* (1898) stood until 1976 as the only complete treatments of *Moraea*. Baker included *Vieusseuxia* as a subgenus, and treated both *Dietes* and *Gynandriris* (as *Helixyra*) at the subgeneric level. These treatments include a good representation not only from the already well-known Cape area but from tropical African areas (now Zimbabwe, Zambia, Angola and Malawi).

THE MODERN PERIOD 1896–1975

At the end of the nineteenth century the scene shifts from Europe to southern Africa where botanical activity stimulated by the important botanical figure Harry Bolus began to bear fruit. South Africa was collected intensively, with Harry Bolus, Rudolf Schlechter, and Peter MacOwan all active throughout the south. Some of their earlier discoveries were described by Baker and included in *Flora Capensis* but subsequently Louisa Bolus, Harry Bolus's neice, and G. J. Lewis, both working in Cape Town, added greatly to the understanding of *Moraea* in the winter rainfall area. Louisa Bolus described nine species of *Moraea*, six recognized today, while Joyce Lewis added five species from 1933 to 1954. Another important collector was Ernest Galpin, who made the first collections of several Transvaal species in 1890–1892 in the Barberton district. Galpin continued to collect throughout southern Africa until 1939, and is commemorated in *M. galpinii*, which he discovered.

At this time, plant collecting in tropical Africa, notably in Zaïre, then a Belgian colony, but also in Tanzania and Zambia, lead to the discovery of several more tropical African species. The good representation of *Moraea* in the African tropics, as well as in southern Africa, thus became increasingly evident.

1929. The *Moraea* species of the summer rainfall part of southern Africa were neglected by South African botanists but this gap was filled by N. E. Brown who recognized 17 species of *Moraea* from the Transvaal, 13 of which were newly described (Brown, 1929). Species from Natal, however, continued to be overlooked, although this province had already been well collected by several people, notably John Medley Wood, whose first collections were made in 1868.

1973. My published studies of *Moraea* began with a revision of the genus for the summer rainfall part of southern Africa (Goldblatt, 1973). In all, I recognized 26 species in this area. With ample material now at hand it became evident that Brown had followed too narrow a species concept, and eight of the 17 species he recognized were reduced to synonymy. Some 11 new species were described in the revision, including the common Natal species *M. inclinata*, *M. modesta*, *M. hiemalis*, the high al-

A woodcut figure from William Burchell's *Travels in the Interior of Southern Africa* (1812) showing the mode of travel of the times.

titude *M. alticola*, as well as some rarer Drakensberg species.

1974–1985. Research and collection over the past ten years has been very productive in increasing the knowledge of *Moraea*. A revised subgeneric classification (Goldblatt, 1976a) and a revision of the species of the winter rainfall area (Goldblatt, 1976b) were published in 1976, the latter treatment including 54 species. The following year the revision of *Moraea* for tropical Africa was completed (Goldblatt, 1977). These studies in turn stimulated interest in the genus and quite remarkably, some 15 undescribed species have been collected since 1976, some already known from imperfect material, but most newly-discovered. Undoubtedly *Moraea* will yield further surprises, and several common species are still far from being perfectly understood. The overall understanding of *Moraea* is, however, clear and the general taxonomy of the genus is reasonably well worked out. The stage is now set for more detailed studies of pollination, evolution and biology that require a basic taxonomic framework before further research can continue. Study is becoming urgent as population expands and more land is needed for housing, agriculture and pasture. Several species of *Moraea* in the Cape, particularly those with limited distributions, are in great danger of extinction, and even at the time of this publication, one species is believed to be extinct and several are severely threatened in the wild as their habitats contract or are changed by the activities of man.

Morphology of *Moraea*

In order to assist the reader in following the discussion, key and descriptions, the morphology of the *Moraea* plant needs to be described briefly and some terms must be explained. A synopsis of the genus is presented in Table 1, in which all species are listed in their taxonomic sequence by subgenus and section. The basic *Moraea* plant consists of an underground storage organ, the corm, from which the flowering stem and the roots are produced. The flowering stem, or simply the stem, bears one or more long foliage leaves, a number of sheathing bracts at the nodes and a terminal inflorescence. The flowers are radially symmetric (actinomorphic), and comprise six petal-like tepals in two series, and like almost all Iridaceae, three fertile stamens and an inferior ovary. The style is unusual, dividing into three, usually broad, flat petaloid branches, each opposite a stamen (Figure 1). Details of all these organs are discussed below.

THE CORM

The corm of *Moraea* and its close allies is derived from a lateral bud near the base of the stem and it consists of a single swollen, starch-filled internode, and an apical primordium or bud. When the corm sprouts, the bud produces roots that rapidly extend downwards and a leaf which grows through the soil to emerge above the ground. The corm is surrounded by a specialized covering, the tunic, which provides protection from desiccation and possibly insect predation. The tunics are resistant to decay and accumulate from year to year, often forming a thick layer of characteristic appearance depending on the species (Figure 2). The tunics are usually fibrous but sometimes comprise unbroken membranous to woody layers. In *M. macronyx* the tunics consist of a peculiar spongy, pith-like material. The corm itself is renewed annually during the growing season, and the old corm tissue is reabsorbed by the plant. In rare cases the old corms persist (*M. vallisavium*), forming a chain behind the current season's corm.

LEAVES

Three distinct kinds of foliar organs are produced; true foliage leaves; modified basal non-green sheathing structures, the cataphylls, that are usually pale or brown; and entirely sheathing bract-like structures that surround the stem or inflorescence (Figure 2).

The cataphylls are most often pale and membranous, and decay at the end of each growing season. However, in some species the cataphylls persist, then usually becoming fibrous and they accumulate around the base of the plant forming what is called a neck. The cataphylls are occasionally useful in classification, particularly in subgenus *Grandiflora*, some species of which can be identified by their cataphylls alone. *Moraea galpinii* and *M. robusta* have rigid fibrous cataphylls that are almost unmistakable, while in *M. alticola* and *M. reticulata* the inner cataphyll forms an open fibrous network above the ground.

The assimilatory leaves are green, and usually elongate. They are bifacial, with an upper and lower surface, unlike most Iridaceae which have unifacial flat leaves with identical lateral surfaces. The leaves are usually channelled, sometimes flat, or in a small number of species, solidly terete (round in section) or with the margins tightly inrolled but with a narrow groove still present on the inner surface. In some species from Namaqualand and the Karoo the leaves may be variously modified, and undulate, twisted or coiled, the most striking being those of *Moraea tortilis* and *M. serpentina* which resemble a corkscrew. The leaves usually have a short pointed apex which may be the homologue of the unifacial leaf of other Iridaceae (Lewis, 1954), and this thick apex is believed to aid the emergence of the leaf through the ground. Leaf number varies from several to only one, and the number is usually

Figure 1. The details of a typical *Moraea* flower with *M. huttonii* as the example. A. flowering stem (× 0,5); B. flower (life size); C. flower with the tepals removed, showing the ovary, style branches and crests, filaments and one anther (life size).

constant for a species or even a subgenus. All members of subgenera *Monocephalae, Vieusseuxia* and *Grandiflora* have a single leaf. The position of the leaf is usually basal but in *M. fugax* and *M. gracilenta* (section *Subracemosae*) and *M. natalensis* and *M. inclinata* (section *Polyanthes*) the leaf is inserted well above the ground at the base of the first branch. Several leaves are characteristic of subgenus *Moraea* but within the subgenus several species have only a single leaf. It seems clear that the evolutionary trend in *Moraea* is for the reduction in leaf number.

Sheathing bract leaves are produced at the aboveground nodes of the stem and in general they resemble the spathes that surround the inflorescence. Sometimes the lower stem bracts have a free, leafy apex, and these are transitional between leaves and bracts. The bracts are usually acute to attenuate, but characteristically obtuse to truncate in subgenera *Monocephalae, Visciramosa* (except *Moraea bubalina*) and a few of subgenus *Moraea*, notably *M. margaretae*. The leaves, sheathing bracts and the spathes are usually smooth, but several species of subgenus *Vieusseuxia* and a few of subgenus *Moraea* have pubescent adaxial surfaces.

THE AERIAL STEM

The flowering stem is usually produced above the ground and is often branched. Repeated branching is a primitive feature, and the reduction in the number of branches specialized. Few species, however, are invariably unbranched except in subgenera *Monocephalae* and *Grandiflora*, in both of which branches are not normally produced. The branches of *M. rigidifolia* (section *Moraea*) and *M. pseudospicata* and *M. verecunda* (section *Polyanthes*) are vestigial so that the lateral inflorescences are virtually sessile.

The stems of species of subgenus *Visciramosa* are sticky, a transparent viscous substance being secreted from the nodes. Similar sticky nodes are usual also in subgenus *Monocephalae*. Pubescent stems are found in *Moraea villosa* and its close allies in subgenus *Vieusseuxia*.

The stems are entirely underground in the four species of section *Acaules*, in the Namibian species *M. graniticola* (section *Moraea*) and in *M. longiflora* (section *Tubiflora*).

THE INFLORESCENCE

The flowers are borne in terminal clusters, inflorescences, on the main and lateral stems. Each inflorescence unit, technically called a rhipidium, is enclosed in a pair of large, opposed bracts, the spathes, that entirely conceal the buds. The one to several flowers of each rhipidium issue from the stem apex and are exserted serially out of the spathes on rapidly elongating pedicels. Very short pedicels are found in the few species which have a perianth tube. The pedicels of the species of section *Acaules* (*Moraea ciliata* and its allies) are contractile and retract the fertilized ovary into the base of the spathes where the fruit develops.

THE FLOWER

The basic flower (Figure 1) consists of three outer and three inner tepals, the outer of which are usually larger and distinctly clawed. The inner tepals may be similar to the outer and thus clawed, or they may be considerably smaller. In many species of subgenus *Vieusseuxia* the inner tepals are reduced to tricuspidate, filiform or ciliate structures (Figure 3). Inner tepals are completely lacking in *Moraea barnardii, M. cooperi* and sometimes in *M. tripetala*. The outer tepals typically have suberect claws and spreading to reflexed limbs, at the base of which are distinct nectar guides. The inner tepals are often similarly oriented but are typically erect in subgenus

Figure 2. The variation in corms and cataphylls in *Moraea*. A. *M. lugubris*; B. *M. saxicola*; C. *M. margaretae*; D. *M. crispa*; E. *M. fugax*; F. *M. barkerae*; G. *M. lurida*; H. *M. graminicola*; I. *M. muddii*; J. *M. galpinii*; K. *M. alticola*. (A-G × approx. life size; H-K × 0,5).

Grandiflora and occasionally so in some species of subgenus *Moraea* (*M. serpentina*). Nectaries are present at the base of the outer tepal claws. The tepals are united in a tube in the two species of section *Tubiflora*, *M. cooperi* and *M. longiflora*, and in *M. graniticola* (section *Moraea*).

The three stamens are opposite the outer tepals and usually monadelphous, with the filaments partly united, but the filaments are free in subgenus *Visciramosa* and in a few species of subgenus *Moraea*, notably *M. ramosissima*. Whether free or united, the filaments usually form a column surrounding the style and they diverge where the style divides into broad flat branches. *Moraea tripetala* and *M. thomasiae* are unusual in having nearly free filaments that diverge almost from the base, thus lying parallel to the diverging style branches. The anthers are appressed to the style branches and are usually concealed by the claw of the outer tepals. In a few species the filaments are longer than the tepal claws and the anthers, then often bright red, are displayed above the tepals. The anthers are occasionally longer than the style branches, and very long in *M. insolens*, *M. neopavonia* and *M. gigandra* (subgenus *Vieusseuxia*) and a few other species.

The flattened and petal-like style branches are a characteristic feature of *Moraea*. The style branches bear a pair of terminal appendages, the crests (Figure 1), at the base of which is a transverse stigma, a simple or bilobed structure. The crests are usually erect and petal-like, but they are finely divided into a feathery plume in *M. lugubris*. In a handful of species (Goldblatt, 1986a) the style branches are narrow and reduced in size, and the crests are vestigial or completely lacking, and the style branches are then terminally forked and apically stigmatic (Figure 3B). Species with these reduced style branches also have subequal tepals with nectaries and nectar guides on both the inner and outer tepals. This type of flower is also found in *Homeria* and is believed to have evolved independently in both genera.

In one species, *Moraea hexaglottis* (section *Moraea*), the style branches are divided almost to the base into paired slender arms that extend outwards on either side of the opposed anthers in much the same way as in the genus *Hexaglottis*, another example of convergent floral evolution in *Moraea*.

The ovary is typically exserted from the spathes, but may be included throughout development. This occurs in the species with a perianth tube and is characteristic of sections *Subracemosae* and *Deserticola*.

FRUIT AND SEEDS

The fruit is a capsule that splits longitudinally into three, dry valves. Shape varies from globose to cylindric. Unusual nodding capsules are found in the related *Moraea vegeta* and *M. indecora*. Shortly-beaked capsules are found in sections *Deserticola* and *Subracemosae* and in *M. rigidifolia* (section *Moraea*). The seeds are usually angular and small, but in subgenera *Monocephalae* and *Grandiflora* the

Figure 3. Flower types in *Moraea*. A. *M. bipartita*, a typical unspecialized *Moraea* flower; B. *M. polyanthos*, with the style branches and crests reduced and nectar guides on both inner and outer tepals, an example of the *Homeria*-type flower; C. *M. unguiculata*, with the inner tepals tricuspidate and the inner cusp long and curving inwards; D. *M. insolens*, another *Homeria*-type flower, the anthers exceeding the style branches; E. *M. tripetala*, with the inner tepals reduced to short cilia-like structures; F. *M. villosa*, with tricuspidate inner tepals and large nectar guides. (approx. life size).

seeds are flattened and discoid. In several species of subgenus *Vieusseuxia* the seeds have a spongy, inflated testa that may aid in dispersal by wind.

CHROMOSOME CYTOLOGY

Chromosome number and morphology have played a considerable role in the present understanding of the systematics and relationships of *Moraea* (Goldblatt, 1971; 1976a; 1986a) and the natural relationships of many species have been established largely by their chromosome number and karyotype. The base number of the genus and for the ancestral *Dietes* is $x = 10$. *Moraea* is well known chromosomally, and some 78 species (65% of the genus and 75% of those found in southern Africa) have been counted at least once. All species of the primitive subgenera *Visciramosa* and *Monocephalae*, and most of subgenus *Moraea* have $x = 10$ and are diploid, $2n = 20$. In subgenus *Moraea* there has been a reduction in chromosome number in several lines. In *M. fugax*, section *Subracemosae*, the diploid number decreases from $2n = 20$ to 10, while in section *Moraea*, *M. papilionacea* has $2n = 18$ and 16, *M. indecora* $2n = 16$, and *M. fergusoniae*, $2n = 12$. In section *Polyanthes* the base number is $x = 6$, and species are either diploid or polyploid; *M. stricta* has $2n = 24, 36$, and 48 and *M. crispa* $2n = 12, 24, 36$ and 48; while *M. inclinata* is apparently a hypopolyploid with $2n = 22$.

All species of subgenera *Vieusseuxia* and *Grandiflora* have $x = 6$ but have different karyotypes and it is likely that the common base was achieved independently in each. In subgenus *Vieusseuxia* the karyotype comprises acrocentric and metacentric chromosomes, while in subgenus *Grandiflora* all the chromosomes are strongly acrocentric to telocentric. Polyploidy is generally rare in *Moraea*, occurring in *M. margaretae* (section *Moraea*), $2n = 40$, the three species of section *Polynthes* mentioned above, and in *M. tulbaghensis* and *M. villosa* subsp. *villosa* (subgenus *Vieusseuxia*), both $2n = 24$, but subsp. *elandsmontana* is diploid, $2n = 12$. Occasional tetraploid populations have also been recorded in *M. ciliata* (section *Acaules*).

Floral Biology and Pollination

The flowers of species of subgenera *Visciramosa*, *Monocephalae* and *Moraea* are short-lived, lasting less than a day. Some species have particularly fugacious flowers that open in the late afternoon and fade shortly after sunset (e.g. *M. viscaria, M. macgregorii, M. gracilenta*). The timing of flowering is generally constant for a species and is probably related to the activity of pollinating insects. The flowers of subgenera *Vieusseuxia* and *Grandiflora* last 2–3 days and the time of opening and fading of the flowers is less significant for these species, since they are accessible to insects at all times of the day. In nearly all species with both flower types, nectar is produced at the base of the outer tepal claws. In the several species with a *Homeria*-type flower, with reduced style branches and nectar guides on the inner and the outer tepals, nectar is produced at the base of both tepal whorls.

Nearly all species are strongly self-incompatible and rely on insect visitors to accomplish pollination. The flowers are usually brightly coloured and have contrasting nectar guides and often a strong scent as additional stimulus to potential pollinators. The only recorded example of self-compatibility and autogamy in *Moraea* is in *M. vegeta* which regularly sets full fruit without cross-pollination. However, this does not apply to all populations and those from the Darling district, north of Cape Town, which have somewhat larger flowers than elsewhere, are self-incompatible. On the Cape Peninsula and in the Stellenbosch district *M. vegeta* is weedy in lawns and pastures. No doubt its weedy habit is related to its self-compatibility.

Little is known about pollination in *Moraea*. Scott Elliot (1890: 380–382) made a few random observations for some Cape species. Small bees are the most important insect visitors and the flowers of the majority of species of *Moraea* seem well-adapted to bee pollination. A bee usually orients itself by the nectar guides on the outer tepals, crawls up the tepal limb and then pushes apart the tepal and closely-opposed style branch as it climbs towards the base of the tepal claw where the nectar is located. In doing so it first brushes past the stigma lobe and then the anther from which pollen is deposited on its back and head. Pollen is deposited on the stigma lobe of the next flower visited as the bee climbs down the tepal claw. Beetles are common visitors to *Moraea* flowers in the south-western Cape especially late in the season, but these insects seldom, if ever, accomplish pollination, and they probably do more damage to the flowers as they clamber over the delicate tepals, randomly consuming the flower parts. Other visitors that have been noted are small, day-flying moths and brown, skipper butterflies. Vogel (1954) has suggested that *M. tripetala* is pollinated by butterflies, but I have regularly seen small black-and-white carpenter bees visiting the species. The handful of late afternoon flowering species may be pollinated by moths, including, according to Vogel, the sweetly-scented *M. viscaria* (syn. *M. odorata*). I have also seen small moths visiting the evening-flowering *M. gracilenta*, which has similar sweet-scented flowers. Vogel's suggestion of fly pollination for the dull-coloured and foul-scented *M. lurida* is surely correct. The

Table 1. Synopsis of *Moraea*. Species marked with an asterisk (*) are described in this paper for the first time. Names in parentheses are species that do not occur in southern Africa, but they are included here for completeness. Only the species dealt with in this treatment are numbered.

SUBGENUS 1. *VISCIRAMOSA* (Goldblatt, 1976a)
1. *M. bubalina* Goldblatt–north-western Cape
2. *M. bituminosa* (Linnaeus fil.) Ker–south-western Cape
3. *M. elsiae* Goldblatt–south-western Cape
4. *M. viscaria* (Linnaeus fil.) Ker–south-western Cape
5. *M. inconspicua* Goldblatt–Namaqualand to Humansdorp, southern Cape

SUBGENUS 2. *MONOCEPHALAE* (Goldblatt, 1976a)
6. *M. vallisavium* Goldblatt–Klein River Mountains, Caledon district, south-western Cape
7. *M. angusta* (Thunberg) Ker–south-western and southern Cape
8. *M. anomala* G. Lewis–south-western Cape
9. *M. neglecta* G. Lewis–south-western Cape

SUBGENUS 3. *MORAEA*
Section *Moraea*
10. *M. ramosissima* (Linnaeus fil.) Druce–western and southern Cape to Grahamstown
11. *M. garipensis* Goldblatt–Orange River Valley below Vioolsdrif
12. *M. namaquamontana* Goldblatt–mountains of the Richtersveld, at high elevations
13. *M. gawleri* Sprengel–Namaqualand, south-western and southern Cape
14. *M. vegeta* Linnaeus–south-western Cape
15. *M. indecora* Goldblatt–northern Namaqualand
16. *M. linderi* Goldblatt–Piketberg, south-western Cape
17. *M. margaretae* Goldblatt–Namaqualand
18. *M. papilionacea* (Linnaeus fil.) Ker–south-western Cape
19. *M. fergusoniae* L. Bolus–southern Cape
20. *M. lugubris* (Salisbury) Goldblatt–south-western Cape
21. *M. nubigena* Goldblatt–Brandwacht Mountains, south-western Cape
22. *M. serpentina* Baker–Namaqualand
23. *M. tortilis* Goldblatt–Namaqualand
24. *M. hexaglottis* Goldblatt–Huib Plateau, southern Namibia
25. *M. rigidifolia* Goldblatt–Süd Witpütz, south-western Namibia
26. *M. graniticola* Goldblatt–Aus, south-western Namibia

Section *Acaules* (Baker, 1896)
27. *M. falcifolia* Klatt–Namaqualand, Karoo, dry parts of south-western Cape
28. *M. ciliata* (Linnaeus fil.) Ker–Namaqualand, south-western Cape to Eastern Cape, and local in the Karoo
29. *M. macronyx* G. Lewis–south-western and southern Cape
30. *M. tricolor* Andrews–south-western Cape

Section *Deserticola* (Goldblatt, 1976a)
31. *M. saxicola* Goldblatt–Namaqualand
32. *M. bolusii* Baker–Namaqualand
33. *M. namibensis* Goldblatt–south-western Namibia
34. *M. macgregorii* Goldblatt–southern Namaqualand

Section 4. *Subracemosae* (Baker, 1896)
35. *M. gracilenta* Goldblatt–western Cape
36. *M. macrocarpa* Goldblatt–western Cape
37. *M. fugax* (de la Roche) Jacq.–Namaqualand to south-western Cape
——— subsp. *filicaulis* (Baker) Goldblatt–Namaqualand and north-western Cape

Section 5. *Tubiflora* (Goldblatt, 1976a)
38. *M. cooperi* Baker–south-western Cape
39. *M. longiflora* Ker–Kamiesberg, Namaqualand

Section 6. *Flexuosa* (Goldblatt, this paper)
40 *M. flexuosa* Goldblatt–Anenous flats, Richtersveld

Section 6. *Polyanthes* (Goldblatt, 1976a)
41. *M. bipartita* L. Bolus–Little Karoo, southern and eastern Cape
42. *M. polyanthos* Linnaeus fil.–Little Karoo and southern Cape
43. *M. crispa* Thunberg–Karoo, Roggeveld and Cedarberg
44. *M. pseudospicata* Goldblatt–Nieuwoudtville plateau
45. *M. verecunda* Goldblatt–Nieuwoudtville plateau
46. *M. polystachya* Thunberg–Karoo, eastern Cape, Little Karoo and central Namibia
47. *M. venenata* Dinter–Karoo and south to central Namibia
48. *M. speciosa* (L. Bolus) Goldblatt–western Karoo
49. *M. deserticola* Goldblatt–Knersvlakte, southern Namaqualand
50. *M. carsonii* Baker–northern Namibia, Botswana, Zimbabwe, Zambia, Malawi, southern Tanzania and south-eastern Zaire
(*M. callista* Goldblatt–Southern Highlands, Tanzania)
(*M afro-orientale* Goldblatt–East Africa, southern Sudan)
(*M. iringensis* Goldblatt–Southern Highlands, Tanzania)
51. *M. elliotti* Baker–eastern Cape, Natal, Transvaal and Malawi
52. *M. exiliflora* Goldblatt–Swartberg Mountains, Ladismith, southern Cape
53. *M. natalensis* Baker–Zimbabwe, Zambia, Malawi and eastern South Africa
54. *M. inclinata* Goldblatt–Drakensberg, Natal and Transkei
55. *M. stricta* Baker–eastern Cape to Ethiopia
56. *M. alpina* Goldblatt–Drakensberg, Natal and Lesotho
57. *M. thomsonii* Baker–eastern Transvaal, Malawi and southern Tanzania

SUBGENUS 4. *VIEUSSEUXIA* (Baker, 1892)

Section 7. *Thomasiae* (Goldblatt, 1976a)

58. *M. thomasiae* Goldblatt–Worcester to Little Karoo

Section 8. *Vieusseuxia*

59. *M. algoensis* Goldblatt–Little Karoo and south-eastern Cape to Port Elizabeth
60. *M. worcesterensis* Goldblatt–Worcester, south-western Cape
61. *M. incurva* G. Lewis–Wellington district, south-western Cape
62. *M. barkerae* Goldblatt–Cedarberg Mountains, south-western Cape
63. *M. debilis* Goldblatt–Caledon district, south-western Cape
64. *M. longiaristata* Goldblatt–Caledon Zwartberg, south-western Cape
65. *M. barnardii* L. Bolus–Caledon district, south-western Cape
66. *M. tripetala* (Linnaeus fil.) Ker–south-western and southern Cape, western Karoo
67. *M. unguiculata* Ker–south-western and southern Cape, Namaqualand and Karoo mountains
68. *M. trifida* R. Foster–Drakensberg, Transkei, Natal, Lesotho to south-eastern Transvaal
69. *M. marionae* N. E. Brown–eastern Transvaal, Swaziland escarpment and Zululand
70. *M. pubiflora* N. E. Brown–eastern Transvaal and Swaziland
71. *M. brevistyla* Goldblatt–Katberg, eastern Cape through Natal and Lesotho to Wakkerstroom, southern Transvaal
72. *M. albicuspa* Goldblatt–southern Drakensberg, Natal, and Transkei
73. *M. dracomontana* Goldblatt–Drakensberg, Natal and Lesotho
74. *M. modesta* Killick–eastern Transvaal, Natal, Lesotho, and Transkei
75. *M. tricuspidata* (Linnaeus fil.) G. Lewis–south-western and southern Cape to Grahamstown
76. *M. bellendenii* (Sweet) N. E. Brown–south-western and southern Cape
77. *M. lurida* Ker–Caledon district to Bredasdorp, south-western Cape
78. *M. insolens* Goldblatt–Caledon district, south-western Cape
79. *M. atropunctata* Goldblatt–Eseljacht Mountains, south-western Cape
80. *M. caeca* Goldblatt–Piketberg district, south-western Cape
81. *M. aristata* (de la Roche) Asch. & Graeb.– Cape Peninsula
82. *M. amissa* Goldblatt–Malmesbury district, south-western Cape
83. *M. villosa* (Ker) Ker subsp. *villosa*–south-western Cape
 ——— subsp. *elandsmontana* Goldblatt–Elandkloof Mountains, western Cape
84. *M. calcicola* Goldblatt–Saldanha district, south-western Cape
85. *M. loubseri* Goldblatt–Langebaan, south-western Cape
86. *M. tulbaghensis* L. Bolus–Tulbagh district to Gouda, south-western Cape
87. *M. neopavonia* Foster–western Cape
88. *M. gigandra* L. Bolus–Piketberg district, south-western Cape

SUBGENUS 5. *GRANDIFLORA* (Goldblatt 1976a)

89. *M. muddii* N. E. Brown–Katberg, eastern Cape to Zimbabwe and Mozambique
90. *M. inyangani* Goldblatt–Inyanga Highlands, Zimbabwe
 (*M. angolensis* Goldblatt–southern Angola)
91. *M. unibracteata* Goldblatt–Natal Midlands
92. *M. carnea* Goldblatt–Drakensberg, Natal
93. *M. ardesiaca* Goldblatt–Drakensberg, Natal
94. *M. graminicola* Oberm. subsp. *graminicola*–Natal Midlands to coast
 ——— subsp. *notata* Goldblatt–Transkei
95. *M. hiemalis* Goldblatt–Natal Midlands
96. *M. moggii* N. E. Brown subsp. *moggii*–northern and eastern Transvaal and Swaziland
 ——— subsp. *albescens* Goldblatt–south-eastern Transvaal and northern Natal
97. *M. spathulata* (Linnaeus fil.) Klatt–southern Cape to eastern Zimbabwe and Mozambique
98. *M. alticola* Goldblatt–Drakensberg, Natal and Lesotho
99. *M. reticulata* Goldblatt–Winterberg Mountains, eastern Cape
100. *M. galpinii* (Baker) N. E. Brown–eastern Transvaal, northern Natal
101. *M. robusta* (Goldblatt) Goldblatt–eastern Transvaal, northern Natal, Transkei
102. *M. huttonii* (Baker Oberm.–Drakensberg of Natal, Lesotho, south-eastern Transvaal, Transkei and eastern Cape
103. *M. schimperi* (Hochstetter) Pichi-Sermolli–Zimbabwe and Angola to Ethiopia, Cameroon and Nigeria
 (*M. bella* Harms–southern Tanzania, Malawi, northern Mozambique, Zambia and southern Zaire
 (*M. verdickii* De Wildeman–eastern Angola, Zambia, Zaire, Malawi, southern Tanzania and Mozambique)
 (*M. macrantha* Baker–Malawi, eastern Zambia and southern Tanzania)
 (*M. ventricosa* Baker–Zambia, Zaire, Burundi and southern Tanzania)
 (*M. textilis* Baker–Angola and western Zambia)
 (*M. tanzanica* Goldblatt–southern Tanzania and Malawi)
 (*M. brevifolia* Goldblatt–Zambia)
 (*M. clavata* Foster–Angola and Zambia)
 (*M. upembana* Goldblatt–southern Zaire)
 (*M. bovonei* Chiovenda–southern Zaire)
 (*M. balundana* Goldblatt–southern Zaire)
 (*M. unifoliata* Foster–southern Zaire)

bright, glossy green flies that pollinate the flowers of many species of similarly scented *Homeria* (Goldblatt, 1981a) can often be seen actively pollinating *M. lurida* which is not visited by bees.

This is about all that has been recorded about pollination of *Moraea*. However, given the degree of floral diversity and the various floral modifications and the different floral phenologies of the flowers of many species, it seems likely that there are significant differences in their pollinators. Much has still to be learned of this aspect of the biology and evolution of *Moraea*.

Conservation

The majority of southern African species of *Moraea* have fairly wide ranges and are consequently not immediately threatened or endangered. However, there are several species, especially in the south-western Cape that have limited ranges, sometimes being known from only a single population. Such very local species are by their very nature threatened, although not necessarily under immediate danger. The flora of the south-western Cape comprises a large number of species of very restricted distribution, and conservation presents particularly difficult problems here because only a limited number of small preserves can possibly be established. The situation is particularly severe in the south-western Cape lowlands that comprise prime agricultural land, and what little remains of the natural vegetation is being affected by such factors as fertilizer run-off, weed killers applied to nearby fields and changes to the water table as streams are channelled or dammed and vleis and marshes are drained. Species native to lowland habitats are thus under increasing threat and a few are in immediate danger of extinction in their natural habitats. A total of 13 of the approximately 60 species of *Moraea* in the south-western Cape occur within a one-degree-square grid of latitude and longitude, and there is reason to believe that the distribution records for these species are fairly complete. Some of these local species are known from single gatherings or from one or two populations only and can be regarded as potentially endangered species, while others have in the last fifty years been so severely affected by the activities of man that they are in imminent danger of extinction or even already extinct.

Only one species is believed to actually be extinct, *Moraea incurva* Lewis, known from two collections, one made in the 1820s and the other in the 1930s, from lowlands in the Tulbagh district, now under intensive cultivation. A second species, *M. amissa*, known from only one collection when described in 1976 (Goldblatt, 1976b), has now been re-collected at or near the type locality, north of Malmesbury, thanks to the work of Chris Burgers of the Cape Department of Nature Conservation. The species is however, very rare, and part of the remaining population was exterminated during recent road construction. The very beautiful *M. aristata*, very well represented in European herbaria and fortunately still in cultivation under the name *M. glaucopis*, is reduced in the wild to a tiny population at the Royal Observatory at Cape Town. Numbers are so low that few if any of the handful of plants at the site flower simultaneously so that reproduction rarely occurs. Plants have now been brought into cultivation and numbers have been increased by hand hybridization. The future of *M. aristata* seems assured through the efforts of horticulture.

Moraea insolens from Drayton siding near Caledon is also reduced to very few individuals, and the main population was ploughed under when the area was planted to wheat. Individuals have been observed on the periphery of this field but numbers are difficult to determine as the shy-flowering species blooms well only after fire (Goldblatt, 1972). The South African Railways, which own the land on which the last few wild individuals of *M. insolens* occur, has recently established a small preserve for the species (Goldblatt, 1981c) and if the area can be carefully watched and alien weeds removed periodically, there seems no reason for this beautiful species to decline further. The last species in danger, at least in the wild, is *M. loubseri*, known from only a single granite hill, Olifantskop, outside Langebaan near Saldanha Bay. This species was only discovered some twelve years ago when the hill was turned into a quarry (Goldblatt, 1976b). A part of Olifantskop has now been fenced off, and as quarrying activity has ceased, the immediate threat has been removed. It is however, desirable to have what is left of Olifantskop made a permanent reserve under the control of an official conservation authority.

A number of other species have recently been much reduced in range owing to the spread of agriculture, mainly wheat farming, on the rolling clay lowlands east and north of Cape Town, and species adapted to this habitat are becoming seriously threatened. Three species endemic to the Swartland, north of Cape Town, *Moraea tulbaghensis*, *M. neopavonia* and *M. gigandra*, all large-flowered, so-called peacock Moraeas, fall in this category. They were once much more common and are now reduced to a few scattered populations among the wheatlands or on the lower slopes of the surrounding mountain ranges. *Moraea debilis*, restricted to the Caledon district west of Cape Town grows in similar conditions, and the spread of agriculture here too has adversely affected this species, which was more common in the past. Also under immediate threat is *M. atropunctata*, described as recently as 1982. The only known plants grow close to wheat and barley fields on a single farm in the Caledon district. Further agricultural activity may result in the extinction of these four species. Other extremely local Cape and Namaqualand species include *Moraea*

indecora, M. garipensis, M. flexuosa, M. macgregorii, M. barnardii, M. longicuspa and *M. barkerae*. There is no evidence that these were ever much more widespread than they are now, nor do they appear to be threatened at present as they grow in areas unsuitable for agriculture and away from major population centres.

In the summer-rainfall area the conservation situation is less serious. Species here tend to have wider ranges than the winter-rainfall area species, and grow far from large urban areas. However, the extensive planting of pine plantations in the eastern Transvaal and Swaziland has already drastically reduced the range of the several species that grow here. Further, the plantations themselves have changed the water relations of surrounding areas, gradually altering habitats nearby. As a result Moraeas are becoming rarer, especially in the eastern Transvaal. However, no species is known to be under immediate threat.

Of total of 103 species of *Moraea* in southern Africa, one from the winter rainfall region is probably extinct, and at least six more are in immediate danger, at least in the wild, being severely reduced in range, although three of these are in cultivation. The south-western Cape is well known for its many very local endemics and this small part of the world probably harbours more rare and seriously-endangered plant species than anywhere else. Solutions to this disturbing situation are not simple, as the spread of agriculture in this region is inevitable as the human population continues to expand. In the south-western Cape an added consideration is the threat to native flora posed by weedy exotics, especially the Australian *Hakea*, *Acacia* and *Leptospermum* and the European *Pinus pinaster* which have spread uncontrollably covering thousands of square kilometres and entirely choking out the native flora in many places. In this light it is difficult to see viable ways to save threatened taxa or to prevent further erosion of their populations.

The introduction of species of geophytes such as Iridaceae to botanic gardens is unlikely to be a long-term solution except perhaps for the most striking species. Natural disease, predation and neglect will almost certainly eventually eliminate species from gardens unless considerably more attention than is currently possible is devoted to the care of such plants. The establishment of many carefully-managed small nature reserves throughout the south-western Cape may prove more workable, and seems in my opinion a better solution to the preservation of threatened species.

Cultivation

Few species of *Moraea* are at present in cultivation, and hardly any are available in the nursery trade. However, Moraeas are easy to grow and maintain in gardens, and several make strikingly beautiful pot plants, so that the effort to obtain plants is well worth the trouble. Some species are available from nurseries specializing in indigenous southern African plants, and seeds of several more are available from the National Botanic Gardens, Kirstenbosch, most easily through membership of the Botanical Society of South Africa which offers a seeds list annually. There are also a few specialist nurseries that deal only in native bulbous plants.

Once seeds or corms have been obtained, more than half the battle is over. Seeds germinate quickly, but plants do not flower until the second year at the earliest, and sometimes not until the third. Corms, of course, flower a few months after planting and must be treated in the same way as other bulbous plants. Corms should be planted two to three times as deep as their diameter, and watered sparingly, but after sprouting they should be kept moist. Moraeas are not especially sensitive to drying-out and prefer to be grown in a well-drained medium so that their roots are never too wet. Occasionally plants in pots may rot if over-watered. In the open ground I have not found this to be a problem.

When planting Moraeas it is essential to be aware of the general climatic requirements of your plants, particularly whether the species is from the winter- or summer-rainfall area. Winter-rainfall area species should be planted in late March or April, at the time when winter rains may be expected in the south-western Cape. Species from the eastern half of southern Africa respond to summer rains and must be planted in September or October. Planting times must be reversed in the Northern Hemisphere so the winter-growing species should be planted in October and summer-growing species in March or April. The larger species like *Moraea spathulata* can be left in the ground permanently, but small species should be lifted at the end of the growing season, mainly to prevent inadvertant damage to the dormant corms by cultivation around them. There is also a danger of corms rotting from being too moist during the resting period. Plants in pots can be kept dry during the dormant period, and watered again at the appropriate time.

Moraeas do not need much fertilizer. A teaspoonful of slow-release, balanced bulb fertilizer per plant pot is adequate for a growing season. Alternatively pot plants can be given a weak liquid fertilizer application about every three weeks until the end of flowering. More important than fertilizer is the soil medium which must be well drained. I find the addition of peat-moss gives good results, but other growers have been successful with very sandy soils or an ordinary, loamy, garden soil, as long as drainage is adequate.

The most desirable species are those with large, brightly-coloured flowers such as the western Cape peacock species, of which *Moraea villosa* is the most well-known and readily available. Equally

striking are *M. neopavonia*, *M. gigandra* and *M. aristata*, the last mentioned widely cultivated in Europe, but hardly known to southern African gardeners.

Several summer rainfall species also make superb garden subjects. Of these *Moraea spathulata* is the most common and it is found occasionally in cultivation. I have found it perfectly hardy thoughout southern Africa and it easily maintains itself in a garden situation. The large flowers last for up to three days and a clump makes a very fine display. The broad, strap-shaped leaves are an attractive accent even when the flowers are past so that the species is especially useful. Other related summer-rainfall area species such as *M. schimperi* and *M. moggii* have also been found to be successful in garden conditions. The semi-aquatic *M. huttonii* would probably be as successful, but it has not, to my knowledge, been tried in gardens.

The other group of Moraeas that are useful garden subjects are those that produce many flowers, so that even when the individual blooms only last a single day, the flowering season continues for weeks as flowers are produced successively from several branches. Most striking are species like *M. polyanthos* from the Little Karoo, and the very tall *M. ramosissima*. Species from desert and semi-desert areas often need special attention and are for the specialist bulb grower. These are often smaller species that are best grown in rock gardens with other small plants so that they are not lost or hidden by more robust vegetation.

These general comments on the cultivation of *Moraeas* are supplemented by more specific paragraphs in the treatments for many species in the main text.

Distribution and Evolution

The geographical distribution of *Moraea* covers most of sub-Saharan Africa, from Nigeria and Ethiopia in the north to the Cape (Figure 5). Only one species, *M. schimperi* occurs in Nigeria and only two in Ethiopia. Species numbers increase southwards and the highest concentration is in the south-western Cape and adjacent Namaqualand where members of all the subgenera occur, and subgenera *Visciramosa* and *Monocephalae* are endemic. These two subgenera may be viewed as relicts of very old lines of evolution that survive in the unusual winter-rainfall climate and the peculiar soils of the region. Most species of subgenus *Moraea* are also found in the winter-rainfall area and several unusual species have recently been discovered in south-western Namibia where they survive on the limited winter precipitation that falls in this desert zone. These species are apparently ancient relics, the ancestors of which must have once thrived here when the climate was wetter, and they may be the remnants of the stock that radiated in the more amenable climate of the south-western Cape. In subgenus *Moraea*, only section *Polyanthes* has radiated outside the winter-rainfall area. Its origins seem to be in the Cape Region and adjacent Karoo, but species extend through the summer-rainfall part of southern Africa into tropical Africa, where a few are endemic (Goldblatt, 1977), and others are shared with southern Africa. One species, *M. stricta* extends from the eastern Cape to Ethiopia, but others have much more restricted ranges.

Subgenus *Vieusseuxia* is also centred in the south-western Cape and it has radiated extensively, giving rise to many unusual and lovely species, often with large brightly-coloured flowers with striking markings. One line of the subgenus extends into the Drakensberg as far north as the eastern Transvaal, where several species have evolved.

Only subgenus *Grandiflora* has radiated extensively in the summer-rainfall area. *Moraea spathulata* extends from George in the southern Cape to Zimbabwe and it is the only species of this subgenus that occurs in the winter-rainfall area. The centres of distribution and radiation for subgenus *Grandiflora* are the Natal and Transvaal Drakensberg and the central African plateau. The widespread *M. schimperi* extends from eastern Zimbabwe to Ethiopia and Nigeria, but other species have more restricted ranges, either in southern Tanzania and adjacent Malawi and Zambia, or Angola, southern Zaïre and northern Zimbabwe.

The general pattern of distribution suggests that *Moraea* may have evolved in south central Africa when the climate became increasingly dry and seasonal during the Oligocene. At this time cold Antarctic waters moved into the Atlantic causing drying of the climate in south tropical Africa and as a consequence closed-canopy forests began to give way to open habitats. An extended dry season would have favoured geophytic plants, especially those with highly specialized underground organs, enabling them to survive long dry periods. During the extreme arid periods of the late Pliocene and the Pleistocene the climate of south-western Africa probably became too severe for most geophytes except in isolated habitats where a range of *Moraea* species persist today. The extreme arid conditions in south central Africa were reached at the same period that a mediterranean climate was being established along the Cape west and south coasts. These conditions eliminated forest and savanna over the area but made it possible for geophytes to become established and to radiate into habitats that were opening up to plants that could survive the hot, dry, summer conditions. *Moraea* fitted the conditions admirably and must have radiated rapidly at the end of the Pliocene. This is probably when subgenus *Vieusseuxia* evolved to fill several lowland and montane habitats in the south-western Cape.

The high concentration of species in the south-west is a common pattern for many genera in the

southern African flora, and in this respect *Moraea* is by no means unusual. It seems likely that the combination of alternating cycles of wet and dry climate here during the late Pliocene and the Pleistocene, together with a landscape that is a mosaic of different soils and a rugged topography, were the driving force that resulted in the radiation and evolution of so many species in many genera of the region. Rapid climatic change has another effect, extinction, and the large number of species of very limited distribution in the winter-rainfall area are the result either of near extinction over geological time or of very recent speciation with no subsequent dispersal. Extinction is also the most likely explanation for the presence of the large number of taxonomically isolated species of *Moraea* in Namaqualand and the south-western Cape. These species are regarded as relicts and their close relatives are

Figure 4. The geographical distribution of *Moraea*. The genus is confined to Africa south of the Sahara.

believed to have become extinct during unfavourable periods of the past few million years.

The pattern of species distribution elsewhere in southern Africa and in tropical Africa is rather different. Species tend to have wide ranges, *M. spathulata*, *M. schimperi* and *M. stricta* are good examples, but a few species of *Moraea* have the restricted distributions that are found in the winter-rainfall area, and those that have limited ranges are usually found in specialized habitats, such as very high-altitude, wet sites for *M. inyangani* in Inyanga in Zimbabwe.

Subgeneric Classification

The subgeneric classification established in 1976 has been changed a little in this treatment. The small, phylogenetically unspecialized subgenera *Visciramosa* and *Monocephalae* are now placed at the beginning of the genus. Also, sectional status has been given to two taxonomically isolated species: *Moraea flexuosa* to section *Flexuosa* (subgenus *Moraea*), and *M. thomasiae* to section *Thomasiae* (subgenus *Vieusseuxia*). Lastly, section *Polyanthes* has been moved from subgenus *Vieusseuxia* to subgenus *Moraea*. The subgenera and their important characteristics are outlined below. The species assigned to each subgenus are listed in Table 1.

Subgenus *Viscramosa*, defined by its sticky stems, two or more leaves, several branches and fugacious flowers with completely free stamens is a close-knit alliance of five species, all of the south-western Cape and Namaqualand. It appears to be isolated from the rest of the genus and is probably a very ancient lineage. The basic chromosome number for *Moraea*, $x = 10$, is preserved in all five species.

Subgenus *Monocephalae*, possibly related to subgenus *Visciramosa*, comprises four species, all of the south-western Cape. The species have a single, usually terete leaf, the stems are unbranched and sometimes sticky. The flowers are unspecialized but the filaments are united for a short distance. Like subgenus *Visciramosa*, subgenus *Monocephalae* seems to be a very old and isolated line. The base number is $x = 10$.

Subgenus *Moraea* is by contrast, large and diverse, and united by the unspecialized fugacious flowers. It is morphologically very variable. The least specialized species have several leaves and branched stems, but all members of section *Deserticola* have a single leaf, while species of section *Acaules* are acaulescent. In section *Subracemosae* the one or two leaves are inserted well above the ground close to the base of the branches. A perianth tube is characteristic of section *Tubiflora*, one species of which lacks inner tepals and the other is acaulescent. The stamens are partially united in all species of the subgenus except *M. ramosissima* in which they are free. Basic chromosome number is $x = 10$ but aneuploid decrease has occurred in several sections (see Cytology), notably section *Subracemosae*, in which $2n = 20, 18, 16, 14, 12$ and 10 occur in *M. fugax*. Section *Polyanthes*, transferred from subgenus *Vieusseuxia*, has $x = 6$. The flowers are fugacious and the inner tepals large and unmodified so that it seems to fit better in subgenus *Moraea*. Several species have only one leaf but the less specialized ones have three or more leaves. All sections of subgenus *Moraea* are centred in the winter-rainfall area, and only section *Polyanthes* extends outside the area, several species reaching tropical Africa, and *M. stricta* as far as Ethiopia.

The flowers of subgenera *Vieusseuxia* and *Grandiflora* are specialized in being long-lived, lasting at least two days, and a single leaf is characteristic of both. In subgenus *Vieusseuxia*, the inner tepals are reduced in size, and either have erect, narrow limbs or are tricuspidate, filiform or ciliate to absent completely (*Moraea barnardii*). The flowers are often relatively small but very variable in form and colour. The basic chromosome number is $x = 6$, and the karyotype consists of metacentric and acrocentric chromosomes. Within the section, a group of species around *M. villosa* have large flowers with orbicular outer tepal limbs and usually conspicuous eye-like nectar guides consisting of concentric bands of contrasting colour. These species are often referred to as the peacock alliance. Subgenus *Vieusseuxia* is centred in the south-western Cape, but species extend northwards into Namaqualand and eastwards through the Drakensberg to the eastern Transvaal.

Large flowers characterize subgenus *Grandiflora*. The inner tepals are typically erect (laxly spreading in *Moraea robusta*) and the flowers are relatively uniform in structure and colour, either yellow to white or shades of blue (pinkish in *M. carnea*). The stems are unbranched except in *M. huttonii* and sheathed by large, often overlapping bracts. The base number is $x = 6$ and the chromosomes are all strongly acrocentric. Subgenus *Grandiflora* is largely confined to eastern, southern Africa and the tropics. Only *M. spathulata* occurs in the winter-rainfall area, extending as far to the west as George in the southern Cape. Centres of species diversity and speciation in the subgenus are the Natal and Transvaal Drakensberg, northern Malawi and southern Tanzania, and eastern Angola, adjacent Zambia and southern Zaïre. The most widespread species is *M. schimperi* which ranges from Zimbabwe to Ethiopia in the north and Cameroon and Nigeria in the west.

Relationships and Systematic Position of *Moraea*

Moraea is a member of Iridoideae, one of the two major subfamilies of Iridaceae, and belongs in the predominantly Old World tribe Irideae (species of *Iris* also occur in North America). Within this group, *Moraea* is distinguished by its bifacial leaf and distinctive apically rooting corm, two features that it shares with only a handful of other genera, including *Homeria*, *Galaxia*, *Hexaglottis* and *Gynandriris*, all centred in the south-western Cape, and poorly or not at all represented outside this area of winter rainfall and summer drought.

Moraea is most closely related to *Homeria* (31 spp.–Goldblatt, 1980b; 1981a), from which it differs in the details of the flower, *Homeria* having similar inner and outer tepals, both usually having nectar guides, filaments united in a slender column, and style branches reduced and narrow and lacking crests. There is often difficulty in distinguishing some species of *Moraea* from *Homeria* because a similar type of flower has evolved independently in several lines in different subgenera of *Moraea*. However, almost all the species of *Moraea* with these floral modifications have blue to purple flowers, whereas all species of *Homeria* have yellow, pink or orange flowers.

The African cormous and bifacial-leafed genera of Irideae are probably derived from ancestral stock similar to the small modern genus *Dietes* (6 spp.– Goldblatt, 1981b), that has often in the past been included in *Moraea*. *Dietes* also has *Iris*-like flowers but differs from *Moraea* in its unifacial sword-shaped leaves of the basic type found in Iridaceae, and in having a rhizome, both these features considered unspecialized (Goldblatt, 1981b). In addition, all *Dietes* species are evergreen, a characteristic that is probably also primitive. *Dietes* fits very well the concept of a very primitive genus of tribe Irideae and it is probably close to the lines that give rise to *Iris* in the Northern Hemisphere and to *Moraea* in Africa. Of the two, *Iris* is perhaps the less specialized, since most species have a rhizome and unifacial leaves, and technically *Iris* differs from *Dietes* in its deciduous habit and in having the tepals united in a tube. Some species of *Iris* are more specialized, having bulbs and bifacial leaves (subgenera *Scorpiris*, *Xiphium*, *Reticulata*), but the less specialized species (subgenera *Iris* and *Crossiris*) are closer to *Dietes* than to *Moraea*.

The large genus *Moraea* has probably given rise to a few small segregate genera, of which *Gynandriris* is the largest. Seven of the nine species of *Gynandriris* (Goldblatt, 1980a) occur in southern Africa and two in the Mediterranean and Middle East. *Gynandriris* is characterized by having a long, slender, tubular ovary, the upper part of which is sterile and simply functions as a means of raising the flower out of the spathes. The ovary tube or beak resembles a perianth tube but its origin is quite different. The two northern species of *Gynandriris* have often been included in *Iris*, but there is no doubt that the genus is very closely allied to *Moraea*, possibly derived from section *Polyanthes*.

Barnardiella, a monotypic genus of Namaqualand has an elongated tubular ovary exactly like that of *Gynandriris* (Goldblatt, 1976c), but has flowers of the *Homeria*-type with similar subequal tepals and reduced style branches. It has a basic chromosome number of $x = 10$, and it now seems likely that it is most closely related to the newly-discovered *Moraea rigidifolia* from south-western Namibia (Goldblatt, 1986a), which has the same basic number and similar unusual sessile lateral inflorescences.

The third genus that seems especially close to *Moraea* is *Rheome* (Goldblatt, 1980b), which comprises two or three species with *Homeria*-like flowers and an unusual vegetative morphology in which the leaves are crowded together well above the ground, the inner spathes are truncate and the outer often have a free apex. The corms are also distinctive, being dark brown, woody and initially unbroken, although fragmenting with age. Similar corm tunics are found in *M. linderi* and *M. margaretae* and it now seems likely that *Rheome* may be related to these two species of *Moraea*. When more is known about *M. linderi* and the species of *Rheome*, it may become desirable to include them in the same genus, possibly in a separate section of subgenus *Moraea*.

The remaining genera of African Irideae are more distantly related to *Moraea*. *Ferraria* (10 spp.–De Vos, 1979) has unifacial leaves and peculiar flowers with plumose style appendages. It has apically rooting corms consisting of several internodes that are generally like those of *Moraea*, but they differ in lacking tunics and in being persistent. *Galaxia* is a small genus of 14 species (Goldblatt, 1979a; 1984a), all acaulescent, and in addition distinguished by having a perianth tube. *Galaxia* has corms of the *Moraea*-type and bifacial leaves and there is no doubt that it is related to *Moraea*, but its origins and relationships are at present obscure. The last two genera of African Irideae are *Hexaglottis* (5 spp.) and *Sessilistigma* (1 sp.), both probably closely allied to *Homeria*, with which *Sessilistigma* (but not *Hexaglottis*) can be crossed. The immediate relationships of *Hexaglottis* are uncertain. It has small, yellow, star-like flowers with style branches divided almost to the base into two filiform arms that extend outwards between the anthers. A similar modification of the style branches characterizes *M. hexaglottis*, but they are probably not immediately related as they differ in several important features, including flower colour, corm tunics and basic chromosome number.

Current classification places *Moraea*, together with *Homeria*, *Hexaglottis*, *Sessilistigma*, *Rheome*, *Gynandriris*, *Barnardiella* and *Galaxia* in subtribe Homeriinae; *Ferraria* in subtribe Ferrariinae; and *Dietes* with *Iris*, *Belamcanda* and segregates of *Iris* in Iridinae (Goldblatt, 1976a; 1980b).

Systematic Treatment

MORAEA Philip Miller

Miller, *Figures of Plants* 2: 159, tab. 238. 1758 (as *Morea*; altered to *Moraea* by Linnaeus) name conserved. TYPE: *Moraea vegeta* L. conserved type.

SYNONYMS
Vieusseuxia de la Roche, *Descriptiones Plantarum Aliquot Novarum* 31. 1766. TYPE: *Vieusseuxia spiralis* de la Roche (= *Moraea bellendenii* (Sweet) N.E. Brown).

Freuchenia Ecklon, *Topographisches Verzeichniss* 14. 1827. nomen nudum. TYPE: *Freuchenia bulbifera* Ecklon (= *Moraea ramosissima* (Linnaeus fil.) Ker).

Phaianthes Rafinesque, *Flora Telluriana* 4: 30. 1836. TYPE: *Phaianthes lurida* (Ker) Rafinesque (= *Moraea lurida* Ker).

Hymenostigma Hochstetter, *Flora* 27: 24. 1844. TYPE: *Hymenostigma schimperi* Hochstetter (= *Moraea schimperi* (Hochstetter) Pichi-Sermolli).

Helixyra Salisbury ex N.E. Brown, *Trans. Roy. Soc. S. Africa* 17: 328. 1929. TYPE: *Helixyra flava* Salisbury (= *Moraea longiflora* Ker), misapplied to *Gynandriris*).

Moraea = (originally *Morea*) named by Miller after 'Robert More, Esquire, of Shropshire', noted botanist and natural historian, contemporary of Miller and Linnaeus. The spelling of the generic name was altered to its present form, *Moraea*, by Linnaeus in 1762, and according to Linnaeus' contemporary Carl Thunberg (1787), the name honours Linnaeus' wife's father Johan Moraeus, a physician of Falun in Sweden.

Seasonal, or rarely more or less evergreen herbs with a cormous rootstock. *Corm* a single swollen internode, covered by membranous to fibrous to nearly woody tunics, rooting from the apex. *Foliage leaves* several to solitary, bifacial, usually with a minute unifacial apex, often channelled, sometimes flat, or terete, or the margins variously inrolled, straight, twisted or undulate, margins sometimes crisped, inserted basally or shortly to well above the ground. *Stem* usually produced above the ground, or sometimes subterranean, unbranched or with 1–several branches, bearing bract leaves at the nodes, these usually entirely sheathing, rarely free distally. *Inflorescence* consisting of 1 or more rhipidia, each terminal on a branch, rarely sessile, consisting of (1-)2–several flowers enclosed by large paired (rarely only 1) sheathing opposed bracts, the spathes; *spathes* herbaceous to dry above or entirely, the inner longer than the outer, acute to attenuate, rarely truncate, the outer entirely sheathing or occasionally free above, the margins united in the lower half, rarely free to the base. *Flowers* pedicellate or rarely nearly sessile, produced serially from the spathes; variously coloured, most often yellow or blue-purple, sometimes violet, white, pink, orange or red, with darker, often contrasting nectar guides; either fugacious, lasting less than a day, or long-lived, lasting up to 3 days; with clawed tepals in 2 unequal whorls, free or rarely united below in a tube; *outer tepals* larger than the inner, claw ascending, closely opposed to a style branch, with a basal nectary, limb spreading to reflexed, with a basal nectar guide; *inner tepals* entire with an expanded blade, erect, or spreading to reflexed like the outer, or variously tricuspidate to linear, ciliate or absent, rarely with nectar guides at the base of the limbs. *Filaments* erect or diverging above, free entirely but contiguous below, or united basally to completely in a column; *anthers* appressed to the style branches, subbasifixed, often concealed between the style branches and the outer tepal claws, sometimes extended beyond the claw, usually reaching to the base of the stigma lobes, or exceeding them, rarely much longer than the style branches, pollen white, yellow, red, or shades of blue. *Ovary* more or less cylindric to 3-lobed or 3-angled, exserted or included in the spathes; *style* dividing into 3 branches at or shortly above the filament column (or contiguous parts of the filaments if these are free); *branches* usually flattened and petaloid, sometimes narrow and only as wide as the anthers, usually terminating in a pair of flat appendages, the crests, at the base of which are transverse stigma lobes, these entire or bilobed, occasionally the style branches terminating in feathery plumes or reduced, and without appendages, then apically bilobed and stigmatic at the tips. *Fruit* a capsule, longitudinally dehiscent along the locules, cylindric to ovoid or elliptic, exserted or included in the spathes; *seeds* small and angular to flattened and discoid, the testa sometimes spongy. Basic chromosome number $x = 10$; diploid numbers $2n = 20, 18, 16, 14, 12, 10, 40, 24, 22$.

Species ca. 120, in five subgenera.

Distribution: Occurring widely in Africa south of the Sahara, from Ethiopia and Nigeria in the north, along the east and central African highlands, and throughout southern Africa; centred in the winter rainfall area of the south and west coast of South Africa, with a secondary centre in the Drakensberg Mountains in the summer rainfall part of eastern southern Africa.

COMMON NAMES
There are a number of common names for Moraeas, none applied to only one species. In the Transvaal and Orange Free State Moraeas are generally called tulps, the name also applied to species of *Homeria*. In the western Cape tulp is used only for *Homeria*. Common Afrikaans names for Moraeas in the Cape are uintjie, applied especially to the edible *M. fugax*; flappie (the English equivalent flag is not used); and the distinctive large flowered species of subgenus *Vieusseuxia* are often called uiltjies (little owls), the name referring to the large nectar guides or 'eyes' on the broad outer tepals. Peacock moraea is sometimes used in English for the uiltjies, especially *M. villosa*. Other names in the literature include butterfly iris, and peacock iris, particularly for the uiltjies, but these are little used in South Africa.

Key to the Species of *MORAEA*

For convenience in using the key, the genus is divided geographically into species occurring in the winter or summer rainfall area of southern Africa. In practice this means that species occurring east of a line drawn north from Port Elizabeth to the Orange River fall into the summer rainfall area and those west of this line, as far north as the Orange River and including extreme south-western Namibia fall in the winter rainfall area. The few species that occur in both areas are included in both keys.

1. Species of the Winter Rainfall Area

1. Plants 3–several branched and stems conspicuously sticky
 - 2. Style branches well developed and with prominent erect linear to lanceolate crests (occasionally only 2 mm long but usually longer) substantially exceeding the anthers
 - 3. Flowers large with the outer tepals more than 23 mm long and the spathes at least 24 mm long
 - 4. Flowers buff to brownish; stem bracts and spathes attenuate and strongly acute; spathes unequal with the outer about half to two-thirds as long as the inner 1. **M. bubalina**
 - 4′. Flowers bright yellow; stem bracts and spathes obtuse to subacute; spathes subequal or the outer only slightly shorter than the inner 2. **M. bituminosa**
 - 3′. Flowers medium to small with the outer tepals less than 24 mm long and the spathes 1,8–2,4(–2,6) mm long
 - 5. Flowers white; tepals 15–23 mm long, the limbs spreading to slightly below the horizontal; pollen red 4. **M. viscaria**
 - 5′. Flowers dull yellow to dark brown, occasionally cream or whitish; tepals 13–18 mm long, the limbs strongly reflexed 45°–90°; pollen yellow to orange 5. **M. inconspicua**
 - 2′. Style branches poorly developed concealed by the anthers, bilobed and obtuse apically, without crests, the anthers usually exceeding the stigma lobes 3. **M. elsiae**
1′. Plants either branched or unbranched, stems rarely sticky and if so always unbranched
 - 6. Stems entirely underground or barely emergent at anthesis; capsules usually borne near ground level within the spathes
 - 7. Flowers with a perianth tube; ovary concealed within the mid- to lower-part of the spathes
 - 8. Leaves glaucous, spreading, clearly channelled; style crests lacking or obscure and style branches apically bilobed; occurring in south-western Namibia 26. **M. graniticola**
 - 8′. Leaves dark green, suberect, narrowly channelled sometimes apparently terete; style crests well developed, erect and to 10 mm long; occurring in the Kamiesberg, Namaqualand 39. **M. longiflora**
 - 7′. Flowers without a perianth tube; ovary situated near the apex of the spathes or exserted at anthesis on long contractile pedicels
 - 9. Corm tunics pale; leaves and/or the spathes often pubescent or at least the margins ciliate; leaves ascending to erect
 - 10. Claw of the outer tepal 10–18 mm long, about as long as the limb
 - 11. Style crests broadly triangular; filaments usually 3–4 mm long; flowers yellow, red or pink 30. **M. tricolor**
 - 11′. Style crests linear to lanceolate; filaments usually 5–10 mm long; flowers often shades of blue, sometimes yellow to brownish or white 28. **M. ciliata**
 - 10′. Claw of the outer tepal 25–40 mm long, 2–3 times as long as the limb 29. **M. macronyx**
 - 9′. Corm tunics usually dark, with blackish fibres; leaves and spathes not pubescent but leaf margins sometimes ciliate; leaves strongly falcate to spreading 27. **M. falcifolia**
 - 6′. Stems produced above the ground, at least several cm long; capsules borne well above the ground, usually exserted, sometimes included in the spathes
 - 12′. Produced leaves two or more
 - 13. Leaves 2 only and these subopposite and inserted on the stem well above the ground, usually just below the first branch 37. **M. fugax**
 - 13′. Leaves few to several, occasionally 2, but then the lowermost usually more or less basal, if inserted above the ground then not subopposite
 - 14. Stems finely pubescent (sometimes microscopically so) and spathes sometimes also pubescent ..
 - 15. Leaves and spathes smooth; outer spathes with the sheath open to the base 14. **M. vegeta**
 - 15′. Leaves and often the spathes lightly pubescent or at least the leaf margins ciliate; outer spathes with margins united in the lower half 18. **M. papilionacea**
 - 14′. Stems and spathes smooth, without pubescence
 - 16. Leaves loosely to tightly twisted to coiled or at least strongly undulate and often crisped ..
 - 17. Leaves terete and helically coiled 23. **M. tortilis**
 - 17′. Leaf surface flat or channelled, the blade undulate to tightly twisted and helical
 - 18. Ovary and capsules exserted from the spathes
 - 19. Flowers with the inner tepals erect and usually trilobed, or lanceolate 19. **M. fergusoniae**
 - 19′. Flowers with inner tepals reflexed and entire
 - 20. Leaves 2 or occasionally 3, then the third smaller and inserted on the lower part of the stem; outer tepals 12–20(–28) mm long; widespread in the winter rainfall area 13. **M. gawleri**
 - 20′. Leaves several, at least 5; outer tepals 22–29 mm long; occurring in the Richtersveld 12. **M. namaquamontana**
 - 18′. Ovary and capsules included in the spathes 22. **M. serpentina**

16'. Leaves straight and erect to falcate or trailing, sometimes lightly undulate but not twisted or coiled ...
 21. Style crests (or apices of the style branches) feathery 20. **M. lugubris**
 21'. Style crests flat, paired and erect or reduced and vestigial but never plumose
 22. Inner tepals reduced to a short cusp or lacking
 23. Flowers shades of yellow to orange; tepals united in a short tube to 10 mm long; ovary included in the spathes 38. **M. cooperi**
 23'. Flowers shades of blue to purple; tepals free and ovary exserted from the spathes .. 66. **M. tripetala**
 22'. Inner tepals well developed and with an expanded surface
24. Style branches reduced and crests vestigial or lacking; nectar guides often present on inner and outer tepals
 25. Anthers diverging from the base, appressed to and as long as the style branches 42. **M. polyanthos**
 25'. Anthers erect and more or less contiguous, style dividing near the apex of the anthers and much shorter than the anthers ..
 26. Leaves narrow, 2–3 mm wide, only 2–3 produced; tepals 30–36 mm long; anthers 5–6,5 mm long .. 49. **M. deserticola**
 26'. Leaves usually fairly broad, 15–40 mm wide, several produced; tepals 35–45 mm long; anthers (8–)12–17 mm long .. 48. **M. speciosa**
24'. Style branches well developed and with distinct paired erect crests; nectar guides only on the outer tepals
 27. Flowers blue to violet ...
 28. Tepals 20–30 mm long ... 41. **M. bipartita**
 28'. Tepals at least 36 mm long and up to 60 mm
 29. Outer tepals 36–50 mm long; ovary 6–10 mm long, exserted from the spathes ... 46. **M. polystachya**
 29'. Outer tepals 50–60 mm long; ovary 15–20 mm long, included in the spathes 47. **M. venenata**
 27'. Flowers shades of yellow, occasionally red or white
 30. Filaments as long or longer than the tepal claws, and anthers exposed above the nectar guides; pollen red ..
 31. Leaves inserted well above the ground and clustered together 15. **M. indecora**
 31'. Lower leaves basal and upper leaves, if present, well spaced on the stem
 32. Tepal claws and filaments about 5 mm long 17. **M. margaretae**
 32'. Tepal claws and filaments 11–12 mm long 11. **M. garipensis**
 30'. Filaments shorter than the tepal claws and anthers largely concealed, seldom reaching the nectar guides; pollen usually whitish to yellow, sometimes red
 33. Outer spathes sheathing only at the base, in the upper half free and curving outwards
 34. Tepals with claws to 15 mm long, the limbs shorter, 11–13 mm long; plants 6–10 cm high; occurring in Namaqualand .. 40. **M. flexuosa**
 34'. Tepals with claws to 15 mm long, the limbs longer, about 20 mm long; plants 30–45 cm high; occurring in the Piketberg Mountains 16. **M. linderi**
 33'. Outer spathes sheathing for their entire length, erect throughout
 35. Foliage leaves 2–3; tepals 12–22(–28) mm long 13. **M. gawleri**
 35'. Foliage leaves several to many (more than 4); outer tepals (22–)25–40 mm long
 36. Sheathing stem bracts with margins united around the axis; outer tepals usually 25–28 mm long; occurring in the Richtersveld 12. **M. namaquamontana**
 36'. Sheathing stem bracts with margins not united around the axis; outer tepals usually 30–40 mm long; occurring in the south-western and southern Cape 10. **M. ramosissima**
12'. Produced leaves one only ...
37. Inner tepals entire and with an expanded limb, narrowly lanceolate to ovate (not trilobed to tricuspidate or filiform) ..
 38. Style branches much reduced, usually concealed by the anthers and crests lacking or vestigial or the style branches deeply forked and emerging between the lower part of the anthers; the inner tepals often also with nectar guides ...
 39. All or at least the upper inflorescences sessile
 40. Ovary included in the spathes; leaf terete, rigid and thick, about 3 mm in diameter . 25. **M. rigidifolia**
 40'. Ovary exserted from the spathes; leaves slender, apparently terete but with a narrow adaxial groove, 1–2 mm wide ...
 41. Ovary and capsules globose; seeds small, less than 1 mm at the longest axis 44. **M. pseudospicata**
 41'. Ovary and capsules elongate and cylindric to fusiform; seeds few, 1,8–2 mm at the longest axis .. 45. **M. verecunda**
 39'. All inflorescences stalked, the stem usually extending beyond the subtending bract
 42. Style branches somewhat shorter than the anthers, appressed to them and apically bifurcate
 43. Tepal claws spreading nearly horizontally; flowers deep violet, lasting 2–3 days 60. **M. worcesterensis**
 43'. Tepal claws erect, often clasping the lower part of the filaments; flowers pale blue to violet, lasting part of an afternoon .. 43. **M. crispa**
 42'. Style branches divided to the base into a pair of filiform arms extended between the base of the anthers .. 24. **M. hexaglottis**
 38'. Style branches usually well developed, not concealed by the anthers, and the crests present and erect usually at least 2 mm long; nectar guides only on the outer tepals
 44. Leaf inserted well above the ground, just below the first branch and the capsule (and ovary) rostrate; branches usually congested ..
 45. Spathes short, 2–3,5(–4) cm long; capsules 8–13 rarely to 15 mm long

46. Leaf filiform, less than 2 mm wide; branches usually congested; flowers opening shortly after midday .. 37. **M. fugax** subsp. **filicaulis**
46'. Leaf linear, usually 2–3 mm wide; branches many and paniculate; flowers opening in the late afternoon after 3:30 p.m. .. 35. **M. gracilenta**
45'. Spathes long, (3,5–)4–6,5 cm long; capsules 15–28(–40) mm long
47. Flowers small, the outer tepals 2–3 cm long; capsules at least 18 mm long; branches solitary or 2–3 and sessile to subsessile .. 36. **M. macrocarpa**
47'. Flowers large, the outer tepals 2,7–4 cm long; capsules 15–28(–40) mm long; branches usually several and stalked .. 37. **M. fugax** subsp. **fugax**
44'. Leaf usually basal, or inserted above the ground, and rarely below the first branch but then the capsule (and ovary) not rostrate; branches usually not congested
48. Leaf terete, either straight or twisted to coiled throughout or above;
49. Spathes and sheathing stem bracts acute-acuminate; leaf coiled throughout or distally; stems often branched
50. Leaf coiled uniformly throughout its length .. 23. **M. tortilis**
50'. Leaf coiled only distally .. 31. **M. saxicola**
49'. Spathes and bracts often obtuse to truncate; ovary strongly 3-angled
51. Filaments joined at the base for 2–3 mm and up to half their length; sheathing stem bracts usually 2
52. Flowers small with outer tepals 20–24 mm long; sheathing stem bracts single .. 6. **M. vallisavium**
52'. Flowers larger with outer tepals 30–45 mm long; sheathing stem bracts usually two .. 8. **M. anomala**
51'. Filaments joined at the base only, for less than 2 mm; sheathing stem bracts usually 1, sometimes 2
53. Style branches shorter than the crests; nectar guide clear, surrounded by darker colour .. 7. **M. angusta**
53'. Style branches longer than the crests; nectar guide with minutely dotted radiating lines .. 9. **M. neglecta**
48'. Leaf channelled, sometimes obscurely so with the margins tightly inrolled especially when dry, or more or less flat, the lamina or only the margins occasionally undulate or crisped
54. Outer tepals more than 35 mm long; inner tepals erect; stem unbranched .. 95. **M. spathulata**
54'. Outer tepals less than 35 mm long or the inner tepals reflexed; stem branched or unbranched
55. Plants tiny, 3–5 cm high; outer tepals 10–14 mm long .. 21. **M. nubigena**
55'. Plants seldom less than 10 cm high; outer tepals more than 15 mm long
56. Ovary and capsule included in the spathes
57. Leaf less than 2 mm wide with the margins inrolled and not thickened and hyaline .. 33. **M. namibensis**
57'. Leaf more than 2 mm wide, channelled, the margins thickened and hyaline, often undulate
58. Filaments about 15 mm long; anthers about 4 mm long .. 34. **M. macgregorii**
58'. Filaments 7–13 mm long; anthers at least 5 mm long
59. Flowers yellow; leaf spreading to prostrate, margins markedly undulate .. 32. **M. bolusii**
59'. Flowers white to blue-purple; leaf ascending or falcate with straight to somewhat undulate margins .. 31. **M. saxicola**
56'. Ovary and capsule exserted from the spathes
60. Anthers exceeding the style crests
61. Stem and leaf smooth .. 78. **M. insolens**
61'. Stem and usually the leaf villous .. 87. **M. neopavonia**
60'. Anthers reaching to the base of the stigma lobe, occasionally slightly longer but not reaching the apex of the style crests
62. Filaments free or united only at the base for less than 1 mm .. 58. **M. thomasiae**
62'. Filaments united for at least half their length, and more than 1,5 mm
63. Filaments more than 10 mm long
64. Flowers pale pink to whitish; filaments free in the upper third .. 62. **M. barkerae**
64'. Flowers violet; filaments entirely united .. 61. **M. incurva**
63'. Filaments 3–6 mm long
65. Filaments united almost to apex, free for less than 1 mm
66. Outer tepal limbs half as long as the claws .. 77. **M. lurida**
66'. Outer tepal limbs about as long to longer than the claws .. 82. **M. amissa**
65'. Filaments united in the lower half
67. Flowers blue to violet; outer tepals more than 20 mm long
68. Inner tepals erect, often spathulate; (flowers lasting at least 2 days) .. 59. **M. algoensis**
68'. Inner tepals suberect to spreading, linear to lanceolate; (flowers lasting less than a day) .. 51. **M. elliotii**
67'. Flowers whitish or pale bluish; outer tepals 14–15 mm long .. 52. **M. exiliflora**
37'. Inner tepals not with an entire expanded surface, but trilobed to tricuspidate, filiform to ciliate or lacking entirely
69. Inner tepals absent, not represented even by cilia .. 65. **M. barnardii**
69'. Inner tepals present at least as cilia
70. Filaments and style branches free almost to the base, lying parallel to the outer tepal claws for their entire length .. 66. **M. tripetala**

70'. Filaments united at least in the lower half into a cylindric column, or united entirely, and the style dividing at the apex of the filament column
 71. Anthers exceeding the style branches, reaching the apex of the crests or exceeding them
 72. Anthers exceeding the style crests by at least 1 mm
 73. Crests about as long as the stigma lobes and appressed to them; flowers usually blue to violet (rarely white or orange) 88. **M. gigandra**
 73'. Crests exceeding the stigma lobes and erect; flowers orange 87. **M. neopavonia**
 72'. Anthers reaching to about the apex of the style crests, rarely more than 1 mm longer
 86. **M. tulbaghensis**
 71'. Anthers not reaching further than the base of the style crests, usually not reaching the stigma lobes
 74. Inner tepals filiform, either entire or trilobed
 75. Filaments 12–15 mm long, united in a column at least 6 mm long; flowers white with blue markings 64. **M. longiaristata**
 75'. Filaments about 4 mm long, united in a column less than 4 mm long; flowers purple fading to mauve and becoming spotted 63. **M. debilis**
 74. Inner tepals narrow, channelled below, trilobed to tricuspidate
 76. Leaf and or stem pubescent or long-ciliate on the margins
 77. Stem smooth 79. **M. atropunctata**
 77'. Stem villous
 78. Outer tepal claws yellow, lightly bearded
 79. Nectar guide comprising a central yellow zone ringed by broad bands of dark colour 83. **M. villosa**
 79'. Nectar guide a small black or yellow mark, the latter often ringed by a thin black line 80. **M. caeca**
 78. Outer tepal claws black, heavily bearded
 80. Outer tepal limbs nearly circular, wider than long 84. **M. calcicola**
 80'. Outer tepal limbs oblong to obovate, longer than wide 85. **M. loubseri**
 76. Leaf and stem without pubescence
 81. Filaments more than 12 mm long 62. **M. barkerae**
 81'. Filaments less than 10 mm long
 82. Central cusp of the inner tepal spreading, at least twice as long as the lateral lobes .
 83. Outer tepal claws yellow to white
 84. Flower white with dark-blue to violet-ringed nectar guides .. 81. **M. aristata**
 84'. Flower lilac to purple with small yellow or black nectar guides 80. **M. caeca**
 83'. Outer tepal claws black 82. **M. amissa**
 82'. Central cusp of the inner tepal erect or incurved, often less than twice as long as the lateral lobes
 85. Outer tepal limbs about half as long as the claws 77. **M. lurida**
 85'. Outer tepal limbs as long to longer than the claws
 86. Outer tepal claws cupped to spreading horizontally; outer tepals 25–35 mm long
 87. Flowers yellow; outer tepal limbs ascending and cupped; filaments 3–5 mm long 76. **M. bellendenii**
 87'. Flowers white with brownish markings; outer tepals spreading; filaments 5–6 mm long 75. **M. tricuspidata**
 86'. Outer tepal claws reflexed 45°–90°; outer tepals 12–30 mm long
 88. Filaments united in the lower half; outer tepals 26–30 mm long
 59. **M. algoensis**
 88'. Filaments united except near the apex; outer tepals 12–24 mm long ...
 67. **M. unguiculata**

2. Key to the Summer Rainfall Area Species

1. Plants acaulescent; leaves several and hardly distinct from the inflorescence spathes
 2'. Leaves glabrous; tunics of dark to blackish fibres; flowers white with yellow nectar guides and purple blotches on the inner tepals 27. **M. falcifolia**
 2'. Leaves ciliate to pubescent; tunics of pale fibres; flowers pale blue with yellow nectar guides ... 28. **M. ciliata**
1'. Plants with a produced aerial stem; leaves solitary or if more than one, then distinct from the inflorescence spathes
 3. Foliage leaves more than one
 4. Produced leaves two (rarely three); occurring in Botswana, northern Namibia and Zimbabwe
 50. **M. carsonii**
 4'. Produced leaves three or more; occurring in the southern and eastern Cape, Karoo, south and central Namibia and southern Botswana
 5. Outer tepals 16–30 mm long 41. **M. bipartita**
 5'. Outer tepals more than 36 mm long
 6. Outer tepals 36–50 mm long; ovary 6–10 mm long, usually exserted from the spathes 46. **M. polystachya**
 6'. Outer tepals 45–60 mm long; ovary 15–20 mm long, included in the spathes 47. **M. venenata**
 3'. Foliages leaves solitary
 7. Flowers large, with the outer tepals at least 35 mm long and the inner tepals entire and with an expanded blade

8. Cataphylls submembranous, white to pale, entire or frayed to torn at the apex only; plants always solitary . 93. **M. graminicola**
8'. Cataphylls brown to blackish, entire, irregularly broken or fibrous .
 9'. Cataphylls of mature plants split regularly into rigid, blackish-fibres, and the innermost cataphyll not forming a open network above .
 10. Flowers deep yellow; leaves slender, to 2,5 mm in diameter 99. **M. galpinii**
 10'. Flowers pale yellow; leaves thick, 4–10 mm in diameter 100. **M. robusta**
 9'. Cataphylls of mature plants brown to black, entire or irregularly broken, but not forming rigid vertical bristles, the innermost cataphyll sometimes forming a pale open fibrous network above
 11. Style crests marked with single dark blotch at the base; plants of running streams
. 102. **M. huttonii**
 11'. Style crests self-coloured; not growing in water .
 12. Flowers slate-blue to violet, pink, or yellow with deep pink style crests
 13. Flowers pinkish or at least the style crests deep pink 92. **M. carnea**
 13'. Flowers slate-blue to violet
 14. Spathes and sheathing stem bracts dry and brownish at flowering time; occurring in Zimbabwe and throughout tropical Africa 103. **M. schimperi**
 14'. Spathes and sheathing stem bracts herbaceous; occurring in the Natal Drakensberg .92. **M. ardesiaca**
 12'. Flowers predominantly yellow to white .
 15. Plants medium in size, seldom more than 40 cm high .
 16. Plants with a single sheathing bract leaf 90. **M. unibracteata**
 16'. Plants with two or more sheathing bract leaves 89. **M. muddii**
 15'. Plants tall, seldom less than 50 cm high .
 17. Leaf terete (with a narrow adaxial groove) with inrolled margins; flowering in winter, June to early September . 94. **M. hiemalis**
 17'. Leaf narrowly channelled to flat, flowering at almost any month, but February to April if the leaf is narrowly channelled .
 18. Cataphyll forming a pale, fibrous network around the base
 19. Leaf surface flat, at least above; margins usually thickened; usually growing in clumps . 96. **M. alticola**
 19'. Leaf channelled; margins not thickened; plants solitary 98. **M. reticulata**
 18'. Cataphyll without a pale fibrous network above .
 20. Plants solitary; leaf channelled; flowering December to March
. .95. **M. moggii**
 20'. Plants usually in clumps; leaf flat above; flowering June to November
. 96. **M. spathulata**
7'. Flowers smaller, with outer tepals less than 35 mm long and the inner tepals either entire, or tricuspidate, linear or lacking .
 21. Inner tepals entire with an expanded lamina, usually at least 1,5 mm wide .
 22. Plants leafless when in bloom, or leaf of the flowering stem dead; the upper lateral inflorescences sessile .
 23. Style crests present, at least 2 mm long and acute .
 24. Inner tepals less than 1 cm long, . 56. **M. alpina**
 24'. Inner tepals more than 10 mm long, . 55. **M. stricta**
 23'. Style crests very short, vestigial; nectar guides present on the inner and outer tepals
. 57. **M. thomsonii**
 22'. Plants with a living basal leaf attached to the stem .
 25. Inner tepals erect and abruptly expanded above, more or less spathulate; flowers violet
. 59. **M. algoensis**
 25'. Inner tepals reflexed or nearly erect to spreading, but never abruptly expanded above, lanceolate to linear; flowers yellow or shades of blue to violet .
 26. Leaf more or less basal .
 27. Tepal claws 2–3 mm long; anthers exceeding the style branches and displayed well above the tepals .43. **M. crispa**
 27'. Tepal claws 8–12 mm long; anthers shorter than the style branches and concealed by the outer tepal claws .
 28. Flowers yellow; sheathing bract leaves 5–8 cm long 90. **M. inyangani**
 28'. Flowers blue-violet; sheathing bract leaves 2,5–5(–6) cm long 51. **M. elliotii**
 26'. Leaf inserted well above the ground near the base of the branches
 29. Capsule spherical; outer spathes brown, less than half as long as the inner; plants occasionally pubescent . 54. **M. inclinata**
 29'. Capsule ovoid to elliptic; outer spathes green or brown, about half as long as the inner; plants never pubescent .
 30. The longest spathes more than 35 mm long; outer tepals more than 20 mm long
. 51. **M. elliotii**
 30'. The longest spathes rarely to 40 mm long, usually less than 35 mm; outer tepals usually less than 20 mm long . 53. **M. natalensis**
 21'. Inner tepals tricuspidate or linear to ciliate, without an expanded limb .
 31. Inner tepals linear to ciliate, not tricuspidate .
 32. Outer tepals more than 25 mm long; flowers cream to pale yellow72. **M. albicuspa**
 32'. Outer tepals less than 25 mm long; flowers white to pale blue-purple 74. **M. modesta**

 31′. Inner tepals tricuspidate .
 33. Inner tepals comprising a long central cusp and shorter lateral lobes
 34. Plants leafless when in bloom, or leaf of the flowering stem dead
 35. Inner tepals less than 1 cm long, not reaching the level of the stigmas
 . 74. **M. modesta**
 35′. Inner tepals more than 10 mm long, extending above the level of the stigmas . .
 . 69. **M. marionae**
 34′. Plants with a living basal leaf attached to the stem .
 36. Outer tepals spreading, white, 26–30 mm long × 15 mm wide
 . 75. **M. tricuspidata**
 36′. Outer tepals reflexed, dull-yellow to brownish, 15–20 mm long × 6–10 mm
 wide . 68. **M. trifida**
 33′. Inner tepals comprising a slender central cusp and long apically expanded lateral lobes
 37. Flowers blue-violet; stems usually simple (or one-branched) . . 73. **M. dracomontana**
 37′. Flowers, or at least the outer tepals predominantly white; stems usually with more
 than 2 branches .
 38. Filaments 6–7 mm long; outer tepals about 20 mm long 71. **M. brevistyla**
 38′. Filaments 13–15 mm long; outer tepals 25–30 mm long 70. **M. pubiflora**

Note: The colour figures are life size with the details variously enlarged. The line drawings have the habit reduced to half natural size, the separate flowers life size and the details usually × 2.

SUBGENUS *VISCIRAMOSA*

1. MORAEA BUBALINA Goldblatt

Goldblatt, *Ann. Mo. bot. Gdn* **64**: 733–735. 1976. TYPE: South Africa, Cape, Zandkraal, Vanrhynsdorp, *Barker 5667* (NBG, holotype).

bubalina = buff coloured, referring to the predominant dull yellow-brown colour of the flowers.

Plants 25–70 cm high. *Corms* 1,5–2 cm in diameter, tunics dark brown, the layer unbroken or the outer becoming irregularly fragmented, sticky and bituminous adaxially. *Cataphylls* brown and coriaceous, persisting for a few years and accumulating around the base, becoming irregularly broken. *Leaves* usually 2 basal and 1 smaller inserted in the lower part of the stem, linear, channelled, the lower as long or longer than the stem, often bent and trailing. *Stem* usually with 3–5 branches, rarely fewer, viscous below the nodes, branches held close to the main axis below, flexed outwards above, sheathing stem bracts 2,5–6 cm long, acute to attenuate. *Spathes* herbaceous, becoming dry above with age, the apices acute and attenuate, straw coloured, *inner* 2,5–4 cm long, *outer* half to two-thirds as long as the inner. *Flowers* buff to light brown with pale yellow nectar guides broadly outlined with dark brown or peacock green on inner and outer tepals, the claws forming a broad shallow cup and limbs spreading; *outer tepals* 22–33 mm long, lanceolate, 7–9 mm wide, claw 2–3 mm shorter than the limb, limb spreading to reflexed to about 30°; *inner tepals* slightly smaller than the outer, to 28 mm long, about 6 mm wide. *Filaments* 8–11 mm long, free entirely, contiguous in the lower two-thirds; *anthers* 4–7 mm long. Ovary 5–7 mm long, exserted from the spathes, *style branches* 6–7 mm long, crests erect, 3–6 mm long. *Capsule* and *seeds* not known. *Chromosome number* not known.

Flowering time: September to October; flowers opening in the late afternoon between 3:30 and 4 p.m. and fading at dusk.

DISTRIBUTION AND HABITAT

Moraea bubalina occurs in the Calvinia and Vanrhynsdorp districts of the north-western Cape and western Karoo, an area of low and almost exclusively winter rainfall. It has been recorded as far north as Loeriesfontein and there is an isolated record well to the south near Lamberts Bay, on the west coast near Clanwilliam. It grows on arid rocky or clay gravel flats and slopes. Although seldom collected, it is probably more common than the record indicates. Sometimes, as at Loeriesfontein, in a year of particularly good rains, it covers vast areas of arid sparsely-vegetated Karoo flats. *Moraea bubalina* is particularly common in the Vanrhynsdorp area where it grows on the slopes of the Gifberg and on the flats below. The paucity of collections may be explained by the fact that flowers open only in the later part of the afternoon and are relatively inconspicuous owing to their dull colour. Also, like all members of subgenus *Visciramosa*, their sticky stems make them most unpleasant to collect so that they may be deliberately overlooked.

DIAGNOSIS

The sticky and branched stems and the dark brown corm tunics leave no doubt that *Moraea bubalina* belongs in subgenus *Visciramosa*. It is isolated in the subgenus in having acute inflorescence spathes and sheathing stem bracts and in often having more than two leaves. The large buff to brown flowers, sometimes with the nectar guides outlined in bright green, as in the plants illustrated here, and long inflorescence spathes exceeding 2,7 cm, separate it from the more common *M. inconspicua* which occurs in the same area. In overall size it most resembles *M. bituminosa*, which has bright yellow flowers and subequal inflorescence spathes often obtuse or truncate, unlike the buff to brown flowers and the unequal and acute to attenuate spathes in *M. bubalina*, and any confusion between these two species is unlikely.

HISTORY

There is little to be said about the history of *Moraea bubalina*. It was first collected relatively recently by the well known South African botanist J. P. H. Acocks on the farm Platberg in the Botterkloof area. This and the few other early collections were identified as *M. bituminosa*. *Moraea bubalina* was recognized as a separate species only in 1976 (Goldblatt, 1976b).

1.

M. cibolina.

2. MORAEA BITUMINOSA (Linnaeus fil.) Ker

Ker, *Ann. Bot.* (Konig & Sims) 1: 240. 1805; Lewis, *Flora Cape Peninsula* 229. 1950; Goldblatt, *Ann. Mo. bot. Gdn* 63: 732–733.

SYNONYMS

Iris bituminosa Linnaeus fil., *Supplementum Plantarum* 98. 1782; Thunberg, *Dissertatio de Iride* no. 42. 1782. TYPE: South Africa, Cape, 'prope Bergrivier, Vierentvintigrivieren et alibi,' *Thunberg s.n.* (Herb. Thunberg *1114*, UPS, lectotype designated by Goldblatt, 1976).

Vieusseuxia bituminosa (Linnaeus fil.) Ecklon, *Topographisches Verzeichniss* 14. 1827.

Moraea viscaria var. *bituminosa* (Linnaeus fil.) Baker, *Flora Capensis* 6: 15. 1896.

bituminosa = bituminous, referring to the sticky, somewhat oily, secretion on the stems below the nodes that is characteristic of this and a few other species of the genus.

Plants 25–50 cm high. *Corms* 1,5–2 cm in diameter, tunics dark brown, the inner layers unbroken, the outer irregularly fragmented, sticky and bituminous on the inner surfaces. *Cataphylls* brown and papery, often irregularly broken and becoming fibrous, accumulating in a neck around the base. *Leaves* 2, the lower basal, the upper attached to the lowest aerial node, linear, channelled, sometimes twisted, falcate to trailing, usually longer than the stem. *Stem* repeatedly branched, viscous below the nodes, branches held close to the stem below, flexed horizontally above but the spathes erect, sheathing stem bracts 3,5–5 cm long. *Spathes* herbaceous, becoming dry and conspicuously nerved with age, the apices obtuse, brown, occasionally lacerated, 2,5–4 cm long, subequal or the outer only slightly shorter. *Flowers* bright yellow (rarely purple) with deep yellow nectar guides on the outer tepals; *outer tepals* 22–32 mm long, limbs spreading to reflexed to ca. 45°; *inner tepals* 20–29 mm long, the limbs also reflexed. *Filaments* 5–8 mm long, free entirely, contiguous in the lower two-thirds, diverging in the upper 1–2 mm; *anthers* 5–7 mm long, pollen yellow. Ovary about 6 mm long, usually exserted from the spathes, *style branches* about 6 mm long, the crests prominent, up to 8 mm long, lanceolate. *Capsule* ovoid, 10–13 mm long; *seeds* angled. Chromosome number $2n = 20$.

Flowering time: October to mid-December; flowers opening at midday and fading in the late afternoon.

DISTRIBUTION AND HABITAT

Moraea bituminosa is native to the higher rainfall areas of the south-western Cape where it is common on flats and slopes between Bredasdorp in the south-east and the Wellington and Tulbagh districts to the north. Plants are not often collected because the stems are sticky and thus difficult and unpleasant to handle. It occurs most frequently on stony sandstone derived soils, but has been collected on the mixed sandy clay of lower mountain slopes. *Moraea bituminosa* generally flowers late in the season, well after most of the herbaceous flora of the south-western Cape has bloomed. Plants sometimes do not come into flower until December at a time when little collecting is done in the south-western Cape.

DIAGNOSIS

Moraea bituminosa has the characteristic branched and sticky stem of subgenus *Visciramosa*. It is distinguished from the other four members of the subgenus by its large yellow flower with well-developed style branches and crests, and long truncate inflorescence spathes 2,5–4 cm long. The tepals are typically all reflexed to about 45° but only the outer have nectar guides. The outer tepals are 20–32 mm long, approached in size within the subgenus only by *M. bubalina*, but the latter has buff-coloured flowers, usually more than 2 foliage leaves and acute spathes.

HISTORY

The first record of this distinctive Cape plant comes from the collections of Carl Peter Thunberg who collected *Moraea bituminosa* north of Cape Town in the 1770's. As with most of the species collected by Thunberg, it was formally named and described by the younger Linnaeus, who used Thunberg's manuscript notes and specimens as the basis for his description. Later in 1782, Thunberg published an amplified description including an illustration and the information that his specimens were found along the Berg River in the vicinity of Twenty-Four Rivers which lies between Porterville and Gouda. His collection is unusual in its coiled leaves and early flowering time, described as September. Other features are, however, in keeping with the large-flowered, bright yellow species of subgenus *Visciramosa*, from the south-western Cape.

In *Flora Capensis*, Baker (1896) treated *Moraea bituminosa* as a variety of the vegetatively similar *M. inconspicua* (under the name *M. viscaria*). This is easy to understand in the light of the few and relatively poor preserved specimens that Baker had at his disposal and the poor state of preservation of most of them. There is no doubt that *M. bituminosa* is quite distinct morphologically in flower size and form and to a lesser extent ecologically from the other members of the subgenus *Visciramosa*. Joyce Lewis, the late specialist on Cape Iridaceae, treated *M. bituminosa* as a species quite distinct from *M. inconspicua* in the *Flora of the Cape Peninsula* in 1950, and I followed her example in my earlier studies of *Moraea* (Goldblatt, 1976b).

2.

M. bituminosa.

3. MORAEA ELSIAE Goldblatt

Goldblatt, *Ann. Mo. bot. Gdn* **63**: 18. 1976 et **63**: 739. 1976. TYPE: as for *H. simulans* Baker (see below).

SYNONYMS
Homeria simulans Baker, *Flora Capensis* **6**: 529. 1896; Lewis, *Flora Cape Peninsula* 232. 1950. TYPE: South Africa, Cape, sandy places near Kenilworth, *H. Bolus 7931* (BOL, lectotype designated by Goldblatt, 1976: 739; K, MO, isolectotypes).

elsiae = named in honour of Elsie Esterhuysen, Cape botanist and collector *par excellence*, who has collected many rare and new species of *Moraea*, and who introduced me to this species on the Cape Peninsula where it is now rare or possibly extinct.

Plants 20–40 cm high. *Corms* 1,5–2,0 cm in diameter, tunics dark brown, sticky and bituminous on the inner surfaces, the layers initially unbroken but becoming irregularly broken and sometimes somewhat fibrous. *Cataphylls* dry and brown at flowering time, persisting for some years and accumulating in a neck around the base. *Leaves* 2, the lower basal, the upper attached to the lowest aerial node, straight to somewhat twisted, 3–5 mm wide, channelled, often bent and trailing, shorter or longer than the stem. *Stem* repeatedly branched, viscous below the nodes, branches held close to the stem below, flexed horizontally above but the spathes erect, sheathing stem bracts, 2,5–3(–4) cm long. *Spathes* herbaceous, becoming dry and conspicuously nerved with age, the apices acute to obtuse, brown, occasionally lacerated, 1,9–3 cm long, subequal or the outer only slightly shorter. *Flowers* bright yellow with darker yellow nectar guides on the inner and outer tepals, the claws broadly cupped and limbs spreading slightly below the horizontal to about 45°; *outer tepals* 15–22 mm long, about 9 mm wide; *inner tepals* somewhat smaller, 14–19 mm long. *Filaments* 4–7 mm long, free but contiguous; *anthers* 3–4 mm long, pollen yellow. Ovary 5–6 mm long, exserted from the spathes, *style branches* 3–4 mm long, narrow, bilobed and obtuse above, partly hidden by the anthers, crests lacking. *Capsule* globose to ovoid, up to 1 cm long; *seeds* angular. Chromosome number $2n = 20$.

Flowering time: November to December (–January); flowers lasting one day and opening about midday and fading towards sunset.

DISTRIBUTION AND HABITAT
Moraea elsiae is a winter rainfall area species, restricted to the south-western Cape. It extends from the Cape Peninsula and Cape Flats eastwards to Bredasdorp and Cape Infanta. The species is usually found on sandy lowland flats.

DIAGNOSIS AND RELATIONSHIPS
The flower of *Moraea elsiae* is typical of the genus *Homeria*, having subequal spreading tepals, reduced style branches which lack crests entirely, and nectar guides on both the inner and the outer tepals. However, its vegetative structure is so strikingly like the species of *Moraea* subgenus *Visciramosa* that its close relationship with this alliance cannot be doubted. It has the typical branching pattern of the subgenus with the lower part of the branch held close to the stem and the upper part nearly horizontal while the spathes are erect. The stems and branches are sticky and the spathes are relatively short, subequal and often obtuse apically. The brown corm tunics with sticky somewhat greasy inner surfaces are also typical of subgenus *Visciramosa* and known in no other species. The morphological similarities are fully confirmed by the cytology. *Moraea elsiae* has a diploid number of $2n = 20$ and a karyotype exactly like that in other members of subgenus *Visciramosa*, whereas species of *Homeria* have a base number of $x = 6$ and $2n = 20$ is unknown in the genus (Goldblatt, 1976a).

Moraea elsiae is almost identical in vegetative morphology to two other species of subgenus *Visciramosa*, *M. viscaria* and *M. inconspicua*, and it has leaves and spathes of a similar size and appearance and small flowers. The absence of style crests and spreading to slightly reflexed subequal tepals distinguish it from *M. inconspicua*, while its yellow colour and lack of scent distinguish it from those forms of the white-flowered *M. viscaria* that have very short or vestigial style crests. The flowers of *M. viscaria* usually have long erect style crests and it is then quite easy to distinguish it from *M. elsiae*.

HISTORY
As far as is known, *Moraea elsiae* was only discovered at the end of the nineteenth century when Harry Bolus collected plants on the flats near Kenilworth on the Cape Peninsula in 1892. Specimens were sent to Kew and reached J. G. Baker in time to be included in the addenda to the volume of the *Flora Capensis* dealing with Iridaceae which was published in 1896. Baker described it as *Homeria simulans* because of the very *Homeria*-like flower structure, and it remained in this genus until 1976 when I transferred it to *Moraea*. G. J. Lewis was aware of its close affinities to *M. bituminosa* and *M. inconspicua* and commented on its apparent natural relationship to *Moraea* in her treatment of Iridaceae in *Flora of the Cape Peninsula*. She did not, however, transfer it to *Moraea* although she realized that leaving the species in *Homeria* made this genus polyphyletic and an unnatural assemblage, a situation unacceptable in modern botany. The way in which the style in *M. elsiae* and in *Homeria* has been reduced is similar and is an example of morphological convergence.

The specific epithet *simulans* must be discarded on transfer to *Moraea* because the name has already been used in the genus for another species, now *Gynandriris simulans* (Baker) R. Foster.

3.

M. elsiae.

4. MORAEA VISCARIA (Linnaeus fil.) Ker

Ker, *Ann. Bot.* (Konig & Sims) 1: 240. 1805, as to name only, not to plant intended (applied to *M. inconspicua*); Goldblatt, *Ann. Mo. bot. Gdn* **63**: 735–737. 1976.

SYNONYMS
Iris viscaria Linnaeus fil. *Supplementum Plantarum* 98. 1782. TYPE: South Africa, Cape, 'Lospers farm', Saldanha district, *Thunberg s.n.* (Herb. Thunberg *1200*, UPS, holotype).

Vieusseuxia viscaria (Linnaeus fil.) Ecklon, *Topographisches Verzeichniss* 12. 1827.

Moraea odorata Lewis, *Jl S. Afr. Bot.* **7**: 53. 1941; *Flora Cape Peninsula* 229. 1950. TYPE: South Africa, Cape, Rondebosch Common, *Barnard s.n.* (BOL–*20341*, holotype; PRE, SAM, isotypes).

viscaria = viscous or sticky, referring to the glutinous secretion on the aerial parts of the stem and branches.

Plants 20–45 cm high. *Corms* 1,5–2 cm in diameter, tunics dark brown, the inner layers unbroken, the outer becoming irregularly fragmented, sticky and bituminous on the inner surfaces. *Cataphylls* membranous, brown and becoming dry at flowering, persisting for a few years and accumulating around the base, becoming irregularly broken. *Leaves* 2, basal, linear, channelled, as long or longer than the stem, often bent and trailing. *Stems* several to many-branched, viscous below the nodes, branches held close to the main axis below, flexed horizontally above, sheathing stem bracts 2,5–3(–4) cm long, acute, dry above. *Spathes* herbaceous, becoming dry above and conspicuously nerved with age, the apices acute to obtuse, occasionally lacerated, 1,8–2,4 cm long, outer about as long as the inner or slightly shorter. *Flowers* white, sometimes flushed with purple, with yellow nectar guides on the outer tepals, sweetly scented; *outer tepals* 15–23 mm long, limbs laxly spreading to slightly reflexed, about 8 mm at the widest point; *inner tepals* 14–20 mm long, the limbs also spreading to reflexed. *Filaments* 5–6 mm, free entirely, contiguous below, diverging above; *anthers* 4–5 mm long, acuminate, pollen red. Ovary about 5 mm long, exserted from the spathes, *style branches* about 5 mm long, the crests usually prominent, 2–6 mm or occasionally reduced to 1 mm. *Capsule* broadly ovoid, 7–10 mm long. Chromosome number 2n = 20

Flowering time: late September to October in the Saldanha area, elsewhere November to December; flowers opening between 2 and 3 pm and fading in the early evening.

DISTRIBUTION AND HABITAT
Moraea viscaria is restricted to coastal areas of the south-western Cape, between Saldanha Bay and Cape Agulhas. It occurs at low elevations on sandy or stony flats and slopes, sometimes on limestone derived soils.

DIAGNOSIS AND RELATIONSHIPS
Moraea viscaria can immediately be recognized from other species of subgenus *Visciramosa* by its white and usually sweetly-scented flowers. The flowers are relatively small, with tepals 15–23 mm long and the inflorescence spathes are correspondingly short, in the 1,8–2,4 cm range. The tepals are narrow and laxly speading, usually oriented slightly below the horizontal. The pollen is bright red but the colour fades after drying and cannot be used reliably for identification. In subgenus *Visciramosa*, *M. inconspicua* and *M. elsiae* also have small flowers and short spathes and they are very similar in general appearance. *Moraea inconspicua* usually has brown or dull-yellow flowers, rarely white, but the tepals are always reflexed at least to 45° and more often to about 90°. *Moraea elsiae* has bright-yellow flowers that in general are like those of *Homeria*, and *M. elsiae* can always be distinguished by the absence of style crests and the presence of nectar guides on the inner and the outer tepals.

Plants with very short style crests have been collected in the Agulhas area but these populations are apparently very local and they are not given taxonomic recognition here as they otherwise conform closely to *M. viscaria*.

HISTORY
Moraea viscaria was first described in 1782 by the younger Linnaeus, who placed it in *Iris*. The description is very brief and *M. viscaria* can only be identified from the amplified description published later the same year by Carl Peter Thunberg, together with Thunberg's collection which is the type of the species. Thunberg made his collection in the vicinity of Saldanha Bay and he clearly described the flowers as white flushed with purple. This information makes it seem very likely that *I. viscaria* is conspecific with *M. odorata*, described by G. J. Lewis in 1941. After careful consideration of the description I came to the conclusion that the name *I. viscaria* must be applied to plants with white, sweetly-scented flowers and not to the species with dull-yellow to brown, odourless flowers that had been known by this name at least since 1802 when Ker named it *M. viscaria* in an illustrated article in the *Botanical Magazine*. With the name *M. viscaria* applied to plants with scented white flowers, the brown flowered species of the *Botanical Magazine* has the new name *M. inconspicua* (Goldblatt, 1976b).

4.

M. viscaria.

5. MORAEA INCONSPICUA
Goldblatt

Goldblatt, *Ann. Mo. bot. Gdn* **63**: 737–738. 1976. TYPE: South Africa, Cape, Wilderness, *Van Niekerk 181* (BOL, holotype; PRE, isotype).

SYNONYMS
Moraea viscaria sensu Ker, *Botanical Magazine* 16: tab. 587. 1802; Baker, *Flora Capensis* 6: 15. 1896, excl. var. *bituminosa*; Lewis, *Flora Cape Peninsula* 229. 1950

inconspicua = inconspicuous, alluding to the small drab coloured flowers of the species.

Plants 20–45 cm high, flexuously branched. *Corms* 1,5–2 cm in diameter, tunics dark brown, sticky and bituminous on the inner surfaces, the layers initially unbroken but becoming irregularly broken from below, often ultimately coarsely fibrous. *Cataphylls* dry and brown at flowering time, persistent and accumulating in a neck around the base, often becoming fibrous with age. *Leaves* 2, the lower basal, the upper attached to the lowest aerial node, straight to somewhat twisted or tightly coiled distally (esp. Namaqualand populations), 3–5 mm wide, flat or channelled, often bent and trailing, shorter or longer than the stem. *Stem* repeatedly branched, viscous below the nodes, branches held close the stem below, flexed horizontally above but the spathes erect, sheathing stem bracts 2,5–3 (–4) cm long. *Spathes* herbaceous, becoming dry and conspicuously nerved with age, the apices acute to obtuse, brown, occasionally lacerated, 1,8–2,8 cm long, subequal or the outer only slightly shorter. *Flowers* small and inconspicuous, cream or dull yellow to dark brown; *outer tepals* 13–18 mm long, reflexed to at least 45° and often to 90° or more, lanceolate, 6–7 mm at the widest, claw 4–6 mm long; *inner tepals* 12–17 mm long, narrowly lanceolate, 3–4 mm wide, also reflexed. *Filaments* 5–6 mm long, free entirely, contiguous below, diverging near the apex; *anthers* 3–4 mm long, pollen usually yellow, occasionally orange. Ovary about 3 mm long, narrowly conic, exserted from the spathes, *style branches* 3–5 mm long, the crests erect, 3–6 mm long. *Capsule* broadly ovate to globose, 6–10 mm long. *Chromosome number* 2n = 20.

Flowering time: September to December (to January).

DISTRIBUTION AND HABITAT
Moraea inconspicua is the most widespread species in subgenus *Visciramosa* and one of the most widespread of all the species of *Moraea* in the southern African winter rainfall area. It extends from northern Namaqualand in the north to the Cape Peninsula, and eastwards as far as Port Elizabeth. It grows in dry, exposed habitats, often in gravelly shale but also on sand, and in Namaqualand it is most common in crevices in granite outcrops. In the south-western Cape plants are found in open exposed sites sometimes in deep sand as in the sandveld on the west coast, or on clay flats and slopes particularly from the Caledon district eastwards.

DIAGNOSIS
Moraea inconspicua is distinguished from the other members of subgenus *Visciramosa* by its small flowers and comparatively short inflorescence spathes and sheathing stem bracts. The flowers are not only small, with tepals 12–17 mm long, but the tepal limbs are strongly reflexed at least to 45° and usually to 90° or more so that they are not easily seen closely appressed to the spathes. They are also dull coloured, often dark brown, although cream, dull yellow and even whitish-flowered forms are known. The spathes, 1,8–2,6 cm long, correspond with the small size of the flowers and are the smallest found in subgenus *Visciramosa* so that the species can often be identified from non-flowering specimens, although *M. viscaria* also has small spathes and it can be confused with *M. inconspicua*.

Flower colour is variable and brown, dull yellow and cream-flowered forms are common, while a white-flowered form occurring in the Bidouw Valley in the Clanwilliam district is tentatively assigned to *M. inconspicua*, though details of tepal orientation are not known. The leaves are usually straight and more or less erect, but plants from Namaqualand have characteristically spirally-coiled leaves.

HISTORY
Moraea inconspicua has been known at least since Ker described the plant figured in the *Botanical Magazine* in 1802, but the name associated with it, *M. viscaria*, based on Thunberg and the younger Linnaeus's *Iris viscaria*, is now believed to have been misapplied. *Iris viscaria* is here regarded as the earliest name for what was, until the publication of my revision of the winter rainfall area species of *Moraea* in 1976, called *M. odorata*, a white-flowered species with spreading tepals. There were no synonyms available for the species and the new name *M. inconspicua* was given to this distinctive Cape and Namaqualand species.

Baker (1896) treated *M. inconspicua* as *M. viscaria* in the *Flora Capensis* and he had a particularly broad interpretation of the species which he regarded as including also *M. bituminosa*, the only other species of subgenus *Visciramosa* known to him at the time that he wrote his treatment of *Moraea* for *Flora Capensis*.

5.

M. inconspicua.

SUBGENUS *MONOCEPHALAE*

6. MORAEA VALLISAVIUM Goldblatt

Goldblatt, *Ann. Mo. bot. Gdn* **69**: 351–369. 1982. TYPE: South Africa, Cape, Vogelgat, Hermanus, mountain slopes, 1 500 ft, *Goldblatt 5394* (MO, holotype; K, NBG, isotypes).

vallisavium = from the Latinized name for Vogelgat near Hermanus, where the only collections of the species have so far been made.

Plants 10–34 cm high. *Corm* small, 4–6 mm in diameter, with corms of past seasons persisting below; tunics of fine reticulate fibres. *Cataphyll* pale, membranous, becoming fibrous and accumulating somewhat around the base. *Leaf* solitary, linear, unifacial, inserted shortly above ground level, 1–2 mm wide, exceeding the stem but often falcate to trailing. *Stem* more or less erect to inclined, unbranched, sheathing stem bract solitary, 15–40 mm long, margins free to base. *Spathes* herbaceous, obtuse to truncate, *inner* 3–4 mm long, *outer* about half as long as inner, margins of the outer free to base. *Flowers* yellow, the claws darkly speckled, with deep yellow nectar guides on the outer tepals; *outer tepals* 20–24 mm long, claw ascending, 9–10 mm long, limb horizontal to slightly reflexed, limb 8–10 mm wide; *inner tepals* 16–19 mm long, claw 6–8 mm long, limb to 7 mm wide, also horizontal to slightly reflexed. *Filaments* about 5 mm long, united in lower 2 mm; *anthers* 5–6 mm long, reaching to the apex of the style branches, pollen red. Ovary 8–10 mm long, trigonous, *style branches* about 8 mm long and 4 mm wide, crests 6–10 mm long, erect. *Capsule* narrowly turbinate, somewhat triangular, 12–17 mm long, dehiscent in the upper third; *seeds* spindle-shaped, 2 mm long and about 1 mm wide. *Chromosome number* unknown.

Flowering time: late December to January.

DISTRIBUTION AND HABITAT

Moraea vallisavium is known only from Vogelgat in the Klein River mountains east of Hermanus. It grows in sites that remain damp during the summer, often on steep south-facing slopes that receive moisture from the prevailing south-easter winds. It has seldom been collected, probably owing to the fact that it grows at relatively high altitudes, and also because it has the habit of blooming well only after a fire the previous summer, although in rocky or cleared sites it will bloom year after year.

DIAGNOSIS AND RELATIONSHIPS

Moraea vallisavium has a single foliage leaf inserted shortly above the ground, an unbranched stem and moderate-sized yellow flowers with the inner tepals smaller than the outer. In these features, it matches subgenus *Monocephalae*, to which it is assigned. However, it is unusual in this subgenus in the finely fibrous and reticulate corm tunics and in having corms that persist, accumulating in a chain behind the current corm, both rare features in *Moraea*. The leaves seem unique in *Moraea* in being flat and monofacial rather than bifacial and channelled as is most frequent in the genus, or terete as in its relatives in subgenus *Monocephalae*. Also unusual are the margins of the sheathing stem bract and outer spathe which are free to the base instead of partly united. Fibrous corm tunics in genera where less broken tunic layers are the rule, sometimes often occur in high mountain species, especially those of damp sites, and persistent old corms are also occasionally found in montane species in other genera of Iridaceae and these two characteristics may be derived rather than primitive as they at first appear. However, the monofacial leaf, unknown elsewhere in *Moraea* except perhaps in the recently discovered and incompletely known *M. linderi* from the Piketberg mountains, seems a truly primitive characteristic, as are the free margins of the sheathing bracts and outer inflorescence spathe.

Moraea vallisavium seems to be most closely related to *M. angusta* and to *M. anomala* of subgenus *Monocephalae*. Except for *M. vallisavium*, species of the subgenus have a single terete leaf, and unusual rotund, relatively short fruits with flat and thin discoid seeds. The capsules of *M. vallisavium* differ in being slender and narrowly tubinate, while the seeds are spindle-shaped, and relatively large for *Moraea* and quite unlike the discoid seeds of other species of subgenus *Monocephalae*.

Moraea vallisavium has the smallest flowers in subgenus *Monocephalae* with outer tepals only 20–24 mm long, filaments about 5 mm long and anthers 5–6 mm long. It is recorded as blooming from late December into January and all specimens have only one stem bract. *Moraea anomala* also has relatively small flowers for the subgenus with outer tepals in the 30–45 mm long range, filaments 6–14 mm long and anthers 4–8 mm long (Goldblatt, 1976b). It almost always has two sheathing bracts on the stem and blooms from September to November at higher elevations. *Moraea vallisavium* thus seems reasonably distinct from *M. anomala* in floral characters as well as in the capsule and seed. *Moraea angusta* usually has large flowers, with outer tepals in the 30–50 mm range, filaments 5–15 mm long, joined only near the base, and anthers normally 7–10 mm long. However, some high altitude collections assigned to the species, notably *Wurts 496* from Eleven O'Clock Mountain at Swellendam, and a recent collection, *Esterhuysen 35606*, made in 1981 in the same area, have smaller flowers with outer tepals 22–25 mm long, filaments about 6 mm long and anthers 4 mm long. These specimens are easily confused with *M. vallisavium* especially as they are late blooming, November to

January and have fibrous corm tunics (corms lacking in the Wurts gathering). The Esterhuysen collection has nearly ripe capsules, and these are rotund and contain discoid seeds, typical of *M. angusta*. It seems then, that *M. vallisavium* lies close to both *M. anomala* and *M. angusta* but differs from both mainly in its fruit and seed characters, although it can be distinguished from most collections of these species by its corm tunics and flowers as well.

HISTORY

Moraea vallasavium appears to have been unknown until 1979 when it was found in Vogelgat Nature Reserve by Ion Williams, who has made a detailed survey of the flora of the Reserve, and independently by myself. It appears to be rare and local at altitudes above 300 m, but it may well occur elsewhere in the Klein River mountains.

7. MORAEA ANGUSTA (Thunberg) Ker

Ker, *Ann. Bot.* (Konig & Sims) 1: 240. 1805; Baker, *Flora Capensis* 6: 13. 1896, in part including also *M. neglecta*; Lewis, *Jl S. Afr. Bot.* 15: 115–118. 1949; *Flora Cape Peninsula* 229–230. 1950; Goldblatt. *Ann. Mo. Bot. Gdn* 63: 740–743. 1976.

SYNONYMS

Iris angusta Thunberg, *Dissertatio de Iride* no. 28. 1782. TYPE: South Africa, Cape, slopes below Devils Peak and Lions Head, Cape Peninsula, *Thunberg s.n.* (Herb. Thunberg *1108*, UPS, lectotype).

Moraea obtusa N. E. Brown, *Kew Bull.* 1931: 195. 1931. TYPE: South Africa, Cape, marsh at Crawford, Cape flats, *Weintraub sub Moss 18185* (K, BM).

angusta = narrow or slender, referring to the slender terete leaves characteristic of this and the other species of subgenus *Monocephalae*.

Plants medium in size, 20–40 cm high, solitary, unbranched. *Corms* 1–2 cm in diameter; tunics pale to dark brown, soft textured, the innermost nearly entire, the outer becoming vertically split, and eventually fibrous. *Cataphylls* membranous and pale. *Leaf* solitary, inserted shortly above ground level, terete and usually rigid, exceeding the inflorescence. *Stem* always unbranched, erect, bearing 1 or 2 bract leaves, the nodes either smooth or sticky. *Spathes* herbaceous, dark green, usually truncate or obtuse at the apex, the apices often brown, inner 6–8 cm long, outer about half as long as the inner. *Flowers* pale yellow, often flushed brown or grey, occasionally pale greyblue, veined purplish below, nectar guides clear yellow, on the outer tepals only; *outer tepals* 30–50 mm long, the limb about two thirds as long as the claw; *inner tepals* 25–35 mm long, initially erect but becoming completely reflexed when fully open. *Filaments* 5–12 mm long, free almost to the base (joined for about 1 mm); *anthers* 7–10 mm, the pollen often orange red, rarely yellow. *Ovary* (8–)10–18 mm long, exserted from the spathes, *style branches* (7–)11–20 mm long, the crests 13–23 mm, equal to or exceeding the style branches. *Capsules* cylindrical, somewhat 3-lobed, 1,5–2 cm long; *seeds* large, flat, discoid. Chromosome number $2n = 20$.

Flowering time: late August to November, to January at higher altitudes; flowers opening after midday and fading shortly after sunset.

DISTRIBUTION AND HABITAT

Moraea angusta occurs in the winter rainfall area and is centred in the south-western Cape, extending north to the Cedarberg and east to Knysna. It grows on flats and mountain slopes and plateaus, usually in stony sandstone soil. Plants flower best when the fynbos vegetation has been burned or heavily grazed as is typical of many species of geophytes of the south-western Cape sandstone soils.

DIAGNOSIS AND RELATIONSHIPS

Moraea angusta has a single terete leaf, an unbranched stem and usually relatively large pale yellow to brownish flowers. It is one of three closely related and morphologically similar species of subgenus *Monocephalae*. It is probably most closely related to *M. anomala*, from which it can be distinguished by filaments free almost to the base, sticky nodes on the stem and usually a single sheathing stem bract. In *M. anomala* the filaments are united for at least one quarter of their length, the nodes are not sticky and there are always two sheathing stem bracts. *Moraea angusta* may also be confused with *M. neglecta* although when live they are very distinct. The nectar guide of *M. neglecta* is unusual in consisting of a series of finely spotted lines radiating from the base of the tepal limb. *Moraea neglecta* also has yellow instead of red pollen and the flower colour is a deeper yellow than in any form of *M. angusta*. In the dry or vegetative state accurate determination is sometimes impossible and dry flowering material must be measured with care because details of flower colour and the nature of the nectar guide are lost on drying.

Habitat differences between the species of subgenus *Monocephalae* are not marked but *Moraea anomala* seems most frequently found on clay soils, notably the shale band of the Cebarberg and Du Toits Kloof Mountains. In contrast, *M. neglecta* is most often encountered on sandy flats, often near the coast. *Moraea angusta* is usually found on flats or lower mountain slopes in seasonally wet sites in a sandy or rocky soil. Though these habitats are not always clear cut, it seems likely that the three species do indeed have subtly different ecological preferences.

HISTORY

Moraea angusta was first collected by Carl Peter Thunberg in the 1770's and it was described by him in 1782, as *Iris angusta*. It was transferred to *Moraea* by Ker in 1805. It remained broadly circumscribed in J. G. Baker's treatment in *Flora Capensis* in 1896. The English botanist, N. E. Brown separated a bluish-flowered form as *M. obtusa* in 1931, and in 1949 the Cape botanist, G. J. Lewis recognized three species among the plants assigned by earlier botanists to *M. angusta*. These were *M. angusta* itself, including Brown's *M. obtusa*, and *M. neglecta* and *M. anomala*. I have made a careful study of living populations and of herbarium material of this group of species and endorse Lewis's treatment. In nearly every living population that I have seen it has been easy to decide which of the three taxa was present, and no significant vari-

7.

M. augusta.

ability was found within any population. Carefully prepared herbarium specimens can usually readily be determined, but in the absence of details of flower colour and form, difficulties arise that are not always fully resolved by measurement.

Fresh flowering material is, however, easy to recognize by flower colour and size, nature of the nectar guide, and pollen colour. The only reliable characters in dried material are the relative lengths of the style branches and crests, and the degree to which the filaments are united. Both *M. angusta* and *M. neglecta* have filaments free almost to the base, while in *M. anomala* they are united for at least 2 mm and one-quarter to half their length. The style crests are narrow and usually exceed a short style branch in *M. angusta* and *M. anomala*, while in *M. neglecta* the style branch is longer than the crest.

8. MORAEA ANOMALA Lewis

Lewis, *Jl S. Afr. Bot.* **15**: 119. 1949; Goldblatt, *Ann. Mo. bot. Gdn* **63**: 743–744. 1976. TYPE: South Africa, Cape, Houw Hoek Pass, Caledon district, *Lewis s.n.* (SAM *58100*, holotype).

anomala = anomalous or usual, presumably referring to the anomaly of being known for many years without being recognized as distinct from the allied *M. angusta*.

Plants medium in size, 20–40 cm high, solitary, unbranched. *Corms* 1– 2 cm in diameter; tunics pale to dark brown, soft textured, the innermost layers ± entire, the outer becoming vertically split, and eventually fibrous. *Cataphylls* membranous and pale. *Leaf* solitary, inserted shortly above ground level, terete and usually rigid, exceeding the inflorescence. *Stem* always unbranched, erect, with 2 sheathing bract leaves, the nodes not sticky. *Spathes* herbaceous, dark green usually truncate or obtuse at the apex, the apices often brown, inner 4,5–6 cm long, outer about half as long as the inner. *Flowers* pale yellow with distinct darker nectar guides on the outer tepals; *outer tepals* 30–45 mm long, the limb about as long as the claw; *inner tepals* 25–35 mm long, initially erect but becoming horizontal or completely reflexed when fully open. *Filaments* 6–14 mm long, united for at least 2 mm and usually ⅓–½ their length; *anthers* 4–8 mm long, pollen usually red, occasionally yellow. *Ovary* 10–15 mm long, usually exserted from the spathes, *style branches* 9–14 mm long, the crests about as long or somewhat longer than the branches, 10–15 mm long. *Capsules* cylindrical, somewhat 3-lobed, 1,5–2 cm long; *seeds* large, flat, discoid. Chromosome number $2n = 20$.

Flowering time: late September to November; flowers opening after midday or rarely in the later afternoon, and fading shortly after sunset.

DISTRIBUTION AND HABITAT

Moraea anomala is restricted to the southwestern and western Cape. It extends from the Cedarberg Mountains in the north to the Caledon and Bredasdorp districts in the south, but is apparently absent from the Cape Peninsula. It grows on mountains and flats, most often on clay soils and very characteristically on the shale band of the higher western Cape mountains. It flowers well only after a fire the previous season, when the surrounding fynbos vegetation cover has been destroyed.

DIAGNOSIS AND RELATIONSHIPS

Moraea anomala is an unmistakable member of subgenus *Monocephalae*, having a single terete leaf, unbranched stem and globose capsule with flat discoid seeds. It can usually be distinguished from the other members of the subgenus by its consistently having two sheathing bract leaves and non-sticky nodes. The flowers are pale yellow with distinct deeper yellow nectar guides and the filaments distinctly united for at least 2 mm and between a third and a half their length. It is most closely related to *M. angusta*, which usually has a single sheathing bract leaf and typically sticky nodes. *Moraea angusta* has pale to deep yellow, or brownish to bluish flowers, distinctly brownish to purple on the reverse, the filaments are barely joined at the base and the pollen is red or yellow. The flowers of *M. anomala* are yellowish on the reverse and the pollen is orange to red.

HISTORY

Moraea anomala has been known at least since the late nineteenth century and it has been collected frequently. The earliest collections that I have seen are those of Harry Bolus and Rudolf Schlechter, made in the 1890's, but there are probably earlier gatherings in European herbaria. It was not considered distinct from *M. angusta* until 1949 when it was described by G. J. Lewis after a detailed study of what had until then been treated as a single species.

8.

M. anomala.

9. MORAEA NEGLECTA Lewis

Lewis, *Jl S. Afr. Bot.* **15**: 118. 1949; *Flora Cape Peninsula* 229. 1950; Obermeyer, *Fl. Pl. Africa* **40**: tab. 1570. 1970; Goldblatt, *Ann. Mo. bot. Gdn* **63**: 744–745. 1976. TYPE: South Africa, Cape, near Sirkels Vlei, Cape Peninsula, *Lewis s.n.* (SAM *57107*, holotype).

neglecta = neglected, alluding to the fact that for many years the species was not recognized as distinct from the related *Moraea angusta*.

Plants medium in size, 20–40 cm high, solitary, unbranched. *Corms* 1–2 cm in diameter; tunics pale to dark brown, soft textured, the innermost layers ± entire, the outer becoming vertically split, and eventually fibrous. *Cataphylls* membranous and pale. *Leaf* solitary, inserted shortly above ground level, terete and usually rigid, exceeding the flowers. *Stem* always unbranched, erect, with 1, occasionally 2 bract leaves, the nodes sticky. *Spathes* herbaceous, dark green, usually truncate or obtuse apically, the apices often brown, inner 5–7,5 cm long, outer about half as long as the inner. *Flowers* deep yellow, the nectar guide lined with black dots; *outer tepals* 38–50 mm long, the limb 20–25 mm long; *inner tepals* 25–35 mm long, oblong, initially erect, usually becoming reflexed in the upper part. *Filaments* 6–12 mm long, united only at the base for about 1 mm; *anthers* 7–9 mm long, pollen yellow. *Ovary* 9–15 mm long, usually exserted from the spathes, *style branches* 14–18(–22) mm long, crests 12–17(–22) mm long, usually slightly shorter than the style branches. *Capsules* oblong, somewhat 3-lobed, 1,5–2 cm long; *seeds* large, flat, discoid. *Chromosome number* 2n = 20.

Flowering time: September to November; flowers opening after midday and fading shortly after sunset.

DISTRIBUTION AND HABITAT

Moraea neglecta occurs in the western and south-western Cape. Its range extends from the Caledon district in the south to the Cedarberg Mountains and the Nieuwoudtville escarpment in the north. It prefers a well-drained, sandy, flat habitat, and may be found either on the lowlands near the coast or inland, or on mountain plateaus. It is most common near the coast between Stanford in the south and the Olifants River mouth in the north. The corms are typically buried deeply in deep coarse sand.

DIAGNOSIS AND RELATIONSHIPS

Moraea neglecta has a single terete leaf, and unbranched stem and large, usually bright-yellow flowers with an unusual nectar guide consisting of finely dotted lines radiating from the base of the tepal limb. When live the nectar guide is so distinctive that it can immediately be recognized by this feature. It is probably most closely related to *M. angusta*, the dull yellow to brownish flowers of which have a clear yellow nectar guide. *Moraea neglecta* can also be distinguished in subgenus *Monocephalae* by its sticky nodes, single sheathing bract leaf, and style crests usually slightly shorter than the style branches. It is generally a more robust species than either *M. angusta* or *M. anomala* and can often be recognized by this alone, but when dry it is sometimes impossible to distinguish from *M. angusta*, and this is the reason it was for so long confused with it. With its sticky nodes, consistently single sheathing bract leaf and unusual nectar guide, *M. neglecta* must be regarded as the most specialized member of subgenus *Monocephalae*.

HISTORY

The earliest records that I have been able to assign with confidence to *Moraea neglecta* are the collections of Rudolf Schlechter and Harry Bolus, made in the 1890's, but almost certainly this common plant must have been collected by earlier botanists whose specimens are probably still misidentified, or cannot be distinguished from *M. angusta*. It was only in 1949 that the Cape botanist and expert on Iridaceae, G. J. Lewis, drew attention to the fact that the species known then as *M. angusta* comprised three separate species, two of them undescribed. *Moraea neglecta* has been consistently recognized since Lewis described it, and when seen live, there can be no doubt that it is very different from *M. angusta*.

9.

M. neglecta.

SUBGENUS *MORAEA*

SECTION *MORAEA*

10. MORAEA RAMOSISSIMA
(Linnaeus fil.) Druce

Druce, *Bot. Soc. Exch. Club. Brit. Isles* **4**: 636. 1914; Lewis, *Flora Cape Peninsula* 228. 1950; Goldblatt, *Ann. Mo. bot. Gdn* **63**: 687–689. 1976.

SYNONYMS
Iris ramosissima Linnaeus fil., *Supplementum Plantarum* 99. 1782. TYPE: South Africa, Cape, sandy places in the Swartland, *Thunberg, s.n.* (Herb. Thunberg *1169*, UPS, lectotype designated by Goldblatt, 1976: 687).
Iris ramosa, Thunberg, *Dissertatio de Iride* no. 24. 1782 nom. illeg. superfl. pro *I. ramosissima*. TYPE: as for *I. ramosissima* Linnaeus fil.
Moraea ramosa (Thunberg) Ker, *Bot. Mag.* **20**: tab. 771. 1804; Baker, *Flora Capensis* **6**: 1896 comb. illeg. bas. illeg.
Moraea bulbifera Jacquin, *Plantarum Horti Schoenbrunnensis* **2**: 38, tab. 197. 1797. TYPE: South Africa, Cape, without precise locality, illustration in *Plantarum Horti Schoenbrunnensis* tab. 197 (lectotype designated by Goldblatt, 1976: 687).
Freuchenia bulbifera Ecklon, *Topographisches Verzeichniss* 14. 1827, nom. nud.
Vieusseuxia freuchenia (Ecklon) Steudel, *Nomenclator Botanicus* **2**: 765. 1841, nom. inval.

ramosissima = very branched, alluding to the extraordinarily branched stem characteristic of the species.

Plants large, 50–120 cm, much branched. *Corm* 12–18 mm in diameter, densely surrounded by many small cormlets round the base; rootstock enclosed in a network of spinous roots. *Cataphylls* membranous, sheathing the base. *Leaves* several to many, mostly basal, decreasing in size above, falcate, more or less channelled, 30–50 cm long, 15–30 mm wide. *Stem* bearing large cormlets in the lower axils, terete or grooved above the nodes, branching repeatedly from the base to the apex, sheathing bract leaves leaf-like below, with open sheaths not united around the axis. *Spathes* herbaceous with dry, acute to attenuate apices, inner 2–2,5 cm long, outer much shorter, less than one-third as long as the inner, sheath usually open or united only towards the base. *Flowers* bright yellow with deeper yellow nectar guides on the outer tepals, the tepals reflexed to 45°; outer tepals 3–4 cm long, about 15 mm wide; inner tepals smaller than the outer, up to 3,5 cm long. *Filaments* 10–15 mm long, entirely free, sometimes contiguous near the base; *anthers* about 10 mm long. Ovary usually exserted from the spathes, 3–5 mm long, obovoid-truncate, *style branches* 20–25 mm long, crests well developed. *Capsule* more or less globose, truncate above, about 6 mm in diameter; *seeds* angled. Chromosome number 2n = 20.

Flowering time: October to December, typically late flowering; flowers opening about 11 a.m. and fading in the late afternoon.

DISTRIBUTION AND HABITAT
Moraea ramosissima is widespread in the winter rainfall area and occurs almost throughout the western and southern Cape. It extends from the Gifberg and Cedarberg Mountains in the north to the Cape Peninsula, and is somewhat scattered through the southern Cape to Grahamstown in the east. It occurs primarily in mountain areas, and always in wet situations, either along streams, seepage zones, or below cliffs.

DIAGNOSIS AND RELATIONSHIPS
Moraea ramosissima is an unmistakeable species, one of the tallest species of *Moraea* in the winter rainfall area and distinctive in its many-branched habit and several to many leaves. The flowers are always bright yellow and unspecialized in their structure, with both the inner and outer tepals speading to reflexed to about 45°. The filaments are among the least specialized in the genus, being free from one another to the base. There seems little doubt in fact, that *M. ramosissima* is one of the most primitive species of *Moraea*. The free filaments, many branches and several leaves are all considered basic and ancestral features of the genus. *Moraea ramosissima* is, however, specialized in its peculiar root system. The main roots grow out and around the corm and the lateral roots form short branches that harden with age and become spiny outgrowths that make the base and corm most uncomfortable to handle. This spiny root system, described in detail by Lewis (1954), is probably an adaptation for protection against predation but it does not seem to be particularly effective as the plants are frequently seen uprooted and with the larger corms eaten away. The species is a favourite of baboons and porcupines. Despite this constant predation, *M. ramosissima* remains relatively common. It reproduces readily either from seed or from the hundreds of small cormlets that are produced around the base and lower internodes.

Moraea ramosissima has no close relatives, but its immediate living allies are probably *M. gawleri*, widespread in the winter rainfall area, and the Richtersveld endemic, *M. namaquamontana*. Both are much smaller species, similar to *M. ramosissima* in having a branched flowering stem, two or more leaves, globose capsules and relatively short outer inflorescence spathes. *Moraea gawleri* has only two or rarely three basal leaves and *M. namaquamontana* several leaves but it is a much smaller plant than *M. ramosissima* and it has smaller flowers in which the filaments are partly united. *Moraea ramosissima* is sufficiently different from these and all other species that it should not be confused.

10.

M. ramosissima.

The species is unusually variable, and while well-grown lowland individuals may be a metre or more in height, I have seen dwarf plants 25–35 cm high, with all their parts smaller than usual. These may represent young plants that have not yet reached adult size, or they may be growing in less than optimal conditions for the species.

HISTORY

Like many of the south-western Cape species of *Moraea*, the first record of *M. ramosissima* in the scientific literature comes from the younger Linnaeus. He described it in 1782, basing the species on the collections and notes of Carl Peter Thunberg. Thunberg gave it the manuscript name *Iris ramosa* but the species epithet was altered to *ramosissima* by Linnaeus fil. Thunberg published an extended description of the species in late 1782, shortly after it was named, but he used his own specific epithet *ramosa*. Despite the clear earlier publication of the name *I. ramosissima*, Thunberg's later, and illegitimate epithet, *ramosa* was adopted when the species was transferred to *Moraea* by Ker at the beginning of the nineteenth century. This name remained in general use in the *Flora Capensis* (Baker, 1896). Only in 1914 did the amateur botanist George Druce point out that the epithet *ramosissima* had priority and he published the combination we must now use, *Moraea ramosissima*.

Moraea ramosissima was described independently in 1797 as *M. bulbifera* by Nicholas Jacquin who was evidently unaware of the description published some fifteen year earlier. Ecklon apparently considered *Moraea ramosissima* so distinct a species that he placed it in its own genus, *Freuchenia*, a name never validated by a published description. Alluding to the unusual bulbiliferous habit, Ecklon used the name *F. bulbifera* for the species. Later botanists ignored Ecklon's opinion. Steudel, the early cataloguer of plant names, reverted to the use of the generic name *Vieusseuxia* for the southern African species of *Moraea* and chose to use the name *V. freuchenia* for *M. ramosissima*, thus using Ecklon's generic name at species level. Steudel's name has no nomenclatural validity.

CULTIVATION

Moraea ramosissima is an easy species to grow, and it makes an interesting accent plant for a rockery or pond area. It is not often seen in gardens, partly because it is largely unknown, and perhaps partly because the individual flowers last only from about midday to later afternoon. However, each plant produces hundreds of large yellow flowers over about a month of its flowering season, with usually at least one and sometimes ten or more flowers open each day which makes it to my mind a most desirable and attractive plant. In the south-western Cape it can be grown readily and does not require watering during the winter and spring growing season but in areas of summer rainfall it does of course need more attention. It tolerates light frost, and does not suffer even from the coldest of winters on the Witwatersrand. I have found *M. ramosissima* to thrive in a light loamy soil with good drainage, and at Kirstenbosch it has been grown well in light shade in a sandy soil rich in organic matter. I doubt whether it is fussy about soil conditions at all, providing it gets enough water.

11. MORAEA GARIPENSIS Goldblatt, sp. nov.

TYPE: Namibia, valley of the Orange River, near Aussenkehr, in crevices in granite, *Goldblatt 7153* (MO, holotype).

garipensis = from the Garip, the Hottentot name for the Orange River.

Planta 25–50 cm alta, cormo 15–20 mm in diametro, foliis pluribus falcatis, caule usitate 2–6 ramoso, spathis 25–35 mm longis herbaceis acutis exteriore parum breviore quam interiore, floribus flavis, tepalis exterioribus ca. 36 mm longis unguibus 10–12 mm longis erectis limbis reflexis in dimidio distalibus, marginibus undulatis, interioribus ca. 28 mm longis 4–6 mm latis adscendentibus ad erectis, filamentis 16 mm longis infra connatis, antheris ca. 8 mm longis ultra apices stigmatum productis, polline rubroaurantiaco, ramis styli ad 12 mm longis, cristis erectis ca. 5 mm longis.

Plants 25–50 mm high. *Corm* 15–20 mm in diameter, tunics brown, comprising imbricate layers each deeply notched below and with the edges minutely fringed, drawn into points above. *Cataphylls* membranous and pale. *Leaves* several, pale green, the lower basal, the upper inserted on the stem, decreasing in size above and becoming bract-like and sheathing, spreading to falcate, the lowermost longest and usually about as long as the stem, 8–10 mm wide, channelled to more or less flat. *Stem* erect, usually 2–6 branched, occasionally simple, sheathing

bract leaves about as long as the spathes, branches ascending. *Spathes* herbaceous, pale green becoming membranous above, apices acute, *inner* 25–35 mm long, *outer* nearly as long as the inner. *Flowers* yellow, sweetly scented, with nectar guides consisting of minute red spots at the base of the outer tepal limbs, the claws of the outer tepals minutely black spotted, especially towards the knee; *outer tepals* about 36 mm long, claws erect, channelled, 10–12 mm long, limb about 24 mm long, spreading and horizontal in the basal half, reflexed and vertical in the distal half, about 15 mm wide, obtuse to emarginate, widest in the distal third, margins undulate, *inner tepals* ascending to erect, distinctly clawed, limb oblong, 4–6 mm wide, red dotted in the lower central parts. *Filaments* 16 mm long, united in the lower half into a cylindric column, diverging above, pale yellow; *anthers* 8 mm long, linear, held above the tepal claws and exceeding the stigma lobe, thecae separated by a wide connective, pollen bright orange. Ovary initially about 4 mm long, exserted from the spathes, *style branches* dividing shortly above the apex of the filament column, diverging, about 12 mm long, 6,5 mm wide, reaching to the middle part of the anthers, crests about 5 mm long. *Capsule* broadly obovoid, 8–10 mm long; *seeds* angled, light brown, about 2 mm in diameter, the testa loose. *Chromosome number* $2n = 20$.

Flowering time: only seen in bloom in July, flowers opening in early afternoon about 2 p.m. and fading at sunset.

DISTRIBUTION AND HABITAT

Moraea garipensis is very local in the lower Orange River valley west of Vioolsdrif, and is known only from the Namibia side of the river. It is apparently confined to granite hills where it grows in cracks in the rock.

DIAGNOSIS AND RELATIONSHIPS

Moraea garipensis is one of the most exciting species of *Moraea* to be discovered in recent years. It has a most unusual combination of features that suggests that it is one of the least specialized species in the genus, yet it grows in a most unexpected locality for a *Moraea*, let alone an unspecialized one. The only known locality is in the lower Orange River valley in southern Namibia. *Moraea garipensis* can be distinguished by its several soft-textured leaves, typically branched flowering stem and large yellow flowers. The flower has oblong nearly erect inner tepals, broad style branches and prominent crests, all fairly unspecialized features for *Moraea*. However, the flower is unusual in its large size, and in having short tepal claws and long filaments that hold the bright orange-red anthers well above the tepals instead of being concealed behind them. *Moraea garipensis* also has a very distinctive corm, the tunics of which are not at all fibrous, but form complete imbricate layers. Each layer is deeply incised below into long truncate segments with minutely fringed edges and the upper margins are drawn into points above. The corm looks for all the world like that of a *Geissorhiza* except that it is much larger.

The several leaves and branches of *Moraea garipensis* and the basically unspecialized flower suggest that it is allied to the basal species of subgenus *Moraea*. I feel that a position closest to the south-western Cape *M. ramosissima* and the recently discovered Richtersveld species *M. namaquamontana* most accurately reflects its affinities. It is clearly quite distinct from these two species in several features and there is no possibility of *M. garipensis* being confused with any other *Moraea*. It must be regarded as an ancient relict species that has somehow managed to persist in the inhospitable mountains of the south-western African interior where there is little rain in the best years and often none at all. Most likely it receives just enough moisture to survive from condensation of water from the mist that rises from the Orange River during the cooler winter months, and this alone is sufficient in some years to permit some plants to flower. *Moraea garipensis* has no obvious adaptations for drought resistance unlike other species of *Moraea* that grow in arid conditions. Its leaves are broad and soft textured and the spathes remain green during flowering, while the flowers are large and the capsules are exserted from the spathes. This is unlike most desert species of *Moraea* which often have leathery leaves with a narrow blade and undulate to crisped or thickened margins, dry spathes, typically small flowers and capsules enclosed in the spathes during fruit development.

HISTORY

The first information about the existence of *Moraea garipensis* came during the exceptionally

wet spring of 1983, when a visitor to the Compton Herbarium at Kirstenbosch brought a collection of photographs of wild flowers taken in Namaqualand and Namibia. Among them was a good picture of a *Moraea* species completely new to science. The exact locality and habitat of the plant was obtained, a south-facing granite hill above the Orange River near Gamkabmond, on the road from Vioolsdrif to the mining settlement of Rosh Pinah. It was too late that season to recollect the species and in fact I doubted whether a *Moraea* could possibly exist in such an arid part of the world. However, the following year I visited the site and despite the season having been a dry one, I found the population. Because there had been no rain for about a year, *M. garipensis* was not at its best. Only two plants were in bloom, but there were many dry fruiting stems, left from the year before. The corms that I managed to extract from the crevices where they were lodged were planted and they continued to grow, one plant actually flowering so that the illustration reproduced here could be made.

12. MORAEA NAMAQUAMONTANA
Goldblatt, sp. nov.

TYPE: South Africa, Cape, Richtersveld, Stinkfonteinberg SW of Vanzylsrus, stony upper east slopes, *Oliver, Tölken & Venter 627* (PRE, holotype; NBG, isotype).

namaquamontana = from the mountains of Namaqualand, referring to the restricted distribution in the higher ranges of the Richtersveld in northern Namaqualand.

Planta 22–35 cm alta, cormo 10–14 mm in diametro, foliis 5–9, marginibus undulatis ad crispis, caule ramoso bracteis 10–15 mm longis, spathis 22–27 cm longis herbaceis acutis interiore longiore quam exteriore, floribus pallide flavis vix aurantiaco colore suffusis, tepalis exterioribus 26–29 mm longis unguibus 9 mm longis adscendentibus nigris notatis ad genua, limbis reflexis, marginibus undulatis, interioribus brevioribus 23–25 mm longis etiam filamentis 6–7 mm longis infra connatis, antheris ca. 4 mm longis ad apices stigmatum productis, polline rubro, ramis styli adscendentibus ca. 7 mm longis ungues tepalorum excedentibus, cristis erectis 9–13 mm longis.

Plants 22–35 cm high. *Corm* 10–14 mm in diameter, tunics dark brown, with coarse fibres arranged in vertical ridges. *Cataphylls* membranous and pale. *Leaves* several, 5–9, pale green, up to 16 cm long and 10–15 mm wide, channelled, spreading to falcate, margins undulate to somewhat crisped, restricted to the lower half of the plant and mostly crowded at the base. *Stem* usually 3–6 branched, occasionally simple, sheathing bract leaves 10–15 mm long, branches ascending. *Spathes* herbaceous, apices acute, *inner* 22–27 mm long, *outer* about half as long as the inner. *Flowers* pale yellow suffused with pale orange and dark veined in the distal two-thirds of the tepal limbs, nectar guides only on the outer tepals, deep yellow, the claws of the outer tepals minutely black-spotted, especially towards the knee; *outer tepals* 22–29 mm long, claws ascending, 8–9 mm long, limb somewhat reflexed, about 12 mm wide, obtuse to emarginate, widest in the distal third, margins undulate; *inner tepals* 23–25 mm long, claw 7–8 mm long, limb oblong, reflexed like the outer, about 8,5 mm wide. *Filaments* 6–7 mm long, united in the lower half, diverging above, pale yellow; *anthers* about 4 mm long, linear, held above the tepal claws, pollen bright red. Ovary obconic, trigonous, 3,5–4 mm long, exserted from the spathes, *style branches* ascending, 7 mm long, about 5 mm wide, crests 9–13 mm long almost linear, erect, margins undulate. *Capsule* more or less globose, 5–7 mm long, to 5 mm in diameter; *seeds* angular, 1,5–2 mm at the longest axis. Chromosome number 2n = 20.

Flowering time: only collected once in bloom, in September; flowers opening in mid-morning and fading in the late afternoon.

DISTRIBUTION AND HABITAT
Moraea namaquamontana is known only from upper elevations in the Stinkfontein Mountains, highest range in the Richtersveld, in northern Namaqualand. The only two collections indicate that it grows in stony ground in full sun on south-facing slopes at altitudes above 1 000 m.

DIAGNOSIS AND RELATIONSHIPS
Moraea namaquamontana has an unspecialized flower with large outer tepals with nectar guides and smaller inner tepals that spread to the same degree as the outer. It stands out in its vegetative morphology, especially the several soft-textured leaves and the well-branched stem. It is clearly closely related to the widespread winter rainfall areas species, *M. gawleri*, to which I first referred

it, although its several leaves and larger flowers and spathes do not conform to this species. *Moraea gawleri* has no more than 1 or 2 basal or sub-basal leaves and sometimes 1 more leaf produced from a lower node on the stem. Also, the inflorescence spathes are no more than 22 mm long and usually in the 12–15 mm range in contrast to the spathes of *M. namaquamontana* which are 25–27 mm long. The flowers of *M. namaquamontana* are as large as the largest flowers recorded in *M. gawleri* but most populations of the species have tepals 18–22 mm long, anthers about 3 mm long and the other parts also proportionately smaller. There seems to be no doubt that *M. namaquamontana* and *M. gawleri* are closely related but the differences are sufficient to merit their separation as distinct species.

HISTORY

Moraea namaquamontana was first collected in 1977, by E. G. Oliver, Helmut Tölken and Stephanus Venter, on an expedition of the Botanical Research Institute, Pretoria, to the higher mountains of the Richtersveld. It was one of several new species or significant range extensions that resulted from their exploration. In Iridaceae, the unusual new *Gladiolus isolatus* Goldblatt was among the most interesting of their discoveries (Goldblatt, 1984). *Moraea namaquamontana* was recollected in 1982, a year of particularly good rainfall along the west coast of southern Africa, this time by Mike Viviers of the South African Department of Forestry. Viviers found a populations of plants in late seed on Cornelsberg, the highest mountain in the Richtersveld, and an extension of the Stinkfontein Mountains where the first collection was made. He gathered several corms from plants that were already dry and not then identifiable as anything but a member of the *Moraea-Homeria* alliance. The corms were given to me and were grown the following year at the Missouri Botanical Garden where root tips from a chromosome count were harvested, and the plants were subsequently flowered and were pressed to make a permanent record. The chromosome number, $2n = 20$ and karyotype of large and small chromosomes in the same as in most species of subgenus *Moraea*.

CULTIVATION

I have found *Moraea namaquamontana* fairly easy to grow in pots, and my few specimens continued to flower sporadically for six weeks, producing two or three flowers every second or third day. The plants are sensitive to overwatering and must be given as little water as possible, and should be kept in a well-drained medium. If the species ever becomes available to the public, wild flower growers would do well to try and grow it. A naturalized setting such as a rock garden would be most suitable.

13. MORAEA GAWLERI Sprengel

Sprengel, *Systema Vegetabilium* ed. 16, 5 (Index): 462. 1828, nom. nov. pro *M. crispa* (Linnaeus fil.) Ker nom. illeg.; Goldblatt, *Ann. Mo. bot. Gdn* 63: 689–692. 1976.

SYNONYMS
Moraea crispa (Linnaeus fil.) Ker, *Bot. Mag.* 20: tab. 754. 1804; Baker, *Flora Capensis* 6: 15. 1896, incl. var., nom. illeg. homonym pro *M. crispa* Thunberg, 1787.
Moraea crispa var. *rectifolia* Baker, *Flora Capensis* 6: 16. 1896. TYPE: South Africa, Cape, Table Mountain, *H. Bolus 4718* (BOL).
Iris crispa Linnaeus fil., *Supplementum Plantarum* 98. 1782. TYPE: South Africa, Cape, hills near Cape Town, *Thunberg s.n.* (Herb. Thunberg *1120*, UPS, lectotype designated by Goldblatt, 1976: 689; S, isolectotype).
Moraea undulata Ker, *Iridearum Generum* 43. 1927, nom. nov. pro *M. crispa* (Linnaeus fil.) Ker, nom. illeg. homonym pro *M. undulata* (Linnaeus) Thunberg 1787 (= *Ferraria crispa* Burman).
Vieusseuxia brehmii Ecklon, *Topographisches Verzeichniss* 12. 1827, nom. nud.
Vieusseuxia angustifolia Ecklon, *Topographisches Verzeichniss* 12. 1827, nom. nud.
Moraea decussata Klatt, *Abh. Naturf. Ges. Halle* 15: 367. 1882. TYPE: South Africa, Cape, *Krauss 1447* (V, holotype, destroyed; authentic material at S).
Moraea sulphurea Baker, *Bot. Mag.* ser. 3, 55: tab. 7658. 1889. TYPE: South Africa, Cape, without precise locality, illustration in *Bot. Mag.* tab. 7658 (lectotype, here designated).

gawleri = named in honour of John Ker-Gawler (who later changed his family name to Belenden Ker), an early nineteenth century botanist who described many species of *Moraea* and drastically revised Linnaean generic concepts in the family, erecting several genera still recognized today including *Sparaxis*, *Anomatheca* and *Tritonia*.

Plants 15–45 cm high, usually several branched. *Corm* 5–15 mm in diameter; tunics usually light brown, the fibres coarse and vertically ridged. *Cataphylls* membranous, pale or brownish. *Leaves* 2–3 (occasionally 1 only), shorter than the stem, the lower 1–2 basal, the upper produced from the lowest aerial node, linear and ± erect or spreading and somewhat coiled, the margins plane, undulate or crisped, 1–6 mm wide. *Stem* rarely simple, usually with 3–5 branches. *Spathes* herbaceous or dry towards the apex, acute, seldom attenuate, *inner* (0,8–)–2,5 cm long, *outer* about half as long as the inner. *Flowers* yellow, cream or pale brick-red, often darkly veined, sometimes bicoloured with the style branches and crests pale and the tepals yellow or red; *outer tepals* 12–22(–28) mm long, the claw somewhat less than half as long as the limb, limb reflexed to about 45°, 5–14 mm wide; *inner tepals* 10–20 mm long, also reflexed. *Filaments* 4–6 mm long, united for about half their length; *anthers* 2–3 mm long, pollen red or yellow. *Ovary* 2–3 mm long, ovoid, usually exserted from the spathes, *style branches* 5–8 mm long, the crests lanceolate, erect. *Capsule* globose to broadly obovoid, 5–10 mm long and 4–5 mm in diameter; *seeds* angular. *Chromosome number* 2n = 20, 20 + 4–6B.
Flowering time: July to September, to October in the south; flowers opening the late morning and fading towards evening.

DISTRIBUTION AND HABITAT
Moraea gawleri has one of the widest ranges of the Cape species of *Moraea* and occurs over almost the entire winter rainfall zone. It extends from Springbok in Namaqualand, where it is rare, along the west coast and interior to the Cape Peninsula and eastwards as far as Humansdorp. It is most common on clay flats and slopes, usually in renosterveld, but it also occurs in sandy situations in fynbos, notably on the Cape Peninsula.

DIAGNOSIS AND RELATIONSHIPS
The rather small, slender *Moraea gawleri* is most easily recognized by its short inflorescence spathes, which are often no more than 12 mm long (but occasionally up to 25 mm long). It most often has two lightly-crisped basal leaves but forms with either solitary leaves or leaves with straight margins occur, the latter usually in moister habitats. The form with leaves with straight margins, described as *M. crispa* var. *rectifolia* by J. G. Baker, is not recognized in this treatment. There are populations in which all possible leaf types from straight-edged to very crisped occur side by side, and I regard the variety as having no taxonomic validity. *Moraea gawleri* is closely allied to the tall south-western Cape species *M. ramosissima*, and to the recently discovered Richtersveld mountain species *M. namaquamontana*, both of which have several foliage leaves in contrast to the two or sometimes three in *M. gawleri*. *Moraea ramosissima* has large yellow flowers and many basal leaves arranged distichously, and is not likely to be confused with *M. gawleri*. *Moraea namaquamontana* resembles *M. gawleri* more closely, and apart from the difference in leaf number, 6–8 in *M. namaquamontana*, it can be difficult to separate them. *Moraea gawleri* has smaller

13.

M. gawleri.

flowers and fruits, with tepals 12–20 mm long, occasionally reaching to 28 mm, the usual tepal size in *M. namaquamontana*.

The flowers of *Moraea gawleri* are usually a bright yellow to buff color, but a brick-red form is found along the west coast, especially in dry situations as far north as Nieuwoudtville. Occasionally populations with red tepals and pale yellow style crests are encountered, notably in the south where the red- and yellow-coloured forms both occur. An attractive form with yellow tepals and white style crests is also recorded from the south-western Cape.

HISTORY AND SYNONYMY

Carl Peter Thunberg was one of the first botanists to collect *Moraea gawleri* and in 1772–5 he made the collections upon which the history of the species begins. His Cape plant collection and manuscripts were sent back to Sweden a few years before his own return, and Linnaeus fil. actually published the original description under the name *Iris crispa*, based on Thunberg's manuscripts and collection.

In 1804, when Ker transferred all the Cape species of '*Iris*' to *Moraea*, he made the combination *M. crispa* based on the younger Linnaeus' species. Thus begins the complex and unfortunate taxonomic history of this common Cape plant. *Moraea crispa* Thunberg, a quite different species, blocks the legitimate transfer of *Iris crispa* to *Moraea*. When Ker (1827) realized his error in using the name *Moraea crispa* for the plant, he proposed the new name *M. undulata*. This, however, is also a homonym, for *M. undulata* (Linnaeus) Thunberg (the familiar *Ferraria crispa*) and hence also unacceptable. It remained for Kurt Sprengel to provide the name *M. gawleri* in 1828, the second new name given to the species, and the one which must now be used. To further complicate the situation, F. W. Klatt, who studied the Iridaceae in the later nineteenth century, also renamed the species as *M. decussata*, intending to replace the illegitimate *M. crispa* (Linnaeus fil.) Ker, and apparently unaware of the existence of Sprengel's legitimate name *M. gawleri*. In spite of its being a homonym, the name *Moraea crispa* was used in *Flora Capensis* by J. G. Baker who also ignored Klatt's *M. decussata*. However, *M. decussata* appears frequently in the literature after 1920 and was used by G. J. Lewis in her treatment in *Flora of the Cape Peninsula*.

Baker's *Moraea sulphurea*, based on an illustration published in the *Botanical Magazine* in 1839, is somewhat hesitantly included here as a synonym of *M. gawleri*. The type illustration agrees generally with this species, but it is unusal in having no branches, and the leaves are without the typical marginal crisping. These discrepancies may, however, be due to the effects of cultivation rather than indicative of any fundamental differences between *M. sulphurea* and more common forms of *M. gawleri*.

14. MORAEA VEGETA Linnaeus

Linnaeus, *Species Plantarum* ed. 2, 59. 1762; *Systema Naturae* ed. 12, 78. 1767; Barnard & Goldblatt, Taxon **24**: 125–131. 1975; Goldblatt, *Ann. Mo. bot. Gdn* **63**: 693–695. 1976. TYPE: South Africa, Cape, without precise locality, illustration in Philip Miller, *Figures of Plants* **2**: tab. 238. 1758 (lectotype here designated).

SYNONYMS

Iris tristis Linnaeus fil., *Supplementum Plantarum* 97. 1782; Thunberg, *Dissertatio de Iride* no. 39. 1782. TYPE: South Africa, Cape, below Devils Peak, near Cape Town, *Thunberg s.n.* (Herb. Thunberg *1190*, UPS, lectotype designated by Goldblatt, 1976: 693).

Moraea tristis (Linnaeus fil.) Ker, *Ann. Bot.* (Konig & Sims) **1**: 241. 1805; Baker, *Flora Capensis* **6**: 18. 1896.

Ferraria tristis (Linnaeus fil.) Salisb., *Prodromus Stirpium* 42. 1796.

Moraea iriopetala Linnaeus fil., *Supplementum Plantarum* 100. 1781, nom. illeg., superfl. pro *M. vegeta* Linnaeus.

Moraea sordescens Jacquin, *Icones Plantarum Rariorum* tab. 225. 1795 et *Collecteana* **5**: 29. 1797. TYPE: South Africa, Cape, without precise locality, illustration in Jacquin, *Icones Plantarum Rariorum* (lectotype here designated).

Vieusseuxia graminifolia Ecklon, *Topographisches Verzeichniss* 11. 1827. TYPE: South Africa, Cape, 'Groene Berg', *Zeyher 1068* (S, lectotype designated by Goldblatt, 1976: 693).

Vieusseuxia rivularis Ecklon, *Topographisches Verzeichniss* 11. 1827, nom. nud.

Moraea juncea Linnaeus sensu N. E. Brown, *J. Linn. Soc. Bot.* **48**: 42. 1928; sensu Lewis, *Flora Cape Peninsula* 228. 1950.

vegeta = from vegetation, referring to the leafy and fleshy appearance of the plants with small flowers and much vegetative growth.

14.

M. vegeta.

Plants (10–)15–30 cm high, usually several branched. *Corms* 1–2 cm in diameter, tunics of fine, pale fibres. *Cataphylls* membranous, pale. *Leaves* several, produced from the base and above the ground, the lower linear, exceeding the inflorescence, grey and glaucous, often dry and torn at the apex, the sheathing part not closed around the stem but open to the base. *Stem* several branched, markedly puberulous, leafy at all the nodes. *Spathes* herbaceous, occasionally with brown apices, *inner* 2–4 cm long, *outer* 1,5–3 cm long, the margins free to the base. *Flowers* dull yellow to brown, or dull bluish to pinkish, with yellow nectar guides on the outer tepals; *outer tepals* 20–25 mm long, lanceolate, the limb to 18 mm long, reflexed to about 45°; *inner tepals* somewhat smaller, the limbs reflexed as the outer. *Filaments* 5–6 mm long, joined in the lower third; *anthers* 3–4 mm long, acute, pollen usually pale blue. *Ovary* about 4 mm long, exserted from the spathes on slender weak pedicels, *style branches* 7–8 mm long, the crests lanceolate, 7–10 mm long. *Capsule* globose to somewhat oblong, soft-walled and showing impression of seeds, pendulous when mature, up to 12 mm long and to 8 mm in diameter; *seeds* round to angular. *Chromosome number* $2n = 20$.

Flowering time: September and October; flowers opening in mid morning and fading towards evening.

DISTRIBUTION AND HABITAT

Moraea vegeta occurs in the extreme south-western Cape, on the Cape Peninsula, north along the west coast as far as Darling, and east to Wellington and the Caledon district where it grows in the Hemel-en-Aarde Valley. It is usually found on heavy, usually granite derived clay soils. Rudolf Marloth recorded *M. vegeta* much further to the east near Swellendam but this seems doubtful and requires confirmation.

DIAGNOSIS AND RELATIONSHIPS

Moraea vegeta is one of the more inconspicuous species of the genus. It has dull-coloured flowers that are usually rather small in size and thus not particularly evident, especially amongst the very leafy vegetative parts. The colour of the flowers is unusual, often a dull yellow-brown flushed with purple on the reverse, or the flowers may be a dull reddish or a peculiar bluish shade. As can be seen from the plants illustrated here, collected south of Darling, the flowers are nevertheless attractive when seen close up. The flowers themselves are unspecialized for the genus with large entire reflexed inner tepals and well-developed style crests. The vegetative morphology is distinctive. The three to several grey glaucous leaves, the unusual lightly pubescent stem and drooping to pendulous capsules combine to make *M. vegeta* unmistakable. The leaf bases are also unusual and instead of forming a closed sheath with the margins united around the stem above the node, the sheath is open to the base so that part of the stem is always visible right down to the node.

Moraea vegeta appears to stand in an isolated position in subgenus *Moraea* but it is probably most closely related to *M. indecora*, a species confined to a small area of Namaqualand around Springbok. *Moraea indecora* is a large plant which has similar subpendulous capsules and most significantly open sheaths on the leaves, stem bracts and inflorescence spathes. However, its smooth elongated stem, very short tepal claws and prominent large red stamens are quite different from those of *M. vegeta* and there is no possibility that the two could be confused. It is not clear to which other members of section *Moraea* these two species are related and they may be very isolated taxonomically. A possible ally is the south-western Cape *M. papilionacea* which also has lightly pubescent stems, but it is uncertain whether they are actually related.

HISTORY

The history of *Moraea vegeta*, the type species of the genus, is complex, owing more to the actions of later systematists than to the early European botanists who studied the plant. It was known for many years as *M. juncea* L. as a result of the what turned out to be an incomplete analysis of Linnaeus' treatment of the species. In fact *M. vegeta* began its recorded history with its current name. It was described by Linnaeus in 1762 together with a second species, *M. juncea*, both with incomplete references to Philip Miller's *Figures of Plants*. Five years later, in 1767, Linnaeus provided a page reference for *M. vegeta*, clearly indicating the plant that he intended for this name. Linnaeus did not provide a page reference for *M. juncea* and to this day the application of the name is uncertain.

This relatively simple situation became confused when the eighth edition of Miller's *Gardeners' Dictionary* misapplied the name *M. vegeta* to a second figure in *Miller's Figures* (tab. 238, fig. 1). This is an illustration of a plant that is the type of a species that had already been described by Linnaeus as *M. iridioides*, now *Dietes iridioides*. In this edition the type illustration of *M. vegeta* is named *M. juncea*.

This error was noted and corrected in subsequent editions of the *Gardener's Dictionary* but it nevertheless provided the English botanist N. E. Brown with the idea that the correct name of the type species of *Moraea* might be *M. juncea*. Following Brown's published work on the subject, *M. juncea* was formally recognized as the 'conserved type' of *Moraea* in the *Botanical Code of Nomenclature* for many years. This error, only corrected ten years ago (Barnard & Goldblatt, 1975), was the reason that the name *M. vegeta* was applied to *Dietes iridioides*, as *D. vegeta* (L.) N. E. Brown subsequent to 1928.

But the nomenclatural confusion does not stop there. The younger Linnaeus described *Iris tristis* in 1782. The type material of this species matches exactly *Moraea vegeta*, and was collected by Thunberg on the Cape Peninsula on the slopes of Devil's Peak. When the Cape species of *Iris* were transferred to *Moraea* by Ker in 1805, it was by Linnaeus fil.'s epithet that that species became known, and so things remained throughout the nineteenth century. The species was named independently by Jacquin in 1795 as *Iris sordescens*, and by Ecklon as *Vieusseuxia graminifolia*, both evidently under the assumption that it had not been previously described. Only after 1975, when this series of errors was fully explained, was the original name, *Moraea vegeta*, once more applied to the plant that is the type species of *Moraea*.

BIOLOGY

Moraea vegeta is one of the few species of the

genus which has adapted to human settlement, and it is most common, almost weedy, in parts of Constantia on the Cape Peninsula and on farms and parks near Stellenbosch, where it thrives under naturalized oaks and pines. Elsewhere it is found in open, sunny situations and always on a heavy soil, usually granite derived clay. Some populations set fruit without cross fertilization and are thus self-compatible and autogamous, a very unusual condition in *Moraea* where most species are strongly self-incompatible. No doubt the autogamy has played an important role in allowing the species to become established after severe disturbance of the natural habitat.

15. MORAEA INDECORA Goldblatt

Goldblatt, *Ann. Mo. bot. Gdn* **63**: 695–697. 1976. TYPE: South Africa, Cape, Namaqualand, sandy flats, 8 km east of Nababeep, *Goldblatt 3053* (MO, holotype; NBG, PRE, S, isotypes).

indecora = unattractive, referring to the untidy appearance of the plants in the field where they are usually windblown and insect-damaged.

Plants large, 35–60 cm high, *Corm* very deep seated, to 25 cm below the surface, about 2 cm in diameter, tunics of fine fibres extending upwards in a neck around the base. *Cataphylls* membranous and pale, probably also contributing to the fibrous neck. *Leaves* 3–6, inserted well above ground level, exceeding the inflorescence, about 1 cm wide, channelled. *Stem* leafless for 10–15 cm above the ground, much branched above, sheathing bract leaves 4–8 cm long or more, attenuate, leaf-like below, sheaths open to the base. *Spathes* herbaceous below, attenuate and dry above with brown apices, the sheath of the outer open to the base, *inner* 4–5 cm long, *outer* about 3–4 cm long. *Flowers* large, pale yellow with large, yellow nectar guides on the outer tepals, the anthers exposed and prominent with red pollen; *outer tepals* 25–40 mm long, lanceolate, limb spreading more or less horizontally, the claw short, erect, about 5 mm long; *inner tepals* 22–35 mm long, limb also spreading horizontally. *Filaments* about 8 mm long, joined in the lower third; *anthers* 8–10 mm long, extending beyond the tepal claws and exceeding the stigma, pollen bright red. Ovary 6–8 mm long, usually included in the spathes at anthesis, *style branches* 8–12 mm long, crests 7–15 mm long. *Capsules* oblong, up to 15 mm long, 7–8 mm wide, exserted, showing impression of the seeds, often nodding; *seeds* globose to somewhat angled by pressure. *Chromosome number* 2n = 16.

Flowering time: late September but mainly October; flowers opening about midday and fading at sunset.

DISTRIBUTION AND HABITAT

Moraea indecora is endemic to central Namaqualand and apparently restricted to the area around Springbok. It grows in hard, flat, sandy ground, the corms deeply buried for up to 25 cm and partly wedged in the underlying rock.

DIAGNOSIS AND RELATIONSHIPS

Moraea indecora is unusual in having the several lowermost leaves inserted well above the ground, clustered close together just below the first branch. This, and the large yellow flowers with very short tepal claws and nearly horizontally extended limbs and bright-red anthers exposed above the tepals distinguish the species from all others. The open sheaths of the leaves, stem bracts and inflorescence spathes and the somewhat nodding capsules are also unusual and found in few other species of *Moraea*.

It clearly belongs in section *Moraea* in which the several leaves and many-branched habit are consistent with the general morphological pattern in the section. *Moraea indecora* is probably most closely related to the south-western Cape *M. vegeta* which shares the unusual open sheaths of the leaves and spathes, and also has a similar soft-walled and nodding capsule and pale, rather fibrous corm tunics. It

is similar in general appearance to *M. margaretae*, but it differs in several aspects such as its repeated branching, fibrous corm tunics, attenuate spathes with open sheaths and general flower structure and it is clearly not at all related to this species.

Moraea indecora has an unusual chromosome number for subgenus *Moraea*, $n = 8$. In subgenus *Moraea* this number is also found in the Cedarberg form of *M. papilionacea*, which elsewhere has $n = 9$, while the base number for the subgenus is $x = 10$. The more distantly related *M. fugax*, also subgenus *Moraea*, has a range of chromosome numbers, from $n = 10$ through 5 (Goldblatt, 1986a), but this is unusual and congruence of number does not indicate any relationship. It seems most likely that *M. indecora* is an aneuploid species that evolved its derived chromosome number independently from ancestors close to *M. vegeta*.

HISTORY

Moraea indecora was discovered in the spring of 1974 during mid-October, after a season of particularly good, but late rains. I found it at two sites, one north of Springbok near Nababeep, and the other west of Springbok on the road to Spektakelberg Pass. It grows in the typical coarse, granite-derived soil of Namaqualand, in level, open areas. At Nababeep it grew together with the superficially similar but much smaller *M. margaretae*. *Moraea indecora* has since been collected at two more sites in the Springbok vicinity, and it seems likely that it is in fact restricted to this small part of Namaqualand.

16. MORAEA LINDERI Goldblatt

Goldblatt, *Ann. Mo. bot. Gdn* **69**: 352–355. 1982. TYPE: South Africa, Cape, Piketberg Mountains, Moutons Hoek, *Linder 638* (MO, holotype).

linderi = named for Peter Linder, South African botanist and specialist in Restionaceae and Orchidaceae, who discovered this species.

Plants 35–45 cm high. *Corm* about 18 mm in diameter, bearing numerous small cormlets at the base, tunics dark brown, initially unbroken, breaking into sections from below, ultimately becoming somewhat fibrous. *Cataphylls* membranous and pale. *Leaves* 3, the lowermost basal, erect or curving outwards, evidently unifacial but perhaps terete when live, upper 2 leaves inserted well above the ground and close together, 20–30 cm long, channelled, to 4 mm wide. *Stem* erect, branching well

above the ground, the branches few and somewhat clustered. *Spathes* herbaceous, with dark brown, truncate to shortly acute apices, *inner* 3–4,5 cm long, *outer* leaf-like and with a free apex, shorter than, to exceeding, the inner. Flowers pale yellow; *outer tepals* about 35 mm long, the limb about 20 mm long, spreading more or less horizontally, ?12 mm wide; *inner tepals* perhaps erect, about 25 mm long, about 4 mm at the widest. *Filaments* 8 mm long, evidently free but contiguous for 2–3 mm; *anthers* 6 mm, pollen probably yellow. Ovary about 7 mm long, cylindric, exserted from the spathes, *style branches* 12 mm long, about 3 mm wide, crests prominent, lanceolate, about 10 mm long. Capsule and seeds unknown. *Chromosome number* unknown.

Flowering time: December.

DISTRIBUTION AND HABITAT

Moraea linderi is known only from the Piketberg Mountains in the western Cape. The type and only known collection was found growing in sandy, mountain soil in seasonally wet sites, flowering after a fire the previous summer.

DIAGNOSIS AND RELATIONSHIPS

Moraea linderi is a tall species which stands out in having a single basal leaf and the other two leaves set close together with the few short branches well above the ground level. The inflorescence spathes are distinctively truncate to broadly acute, thus similar to those of *M. margaretae*. The corms of these two species are also very alike and are distinctive in having dark-brown, partly unbroken tunics, but in *M. linderi* the corm is surrounded by many small cormlets. The yellow flowers are unspecialized and typical of those of several species of section *Moraea*. The style branches are well developed and the crests conspicuous and erect.

Moraea linderi is probably most closely related to the Namaqualand species *M. margaretae*. The two species have similar truncate to broadly acute inflorescence spathes as well as distinctive brown, partly unbroken corm tunics and the resemblance here is so striking that a close relationship cannot be doubted. *Moraea linderi* has a well developed aerial stem and a prominent basal leaf and it probably lies close to the ancestral form that gave rise to the short stemmed *M. margaretae*. The corm of *M. linderi* is virtually identical to that found in the genus *Rheome*, especially *R. umbellata* (Thunberg) Goldblatt, and it seems likely that *Rheome* is derived from the ancestors of *M. linderi* and *M. margaretae*. *Rheome* is distinguished by having style branches that are very reduced in size and not flat and petaloid and lack crests, while there are nectar guides on both the inner and the outer tepals.

HISTORY

Moraea linderi is known from only one collection from the Piketberg Mountains in the western Cape. It was discovered by the Cape botanist Peter Linder during a survey of the flora of the Piketberg Range. Repeated searches for more plants in the area where it was found have been unsuccessful. Apparently this, like so many Cape mountain species, flowers only after a fire the previous summer and it may therefore not be collected again until another fire sweeps through the section of the Piketberg where it grows. It will probably be many years before this interesting, and in many ways taxonomically critical species, will be seen again. Only then will it be possible to answer several questions about it and to complete its basic description.

17. MORAEA MARGARETAE
Goldblatt

Goldblatt, *Ann. Mo. bot. Gdn* 63: 19. 1976. TYPE: South Africa, Cape, Namaqualand, pipeline track SW of Nababeep, *Goldblatt 628* (BOL, holotype; K, MO, PRE, S, isotypes).

margaretae = named for Margaret Goldblatt, my wife, for her company, help and encouragement on my many field trips in search of *Moraea* and other Iridaceae.

Plants to 15 cm high, usually 1–2-branched. *Corm* 5–7 mm in diameter, tunics dark brown, inner layers more or less unbroken, outer becoming coarsely fibrous. *Cataphylls* membranous, often persistent and forming a fine fibrous reticulum around the base. *Leaves* (2–)3, clustered at ground level, the lowermost much longer than the others, usually exceeding the stem, others shorter than the stem, linear and narrowly channelled, often terete and twisted near the apex. *Stem* with 2–5 branches, each 1(–2) internodes, long, branching from the base only. *Spathes* herbaceous, with dark brown, acute to obtuse or emarginate apices, inner 3–4,5 cm long, outer 2–3 cm long. *Flowers* pale yellow with dark veins, nectar guides deep yellow, on the outer tepals only; *outer tepals* 2–3 cm long, the limb 1,5–2 cm long, spreading to reflexed somewhat below the horizontal; *inner tepals* initially erect, later spreading, lanceolate, obtuse, to 2 cm long. *Filaments* about 5 mm long, joined for 4 mm; *anthers* 4–5 mm, pollen red. Ovary 4–5 mm long, cylindric, exserted from the spathes, *style branches* 6–8 mm long, broad and petaloid, crests lanceolate, 6–10 mm long. *Capsule* narrowly obovoid, 8–10 mm long; *seeds* many, angular, about 1 mm at the longest. Chromosome number $2n = 40$.

Flowering time: late September and October, rarely into November; flowers opening in the late morning and fading near sunset.

DISTRIBUTION AND HABITAT

Moraea margaretae occurs in central and northern Namaqualand from Garies in the south to the area around Steinkopf in the north, and it is particularly common around Nababeep and Springbok. It grows in coarse, sandy soils of decomposed granite, mainly in flat places but also on stony slopes and hills. *Moraea margaretae* is still poorly collected, although quite common north of Kamieskroon, probably because it blooms after the end of the Namaqualand wild flower season. Further collecting in seasons of ample rainfall will undoubtedly extend the range of this attractive species.

DIAGNOSIS AND RELATIONSHIPS

Moraea margaretae is a low growing species with its few narrow leaves and stiff erect branches all clustered together at ground level. The inflorescence spathes are distinctively truncate or obtuse in most specimens and the above-ground branches are one or no more than two internodes long. The corms are also distinctive in consisting of dark brown, partly unbroken tunics, but the yellow flowers are unspecialized and typical of those of several species of section *Moraea*. The flowers are somewhat different in having the tepal claws comparatively short and the limbs strongly reflexed so that they are well separated from the erect style crests.

Moraea margaretae is probably most closely related to the recently discovered *M. linderi* which is endemic to the Piketberg Mountains in the south-western Cape. *Moraea linderi* has similar distinctive brown, partly unbroken corm tunics and the inner spathes are also obtuse to truncate. *Moraea linderi* has a well-developed aerial stem, and it is probably close to the ancestral form that gave rise to the short-stemmed *M. margaretae*. The common south-western Cape *M. papilionacea* may also be allied to *M. margaretae* but their relationship is less clear. These two species have a similar habit, low stature and brown corm tunics, possibly of the same basic type. The two can readily be distinguished by the lightly pubescent stems and often leaves and spathes of *M. papilionacea* in contrast to the entirely glabrous *M. margaretae*.

Moraea margaretae is evidently a polyploid species, with two reports of $2n = 40$. It is one of few polypoid species of *Moraea* and the only recorded polypoid in section *Moraea*, in which $x = 10$ is the basic chromosome number. *Moraea linderi* is unknown cytologically.

HISTORY

The first collections of *Moraea margaretae* were made in the later nineteenth century by William Scully, who was for a time Resident Magistrate in Namaqualand. It remained almost totally unknown until I accidentally rediscovered it some 15 years ago, in 1970, when I was beginning my studies of *Moraea*. By the time my revision of the genus for the winter rainfall area had been published in 1976, *M. margaretae* was known from several places in the northern half of Namaqualand, and it is now clear that the species is by no means uncommon. For some reason, perhaps its comparatively late flowering at the end of spring, it was seldom seen by the many botanists who have collected extensively in Namaqualand over the last seventy years.

17.

M. margaretae.

18. MORAEA PAPILIONACEA
(Linnaeus fil.) Ker

Ker, *Bot. Mag.* 20: tab. 750. 1804; Baker, *Flora Capensis* 6: 12. 1896; Lewis, *Flora Cape Peninsula* 228. 1950; *Ann. Mo. bot. Gdn* 63: 699–700. 1976.

SYNONYMS

Iris papilionacea Linnaeus fil., *Supplementum Plantarum* 98. 1781. TYPE: South Africa, Cape, hills near Cape Town, *Thunberg s.n.* (Herb. Thunberg *1145*, UPS, lectotype designated by Goldblatt, 1976).

Moraea pilosa Wendl., *Bot. Beob.* 42. 1789. TYPE: unknown.

Iris hirsuta Lichtenstein ex Roemer & Schultes, *Systema Vegetabile* 1: 478. 1817. TYPE: South Africa, Cape, Tulbagh district, *Lichtenstein s.n.* (location unknown, probably destroyed in World War II).

Moraea hirsuta (Lichtenstein ex Roemer & Schultes) Ker, *Iridearum Generum* 43. 1827.

Vieusseuxia intermedia Ecklon, *Topographisches Verzeichniss* 12. 1827, nom. nud.

Vieusseuxia nervosa Ecklon, *Topographisches Verzeichniss* 12. 1827, nom. nud.

Moraea papilionacea var. *maythamiae* Lewis, *Jl S. Afr. Bot.* 37. 1949. TYPE: South Africa, Cape, Rondebosch Common, *Salter 8989* (SAM, lectotype designated by Goldblatt, 1976b; BOL, NBG, isolectotypes).

papilionacea = like a butterfly, from the Latin *papilio* for butterfly, alluding to the appearance of the flowers.

Plants 10–15 cm high, simple to 5-branched. *Corm* 5–15 mm in diameter, tunics brown to black, the fibres medium to coarse. *Cataphylls* membranous, becoming dry above and irregularly broken. *Leaves* 2–4, linear, to 7 mm wide, occasionally exceeding the inflorescence, falcate, lightly pubescent on the abaxial surface, occasionally glabrous, the margins sparsely ciliate. *Stem* lightly puberulous to villous, 1–2 internodes long, usually several branched, mainly from the base, sometimes also from an upper node. *Spathes* herbaceous, often with dry, brown apices, pubescent or occasionally glabrous, *inner* 3–6 cm long, *outer* usually half to two-thirds as long as the inner. *Flowers* salmon pink or pale yellow, with yellow nectar guides on the outer tepals outlined in yellow, green or red, sweetly scented; *outer tepals* 22–28 mm long, 8–14 mm wide, claw 8–10 mm long, ascending, limb spreading to reflexed; *inner tepals* 20–22 mm long, narrowly lanceolate, limb also reflexed, 5–8 mm wide. *Filaments* 3–6 mm long, united in the lower half to one third; *anthers* 3–4 mm long, pollen red, or yellow in forms with yellow tepals. Ovary 5–7 mm long, nearly cylindric or widening above, exserted from the spathes, *style branches* 5–8 mm long, the crests lanceolate, 8–15 mm long. *Capsule* obovate, 7–8 mm long, about 5 mm wide; *seeds* angular. *Chromosome number* $2n = 18$, 16 in the Cedarberg populations.

Flowering time: August to October in the south but to mid-November in the Cedarberg.

DISTRIBUTION AND HABITAT

Moraea papilionacea is common in the southwestern Cape, extending north from the Cape Peninsula to the Cedarberg Mountains, and east to Bredasdorp. It is rare north of Piketberg and Porterville, and the Cedarberg populations represent a disjunct, and distinct form. *Moraea papilionacea* occurs on a variety of soils, from poorly-drained sands to seasonally damp clays.

DIAGNOSIS AND RELATIONSHIPS

Moraea papilionacea is readily distinguished from its allies by its vegetative characteristics which include 3–4 leaves all clustered around the base, a few to several branches, the main axes also clustered towards the base and at least in the majority of populations, a fine woolly pubescence on the stems, leaves and inflorescence spathes. The flowers are unspecialized and have entire spreading inner and outer tepals and well-developed style branches and crests. The flowers are brightly coloured and often a distinctive shade of salmon pink, most unusual in *Moraea*. In the east of its range, in the Caledon and Bredasdorp districts, the flowers are more often yellow and on the Cape Peninsula a pale yellow form with the nectar guide outlined in green has been named var. *maythamiae*. Cedarberg populations are not well known and appear to be disjunct in distribution with the next records to the south at Elands Kloof and Warm Baths in the Olifants River Valley. The Cedarberg plants have pale yellow flowers and a poory-developed pubescence. Hairs are confined to the leaf margins and only a few scattered hairs are present on the stems. These populations also differ cytologically, having a diploid chromosome number of $2n = 16$, in contrast to the $2n = 18$ known for several populations in the main part of the range.

The variety var. *maythamiae* was described by G. J. Lewis for populations of plants on the Cape Peninsula that have slender, almost glabrous, leaves, pale yellow flowers with a green margin to the nectar guide and, according to Lewis, blooms in late afternoon, whereas other forms flower from midmorning. I prefer not to recognize minor colour variants and var. *maythamiae* is treated here simply as a synonym of *Moraea papilionacea*. Also, since none of the other distinct forms of *M. papilionacea* are accorded taxonomic status, it would be inconsistent to accept var. *maythamiae*.

19.

18.

M. fergusoniae

M. papilionacea

The relationships of *Moraea papilionacea* are uncertain. *Moraea fergusoniae* may be closely related and it is similar in general habit. It has white to blue flowers, glabrous leaves with ciliate margins, smooth stems and pale, netted corm tunics very different from those of *M. papilionacea*. It also has a different chromosome number, $2n = 12$ (not 20 as published previously). Another possible ally is *M. margaretae*, which has similar flowers, glabrous stems and leaves which have minutely ciliate leaf margins. *Moraea margaretae* has distinctive partly unbroken and dark-brown corm tunics that tend to make it appear very distinct, but the tunics of *M. papilionacea* are also dark brown and in some plants the inner layers are only partly broken so that the corm tunics that initially appear different may in fact indicate a link between the two. At present all that can be said is that *M. papilionacea* is a good member of section *Moraea* as currently constituted, but that its affinities within the section are obscure. Its chromosome number, $2n = 18$, or 16 in the northern populations, is clearly derived and *M. papilionacea* must be regarded as an aneuploid species, derived from ancestors with the basic $x = 10$ in subgenus *Moraea*.

HISTORY

Moraea papilionacea was brought to the attention of science by Carl Peter Thunberg who collected the species in the south-western Cape in the early 1770's. He was, however, certainly not the first to collect this common species and corms were almost certainly sent back to Holland from the late seventeenth century onward. Thunberg gave it the name *Iris papilionacea*, actually first published by the younger Linnaeus in 1782. The description was based on Thunberg's manuscripts and collections that reached Sweden before Thunberg himself returned from his travels in the Cape and Japan. Later, in 1804, Ker transferred the species to *Moraea*, but not before the German horticulturist Johann Wendland had described *Moraea pilosa*, almost certainly a later synonym for *M. papilionacea*. Somewhat later, Johann Roemer and Josef Schultes described another synonym, *Iris hirsuta*, in 1817, believing it to be different from *M. papilionacea*. The type specimens have not been located and were probably at Berlin where they were destroyed in World War II when the Berlin Herbarium was burnt and many irreplaceable collections were destroyed. Ecklon named two species *Vieusseuxia intermedia* and *V. nervosa*, in 1827 that are also synonyms of *M. papilionacea*, but both lack descriptions and are *nomina nuda*. Their identities are known from annotations on Ecklon and Zeyher collections at the Riksmuseum at Stockholm and elsewhere.

CULTIVATION

Moraea papilionacea is seldom grown in gardens, which is a pity since the small plants with large pink flowers are very attractive and would be ideal subjects for a rock garden or for pot culture. The individual flowers last only one day but almost every day for weeks new blooms are produced to continue the display. The foliage is inconspicuous and not unsightly as the plants die back. Because the corms are small they should probably be lifted each season to prevent inadvertant disturbance and damage. This will also safeguard against rotting and predation by insects and rodents.

19. MORAEA FERGUSONIAE
L. Bolus

L. Bolus, *S. African Gard.* **19**: 294. 1929; Goldblatt, *Ann. Mo. bot. Gdn* **63**: 697–699. 1976. TYPE: South Africa, Cape, Riversdale, *Ferguson s.n.* (BOL *18970*, holotype).

SYNONYMS

Moraea fimbriata Klatt, *Linnaea* **34**: 561. 1866; Baker, *Flora Capensis* **6**: 13. 1896, nom. illeg. homonym pro *M. fimbriata* Loisel, 1822 (= *Iris cristata* Solander). TYPE: South Africa, Cape, Caledon, *Ecklon & Zeyher Irid. 42* (SAM, lectotype).

fergusoniae = named in honour of Emily Ferguson of Riversdale in the southern Cape, who collected this and many other new species in the Riversdale area in the 1930's.

* Illustration facing page 62

Plants 10–20 cm high, simple or usually 2–4-branched from the base. *Corm* 5–15 mm in diameter, tunics of pale medium to fine reticulate fibres. *Cataphylls* membranous and pale, sometimes becoming brown with age and persisting for a few years. *Leaves* 3–6, all basal, seldom exceeding 10 cm long and shorter than the stems, 3–6(–10) mm wide, loosely coiled to helical, margins ciliate to pubescent and often undulate to crisped. *Stem* terete, glabrous, simple to several branched, the branches clustered at the base, aerial stems 1 or occasionally 2 internodes long. *Spathes* herbaceous, attenuate, with brown apices, *inner* (2,6–)3,5–4,2 cm long, *outer* about half as long as the inner. *Flowers* white to cream, rarely blue, with yellow guides on the outer tepals; *outer tepals* about 20 mm long, lanceolate, limb about 11 mm long, speading horizontally to slightly reflexed; *inner tepals* erect, 8–12 mm long, entire and narrowly lanceolate or trifid with a long central cusp and 2 small obtuse lateral lobes near the midline. *Filaments* about 4 mm long, entirely united or free for the upper 1 mm; *anthers* 3 mm long, pollen yellow. Ovary 5–6 mm long, nearly cylindric, usually exserted from the spathes, *style branches* 3–5 mm long, crests erect, linear, 5–7 mm long. *Capsule* about 7 mm long, more or less obovate; *seeds* many, angled. *Chromosome number* $2n = 12$.

Flowering time: late July and August.

DISTRIBUTION AND HABITAT

Moraea fergusoniae occurs in the south-western and southern Cape. It extends from Houw Hoek Pass west of Caledon eastwards to Robinson Pass near Mossel Bay. It grows at low altitudes on clay and shale slopes and flats, in renosterveld, and flowers poorly except when the surrounding bush is cleared, burned or heavily grazed and the plants are not shaded.

DIAGNOSIS AND RELATIONSHIPS

Moraea fergusoniae is usually easy to recognize by its several basal leaves clustered at ground level and with undulate or more, often, coiled blades. The stem is usually branched and the branches are also clustered at ground level and typically only one internode long, but on very robust plants there may be a second short lower internode. The flowers usually have trifid inner tepals, with a long acute central cusp and short obtuse lateral lobes. However, in a few populations the inner tepals are entire, erect and lanceolate. The combination of several clustered basal leaves and flowers with trifid inner tepals is unique in *Moraea*, but specimens of *M. fergusoniae* with entire inner tepals may cause confusion and can easily be misidentified.

The relationships of *Moraea fergusoniae* have become more rather then less obscure as more has been learned about the species. I initially believed that it was allied to *M. papilionacea* with which it is very similar in gross morphology. The two both have clustered basal leaves and typically short basally congested branches. *Moraea papilionacea* usually has pubescent stems, leaves and spathes and the flowers have entire inner tepals that are spreading to reflexed like the outer, and careful examination of the flowers should make confusion between these two species unlikely.

Doubt about the correct affinities of *Moraea fergusoniae* have arisen as more chromosome counts have accumulated for the species and it has become clear that the number initially reported for the species, $2n = 20$ (Goldblatt, 1971), is apparently not correct. Several populations over the entire range of *M. fergusoniae* have now been examined (Goldblatt, in preparation) and all have $2n = 12$. The latter number is characteristic of subgenus *Vieusseuxia* and trifid inner tepals are common, and nearly restricted to this subgenus. Subgenus *Moraea*, in which I have placed *M. fergusoniae*, has $x = 10$ as the basic chromosome number but several species exhibit aneuploid reduction to $n = 9, 8$ or in *M. fugax*, to $n = 7, 6$ and 5. The conflict lies in the several leaves of *M. fergusoniae*, a feature characteristic of subgenus *Moraea*, while no species of subgenus *Vieusseuxia* have several leaves. The resolution to the problem of the relationships of *M. fergusoniae* probably lies in hybridization studies and this work remains to be done.

HISTORY

According to the available record, *Moraea fergusoniae* was first collected by Ecklon & Zeyher in the 1820's at Caledon. Their collections were widely distributed to European herbaria and in 1866 Klatt described *M. fimbriata* based on their collection in the Berlin Herbarium. Unfortunately the name Klatt chose was a homonym for *M. fimbriata* Loisel (a later synonym of *Iris cristata* Solander). The name is thus nomenclaturaly illegitimate in *Moraea* and cannot be used for the species, although it was treated under this name by Baker in *Flora Capensis*.

The name we now use for this species, *Moraea fergusoniae*, was provided by Louisa Bolus who was apparently unaware that her species was conspecific with Klatt's *M. fimbriata*. *Moraea fergusoniae* is small and inconspicuous, and flowers early in the season, often in July or early August when little collecting is normally done in the southern Cape, and it is consequently poorly known. However, collections are now accumulating and it is becoming clear that it is a common plant in shale soils in the southern Cape between Caledon and Riversdale.

Moraea fergusoniae has not to my knowledge ever been grown as a garden plant, but my experience in the greenhouse indicates that it thrives under cultivation. The small flowers, however, make *M. fergusoniae* of little appeal for garden or pot culture.

20. MORAEA LUGUBRIS (Salisbury) Goldblatt

Goldblatt, *Ann. Mo. bot. Gdn* **63**: 18. 1976; **63**: 706–708. 1976.

SYNONYMS
Ferraria lugubris Salisbury, *Prodromus Stirpium ad Chapel Allerton* 42. 1796, nom. nov. pro. *Iris plumaria* Thunberg.

Moraea iriopetala Linnaeus fil., *Supplementum Plantarum* 100. 1782, as to plant intended, not to name; Baker, *Flora Capensis* 6: 17. 1896, nom. illeg. superfluous pro *M. vegeta* Linnaeus.

Iris plumaria Thunberg, *Dissertatio de Iride* no. 16. 1782, nom. illeg. superfluous pro *M. juncea* Linnaeus, *M. vegeta* Linnaeus et *M. iriopetala* Linnaeus fil. TYPE: South Africa, Cape, below Devils Peak, near Cape Town, *Thunberg s.n.* (Herb. Thunberg *1153*, UPS, lectotype).

Moraea plumaria (Thunberg) Ker, *Ann. Bot.* (Konig & Sims) 1: 240. 1805; Lewis, *Flora Cape Peninsula* 227. 1950.

Vieusseuxia geniculata Ecklon, *Topographisches Verzeichniss* 12. 1827, nom. nud.

Moraea mira Klatt, *Trans. S. African Philos. Soc.* 3: 202. 1885; Baker, *Flora Capensis* 6: 17. 1896. TYPE: South Africa, Cape, Caledon district, slopes of Zwartberg near the Baths, *Templeman s.n.* sub *MacOwan 2162* (K, S).

lugubris = dull or dark, referring (in error I think) to the dark-blue-coloured flowers, sometimes a dull slate blue.

Plants 6–16 cm high, usually 2–4-branched. *Corm* small, but enclosed in large basket-like tunics consisting of a course open reticulum, cormlets produced round the base. *Cataphylls* membranous and pale or brownish. *Leaves* 2–3, the lower inserted below ground and the second more or less basal, longer than the stem, the third – if present – inserted on the lower part of the stem, channelled, linear, 2–4 mm wide, straight or falcate. *Stem* strongly flexed, usually with 2 aerial internodes, branched from the base, or more often only from the aerial node. *Spathes* herbaceous, pale green, attenuate, sometimes with brown apices, inner 3–5 cm long, the *outer* usually about half as long as the inner. *Flowers* bright to dull slate blue with yellow nectar guides on the outer tepals; *outer tepals* 16–18 mm long, the claw short, about 5 mm long, limb reflexed to 45°; *inner tepals* 14–16 mm long, similarly reflexed. *Filaments* to 6 mm long, united below into a slender column, free at the apex only; *anthers* oblong, about 3 mm long, apiculate, pollen red. Ovary cylindric, 2–3 mm long, exserted from the spathes, *style branches* apically plumose, the crests single with feathery outgrowths from the base. *Capsule* spherical-ovoid, 6–8 mm long; *seeds* angled. Chromosome number 2n = 20.

Flowering time: late August to early November.

DISTRIBUTION AND HABITAT
Moraea lugubris is widespread in the western part of the winter rainfall area, extending from the Nieuwoudtville plateau in the north to the Cape Peninsula and the Caledon and Bredasdorp districts in the south. It is apparently rare in the north of its range, or at least poorly collected, but is relatively common in the south in seasonally wet sandy sites.

DIAGNOSIS AND RELATIONSHIPS
Moraea lugubris is a rather isolated species within section *Moraea*. It is distinct in several characteristics, particularly its remarkable corm tunics which form a large open basket-like network around the tiny corm (a feature apparently not strongly developed in some forms), and flowers with unique plumose style branches. The flowers are fairly typical of section *Moraea* in having broad reflexed inner tepals except that instead of paired erect crest being developed at the apex of the style branches, they terminate in a feathery, irregularly dissected plumose structure. The flowering stem is short, one to two internodes long, and usually branched from near the base. Plants are usually quite small, and although common, are easily overlooked. The immediate relationships of *M. lugubris* are not clear.

HISTORY
Moraea lugubris has a long and particularly complex taxonomic history. The first record of its existence is a collection made by the Swedish traveller and correspondent of Linnaeus, Anders Sparrman who sent specimens to Linnaeus in 1773. Nothing was apparently done with the species until after Linnaeus's death when the younger Linnaeus described it as *M. iriopetala* in 1782. His description in the *Supplementum Plantarum* is, however, written in a most confusing manner and the Linnaean species *M. vegeta* is cited as a synonym which makes the name *M. iriopetala* a superfluous and illegitimate name according to the *Code of Botanical Nomenclature* (Goldblatt, 1976a).

Thunberg also collected *Moraea lugubris* and in his *Dissertatio de Iride*, published in late 1782, he gave it the name *Iris plumaria*. Thunberg cited no less than three species as synonyms, *M. vegeta*, *M. juncea* and *M. iriopetala*, so that *Iris plumaria* must also be regarded as superfluous and illegitimate. Botanists of the nineteenth century were often not concerned with considerations of nomenclatural priority and the concept of superfluous names was not even in existence. Thus when Ker formally treated all the southern African species until then placed in Iris, as *Moraea*, he used Thunberg's name for the species, as *M. plumaria* (Thun-

M. nubigena. *M. lugubris.*

berg) Ker, and this distinctive plant remained widely known by this epithet throughout the nineteenth century.

The name we now use for the species was provided by the English botanist Richard Salisbury in 1796, when he described *Ferraria lugubris*. There is no known type for the name, but Salisbury cited the two earlier illegitimate synonyms, *M. iriopetala* and *I. plumaria*, in his description and there can be no doubt about the species he intended to name. *Ferraria lugubris* is a valid name, and in 1976 I transferred it to *Moraea*. Another synonym, and one recognized by J. G. Baker in *Flora Capensis*, is *Moraea mira*, described by Klatt in 1885. There is no indication that Klatt considered *M. mira* distinct from *M. lugubris* (known at that time as *M. iriopetala* or *M. plumaria*) and the type is in no way different from *M. lugubris*.

21. MORAEA NUBIGENA Goldblatt

Goldblatt, *Ann. Mo. bot. Gdn* **63**: 749–750. 1976; **69**: 352. 1982. TYPE: South Africa, Cape, Worcester district, near Fonteintjiesberg hut at 1 400 m, *Goldblatt 4208* (MO, holotype; K, NBG, PRE, S, isotypes).

*Illustration facing page 66

nubigena = born in the clouds, alluding to the high altitude in the mountains above Worcester in the south-western Cape where the species grows.

Plants very small, 3–5 cm high at flowering time. *Corm* globose, to 1 cm in diameter, thickly covered with finely fibrous reticulate tunics. *Cataphylls* membranous and pale. *Leaf* solitary, inserted at ground level, somewhat succulent, falcate, channelled, 3–4 cm long. *Stem* simple, 2 internodes long with a node and a short sheathing stem bract near the base. *Spathes* herbaceous, often red flushed, *inner* 12–14 mm long, *outer* about two thirds as long as the inner. *Flowers* 2(–3), deep blue, with small striped yellow nectar guides on the outer tepals; *outer tepals* 10–14 mm long, the limb 6–8 mm long, flexed sharply 30°–45°; *inner tepals* 8–10 mm long, the limb also sharply reflexed. *Filaments* about 3 mm long, united below, free and diverging in the upper third; *anthers* 1,5–2 mm long, pollen yellow. Ovary almost 3 mm long, exserted from the spathes, *style branches* 3 mm long, crests short, to 2 mm. *Capsule* globose, about 7 mm long; *seeds* not known. Chromosome number $2n = 20$.

Flowering time: late September and probably October.

DISTRIBUTION AND HABITAT

Moraea nubigena is known only from Fonteintjiesberg in the mountains north of Worcester in the south-western Cape. It grows on wet, moss-covered rocks at 1 400 m. The specialized habitat is unusual for a *Moraea* but several other Iridaceae grow in these rock flushes in the Cape mountains where the very shallow soil prevents the establishment of larger plants that would otherwise shade out the small plants that grow there.

DIAGNOSIS AND RELATIONSHIPS

The species is remarkable in the genus for its size, by far the smallest species of *Moraea*. The flower is quite typical of the genus and the inner and outer tepals are both reflexed. The style branches are flat and petaloid, the crests are present and relatively prominent, and the nectar guides are located only on the outer tepals. Only in the reduced size and lack of branches is it unusual. I initially placed *M. nubigena* in section *Polyanthes* because the flowers corresponded well with several unspecialized members of the alliance such as *M. bipartita*. However, when I later obtained a chromosome count for the species, $2n = 20$, it became clear that *M. nubigena* must be allied with species of section *Moraea* in which this chromosome number is common and basic. The flower is equally consistent with this placement, but the single leaf and unbranched stem are unusual for the section and are apparently a specialization in this species alone. A possible close relative of *M. nubigena* is *M. lugubris*, also a small plant but distinct in having more than one leaf, unusual basket-like corm tunics and plumose style crests.

HISTORY

Moraea nubigena was apparently first gathered in 1925 by Thomas P. Stokoe, the well-known mountain climber and collector of the mountain flora of the south-western Cape and Namaqualand. Stokoe found plants in fruit and he gave his collection to Rudolf Marloth. These specimens are preserved at the National Herbarium in Pretoria where I found them placed among the unnamed collections of *Homeria*. It was of course not possible to assign the

fruiting plants to a genus but they were clearly related to the *Moraea-Homeria* alliance.

With the help of Elsie Esterhuysen and John Howes, my father-in-law, I visited the locality of the original Stokoe gathering in September 1976, and we located a population on Fonteintjiesberg, part of the Brandwacht Range. Plants were distributed very locally at about 1 400 m near the Cape Mountain Club hut in an area of shelving rock outcrops over which water percolates.

22. MORAEA SERPENTINA Baker

Baker, *Handbook Irideae* 52. 1892; *Flora Capensis* 6: 16. 1896; Goldblatt, *Ann. Mo. bot. Gdn* 63: 701–705. 1976. TYPES: South Africa, Cape, Okiep, stony places, *Bolus 6572* (K, lectotype designated by Goldblatt, 1976b; GRA, isolectotype); Little Namaqualand, *Bolus 6571* (BOL, K, syntypes); Ezelskop-Roodeberg, Khamiesberg, *Drège 2599* (K, S, syntypes).

SYNONYMS

Moraea arenaria Baker, *Handbook Irideae* 52. 1892. TYPE: South Africa, Cape, sandhills, Ebenezer, *Drège 8324* (K, holotypes; BM, MO, S, isotypes).

Moraea framesii L. Bolus, *S. African Gard.* 17: 418. 1927. TYPE: South Africa, Cape, near Calvinia, *Ross Frames s.n.* (BOL, holotype).

serpentina = serpentine or coiled, describing the characteristic twisted leaves.

Plants 4–20 cm high, usually branched. *Corm* 8–20 mm in diameter, asymmetric at the base; tunics of tough coarse, usually dark fibres. *Cataphylls* membranous and pale to brown, usually becoming somewhat hard and persisting around the base, occasionally accumulating as a fibrous neck. *Leaves* basal only, or occasionally cauline, (1–)3(–5), rarely solitary, channelled or ± flat, undulate to flexuose or coiled, glabrous or lightly pubescent on the margins or on the abaxial surface. *Stem* 2–3 internodes long, branching from the base or the upper nodes. *Spathes* usually dry, membranous, the apices entire, attenuate, or often lacerated, *inner* 1,5–3 cm long, *outer* about half as long as the inner. *Flowers* white to yellow, sometimes flushed with mauve or pink especially on the inner tepals, and with large deep yellow nectar guides on the outer tepals; *outer tepals* 24–30 mm long, claw about 10 mm long, the limb 15–24 mm wide, obtuse or retuse; *inner tepals* 20–30 mm long, erect, broadest near the apex. *Filaments* 5–7 mm long, joined near the base only or to the midline; *anthers* 3–5 mm long, pollen yellow or white. *Ovary* 5–6 mm long, included in the spathes, *style branches* about 6 mm long, the crests 4–8 mm, lanceolate. *Capsule* enclosed in the spathes, obovoid to elliptic, about 10 mm long; *seeds* angled. *Chromosome number* $2n = 20$.

Flowering time: September to October.

DISTRIBUTION AND HABITAT

Moraea serpentina occurs in arid parts of the interior and north-western Cape Province. It is especially common in Namaqualand, but is also recorded in the Richtersveld and in part of Bushmanland and the Karoo, extending as far east as Prieska and as far south as the Vanrhynsdorp district. The records from Bushmanland and the Karoo are few, which probably indicates a scattered distribution here. *Moraea serpentina* grows in stony or gravelly soil and sometimes in crevices in granite rock.

DIAGNOSIS AND RELATIONSHIPS

Moraea serpentina can be recognized by its somewhat unusual flower and its 3–5 twisted or coiled basal leaves. The flower is white or yellow with unusually large deep yellow nectar guides on the outer tepals and the inner tepals are erect and broadest towards the apex. It has a chromosome number of $2n = 20$ and a karyotype characteristic of subgenus *Moraea*, and this together with the number of leaves and the generally unspecialized nature of the flower makes it appear well placed in section *Moraea*. It usually blooms quite late, in October, but has been collected in flower from the end of August in years of lower than normal rain-

fall. *Moraea serpentina*, especially its synonym *M. arenaria*, has often been associated with another Namaqualand species with coiled leaves, *M. tortilis*, and the two are probably closely related. *Moraea tortilis* is very like *M. serpentina* in general aspect and they can easily be confused when examined casually. *Moraea tortilis* has a terete leaf which is usually more tightly coiled than in *M. serpentina* and the flowers are quite different. *Moraea serpentina* has a white to yellow flower often flushed purple or pink, with large nectar guides and erect spathulate inner tepals, while *M. tortilis* has dark blue, or occasionally white flowers with smaller nectar guides and broad reflexed inner tepals. These significant floral differences are often quite obscured in dried material so that the leaf must be used for distinguishing these two taxa.

HISTORY

The first record we have of *Moraea serpentina* are collections made by the early plant collector Jean Francois Drège at two localities along the Cape west coast in 1830, at Ebenezer near the mouth of the Olifants River and in the Kamiesberg in Namaqualand. Drège's collections were widely distributed to major European herbaria, but this very distinct species was nevertheless ignored or overlooked for sixty years. Only in 1892 did J. G. Baker describe the species. At this time Baker actually named two separate species, *M. serpentina* based on Drège's Kamiesberg collection and two other gatherings that had been made in the 1880s, and *M. arenaria* based on the plants from Ebenezer.

Baker described *Moraea serpentina* as having a pilose, very flexuose, linear leaf, and *M. arenaria* as having a spirally twisted, glabrous, nearly terete leaf. Examination of type material, however, reveals that *M. arenaria* does not have a truly terete leaf, rather it is of the same type as *M. serpentina*, only narrower but distinctly bifacial and channelled. It is glabrous, but this is a poor character, for among the three collections of *M. serpentina* cited by Baker, only the Drège specimens from the Kamiesberg are clearly pilose. In fact, examination of many wild populations of this species from Namaqualand reveals that the pilose leaf occurs occasionally in several areas in forms with a bifacial leaf. It is commonest in the Kamiesberg but is also found near Okiep and Steinkopf. When the variation in leaf form is taken into account, *M. serpentina* and *M. arenaria* cannot be regarded as separate species.

Moraea framesii, a species described by H. M. L. Bolus in 1927 from plants collected at the foot of Vanrhyns Pass in the north-western Cape, is clearly conspecific with *M. serpentina* and it can be distinguished, if at all, only by its somewhat broader and glabrous leaf.

CULTIVATION

Moraea serpentina has been grown successfully at Kirstenbosch several times over the past forty years, and it makes an interesting pot plant with its twisted leaves and large white and yellow flowers. The flowers last only a single day each but several are produced from each of the several inflorescences so that a pot of several plants will bloom for two to three weeks. I have found *M. serpentina* difficult to grow and very reluctant to sprout and produce leaves. This difficulty can probably be overcome by ripening the corms by letting the pots bake in the sun during the summer, mimicking the natural conditions. Although *M. serpentina* is usually a small plant, adequate watering results in more robust specimens, the leaves of which are often less coiled and broader than in the wild. *Moraea serpentina* would make an interesting contrast in growth form planted in the open in a rock garden largely devoted to dwarf succulents and there should be no problem in growing the species in open ground instead of pots in areas of low rainfall.

22.

N. serpentina.

23. MORAEA TORTILIS Goldblatt

Goldblatt, *Ann. Mo. bot. Gdn* 63: 705–706. 1976. TYPE: South Africa, Cape quartzite slopes between Okiep and Steinkopf, *Goldblatt 2771* (MO, holotype; K, NBG, PRE, isotypes).

tortilis = twisted or coiled, alluding to the remarkable helical cork-screw-like leaves, unique in *Moraea*.

Plants 10–15 cm high, usually branched. *Corm* ca. 10 mm diameter, asymmetric at the base, with tunics of tough, dark fibres. *Cataphylls* brown and membranous, becoming firm and irregularly broken, sometimes accumulating around the base. *Leaves* basal and sometimes cauline (1–)2–3, terete (becoming flattened adaxially when dry) and coiled helically like a corkscrew. *Stem* 2–3 internodes long, branching from the base and sometimes also from the upper nodes. *Spathes* herbaceous below, becoming completely dry and lacerated, inner 2,5–4 cm long, outer about half as long as the inner. *Flowers* blue to white with small yellow nectar guides on the outer tepals; *outer tepals* 25–35 mm long, claw to 14 mm long, the limb about 20 mm wide, obtuse to retuse, reflexed to about 30° below the horizontal; *inner tepals* up to 30 mm long, reflexed like the outer. *Filaments* to 8 mm long, joined in the lower half; *anthers* 5 mm long, pollen yellow. Ovary about 9 mm long, included in the spathes, *style branches* to 10 mm long, crests narrow, to 10 mm long. *Capsule* obloid-elliptic, to 13 mm long, remaining in the spathes; *seeds* angled. Chromosome number $2n = 20$.

Flowering time: September to October; flowers open at about midday and fade in the late afternoon.

DISTRIBUTION AND HABITAT

Moraea tortilis occurs locally along the interior west coast from the Vanrhynsdorp district in the south to Steinkopf, Namaqualand in the north. It grows in sandy gravel, and is frequently associated with quartzite outcrops.

DIAGNOSIS AND RELATIONSHIPS

Moraea tortilis is closely related to the more common Namaqualand species, *M. serpentina*, but when fresh flowers are examined the differences become very obvious. The blue or white flowers of *M. tortilis* have reflexed inner tepals and small nectar guides in marked contrast to the flowers of *M. serpentina* which have erect inner tepals and large yellow nectar guides. The vegetative aspect of the two species is similar, but the leaves of *M. tortilis* are terete when fresh and coiled like a corkscrew, while those of *M. sepentina* are channelled or flat, though often very narrow, and are usually laxly undulate and twisted, but sometimes coiled as in *M. tortilis*.

HISTORY

This beautiful species has been known for many years and though collected occasionally, it was frequently associated with the name *M. arenaria*. Examination of the type material has made it clear that *M. serpentina* and *M. arenaria* are conspecific (Goldblatt, 1976b), and *M. tortilis* was formally described in 1976.

23.

M. tortilis.

24. MORAEA HEXAGLOTTIS
Goldblatt

Goldblatt, *Ann. Mo. bot. Gdn* **73**: in press. 1986. TYPE: Namibia, southern Namib desert, farm Aub, Huib Plateau, about 80 km north of Rosh Pinah, 1 200–1 400 m, *Lavranos & Pehlemann 21704* (MO, holotype; WIND, isotype).

hexaglottis = six-tongued, referring to the three deeply-divided style branches that extend between the filaments.

Plants small, 8–10 cm high. *Corm* 10–15 mm in diameter, with coarse brown fibrous tunics. *Cataphyll* membranous and pale. *Leaf* solitary or 2, basal, slender and sometimes apparently terete but linear and channelled, with margins inrolled, often tightly, sometimes somewhat twisted above, about twice as long as the plant. *Stem* somewhat flexuose, 1–2 branched, sheathing stem bracts 12–18 mm long, herbaceous, becoming dry above, axes flexed slightly below the spathes. *Spathes* green, becoming dry and pale straw-coloured above, *inner* 16–19 mm long, *outer* about half to nearly as long as the inner. *Flowers* blue-violet with pale yellow nectar guides on the outer tepals, claws forming a shallow cup including the base of the filament column, limbs laxly speading; *outer tepals* 12–14 mm long, claw vestigial, less than 0,5 mm long, limb spreading almost from the base, 6–7 mm wide, widest in the upper third; *inner tepals* similar to but slightly smaller than the outer. *Filaments* about 4 mm long, united below into a smooth cylindrical column, free in upper third; *anthers* 3–4 mm long, ascending, pollen yellow. Ovary narrow, cylindric, about 3 mm long, at least partly exserted from the spathes, *style branches* divided almost to the base into paired slender tapering arms extending upwards between the filaments, the arms 2,5–3 mm long, apically stigmatic, crests lacking. *Capsules* globose, 4–6 mm in diameter; *seeds* angular. Chromosome number $2n = 20$.

Flowering time: September to October, flowers opening in mid-afternoon, about 4 p.m. and fading in the early evening.

DISTRIBUTION AND HABITAT
Moraea hexaglottis is endemic to the Huib Plateau in southern Namibia, where it is known only from the farm Aub. It grows in silt on black limestone in the western part of the plateau at elevations of about 1 300 m.

RELATIONSHIPS
The small blue-violet flowers with spreading short claws and subequal tepals of *Moraea hexaglottis* are very much like those found in several other species of *Moraea* with reduced style branches and lacking style crests, such as *M. rigidifolia* and the Karoo species *M. crispa*. However, the short style branches each divided almost to the base into slender paired ascending arms are unlike those of any other species of *Moraea*, and are reminiscent of the related genus *Hexaglottis*. In *Hexaglottis* the filaments are united only towards the base and the style arms are more slender than in *M. hexaglottis*. In addition, the basic chromosome number in *Hexaglottis* is $x = 6$ (Goldblatt, 1971 and in prep.) in contrast to the haploid number of $n = 10$ in *M. hexaglottis*. It is clear that *M. hexaglottis* and *Hexaglottis* acquired similar style branches independently, but the similarity is striking. *Moraea hexaglottis* is probably most closely related to *M. tortilis* of section *Moraea*, judging from their similarity in vegetative morphology.

HISTORY
Moraea hexaglottis was discovered by John Lavranos and Inge Pehlemann in 1983 on the farm Aub in the Huib Plateau in southern Namibia. It has been formally described recently in a separate publication (Goldblatt, 1986a). The species is so far known from several sites on a single farm but the whole area is so poorly collected that it is almost certain that *M. hexaglottis* has a wider range on the Huib Plateau and perhaps elsewhere in the interior Namib Desert.

25. MORAEA RIGIDIFOLIA Goldblatt

Goldblatt, *Ann. Mo. bot. Gdn* **73**: in press. 1986. TYPE: Namibia, southern Namib, farm Süd Witpütz, rocky granite flats, about 35 km north of Rosh Pinah, *Goldblatt 7016* (WIND, holotype; MO, NBG, PRE, S, US, WAG, isotypes).

rigidifolia = rigid-leafed, referring to the unusual and characteristic thick rigid terete leaf.

Plants slender, 7–12 cm high. *Corm* 2–3 cm in diameter, with dark brown, coarsely fibrous tunics accumulating to form a thick layer and extending upwards in a neck, live corm about 8 mm in diameter. *Cataphylls* brown and membranous, becoming finely fibrous and accumulating in a neck around the base. *Leaf* solitary, basal, terete, to 3 mm in diameter, solid and pithy internally, falcate to recurved. *Stem* simple or branched from below, bearing several sessile inflorescences above, sheathing stem bracts dry, light brown, to 2,5 cm long. *Spathes* of the lateral inflorescences sessile except the terminal, herbaceous, becoming dry and brown above at anthesis, *inner* 1,7–2,2 cm long, *outer* slightly shorter than the inner. *Flowers* blue-mauve with cream nectar guides on the outer tepals, the claws forming a shallow cup around the base of the filament column, limbs spreading horizontally; *outer tepals* lanceolate, 14–18 mm long, claw 3–4 mm, limb 6–7 mm wide, widest in the upper third; *inner tepals* 13–15 mm long, 5–6 mm wide. *Filaments* 4–5,5 mm long, united below in smooth cylindric column, free in the upper 1,3–2 mm and diverging; *anthers* 2,2–3 mm long, diverging, pollen white. Ovary linear-fusiform, included in the spathes, 5–7 mm long, with a sterile beak 1–2 mm long, *style branches* diverging, 2–2,5 mm long, bilobed above and stigmatic at the apices, reaching to mid-anther level, crests lacking. *Capsules* not known. Chromosome number $2n = 20$.

Flowering time: late September to October; flowers opening in late afternoon usually after 4.30 and fading in early evening at about 7 p.m.

DISTRIBUTION AND HABITAT

Moraea rigidifolia is locally endemic in the southern Namib Desert in south-western Namibia. It is recorded only from the farm Süd Witpütz north of the mining settlement of Rosh Pinah. The habitat of *M. rigidifolia* is rocky and consists of thin soil on low outcrops of weathered granite. It is locally fairly common in open places, the corms often wedged in cracks in rock, but not deeply buried.

DIAGNOSIS AND RELATIONSHIPS

The small pale blue-mauve flowers of *Moraea rigidifolia* with subequal tepals, short claws that enclose the lower part of the filaments and divergent anthers appressed to short narrow style branches closely resemble those of the Karoo species *M. crispa*. My initial presumption was that the two species were closely related. However, *M. rigidifolia* has a chromosome number of $2n = 20$ and a karyotype quite different from that of *M. crispa* ($2n = 12$) and of section *Polyanthes* generally. The basic chromosome number for *Moraea* is $x = 10$ and both in number and in the details of its karyotype, *M. rigidifolia* conforms with species of *Moraea* subgenus *Moraea* that have this number. The cytological evidence is assumed here to be a more reliable indicator of natural relationship and *M. rigidifolia* is regarded as allied to species of section *Moraea*. In its general habit, *M. rigidifolia* resembles quite closely *Barnardiella*, a monotypic Namaqualand endemic genus, which has similar, though more often smaller corms, a single terete but slender leaf, and sessile lateral inflorescences with relatively short and subequal spathes. It also has the same basic chromosome number and karyotype. *Barnardiella* differs mainly in its flower which has a long slender tube composed of sterile ovary tissue (Goldblatt, 1976c) and a subsessile ovary located in the base of the spathes. Details of the style and anthers also differ slightly from *M. rigidifolia*. However, it seems likely that *M. rigidifolia* is close to the line that gave rise to *Barnardiella* and the slender ovary of *M. rigidifolia*, which is sterile in the upper 1–1,5 mm, is perhaps a link with the unusual ovary found in *Barnardiella*. *Moraea rigidifolia* is easily recognized by its very unusual

thick and relatively short terete leaf. The swollen leaf, which consists of green tissue surrounding a firm, white pith-like parenchyma is so striking that *M. rigidifolia* can immediately be identified from this characteristic alone.

HISTORY

Moraea rigidifolia was discovered by the amateur botanists, John Lavranos and Inge Pehlemann, in 1982. Sterile material sent to me prompted further investigation, and in the very good spring season of 1983, I was able to collect ample flowering specimens. It seems likely that *M. rigidifolia* occurs elsewhere in the rocky southern Namib Desert which is poorly known botanically. Owing to its inconspicuous and fugacious flowers that open only in the late afternoon and early evening this species is easily overlooked.

26. MORAEA GRANITICOLA
Goldblatt

Goldblatt, *Ann. Mo. bot. Gdn* **73**: in press. 1986. TYPE: Namibia, southern Namib Desert, Aus townlands, ca. 1 300 m, in sand around granite domes (cult. Kirstenbosch Botanic Gardens), *Lavranos & Pehlemann 20007* (WIND, holotype; MO, isotype).

graniticola = granite loving, referring to the habitat in decomposed granite around granite domes.

Plants low, acaulescent or nearly so, to 5 cm high. *Corm* 2,5–3,5 cm in diameter, with dark-brown, coarsely fibrous tunics, live corm to 8 mm in diameter. *Cataphylls* brown and membranous, becoming finely fibrous and accumulating in a neck around the base. *Leaves* usually 2, the second much smaller than the basal, grey-green, channelled, spreading, white in the midline, somewhat twisted, margins undulate, to 20 cm long, 5–6 mm wide. *Stem* subterranean or produced shortly above the ground, with several branches clustered near the base. *Spathes* herbaceous, inner 2,5–3 cm long, outer somewhat membranous and slightly shorter than the inner. *Flowers* with a perianth tube, blue-violet with yellow nectar guides, tepal claws ascending and enclosing the lower part of the filament column, limbs spreading horitzontally; *tube* 5–6 mm long, white; *outer tepals* 18–20 mm long, obovate, 9–11 mm wide, claws to 3 mm long; *inner tepals* to 17 mm long and 9 mm wide. *Filaments* 5–6 mm long, united into a white cylindrical column, free and diverging in the upper 1 mm; *anthers* to 3,5 mm long, diverging, cream. Ovary 7–8 mm long, fusiform, included in the spathes, with a short sterile beak to 2 mm long; *style* dividing near the base of the anthers, branches diverging, 2 mm long, deeply bilobed, the lobes diverging, to 1 mm long, stigmatic towards apices. *Capsule* and *seeds* unknown. *Chromosome number* $2n = 20$.

Flowering time: September to early October (in cultivation).

DISTRIBUTION AND HABITAT

Moraea graniticola is known only from a single population near the settlement of Aus in the Namib desert in south-western Namibia. The region receives a small amount of winter precipitation, just sufficient to allow small geophytic plants like *M. graniticola* to complete its growth cycle in the cool part of the year. It occurs in sandy soil around granite domes.

RELATIONSHIPS

Moraea graniticola has an entirely underground stem, at least two channelled leaves and a blue-purple flower unusual for several reasons. The tepals and filaments are united in a well-developed tube, a structure rare in *Moraea*, the subequal tepals have short claws enclosing the base of the filament column and the style branches are narrow and shorter than the anthers and lack style crests. Except for the tube, the flower resembles most closely that of the widespread Karoo species, *M. crispa* and the new *M. pseudospicata* and *M. rigidifolia*, the latter also from south-western Namibia.

The vegetative morphology and cytology indicate that the resemblance, especially to *M. crispa* and *M. pseudospicata*, both section *Polyanthes*, is due to convergence. The last mentioned species have chromosome numbers of $2n = 12$ while *M. graniticola* has $2n = 20$. It seems most likely that *M. graniticola* belongs in section *Moraea*, in which $2n = 20$ is the diploid base number, but all

species of the section except *M. rigidifolia* and *M. hexaglottis* have a typical *Moraea* flower with well-developed style branches and style crests. However, *M. graniticola* differs from all members of the section in its acaulescent habit and in having the perianth and filaments united into a tube. The tube is completely closed and apparently functions simply to raise the flower above the spathes and thus better display them to pollinators. The acaulescent habit is unknown elsewhere in the section and is rare in *Moraea*, being restricted to the four species of section *Acaules*. This apparently monophyletic alliance is distinguished by having in addition contractile pedicels that first raise the tubeless flowers above the spathes and then draw them back for the completion of fruit development. It seems unlikely on morphological grounds that *M. graniticola* is related directly to *M. rigidifolia* despite the similarity of their subequal short-clawed spreading tepals and short, narrow crestless style branches. This unusual flower morphology is probably an adaptation to the desert environment, and has evolved several times in different sections of *Moraea* in dry habitats in southern Africa.

HISTORY

The species was discovered in 1982 by John Lavranos and Inge Pehlemann in a sterile state, growing in dry ground near granite boulders on the townlands in Aus, in southern Namibia. The town lies inland from Lüderitz on the rail line to the interior, and towards the inner edge of the Namib Desert. Corms grown at Kirstenbosch Botanic Gardens flowered in 1983 when the illustration here and the type specimens were prepared. *Moraea graniticola* is apparently rare in the wild, at least at the single site that it is known from. It seems all but certain that the species occurs elsewhere in rocky parts of the southern Namib where some winter precipitation occurs.

SECTION *ACAULES*

27. **MORAEA FALCIFOLIA** Klatt

Klatt, *Abh. Naturf. Ges. Halle* **15**: 366. 1882; Baker, *Flora Capensis* **6**: 12. 1896; Goldblatt, *Ann. Mo. bot. Gdn* **63**: 709–711. 1976. TYPE: South Africa, Cape, Hantam Mountain, *Meyer s.n.* anno 1869 (B, lectotype designated by Goldblatt, 1976: 704; S, isolectotype).

SYNONYMS

Moraea fasciculata Klatt, *Abh. Naturf. Ges. Halle* **15**: 366. 1882; Baker, *Flora Capensis* **6**: 12. 1896. TYPE: South Africa, Cape, 'Langevaley,' *Drège 2600* (B, holotype; K, P, S, isotypes).

Moraea galaxioides Baker, *Handbook Irideae* 49. 1892 et *Flora Capensis* **6**: 12. 1896. TYPE: South Africa, Transvaal, *Barber s.n.* anno 1872 (K, holotype).

Galaxia peduncularis Beguinot, *Malpighia* **23**: 211. 1909. TYPE: South Africa, Cape 'Langevaley,' *Drège 2600* (B, holotype).

* Illustration facing page 84

falcifolia = falcate-leafed, describing the characteristic sickle-shaped leaves.

Plants small, to 5 cm high, forming a dense sessile rosette. *Corm* 1–2 cm in diameter, with tunics of coarse dark fibres,

often bearing cormlets round the base. *Cataphylls* pale and membranous. *Leaves* several, some indistinguishable from the inflorescence spathes, slender, channelled, to 10 cm long, linear to lanceolate, falcate or loosely twisted, the margins frequently undulate or lightly crisped. *Stem* subterranean, usually branching to give rise to several basally clustered inflorescences. *Spathes* herbaceous, margins usually membranous, sheathing at the base only, often with well-developed monofacial apices and not clearly distinct from the leaves, *inner* usually entirely sheathing, to 2,5 cm long, *outer* usually about as long as the inner. *Flowers* several, white to cream with yellow nectar guides outlined in purple on the outer tepals and often a large purple blotch on the inner tepal limb; *outer tepals* 15–22 mm long, limb 8–11 mm long, to 15 mm wide, spreading horizontally; *inner tepals* 13–20 mm long, much narrower than the outer, limbs spreading. *Filaments* to 6 mm long, joined in the lower half; *anthers* 3–4 mm long, pollen white. Ovary 4–5 mm long, exserted from the spathes, *style branches* to 8 mm long, crests 5–8 mm long. *Capsule* globose to oboviod, about 1 cm long, retracted on contractile pedicels into the base of the spathes; *seeds* globose to slightly angled. *Chromosome number* 2n = 20.

Flowering time: May to August (–September); flowers opening after 11 a.m. and fading in the late afternoon.

DISTRIBUTION AND HABITAT

Moraea falcifolia is widespread in the dry parts of southern Africa that receive at least some winter rainfall. It extends from the interior south-western Cape through Namaqualand to south-western Namibia and across the Karoo as far as the extreme western Transvaal and the Kimberley district, close to the Orange Free State border. It is most common in the western Karoo, especially in the Calvinia and Vanrhynsdorp districts. In the south it has been found locally in the Worcester–Robertson Karoo, at Montagu and Swellendam, and in the Long Kloof. It is usually found on dry open stony or clay flats, often among low bushes. Records from the Karoo are scattered and it is not yet clear whether this indicates incomplete collecting or a sparse distribution here. *Moraea falcifolia* is much more common than the record indicates. The very fugacious flowers are seldom seen and the small plants themselves are often overlooked.

DIAGNOSIS AND RELATIONSHIPS

Moraea falcifolia is a low-growing acaulescent species with several falcate leaves and few to several nearly sessile inflorescences crowded at ground level. The flowers are white with yellow nectar guides on the outer tepals and have unusual dark purple blotches on the inner tepal limbs. They are raised out of the spathes on long contractile pedicels that retract the flower into the base of the spathes after fertilization. It is a very distinctive species that cannot be mistaken for any other *Moraea*, but in the absence of flowers, plants may be confused with the vegetatively similar genus *Galaxia*.

Moraea falcifolia is most probably most closely related to the common western Cape species, *M. ciliata*, with which it is included in section *Acuales*, an alliance characterized by a subterranean stem and a contractile pedicel. *Moraea falcifolia* is isolated within section *Acaules*. It is distinguished from the other species of the section by its several, usually falcate, leaves, basal branching giving rise to more than one inflorescence and dark corm tunics.

HISTORY

Moraea falcifolia was apparently first collected by J. F. Drège in the west of its range in the north-west Cape, probably in July 1830. Drège's collection was described by the German expert on Iridaceae F. W. Klatt in 1882 as *M. fasciculata* and independently by Augusto Beguinot as *Galaxia peduncularis* in 1909. A collection from the Hantamsberg, made later by Heinrich Meyer, a doctor at nearby Calvina, was described as *M. falcifolia* by Klatt at the same time that he named *M. fasciculata*. The latter species, represented by poorly-preserved type material, has been placed in synonymy (Goldblatt, 1973). *Moraea falcifolia* is one of the few species of *Moraea* that range across southern Africa from a truly winter rainfall area to what is normally regarded as a region of summer rain, although it always responds to winter precipitation and grows in the winter and early spring. The extreme eastern form, from the western Transvaal, recognized by Baker (1892) as *M. galaxioides*, grades without noticeable discontinuity into western Karoo and north-west Cape plants, and is regarded as conspecific with *M. falcifolia*.

28. MORAEA CILIATA (Linnaeus fil.) Ker

Ker, *Ann. Bot.* (Konig & Sims) 1: 241. 1805; Baker, *Flora Capensis* 6: 11. 1896, excluding varieties; Lewis, *Flora Cape Peninsula* 227. 1950; Goldblatt, *Ann. Mo. bot. Gdn* 63: 711–713. 1976.

SYNONYMS

Iris ciliata Linnaeus fil., *Supplementum Plantarum* 98. 1782; Thunberg, *Dissertatio de Iride* no. 1. 1782. TYPE: South Africa, Cape, hills near Cape Town, *Thunberg s.n.* (Herb. Thunberg *1116*, UPS, lectotype designated by Goldblatt, 1976b).

Moraea hantamensis Klatt, *Abh. Naturf. Ges. Halle* 15: 365 1882. TYPE: South Africa, Cape, Calvinia district, Hantam Mountain, *Meyer s.n.* (B, holotype).

Moraea macrochlamys Baker, *Handbook Irideae* 49. 1892; *Flora Capensis* 6: 12. 1896. TYPE: South Africa, Cape, Sneeubergen, Graaff-Reinet, *Drège 2186* (K, lectotype designated by Goldblatt, 1976b; B, S, isolectotypes).

ciliata = ciliated, describing the fine and usually fairly sparse hairs on the leaf margins and often on the inflorescence spathes.

Plants usually small, 2,5–15(–20) cm high, unbranched and with the stem entirely subterranean. *Corm* to 1,5 cm in diameter, with tunics of medium to coarse pale fibres. *Cataphylls* pale and membranous. *Leaves* usually 3–4, occasionally up to 6, erect and usually exceeding the inflorescence, or falcate, channelled, 5–35 mm wide, lightly pubescent, rarely glabrous, the margins always ciliate, often undulate and sometimes lightly or strongly crisped, inserted on the stem at about ground level at the base of the inflorescence. *Stem* subterranean, unbranched, often bearing cormlets at the nodes. *Spathes* enclosing the inflorescence solitary (the uppermost leaf perhaps corresponding to the outer spathe of the inflorescence), herbaceous, often pubescent. *Flowers* white, blue, or yellow to pale brown, with yellow nectar guides on the outer tepals, heavily scented; *outer tepals* lanceolate, 20–35 mm long, the limb 10–25 mm long, reflexed slightly below the horizontal; *inner tepals* 16–30 mm long, linear-spathulate to narrowly lanceolate and erect or spreading. *Filaments* (3–)5–10 mm long, usually united only at the base; *anthers* 3–5 mm long, pollen whitish or yellow. Ovary about 10 mm long, included to exserted from the spathes, *style branches* 7–15 mm long, crests 8–15 mm, linear to lanceolate. *Capsule* obovoid, 14–20 mm long, included in the base of the spathes and close to ground level, soft-walled; *seeds* with a somewhat spongy testa. Chromosome number $2n = 20, 40$.

Flowering time: July to September; flowers open near noon and fade towards the evening.

DISTRIBUTION AND HABITAT

Moraea ciliata is widespread, occurring over the entire winter rainfall area and it extends locally into the summer rainfall part of southern Africa. It is recorded from Namaqualand in the north-west to the Cape Peninsula, and eastwards to Grahamstown and Graaff-Reinet, including the Roggeveld and western Karoo and a few isolated sites in the southern part of the Great Karoo. Plants occur on clay or sandy slopes and flats. *Moraea ciliata* tolerates very varied conditions, from high rainfall on the Cape Peninsula (over 700 mm p.a.) to less than 120 mm in parts of Namaqualand and the Karoo.

DIAGNOSIS AND RELATIONSHIPS

Moraea ciliata is extremely specialized vegetatively. It is usually a small plant with an unbranched subterranean stem with a single inflorescence, the flowers of which are enclosed in a single spathe instead of two. The uppermost leaf may correspond to the outer spathe but it is entirely leaf-like. Although seedlings have a fairly typical, long, channelled leaf, mature plants have short, broadly channelled and ciliate to pubescent leaves. Despite the vegetative reduction, the flowers of this and the other species of section *Acuales* are little modified from the basic pattern in *Moraea* except that the pedicels are contractile and after blooming the ovary is withdrawn into the base of the spathe where the fruit develops.

The flowers of *Moraea ciliata* are unusually variable in colour. Blue is the most common, but yellow to brown or white also occur. An unusual colour variant from the Swellendam district has white flowers with dark purple blotches on the inner tepals. The flower is always strongly scented with a rich, sweet, spicy odour. *Moraea ciliata* has two close allies which are very alike vegetatively. *Moraea macronyx*, a high-altitude species from the interior Cape mountains, can always be recognized by its pale yellow flowers with long tepal claws much exceeding the limbs, and by unusual soft pith-like corm tunics. The other, *M. tricolor*, from the western Cape lowlands, has tepals with relatively short claws, broad, horizontally spreading limbs and prominent broad style crests held closely together in contrast with the narrow, laxly-arranged tepals and narrow style crests of *M. ciliata*. Most forms of *M. ciliata* are diploid, $2n = 20$, but a polyploid population, $2n = 40$, has been found on clay soil in the Caledon district where *M. ciliata* occurs together with *M. tricolour*, the latter $2n = 20$ here.

HISTORY AND SYNONYMY

Moraea ciliata was one of the several species of *Moraea* that were brought to the attention of botanists by Carl Peter Thunberg. Thunberg collected specimens of what he called *Iris ciliata* on the hills about Cape Town and blue-flowered plants

that are probably the type form still grow on Signal Hill overlooking Table Bay. It was described formally by the younger Linnaeus only a few months before Thunberg's own more thorough study of the Cape species of 'Iris' was published. *Moraea ciliata* is a very distinct species and its taxonomic history reflects this for there were no significant problems in its nomenclature or circumscription for many years. It was transferred to *Moraea* by Ker when it was established that the Cape *Iris* species were generically distinct from *Iris* itself, which is restricted to the Northern Hemisphere.

Two species, described in the later part of the nineteenth century, are treated today as conspecific with *Moraea ciliata*. These are *M. macrochlamys* Baker, typified by robust plants from the Graaff-Reinet area of the south-eastern Karoo, and *M. hantamensis* from the Calvinia district in the western Karoo. The type of the latter matches exactly plants of *M. ciliata* from the Cape Peninsula. Robust plants that match *M. macrochlamys* can be found at several places growing among smaller plants that match closely typical *M. ciliata*, and it is clear that *M. macrochlamys* is no more than a very robust form of *M. ciliata*.

Another species, *Moraea minuta*, described at the same time as *M. ciliata* by the younger Linnaeus and often regarded as a synonym of *M. ciliata*, is difficult to match with a living plant because the flowers are poorly preserved. It is either a very depauperate form of *M. ciliata* or conspecific with the western Cape relative of *M. ciliata*, *M. tricolor*. As accurate typification is not possible the name has been rejected.

CULTIVATION

Moraea ciliata is not in general cultivation but experience at Kirstenbosch is that it responds readily to pot or rock garden culture and increases rapidly given very little attention. The plants are often small in the wild but become tall and robust when given ample water and then produce numerous large flowers that make a lovely display during the late winter. Each flower lasts only a day and fades in the early evening so that the value of the species for display is limited. The flowering season lasts about three weeks.

28.

N. ciliata.

29. MORAEA MACRONYX G. Lewis

Lewis, *Ann. S. Afr. Mus.* **40**: 115. 1954; Goldblatt, *Ann. Mo. bot. Gdn* **63**: 714. 1976. TYPE: South Africa, Cape, Ceres Division, Gydo Pass, *Lewis s.n.* (SAM *61920*, holotype).

macronyx = with large claws, referring to the exceedingly long tepal claws of the flowers, well exceeding the limbs.

Plants small to medium in size, 9–18(–25) cm high, unbranched and with the stem entirely subterranean. *Corm* to 1,3 cm in diameter, with pale tunics of netted fibres or entire, corky or pith-like layers, these sometimes ultimately becoming fibrous. *Cataphylls* pale and membranous. *Leaves* 3, channelled and falcate, glabrous or lightly pubescent, inserted on the stem at about ground level at the base of the inflorescence, the margins ciliate, straight to undulate. *Stem* subterranean, unbranched, cormiferous at the nodes and often with suckers. *Spathes* enclosing the inflorescence solitary, herbaceous, glabrous or pubescent. *Flowers* pale yellow and white with deep-yellow nectar guides on the outer tepals, sweetly scented; *outer tepals* 40–55(–60) mm long, claw up to twice as long as the limb, 25–40 mm long, limb 14–18 mm long, 18–20 mm wide, spreading horizontally; *inner tepals* 30–45 mm long, linear-lanceolate, obtuse, to 7 mm at the widest point, claws also long and limbs spreading like the outer. *Filaments* 12–18 mm long, united in the lower 5–8 mm; *anthers* linear, to 9 mm long, apiculate, pollen yellow. Ovary about 15 mm long, usually exserted from the spathes, *style branches* about 20 mm long, to 5 mm wide, crests 20–25 mm long. *Capsule* and *seeds* not known. *Chromosome number* $2n = 20$.

Flowering time: September to mid-October; flowers opening near noon and fading in the late afternoon.

DISTRIBUTION AND HABITAT

Moraea macronyx is restricted to the interior mountainous areas of the winter rainfall area, extending from the Cold Bokkeveld north of Ceres, eastwards through the Hex River and Swartberg mountains to the upper Long Kloof. It is common in the Cold Bokkeveld and has only recently been found to the east, where it is now known from Tweedside near Touws River, Seweweekspoort and near Avontuur. It seems likely that more records will come to light in the areas between these isolated stations. All records have in common a fairly high altitude, but plants apparently grow in both sandy and clay soils.

DIAGNOSIS

Moraea macronyx is closely allied to the well-known and widespread *M. ciliata*, and falls entirely within the geographic range of this species. It differs consistently from *M. ciliata* and remains quite distinct from forms of the latter growing in the same area. *Moraea macronyx* can readily be distinguished from other species of section *Acaules* by the very long tepal claws which are up to twice as long as the limbs. The corm tunics are also distinctive, being unbroken and spongy or pith-like, soft, apparently composed of loosely packed cells. *Moraea ciliata* has fibrous tunics, occasionally approaching the type found in *M. macronyx*.

HISTORY

Moraea macronyx was discovered by Rudolf Schlechter at the end of the nineteenth century in the Cold Bokkeveld. Most of the other collections of the species are from the same general area and at the time that *M. macronyx* was described by G. J. Lewis in 1954, it was thought to be restricted to this small area of the western Cape mountains. More recent collecting has now substantially extended the known range of the species.

CULTIVATION

Moraea macronyx is not known in cultivation but there seems little doubt that it would grow as easily as its close ally *M. ciliata*. The plants are often small in the wild but several collections of very tall and robust specimens suggest that in pots or in the open ground, *M. macronyx* will grow well and produce numerous large flowers. The flowers last only a day each and fade in the early evening so that the value of the species for display is limited. The flowering season lasts about two weeks.

29.

28.

M. macronyx.

M. ciliata.

30. MORAEA TRICOLOR Andrews

Andrews, *Botanists Repository* 2: tab. 83. 1800; Goldblatt, *Ann. Mo. bot. Gdn* 63: 714–716. 1976. TYPE: South Africa, Cape, without precise locality, illustration in *Botanists Repository* tab. 83.

SYNONYMS

Moraea ciliata (Linnaeus fil.) Ker var. *tricolor* (Andrews) Baker, *Flora Capensis* 6: 11. 1896.

Iris fugax Persoon, *Synopsis Plantarum* 1: 54. 1810, nom. illeg., superfl. pro *Moraea tricolor* Andrews. TYPE: As for *M. tricolor* Andrews.

Moraea barbigera Salisbury, *Trans. Hort. Soc. London* 1: 306. 1812. TYPE: South Africa, Cape, without precise locality, illustration in *Bot. Mag.* 25: tab. 1012 (*M. ciliata* var. γ, corolla purpureo-rubens).

Moraea ciliata var. *barbigera* (Salisbury) Baker, *Flora Capensis* 6: 11. 1896.

Moraea duthieana L. Bolus, *Ann. Bolus Herb.* 4: 113. 1927. TYPE: South Africa, Cape, 15 km west of Stellenbosch, *L. Bolus s.n.* (BOL *18529*, holotype; K, isotype).

tricolor = three-coloured, referring to the pink to red, maroon and yellow colour of the flowers of the type form.

Plants small, 5–15 cm high, unbranched, the stem entirely subterranean. *Corm* 1–1,5 cm in diameter, with tunics of medium to coarse, pale fibres. *Cataphylls* pale and membranous. *Leaves* usually 3, nearly erect, exceeding the spathe, channelled, glabrous or lightly pubescent, the margins ciliate, usually straight, or lightly undulate. *Stem* subterranean, cormiferous at the nodes. *Spathe* solitary, herbaceous, glabrous or lightly pubescent. *Flowers* yellow, pink to red or light purple, with yellow nectar guides sometimes edged in dark maroon on the outer tepals; *outer tepals* 20–25 mm long, lanceolate, claw ascending, about as long as the limb, limb 8–13 mm long, spreading horizontally, *inner tepals* 20–25 mm long, lanceolate, distinctly clawed, limb spreading like the outer. *Filaments* 3–4 mm long, united at the base only, *anthers* 2,5–3 mm long, pollen yellow. *Ovary* 8–10 mm long, included or exserted from the spathes, *style branches* to 5 mm long, crests 8–10 mm long, exceeding the style branches and broadly triangular, to 5 mm wide. *Capsules* enclosed in the base of the spathe and leaf bases, soft-walled; *seeds* unknown. *Chromosome number* $2n = 20, 18$.

Flowering time: late July to mid-September; flowers opening in mid morning and fading in the late afternoon.

DISTRIBUTION AND HABITAT

Moraea tricolor is restricted to the south-western Cape, where it occurs in the northern Cape Peninsula, Cape Flats, the Darling and Malmesbury district and in the Caledon area. It is most common in wet low-lying depressions in sandy soil but in the east of its range near Caledon it grows on damp clay slopes. Its range has been much reduced by farming activity and urban expansion and it is now rare, and probably no longer present on the Cape Peninsula.

DIAGNOSIS AND RELATIONSHIPS

Moraea tricolor is a dwarf species, closely related to the more widespread *M. ciliata* with which it easily confused. It is distinguished by its small flowers with tepals 20–25 mm long with suberect claws and horizontally spreading limbs. The stamens are short with the anthers 2,5–3 mm long, and the style crests are broad and prominent and crowded together in the centre of the flower. The western form of *M. tricolor* has smooth leaves and spathes with minutely ciliate margins, while the Caledon form has lightly pubescent foliage.

Plants with the pink to red, maroon and yellow flowers of the type figure are uncommon, and occur only in the Darling district where plants with yellow flowers are also found, sometimes mixed with the pink. Yellow-flowered plants are more common, extending north and east to Hopefield and Stellenbosch. The Caledon form has a pale purple-pink flower.

Cytologically *Moraea tricolor* is variable. The western populations (four examined) have $2n = 18$ while the Caledon form (two populations) has $2n = 20$, the latter the basic diploid number in subgenus *Moraea*. The western form of *M. tricolor* thus appears to represent a derived aneuploid cytotype. Flowers of the $2n = 20$ and $2n = 18$ forms are very similar, except in colour, and they are not separated taxonomically.

HISTORY

Moraea tricolor was described by the English botanical painter, Henry Andrews, in 1800, and his illustration of the beautiful pink-, red- and yellow-flowered form is now the type as there are no preserved specimens known. Andrews received his plants from the collection of the wealthy merchant George Hibbert who, a few years before, had commissioned the gardener James Niven to collect for him at the Cape. It was presumably Niven who originally collected *M. tricolor* and sent it to Hibbert in 1799. The same form of *M. tricolor* was figured in the *Botanical Magazine* in 1807 where it was called *M. ciliata* var. *corolla purpurea-rubens* (Ker, 1807). Richard Salisbury named the variety in the *Botanical Magazine* *M. barbigera* shortly afterwards in 1812. The yellow-flowered form, described in 1927 by Louisa Bolus as *M. duthieana*, differs only in flower colour, and is now included in *M. tricolor*.

30.

27.

M. falcifolia *M. tricolor.*

CULTIVATION

Moraea tricolor has been grown for many years at Kirstenbosch but it is not yet available to wild flower growers. Like *M. ciliata*, it makes an excellent pot plant and a display of the species is very striking, especially when the different colour forms are mixed together.

SECTION *DESERTICOLA*

31. MORAEA SAXICOLA Goldblatt

Goldblatt, *Ann. Mo. bot. Gdn* **63**: 717–718. 1976. TYPE: South Africa, Cape, Namaqualand, 5 km west of Steinkopf, *Goldblatt 3057*, (MO, holotype; K, NBG, PRE, S, isotypes).

saxicola = rock loving, describing the habitat of the species, stony ground or crevices in rock outcrops.

Plants (10–)20–40 cm high, usually several branched. *Corms* 15–30 mm in diameter, with dark brown, finely netted tunics extending upwards. *Cataphylls* papery and brown, becoming finely fibrous and accumulating for some years and together with the fibrous remains of the leaf bases, forming a neck around the base. *Leaf* solitary, somewhat to much exceeding the inflorescence, usually channelled to flat, terete in juvenile plants, 4–8 mm wide, with thickened yellow margins, either straight or undulate, sometimes crisped. *Stem* erect, with short branches held close to the axis below, later diverging above, sheathing stem bracts 4–5,5 cm long, herbaceous below or entirely dry and straw-coloured, attenuate. *Spathes* usually dry at flowering time, often lacerated, *inner* 3–6 cm long, *outer* about 1 cm shorter. *Flowers* pale blue or white to cream, with yellow to orange nectar guides on the outer tepals; *outer tepals* 30–40 mm long, the limb 15–20 mm, reflexed to about 45°; *inner tepals* smaller and shorter, the limbs also reflexed. *Filaments* 7–13 mm long, united in the lower half; *anthers* 6–9 mm long, slightly exceeding the stigma lobes, pollen white. Ovary nearly cylindric, 8–10 mm long, included in the spathes, *style branches* 8–15 mm long, the crests 10–15 mm long, lanceolate. *Capsules* narrowly elliptic, beaked for about 1 mm, remaining included in the spathes; *seeds* softly angular, about 2 mm at the widest. Chromosome number $2n = 20$.

Flowering time: September to October; flowers opening in the mid-afternoon, usually after 3 p.m., and fading towards sunset.

DISTRIBUTION AND HABITAT

Moraea saxicola is widespread and frequent throughout Namaqualand. It extends from Nuwerus in the south to the northern Richtersveld. Once thought to be rare, it is now known to be common, and plants were probably overlooked because they bloom late in the season, and the flowers last for a few hours in the later afternoon. *Moraea saxicola* grows on rocky granite or clay soils, and it is especially common around Steinkopf and Spektakel Pass on local outcrops of Nama shale towards the edge of the Namaqualand escarpment.

DIAGNOSIS AND RELATIONSHIPS

Moraea saxicola has a flower typical of subgenus *Moraea* with prominent style branches and crests, and the inner tepals are large and reflexed like the outer, but without nectar guides. It has only a single leaf, like the other members of section *Deserticola*. The flowers are comparatively large with outer tepals 30–40 mm long and are usually white but occasionally pale purplish-blue.

Moraea saxicola is allied to *M. bolusii*, a yellow-flowered Namaqualand species with an undulate and trailing to almost prostrate leaf. It is difficult to tell these two species from one another without knowledge of the flower colour but they are not merely colour forms of one species. They sometimes grow together or close by and *M. saxicola* is always the taller and more branched species. The sheathing stem bracts are longer in *M. saxicola*, 30–40 mm, and only 15–25 mm in *M. bolusii*. In addition, from the limited number of fruiting specimens available, it seems that *M. saxicola* also differs from *M. bolusii* in having a shortly beaked capsule whereas the latter has a capsule with a rounded apex.

In northern Namaqualand, on the clay soils near Steinkopf and at Spektakel Pass, a pale-blue form occurs, while in the Richtersveld and to the south of Springbok plants have white flowers. The leaves are generally broad and slightly undulate, but

31.

N. saxicola.

crisped margins may be found in plants growing in especially arid situations. Unusually for *Moraea*, young plants have a juvenile leaf form which is terete and coiled towards the apex. By the time these plants reach flowering age, the leaf is usually channelled, but occasionally, as for example in a collection from south of Springbok, *Acocks 19584*, plants with a juvenile leaf produce flowers. It is not known whether these plants have a terete leaf throughout their life cycle.

HISTORY

Moraea saxicola was first collected by the horticulturalist A. G. (Hans) Herre, for many years the curator of the Stellenbosch University Botanic Garden, but his rather fragmentary specimens were overlooked by botanists. J. H. P. Acocks made more extensive collections several years later and his collections prompted me to search for the species in Namaqualand. I subsequently found *M. saxicola* to be quite common but generally late flowering. It has recently been found in Helskloof in the northern Richtersveld close to the Orange River and the Namibia border.

CULTIVATION

Moraea saxicola is not known in cultivation and, like most of the *Moraea* species from arid parts of southern Africa, it is probably difficult to grow. Its large flower makes it a tempting prospect for the garden, but the difficulty of obtaining corms or seeds, combined with the short-lasting flowers that only open in the mid-afternoon and fade at sunset, must temper any effort to obtain specimens.

32. MORAEA BOLUSII Baker

Baker, *Handbook Irideae* 57. 1892; *Flora Capensis* 6: 20. 1896; Goldblatt, *Ann. Mo. bot. Gdn* 63: 721–723. 1976. TYPE: South Africa, Cape, near Okiep, *H. Bolus 6574* (K, lectotype designated by Goldblatt, 1976b; BOL, isolectotype).

bolusii = named in honour of Harry Bolus, founder of the Bolus Herbarium at the University of Cape Town and noted botanist and collector of southern African flora.

Plants 7–20 cm high, few branched, solitary or in clumps. *Corm* 1–2 cm in diameter, with tunics of coarse black fibres. *Cataphylls* firm-papery and brown, becoming broken or fibrous, accumulating with the fibrous remains of the leaf bases, forming a neck around the base. *Leaf* solitary, glabrous, often longer than the stem, falcate to trailing, linear, channelled, the margins undulate or sometimes crisped. *Stem* simple or more often few branched, the branches diverging from the axis, sheathing stem bracts 15–25(–30) mm long, dry and membranous. *Spathes* usually dry at flowering time, acute, becoming lacerated with age, *inner* 3–4,5 cm long, *outer* about half as long as the inner. *Flowers* pale yellow and white with deeper yellow nectar guides on the outer tepals; *outer tepals* 26–33 mm long, broadly lanceolate, 12–15 mm wide, limb reflexed to 45°; *inner tepals* 24–27 mm long, limb narrowly obovate, also reflexed. *Filaments* 7–10 mm long, united in the lower half to two-thirds; *anthers* 5–6 mm long, pollen white to pale yellow. Ovary included in the spathes, 6–8 mm long, *style branches* about 10 mm long, crests 10–15 mm long, lanceolate. *Capsule* ovoid-cylindric, 10–12 mm long, remaining in the spathes; mature seeds not known. *Chromosome number* $2n = 20$.

Flowering time: September to October; flowers open in the early afternoon, about 1 p.m. and fade towards sunset.

DISTRIBUTION AND HABITAT

Moraea bolusii has a localized distribution in central and northern Namaqualand. It extends from Garies in south-central Namaqualand to Steinkopf in the north, but is common only in the area around Springbok. It grows on rocky flats and hills in thin sandy soils.

DIAGNOSIS AND RELATIONSHIPS

Moraea bolusii is distinctive in its solitary trailing to prostrate undulate leaf, sometimes with crisped margins and it can often be recognized by this character alone even when not in flower. The flower is similar to most species of subgenus

32.

M. bolusii.

Moraea, having well-developed style branches and crests and broad, reflexed inner tepals. The flower is pale yellow with pale, or often white, style branches and crests. *Moraea bolusii* is closely related to *M. saxicola*, with which it can easily be confused. *Moraea saxicola* is usually a more robust species with a longer, often erect leaf and larger white to pale purple-blue flowers. The outer tepals of *M. bolusii* are in the 26–33 mm range, while those of *M. saxicola* are 30–40 mm long. Fruiting specimens are rarely collected but the few that I have seen differ markedly between the two species. *Moraea bolusii* has ovoid-cylindric capsules with a rounded apex, while those of *M. saxicola* are elliptic and have a beak about 1 mm long.

A collection made by R. H. Compton near Klawer, on the Olifants River, which comprises plants with pale lilac flowers, has in the past been referred to *Moraea bolusii*, somewhat expanding the concept and distribution of this species. The Klawer specimens have undulate leaves, black corm tunics, and few-branched scape and apparently differ from *M. bolusii* mainly in flower colour. The collection is excluded from *M. bolusii* here pending a study of living plants from this locality.

HISTORY

Moraea bolusii was first collected by Harry Bolus in the late nineteenth century near the Okiep Copper Mine in Namaqualand. Specimens sent to Kew were immediately recognized as a new species by the English botanist and expert on Iridaceae, J. G. Baker, who named it in Bolus' honour. It was also collected by Rudolf Schlechter at the same period but there have been few later collections despite the fact that it is locally common. Like the other Namaqualand species of *Moraea*, *M. bolusii* is not in cultivation.

33. MORAEA NAMIBENSIS Goldblatt

Goldblatt, *Ann. Mo. bot. Gdn* **63**: 721. 1976. TYPE: Namibia, sandy flats near Udabib, *Merxmüller & Giess 3299* (M, holotype; PRE, isotype).

SYNONYMS

Moraea edulis (Linnaeus fil.) Ker sensu Sölch, *Prodromus Flora Südwestafrika* **155**: 11. 1969.

namibensis = from the Namib, indicating the native habitat in the Namib Desert of southern Namibia.

Plants erect, 12–40 cm high. *Corm* about 2 cm diameter, with dark, finely reticulate tunics. *Cataphylls* membranous, becoming dry and finely reticulate above. *Leaf* solitary, inserted at ground level, linear, channelled, exceeding the inflorescence. *Stem* erect, usually several-branched, sheathing stem bracts 1,5–3 cm long, dry above or entirely. *Spathes* herbaceous with membranous, brown-tipped apices, *inner* 3–5 cm long, *outer* about half to somewhat less than half as long as the inner. *Flowers* white or pale blue, with yellow nectar guides on the outer tepals; *outer tepals* to 40 mm long, claw ascending, as long as the limb, limb about 20 mm long, reflexed; *inner tepals* to 35 mm long, lanceolate and obtuse, limb also reflexed when fully open. *Filaments* about 10 mm long, united in the lower half; *anthers* 6 mm long. Ovary included in the spathes, 8–12 mm long, style branches to 10 mm long, crests lanceolate, to 15 cm long. *Capsule* 10–? mm long, more or less elliptic, beaked apically for about 1 mm (mature capsules not seen); seeds unknown. Chromosome number $2n = 20$.

Flowering time: August to October; floral phenology not known.

DISTRIBUTION AND HABITAT

Moraea namibensis is endemic to the southern Namib Desert in south-western Namibia. The area receives limited but sufficient winter rainfall for plant growth. *Moraea namibensis* grows on sandy flats among low scattered bushes and small annuals.

DIAGNOSIS AND RELATIONSHIPS

Moraea namibensis has a generalized flower with slightly reflexed inner and outer tepal limbs and filaments free in the upper half. Plants have a single narrow basal leaf and the stem is usually branched. The corm tunics are distinctive, being dark brown to blackish, and the cataphylls form a fine fibrous network above. The first collections of *M. namibensis* were initially assigned to the Cape and Namaqualand species *M. edulis*, currently regarded as a

later synonym of *M. fugax*, and the plants were so treated in Merxmüller's *Prodromus einer Flora von Südwestafrika*. The type collection is excellent and it is quite clear that the plants are distinct from *M. fugax*, the most characteristic feature of which is that the leaf or leaves are inserted on the stem well above the ground. The branches of *M. fugax* are also clustered at the point of leaf insertion, a feature not found in *M. namibensis*. *Moraea namibensis* has been placed in section *Deserticola* of subgenus *Moraea* (Goldblatt, 1976b). It is probably closely allied to the Namaqualand species, *M. saxicola* and *M. bolusii*, both of which have similar unspecialized flowers but much broader and shorter leaves.

HISTORY

The type collection of *Moraea namibensis* was made in 1963 by the well known collectors of South West African flora, Hermann Merxmüller and J. W. Giess, on the arid sand flats near Udabib, in the far south of Namibia. When *Moraea namibensis* was described (Goldblatt, 1976b), it was the only species of *Moraea* known from Namibia that grew in the south-west of the country where limited winter rainfall is sufficient for plant growth. This small corner of Namibia is poorly known botanically, but recent collecting there in the past five years, largely by John Lavranos and Inge Pehlemann, has resulted in the discovery of several more species of *Moraea* in the extreme southern part of the Namib Desert (Goldblatt, 1986a), and *M. namibensis* no longer stands out as such a geographically isolated member of the genus. The geophyte flora of the southern Namib is still poorly known and requires much more field study. No doubt more unusual endemic species remain to be found by those willing to explore the rugged terrain closely.

34. MORAEA MACGREGORII
Goldblatt

Goldblatt, *Ann. Mo. bot. Gdn* **63**: 719–721. 1976. TYPE: South Africa, Cape, foot of Vanrhyns Pass, *Goldblatt 3097* (MO, holotype; NBG, isotype).

macgregorii = named in honour of the Macgregor family of Glenlyon farm, Nieuwoudtville, in the north-west Cape, who have for many years fostered conservation of the native plants of the region and have provided a haven and welcome for botanists studying the local flora.

Plants medium to small, 12–25 cm high. *Corm* about 2 cm in diameter, with tunics of light-brown, finely reticulate fibres. *Cataphylls* membranous and more or less dry at flowering time, finely fibrous and reticulate above, accumulating in a neck around the base. *Leaf* solitary, much exceeding the inflorescence, erect or trailing above or completely, 3–4 mm wide, channelled, the margins thickened and pale. *Stem* flexuose, usually several-branched, sheathing stem bracts about 2 cm long, attenuate. *Spathes* herbaceous in the lower part to completely dry at flowering, occasionally lacerated, *inner* 3–4 cm long, *outer* slightly shorter than the inner. *Flowers* pale lilac, with prominent golden nectar guides spotted with orange on the outer tepals; *outer tepals* about 30 mm long, claw about 15 mm long, very narrow, ascending, not contiguous with adjacent tepals, limb as long as the claw, widest at base, 7–8 mm wide, reflexed to 45°; *inner tepals* to 25 mm long, claw about 1 mm wide, limb linear-oblong, about 3 mm wide, reflexed like the inner. *Filaments* 15 mm long, joined in the lower half; *anthers* 3–4 mm long, pollen whitish. Ovary 7–8 mm long, included in the spathes, *style branches* about 18 mm long, the crests narrow, to 10 mm long. *Capsule* 12–15 mm long, included, eventually breaking through the spathes, obovoid, distinctly beaked for 1,5 mm; *seeds* small, angled. Chromosome number $2n = 20$.

Flowering time: October; flowers opening in the late afternoon about 4 p.m. and fading shortly after nightfall.

DISTRIBUTION AND HABITAT
Moraea macgregorii has a limited range in the Vanrhynsdorp district of the north-west Cape where it is known only from the lower slopes of the Bokkeveld escarpment near Vanrhyns Pass. Plants are common on dry stony slopes where the corms are wedged among rocks. It seems likely that *M. macgregorii* occurs elsewhere along the foot of the mountains in the Vanrhynsdorp area, but it has not yet been found at other places in this botanically poorly-known and arid part of South Africa.

DIAGNOSIS AND RELATIONSHIPS
Moraea macgregorii has a solitary, narrow undulate leaf, a short, branched stem, and rather dry, scarious spathes. The flowers are pale lilac with conspicuous golden nectar guides, and the tepal claws are unusually narrow. The capsules are distinctly beaked, as are those of some other members of section *Deserticola*, to which *M. macgregorii* is assigned. *Moraea macgregorii* is related to the Namaqualand species *M. saxicola* and *M. bolusii*, but its narrow, clawed tepals and particularly long filaments, up to 15 mm long, make confusion unlikely.

HISTORY
The first collections of *Moraea macgregorii* were made by W. F. Barker, retired curator of the Compton Herbarium at Kirstenbosch. Her specimens were in fruit and identified as *M. edulis* (now *M. fugax*), but were clearly not this species which has leaves inserted well above the ground. I later found the species, by sheer good luck in the late afternoon when hundreds of plants were just beginning to open their flowers. The reason that *M. macgregorii* had until then been unknown became clear, the flowers open after 4 p.m. and fade in the early evening, thus lasting only about three hours and plants not in bloom are of course overlooked by most people.

34.

M. macgregorii.

SECTION *SUBRACEMOSAE*

35. MORAEA GRACILENTA
Goldblatt

Goldblatt, *Ann. Mo. bot. Gdn* **63**: 724. 1976; *Fl. Pl. Africa* **44**: tab. 1748. 1977; *Ann. Mo. bot. Gdn* **73**: in press. 1986. TYPE: South Africa, Cape, sandy flats south of Piekenierskloof Pass, Piketberg district, *Goldblatt 3279* (MO, holotype; K, NBG, PRE, S, isotypes).

SYNONYMS
Moraea edulis Linnaeus fil. var. *gracilis* Baker, *Handbook Irideae* 56. 1892; *Flora Capensis* **6**: 21. 1896. TYPE: South Africa, Cape, Tulbagh Kloof to Piekenierskloof, *Zeyher 1647* (K, lectotype designated by Goldblatt, 1976; PRE, S, isolectotypes).

gracilenta = graceful, referring to the slender leaf and flowering stem and the generally light appearance of the plants.

Plants 30–80 cm high, many-branched. *Corm* 1,5–2 cm in diameter, deeply buried to 25 cm; tunics of fine to medium pale fibres. *Cataphyll* pale and membranous, sometimes becoming netted above. *Leaf* solitary, channelled, linear, exceeding the inflorescence but usually trailing, inserted well above the ground at the base of the first branch. *Stem* erect and multi-branched. *Spathes* herbaceous, becoming dry, the apices brown, acute, *inner* 2,5–3,5(–4) cm long, *outer* slightly less than half as long as the inner. *Flowers* pale blue-mauve, strongly scented; *outer tepals* 20–30 mm long, 6–8 mm at the widest point, lanceolate, claw about as long as the limb, limb reflexed to about 45°; *inner tepals* 18–28 mm long, 5–6 mm wide, the limb spreading like the outer. *Filaments* about 5 mm long, united in the lower half; *anthers* 4–6 mm long, pollen white. Ovary 8–10 mm long, included in the spathes, *style branches* 7–9 mm long, crests linear-lanceolate, 7–12 mm long. *Capsule* 8–12 mm long, shortly beaked; *seeds* angular. *Chromosome number* $2n = 20$.

Flowering time: late September to November, extending to December at higher altitudes; flowers opening after 3.30 p.m. sometimes as late as 5 p.m. and fading by 7 p.m.

DISTRIBUTION AND HABITAT
Moraea gracilenta has a fairly limited distribution in the south-western Cape, occurring between Gouda and Clanwilliam, mainly at the foot of the north-south trending mountains that extend parallel to the western Cape coast. It has also been found in Elands Kloof, east of Citrusdal. It grows in deep sandy soil and usually near streams or seeps.

DIAGNOSIS AND RELATIONSHIPS
Moraea gracilenta has small pale-bluish flowers with spreading inner and outer tepals, an open panicle-like, branched inflorescence and a single foliage leaf inserted well above ground level. The latter feature, as well as a beaked capsule, places *M. gracilenta* in section *Subracemosae* and close to the more common *M. fugax*. *Moraea gracilenta* differs consistently from all the forms of the variable *M. fugax* in its open and many-branched inflorescence, small blue flowers, and short inflorescence spathes and capsules.

Its floral phenology is also markedly different from that of *M. fugax*. Blooming occurs in the same months, and the flowers of both species last only a day, but while those of *M. gracilenta* open between 3.30 and 5 p.m. and last until at least 7 p.m., the flowers of *M. fugax* open at about midday and are usually completely wilted by 6 p.m. The difference in phenology has been observed on several occasions in wild populations and appears to vary little. *Moraea gracilenta* is apparently pollinated by small moths which I have seen visiting the pale, sweetly-scented flowers as they open in the late afternoon.

HISTORY
The first recorded collections of *Moraea gracilenta* were made by the famous early nineteenth century collectors C. F. Ecklon and C. L. Zeyher. Their collections were made near Tulbagh Kloof, probably near the present day towns of Gouda and Porterville. The species was first recognized by J. G. Baker as *M. edulis* var. *gracilis*, and only in 1976 was it accorded species rank. *Moraea gracilenta* is not known in cultivation but it is to my mind one of the most attractive species of *Moraea* and it is probably easy to grow.

55.

M. gracilenta.

36. MORAEA MACROCARPA
Goldblatt

Goldblatt, *Ann. Mo. bot. Gdn* **73**: in press. 1986. TYPE: South Africa, Cape, south of Redelinghuys, Piketberg district, *Acocks 24359* (PRE, holotype; MO, isotype).

macrocarpa = with a large fruit, referring to the disproportionately long capsule of this usually small plant.

Plants 30–80 cm high, simple or few-branched. *Corm* 8–12 mm in diameter, with tunics of fine pale fibres. *Cataphylls* membranous and pale to dark brown. *Leaf* solitary, channelled, terete to linear-filiform, 0,5–2 mm wide, erect, much longer than the spathes, inserted near, to well above the ground. *Stem* erect, filiform, simple or with 2(–3) sessile or subsessile inflorescences. *Spathes* herbaceous, becoming dry above, the apices brown, acute, *inner* (3,4–)4–5(–6,5) cm long, *outer* about a third as long as the inner. *Flowers* blue-mauve, with yellow nectar guides on the outer tepals, darkly spotted on the claws, scented; *outer tepals* 20–30 mm long, 7–10 mm at the widest, lanceolate, limbs reflexed; *inner tepals* 18–28 mm long, 5–7 mm wide, limbs also reflexed. *Filaments* 5–6 mm long, united in the lower half; *anthers* 4–5 mm long, pollen white. *Ovary* 17–21 mm long, included in the spathes, *style branches* 6–7 mm long, crests linear-lanceolate, 12–18 mm long. *Capsule* cylindric, (18–)20–25 mm long; *seeds* many, small, angular. Chromosome number $2n = 20$.

Flowering time: (May–) August to early October; flowers opening soon after midday and fading at about 5 p.m.

DISTRIBUTION AND HABITAT
Moraea macrocarpa is a winter rainfall area species with a limited range along the Cape west coast where it extends from Hopefield and the Saldanha Bay area northwards to Pakhuis Pass and the Olifants River mountains near Klawer. It has also been recorded locally in the Breede River valley, south of Worcester. *Moraea macrocarpa* is always found in deep, coarse-grained white sand. It has occasionally been found growing with closely related, taller and robust *M. fugax* subsp. *fugax*.

DIAGNOSIS AND RELATIONSHIPS
Moraea macrocarpa has, until recently (Goldblatt, 1986b), been associated with *M. filicaulis*, now *M. fugax* subsp. *filicaulis*, to which it bears a strong resemblance in its slender stem, small corm, and small flower. Chromosome cytology has, however, suggested that their morphological differences are significant and that they are separate species. *Moraea macrocarpa* has $2n = 20$, the basal diploid number for section *Subracemosae*, while *M. fugax* subsp. *filicaulis* has $2n = 18$, 12 and 10.

The morphological differences between *Moraea macrocarpa* and *M. fugax* subsp. *filicaulis* include spathe, ovary and capsule length, and leaf number. The majority of specimens that I have examined of subsp. *filicaulis* have two leaves whil *M. macrocarpa* has only one. The capsules of *M. macrocarpa*, its most striking attribute, are disproportionately long for the small plants and are in the 20–25 mm range, and have a conspicuous long beak, better developed than in other members of the section. The ovary and the spathes are correspondingly long because the capsule remains enclosed throughout development in spathes 4–6,5 cm long. In subsp. *filicaulis* the capsules are only 8–13(–15) mm long and the spathes 2–3,5(–4) mm long. The flowering stem of subsp. *filicaulis* is typically branched, and the branches usually distinctly stalked. In contrast the flowering stems of *M. macrocarpa* usually have only a single terminal inflorescence, rarely 1–2 branches, and the branches are more or less sessile.

HISTORY
Moraea macrocarpa has been known for at least 100 years, since the first collections that can be identified with the species were made in the 1890's by Harry Bolus and independently by Rudolf Schlechter. However, it was either considered conspecific with *M. fugax* (as *M. edulis*), particularly with what is now subsp. *filicaulis*, or left unnamed. Only in the past few years have I come to realize that it was distinct from subsp. *filicaulis*, and probably not directly related to it (Goldblatt, 1986b) although both undoubtedly belong in the small section *Subracemosae*.

37.

M. fugax subsp. *filicaulis*. *M. macrocarpa*.

36.

37. MORAEA FUGAX (de la Roche) Jacquin

Jacquin, *Hortus Botanicus Vindobonensis* 3: 14, tab. 20. 1776; Goldblatt, *Jl S. Afr. Bot.* 36: 316. 1970; *Ann. Mo. bot. Gdn* 63: 725. 1976; *Ann. Mo. bot. Gdn.* 73: in press. 1986.

SYNONYMS

Vieusseuxia fugax de la Roche, *Descriptiones Plantarum Aliquot Novarum* 33. 1776. TYPE: South Africa, without precise locality, figure in van Hazen, *Cat. Arb. & Pl.* 67. 1759 (lectotype designated by Goldblatt, 1970).

Iris edulis Linnaeus fil., *Supplementum Plantarum* 93. 1781. TYPE: South Africa, Cape, exact locality uncertain, *Thunberg s.n.* (Herb. Thunb. *1123*, UPS, lectotype designated by Goldblatt, 1976b).

Moraea edulis (Linnaeus fil.) Ker, *Bot. Mag.* 17: tab. 613. 1803; Baker, *Flora Capensis* 6: 20. 1896; Lewis, *Flora Cape Peninsula* 230. 1950.

Vieusseuxia edulis (Linnaeus fil.) Link, *Enumeratio Plantarum Horti Berolinensis* 1: 56. 1821.

Moraea corniculata Lamarck, *Tableau Encyclopedique et Methodique* 1: 114. 1791; *Encyclopedie Methodique Botanique* 4: 227. 1797. TYPE: South Africa, Cape, *Sonnerat s.n.* (P, lectotype designated by Goldblatt, 1976b).

Iris longifolia Schneevogt, *Icones Plantarum Rariorum* tab. 20. 1792. TYPE: South Africa, Cape, without precise locality, illustration in Schneevogt, *Icones Plantarum Rariorum* tab. 20 (lectotype designated by Goldblatt, 1976b).

Moraea longifolia (Schneevogt) Sweet, *Hortus Britanicus*, ed. 2, 496. 1830, nom. illeg., non *M. longifolia* (Jacquin) Persoon, 1805.

Moraea odora Salisbury, *Paradisus Londonensis* tab. 10. 1805. TYPE: South Africa, precise locality unknown, illustration in *Paradisus Londonensis* tab. 10 (lectotype designated by Goldblatt, 1976b).

For further synonyms see under subspecies *filicaulis*.

fugax = fugacious, referring to the short-lived flowers, each lasting about half, or less than half, the day.

Plants medium to large, 12–40(–50) cm high, branched. *Corm* (1–)1,5–3 cm in diameter; tunics usually pale, rarely dark, of fine to medium fibres. *Cataphylls* usually 2, membranous, pale, becoming dry and brownish and often broken above. *Leaf* solitary or 2, equal or unequal in length, subopposite, inserted well above ground immediately below the first branch, channelled, usually much exceeding the stem and trailing, occasionally loosely twisted distally. *Stem* erect, or more often somewhat inclined, with a conspicuous, long lower internode, the branches crowded, occasionally subracemose. *Spathes* herbaceous, becoming dry, the upper margin light brown, apices attenuate, *inner* (2–)2,5–6(–8) cm long, *outer* half to two-thirds as long as the inner. *Flowers* white, blue, or yellow, strongly scented; *outer tepals* 2–4 cm long, lanceolate, the limb more or less equal to the claw, the limb spreading horizontally to somewhat reflexed; *inner tepals* 2–3,5 cm long, 5–8 mm wide, smaller than the outer, the limbs usually spreading like the outer or sometimes erect. *Filaments* 5–10 mm long, united in the lower half; anthers 4–10 mm long. Ovary 8–20 mm long, included in the spathes, style branches 12–20 mm long, crests lanceolate, 6–18 mm long. *Capsule* oblong to cylindric, distinctly beaked, 9–28(–40) mm long. *Chromosome number* $2n = 20, 18, 16, 14, 12, 10$.

Flowering time: August to October, occasionally extending into December at high elevations; flowers opening near midday and fading towards sunset.

DISTRIBUTION AND HABITAT

Moraea fugax has a wide range in the winter rainfall area where it extends from northern Namaqualand to the southern Cape. It grows in deep, sandy or rocky sandstone or granitic soil. *Moraea fugax* is one of the most common and conspicuous species of the Cape Moraeas, especially along the west coast and interior, where it occurs in almost all sandy areas still covered with natural vegetation. It is less frequent in the southern Cape east of Caledon.

The corms of *Moraea fugax* are edible and pleasant tasting. The species was an important food source for early man, and the corm tunics are abundant in caves and shelters occupied by the first human inhabitants of the western Cape. Today the corms are occasionally eaten as a curiosity by humans but they are a favourite of mole rats, baboons and porcupines.

DIAGNOSIS AND RELATIONSHIPS

Moraea fugax is one of three species that comprise section *Subracemosae*. They are united by the unusual feature of a beaked ovary and a leaf or leaves inserted high on the stem, well above the ground. The flowers are unspecialized except for the beak, hardly evident on the unfertilized ovary, and the inner tepals usually have a spreading limb. There is a strong tendency in *M. fugax* for the branches to be short and somewhat crowded together above the insertion of the leaves, but this feature is variable and cannot be relied upon for identifying the species. In general, *M. fugax* can be separated from *M. gracilenta* and *M. macrocarpa*, the two other species of section *Subracemosae*, by its larger flower with tepals 2–4 cm long. Subsp. *filicaulis* has smaller flowers and it is a smaller plant with capsules 1–1,5 cm long. The latter feature easily separates it from *M. macrocarpa*, which although small, has large capsules usually more than 2 cm long.

As circumscribed in a recent study (Goldblatt, 1986b), *Moraea fugax* is unusually variable and comprises several distinct forms or races. Of these only a series of dwarf, small-flowered and usually two-leafed populations, described in the past as separate species, *M. filicaulis* and *M. diphylla*, are given taxonomic recognition as subsp. *filicaulis*. This subspecies occurs throught Namaqualand and extends south to the Clanwilliam district. Although somewhat variable, subsp. *filicaulis* appears to constitute a natural assemblage, united by its slender stem, filiform leaves, relatively small flower with tepals 2–2,6 (–3,5) mm long and small capsules, 10–15 mm long.

The pattern of variation is more complex in subsp. *fugax*, the several forms of which are united by their large size, long, broad leaves and relatively large flowers with tepals 23–40 mm long and capsules 15–40 mm long. Chromosomal variation is

37.

M. fugax. subsp. fugax.

b. a.

particularly extensive in this subspecies with numbers ranging from $2n = 20$ to 10. The variation within subsp. *fugax* is discussed in detail after the subspecies description. Subsp. *filicaulis* apparently has $x = 9$. Cytological variation is evident in karyotypes from several localities, and derived numbers of $n = 6$ and 5 have been recorded.

HISTORY

Moraea fugax is typified by an illustration of a yellow-flowered plant of unknown origin, most probably collected on or near the Cape Peninsula. It was cultivated in Holland in the mid-seventeenth century and figured in the 1759 Catalogue of the Van Hazen, Vakinburg & Company Nursery. The plant was described by Daniel de la Roche in 1766 and the illustration in Van Hazen's Catalogue is assumed to be the type, there being no known preserved specimen. *Moraea fugax* was first assigned to the genus *Vieusseuxia* but was transferred to *Moraea* by Nicholas Jacquin in 1776, who figured the blue-purple flowered form of subsp. *fugax*.

Thunberg collected *Moraea fugax* during his four years spent at the Cape, 1772–1775 and he gave it the manuscript name *Iris edulis*, which the younger Linnaeus published in 1782. It was under this epithet that the species was first placed in *Moraea* (Ker, 1803) and it was known until 1970 as *Moraea edulis*. The reason for ignoring the earlier epithet *fugax* is a printer's error in De la Roche's *Descriptiones*. The epithets for *Vieusseuxia fugax* and *V. tricuspidata* were placed opposite the wrong descriptions, and the error, although obvious, was used as justification for rejecting both species names. The *Botanical Code of Nomenclature* allows for the correction of typographic errors (Goldblatt & Barnard, 1970) and the earlier epithet must be used for this species.

Subsequently, the white-flowered form of subsp. *fugax* was described from plants in cultivation in Europe, first as *Moraea longifolia* (as *Iris*) by George Schneevoogt in 1792, and then as *M. odora* by R. A. Salisbury in 1805. After the publication of the volume of *Flora Capensis* containing Iridaceae, J. G. Baker described *Moraea filicaulis* based on plants collected by J. F. Drège in the 1820s and *M. diphylla* based on an Arnold Penther collection made in 1894. Both species are here regarded as *M. fugax* subsp. *filicaulis*.

KEY TO THE SUBSPECIES

1. Spathes long, (3,5–)4–6,5 cm long; capsules 15–28(–40) mm long; outer tepals 2,7–4 cm long; leaves channelled, linear, either 1 or 2 37A. subsp. **fugax**
1'. Spathes short, 2–3,5(–4) cm long, capsules 9–13 rarely to 15 mm long; outer tepals 2–2,6(–3,5) cm long; leaves filiform and usually two 37B. subsp. **filicaulis**

37A. Subsp. **fugax**

Plants medium to large, 12–40(–50) cm high, branched, *Corm* (1–)1,5–3 cm in diameter. *Leaf* usually solitary, occasionally 2, equal or unequal in length, channelled, usually much exceeding the stem and trailing. *Stem* sturdy, 2–3 mm thick. *Inner spathe* 4–8 cm long. *Flowers* white, blue, or yellow, strongly scented; *outer tepals* 23–40 mm long, lanceolate, the limb ± equal the claw; *inner tepals* 20–35 mm long, erect or spreading to slightly reflexed, 5–8 mm wide. *Filaments* 6–10 mm long; *anthers* 4–8 mm long. *Ovary* 14–20 mm long, *style branches* 1,5–2 cm long, crests lanceolate, 10–18 mm long. *Capsule* clavate to cylindrical, distinctly beaked, 1,5–2,8(–4) cm long. *Chromosome number* $2n = 20, 18, 16, 14, 12, 10$.

Flowering time: August to November, extending into December at higher elevations.

DISTRIBUTION

Subspecies *fugax* has a wide range in the winter rainfall area. It extends from Springbok in Namaqualand to the southern Cape. The most common habitat is deep sand, but plants also occur in rocky sandstone soils. Except in Namaqualand, *M. fugax* usually grows at low elevations and it is most common along the coastal plain in alluvial sands.

VARIATION

Plants corresponding to the type of *Moraea fugax* have large, yellow flowers, a single leaf and are of generally moderate size with an umbellate branching pattern (although plants may also be tall and racemosely-branched). Populations of this form occur in the south of the range of subsp. *fugax* and extend from south of Malmesbury to the Cape Peninsula and east to Robertson and Swellendam. They have $n = 5$ or rarely $n = 7$ (Goldblatt, 1986b). Similar but more slender yellow-flowered populations in the interior near Robertson and to the north in the Cedarberg and Pakhuis Mountains have $n = 9$ and 8. Despite this range of chromosome number, there seem to be no morphological features that distinguish the cytotypes. A yellow-flowered form from the Olifants River valley and adjacent valleys in similar to yellow-flowered plants

that occur to the south except that they consistently have erect inner tepals. These plants also have $n = 5$ but a somewhat different karyotype from the southern form that has the same number.

A second form that occurs in the southern part of the range of subsp. *fugax* has deep-blue flowers, is relatively tall, and is late blooming. On the Cape Peninsula and the Cape Flats the yellow-flowered form, described above, blooms in August and September, while the blue-flowered form blooms only in October or later, and flowering plants have been collected as late as January. This form usually has $n = 6$, but also $n = 7$.

Along the west coast from near Malmesbury as far north as Hondeklipbaai in Namaqualand, there is a large, white-flowered form of the subspecies, corresponding to Baker's *Moraea edulis* var. *longifolia*. It is generally tall and racemosely-branched. This robust form also occurs in the Olifants River valley. Most populations have $n = 10$ or 9 but $n = 7$ and 6 are found in the Velddrif and Hopefield areas (Goldblatt, 1986b).

In the Malmesbury district there is another white-flowered form which has smaller flowers with unusually narrow tepals. Populations near Malmesbury and to the north towards Hopefield, have $n = 8$, but plants corresponding to this form from south near Gouda, have $n = 6$. In the Breede River Valley similar plants have $n = 9$.

There is no recorded intrapopulational variation for flower colour. Occasionally there is a trend for white flowers to be replaced gradually over some distance by blue as in the Piketberg district. In the Olifants River valley populations of white- or yellow-flowered plants alternate over distances of several kilometres without any clear pattern.

37B. Subsp. **filicaulis** (Baker) Goldblatt

Goldblatt, *Ann. Mo. bot. Gdn* **73**: in press. 1986

*Illustration facing page 96

SYNONYMS

Moraea filicaulis Baker, *Handbook Irideae* 56. 1892. TYPE: South Africa, Cape, Kamiesberg between Roodeberg and Ezelskop, *Drège 2605* (K, lectotype designated by Goldblatt, 1976b; MO, P, isolectotypes).

Moraea diphylla Baker, *Kew Bull.* 1906: 42. 1906. TYPE: South Africa, Cape, Olifants River, *Penther 734* (K, lectotype designated by Goldblatt, 1976b).

Plants small to medium, 6–12(–20) cm high, few to several-branched. *Corm* 7–16 mm in diameter. *Leaves* usually two and subopposite, sometimes solitary, linear-filiform, channelled, 1–2 mm wide, equal or unequal in length, rarely loosely-spiralled distally. *Stem* slender, to 1 mm in diameter. *Inner spathe* 2–3,5(–4) cm long. *Flowers* white, sometimes shaded bluish or pinkish, rarely dark blue-violet, scented, with yellow nectar guides; *outer tepals* 20–28(–35) mm long, 0,8–12 mm wide, the limb sometimes longer than the claw; *inner tepals* 18–30 mm long, 5–7 mm wide. *Filaments* 5–6 mm long; *anthers* 4–5(–6) mm long. *Ovary* 8–10 mm long, *style branches* 8–10 mm long, crests lanceolate 8–14 mm long. *Capsule* 10–13(–15) mm long. Chromosome number $2n = 18, 12, 10$.

Flowering time: August to October.

DISTRIBUTION

Subspecies *filicaulis* is most common in Namaqualand but it extends south through the Knersvlakte into the Olifants River valley where it has been recorded as far south as Clanwilliam. It is usually found in rocky ground but also grows in deep sand. The type form has deep violet flowers and is restricted to the Kamiesberg mountains. Elsewhere flower colour is white to cream, sometimes flushed with pink or pale blue.

SECTION *TUBIFLORA*

38. MORAEA COOPERI Baker

Baker, *Handbook Irideae* 54. 1892; *Flora Capensis* **6**: 16. 1896; Goldblatt, *Ann. Mo. bot. Gdn* **63**: 729–731. 1976. TYPES: South Africa, Cape, Worcester, *Cooper 1661* (K, lectotype designated by Goldblatt, 1976: 729); Tulbagh, *H. Bolus 5428* (K, syntype).

SYNONYMS

Moraea stenocarpa Schlechter, *Bot. Jahrb. Syst.* **27**: 93. 1900. TYPE: South Africa, Cape, between Bains Kloof and Ceres Road, *Schlechter 9082* (B, lectotype designated by Goldblatt, 1976; BOL, GRA, MO, PRE, S, SAM, isolectotypes).

Gynandriris stenocarpa (Schlechter) Foster, *Contr. Gray Herb.* **127**: 47. 1939.

Moraea apetala L. Bolus, *S. African Gard.* **19**: 385. 1929. TYPE: South Africa, Cape, Stellenbosch Flats, *Duthie 1770* (BOL, holotype; K, isotype).

Gynandriris apetala (L. Bolus) Foster, *Contr. Gray Herb.* **127**: 48. 1939.

cooperi = named after Thomas Cooper, an English plant collector of the mid-nineteenth century, who was one of the first to collect this species.

Plants 15–25 cm high, moderately to much branched. *Corm* 1–1,5 cm in diameter, with tunics of dark fibres. *Cataphylls* brown and fibrous, forming a neck around the stem base. *Leaves* usually 2, linear, channelled, the lower basal, exceeding the stem, the upper inserted well above ground. *Stem* flexuose, usually much branched, sheathing stem bracts 3–4 cm long, the lower sometimes longer and somewhat leaf-like, attenuate, the apices diverging from the axes. *Spathes* herbaceous with brown attenuate apices, *inner* 3–5 cm long, *outer* about one-third as long as the inner. *Flowers* solitary in the spathes, pale yellow with delicate purple veins, nectar guides deep yellow, the tepals united in a tube 8–10 mm long; *outer tepals* 33–40 mm long, claw ascending, limb to 20 mm long, to 20 mm wide, lanceolate; *inner tepals* completely lacking. *Filaments* to 6 mm long, united in the lower 1,5–0,5 mm; *anthers* 7–9 mm long, pollen yellow. *Ovary* 10–12 mm long, included in the spathes, *style branches* 12–15 mm long, crests lanceolate, 9–12 mm long. *Capsules* to 30 mm long, narrowly fusiform, included in the spathes; *seeds* flattened and elongate, to 4 mm long, winged at opposite ends. *Chromosome number* $2n = 20$.

Flowering time: late September and October, occasionally in November at higher elevations; flowers opening in the late morning and fading towards evening.

DISTRIBUTION AND HABITAT

Moraea cooperi occurs in the south-western Cape, ranging from Tulbagh in the north through the Worcester district to Caledon and Stanford in the south-east, but does not occur on the Cape Peninsula. It is usually found on well-watered flats, in sandy soil, sometimes in very rocky alluvium at the base of high mountains. *Moraea cooperi* is nowhere common and the fertile, well-watered flats where it grows, are now largely under cultivation, so that it is becoming rare. It is notably responsive to fire and is seen most often on recently burnt ground.

DIAGNOSIS AND RELATIONSHIPS

Moraea cooperi is an unusual species in several features, most remarkable of which is the well-developed perianth tube. The large, yellow, delicately purple-veined flowers have only three tepals, united below in a tube 8–10 mm long. The inner whorl of tepals is completely absent. The flowers are always solitary in the spathes and the ovary remains included in the spathes throughout the development of the capsule. The seeds are also unusual in being flattened and two-winged. The plants have two or more leaves and several to many branches and a basic chromosome number of $x = 10$, all of which are consistent with the characteristics of subgenus *Moraea*. However, it seems so isolated taxonomically in its specialized features that it has been segregated in section *Tubiflora*. The only other species of the section is *M. longiflora*, from the Kamiesberg in Namaqualand. It also has a flower with perianth tube, but the flowers have well-developed inner tepals and the stems are subterranean and only 1–2 branched (Goldblatt, 1976b).

HISTORY AND SYNONYMS

Moraea cooperi was apparently first collected by C. F. Ecklon and C. L. Zeyher in the 1820's, but their collections, widely distributed in European herbaria, remained undescribed. Later, when the species was found by Thomas Cooper in 1859, it attracted the attention of J. G. Baker at Kew, who described it in 1892. Two synonyms appeared later and it is clear that neither Rudolf Schlechter, who named the species *M. stenocarpa*, and Louisa Bolus, who called it *M. apetala*, realized the correct identity of Baker's plant (his description is poor and incorrect in some aspects). The American, R. C. Foster (1939) believed that *M. cooperi*, which he knew as *M. stenocarpa*, belonged in the genus *Gynandriris* owing to its perianth tube and he transferred it here. The floral tube in *Gynandriris* is, however, derived from a sterile prolongation of the ovary, while *M. cooperi* has a true perianth tube of united tepals. There is, in fact, no relationship between *M. cooperi* and *Gynandriris*.

38.

M. cooperi.

39. MORAEA LONGIFLORA Ker

Ker, *Bot. Mag.* **17**: tab. 712. 1804; Baker, *Flora Capensis* **6**: 22. 1896; Goldblatt, *Ann. Mo. bot. Gdn* **63**: 731–732. 1976. TYPE: South Africa, Cape, without precise locality (but probably Kamiesberg, Namaqualand), illustration in *Bot. Mag.* tab. 712 (lectotype here designated).

SYNONYMS

Helixyra longiflora (Ker) N. E. Brown, *Trans. R. Soc. S. Afr.* **17**: 349. 1929.

Gynandriris longiflora (Ker) Foster, *Contr. Gray Herb.* **114**: 40. 1936.

Helixyra flava Salisbury, *Trans. Hort. Soc. London* **1**: 305. 1812, nom. illeg. superfl. pro *M. longiflora* Ker. TYPE: as for *Moraea longiflora* Ker.

longiflora = long-flowered, describing the unusual flower with a long perianth tube in addition to large tepals and style branches.

Plants small, about 5 cm high with 2–4 branches clustered at ground level. *Corm* somewhat spindle-shaped, 8–10 mm in diameter, with tunics of dark brown, wiry reticulate fibres. *Cataphylls* pale and membranous. *Leaves* several, 1 basal and inserted below the ground, 4–6 cm long, rigid linear-filiform, channelled, the other leaves similar, clustered at ground level. *Stem* subterranean at flowering time, later extending shortly above the ground, usually with 2–4 sessile branches clustered at the apex. *Spathes* herbaceous, *inner* 2,5–3 cm long, *outer* somewhat leaf-like, about as long as the inner, sheathing below for about 5 mm, free above and extending outwards. *Flowers* yellow with yellow-orange nectar guides on the outer tepals; perianth united in a tube 20–30 mm long; *outer tepals* 23–30 mm long, the limb to 20 mm long, spreading to weakly reflexed; *inner tepals* 17–22 mm long, limbs also spreading or becoming reflexed. *Filaments* 5–6 mm long, united in the lower third; *anthers* about 5 mm long, pollen yellow. Ovary concealed in the lower part of the spathes, *style branches* 10–12 mm long, the crests to 1 cm long. *Capsule* and *seeds* not known. *Chromosome number* 2n = 20

Flowering time: October; flowers open at about midday and fade after 5 pm.

DISTRIBUTION AND HABITAT

Moraea longiflora is known only from the Kamiesberg mountains in Namaqualand above 1 200 m. It is local at higher elevations in moist, sandy places growing among low shrubs and clumps of Restionaceae. Flowering occurs only after the surrounding vegetation is burned or cleared.

DIAGNOSIS AND RELATIONSHIPS

Moraea longiflora has a number of remarkable features that make is unmistakeable in the genus. The flower at first seems representative of *Moraea* with spreading inner and outer tepals and prominent style branches and crests, but the whole flower is carried on a long tube some 2–3 cm long and the ovary is concealed in the base of the inflorescence spathes. The other unusual feature of *M. longiflora* is the stem which is entirely underground at the time of flowering. Only after the capsules ripen does the stem elongate and raise the fruits above ground level.

Unusual as *Moraea longiflora* is, it bears a fair resemblance to the south-western Cape *M. cooperi*, one of only two other species of *Moraea* with a perianth tube, the other being the very different *M. graniticola* from southern Namibia. *Moraea cooperi* and *M. longiflora* have similar spathes and corms, and are almost certainly closely related. They have been grouped together in the ditypic section *Tubiflora*, distinguished by the presence of a perianth tube (Goldblatt, 1976b). *Moraea cooperi* differs from *M. longiflora* in having a well-developed and many-branched aerial stem, and in flowers which completely lack inner tepals. Section *Tubiflora* is probably a very ancient and taxonomically isolated segregate of subgenus *Moraea*.

HISTORY

Moraea longiflora was for over 170 years an enigma. No known wild southern African plant matched in any way the excellent illustration in *Curtis's Botanical Magazine*, which is the type of the species. According to Ker who described it, plants were sent to him by the wealthy English magnate and Member of Parliament, George Hibbert, a director of the East India Company. Hibbert was an enthusiastic plant collector and grew plants from many parts of the world in his gardens in Clapham, London. Ker received the specimens figured in the *Botanical Magazine* two years after Hibbert had himself flowered it. Hibbert had received the corms from the Cape shortly before this, probably in 1800 or 1801. According to *Hortus Kewensis* ed. 2, which includes *Moraea longiflora*, the corms were collected and sent to Hibbert by James Niven who, in 1798, had been employed by Hibbert and sent to collect plants for him in the Cape.

Moraea longiflora remained known only from the painting until 1976 when I visited the Kamiesberg mountains late in the spring season, in mid-Oc-

39.

N. longiflora.

40.

N. flexuosa.

tober. Nothing could have been more surprising than the rediscovery of this remarkable plant. At first I thought that it was entirely new, but the two unusual features, a long perianth tube and an underground stem, recalled the *Botanical Magazine* plate of *M. longiflora*, which it was found on later examination to match in every detail. It is almost certain that the original collection of *M. longiflora* was made (Goldblatt, 1976b) when Niven visited the Kamiesberg in 1799 or 1800, soon after his arrival at the Cape.

CULTIVATION

Moraea longiflora has proved to be easy to grow and maintain as a pot plant in St. Louis, and I have grown it for many years without difficulty. The plants make a cheerful display in the late winter, but the flowers last only a few hours in the middle part of the day. I have no doubt the *M. longiflora* would be adaptable to alpine or rock gardens, but its small size makes it difficult to maintain and plants are easily overlooked when not in flower and worth trouble only to the wild-flower enthusiast.

SECTION *FLEXUOSA*

40. MORAEA FLEXUOSA Goldblatt

Goldblatt, *Ann. Mo. bot. Gdn* **69**: 356–357. 1982. TYPE: South Africa, Cape, Richtersveld, Eksteenfontein Road, *Goldblatt 6000A* (MO, holotype; K, NBG, PRE, S, WAG, isotypes).

*Illustration facing page 104

flexuosa = with a flexed or zig-zag stem, referring to the characteristic very bent stem of this species.

Plants 6–10 cm high. *Corm* 10–15 mm in diameter, tunics of matted coarsely reticulate dark brown to black fibres. *Cataphylls* membranous and pale, sometimes becoming fibrous and accumulating around the base in a neck. *Leaves* 3–5, the lowermost inserted shortly, to 2 cm above the ground and largest, the upper leaves progressively shorter, all falcate, channelled, up to 6 cm long, 3–6 mm wide. *Stem* erect, strongly flexouse, flexed above the sheathing base of each leaf, simple or with up to 4 branches. *Spathes* herbaceous, acuminate, inner 2,5–4 cm long, outer about as long to 10 mm shorter than the inner, sheathing below only, somewhat leafy and with a free apex in the upper two-thirds. *Flowers* pale yellow at the edges of the tepals, deep yellow towards the centre, with nectar guides consisting of minute green speckles on the outer tepals; outer tepals 28–30 mm long, claw erect, slightly longer than the limb, to 15 mm long, limb spreading horizontally, 13–14 mm long, about 8 mm wide; inner tepals similar, 25–27 mm long, limb about 12 mm long, 7 mm wide. *Filaments* 11–12 mm long, united into a cylindrical column, free and diverging in the upper 1,5 mm; anthers about 3,5 mm long, pollen white. Ovary about 7 mm long, cylindric, usually exserted from the spathes, *style branches* 4 mm long, crests short, erect, about 2 mm long. *Capsule* oblong, 12–15 mm long; *seeds* angled. *Chromosome number* $2n = 12$.

Flowering time: late winter, July to early August; flowers opening near noon and fading in the late afternoon.

DISTRIBUTION AND HABITAT

Moraea flexuosa is a rare local endemic of the southern Richtersveld where it occurs on the plains west of the Anenous mountains. It is found in fine, sandy loess on exposed arid flats, flowering 3–4 weeks after the first soaking winter rains.

DIAGNOSIS AND RELATIONSHIPS

Moraea flexuosa is an unusual species and from an unusual area of southern Africa. It can immediately be recognized by its peculiar flexuose stem that bends in zig-zag fashion above the sheath of each leaf. The inflorescence spathes are also unusual in having the outer sheathing only in the lower part. The upper two-thirds are free and curve outwards, appearing somewhat leaf-like. The tepals have unusually long claws, 2–3 mm longer than the limbs, and this gives the flowers a very characteristic elongated appearance.

Moraea flexuosa has a chromosome number of $n = 12$, characteristic of subgenera *Vieusseuxia* and *Grandiflora*. However, it is so different from the species of both subgenera that it is not related to either. Its several leaves and similar inner and outer tepals suggests that it belongs in subgenus *Moraea*, which has a basic chromosome number of $x = 10$. The difference in chromosome number must have arisen during the evolution of *M. flexuosa*. It is so different from any other species of subgenus *Moraea* that it is not yet possible to suggest where its relationships lie.

HISTORY

Moraea flexuosa was discovered in 1979 by Nikki van Berkel, an amateur botanist who has lived for several years in Namaqualand, and it was probably due to her having ample time in the area at all seasons of the year that this very unusual species was discovered. With careful directions as to how to locate the area where the plants grew, I visited the only known locality of the species in 1980, accompanied by Dierdre Snijman of the Compton Herbarium, Kirstenbosch. We were too late to find plants in flower and on a second visit plants were only just emerging from the ground. However, specimens transplanted in pots flowered just three weeks later, when Fay Anderson completed the painting published here. The species was named and described two years later (Goldblatt, 1982) together with several other species of *Moraea* that had been discovered in the few preceding years.

SECTION *POLYANTHES*

41. MORAEA BIPARTITA L. Bolus

L. Bolus, *J. Bot.* **71**: 122. 1933; Goldblatt, *Ann. Mo. bot. Gdn* **66**: 589–590. 1979. TYPE: South Africa, Cape, Riversdale Karoo, road to Adams Kraal, *Ferguson s.n.* (BOL-20068, holotype).

SYNONYMS

Moraea polyanthos Linnaeus fil. sensu Baker, *Flora Capensis* **6**: 16–17. 1896; Goldblatt, *Ann. Mo. bot. Gdn* **63**: 746–747. 1976, excl. type; Vahrmeier, *Poisonous Plants Southern Africa* 56–57. 1981.

bipartita = two-parted, referring to the two-lobed nature of the stigmatic flap in many specimens of the species.

Plants (10–)20–30 cm high, occasionally reaching 40 cm, usually much branched. *Corms* 1–1,5 cm in diameter, with tunics of dark brown to black fibres. *Cataphylls* membranous and pale, reaching shortly above the ground. *Leaves* usually 3, occasionally 2 or 4, linear, 2–6 mm wide, channelled, the lower basal and usually exceeding the inflorescence, the upper shorter. *Stem* branching repeatedly. *Spathes* herbaceous or becoming dry above, the apex attenuate, dark brown, inner (2–)2,5–4,5 cm long, outer about half as long as the inner. *Flowers* pale blue or sometimes deep violet, with white to yellow nectar guides on the outer tepals; *outer tepals* (16–)22–30 mm long, lanceolate, the limb reflexed to 45°, more or less as long as the claw; *inner tepals* smaller, 14–25 mm long, lanceolate, the limb also reflexed. *Filaments* 4–6 mm long, free in the upper 1–2 mm; *anthers* about 5 mm long; pollen whitish. Ovary globose, 4–5 mm long, exserted from the spathes, *style branches* about 5 mm long, *crests* erect, prominent, 5–8 mm long. *Capsule* oblong to broadly obovate, 8–10 mm long; *seeds* many, angled. Chromosome number $2n = 12$.

Flowering time: (June to) August to October (to November); flowers opening after midday and fading in the late afternoon.

DISTRIBUTION AND HABITAT

Moraea bipartita is common in the Little Karoo from about Barrydale, eastwards to Oudtshoorn, and occasional in dry situations in the southern Cape as far east as Uitenhage. It has also been recorded from Graaff-Reinet, some distance to the north-east of the main part of the range.

DIAGNOSIS AND RELATIONSHIPS

Moraea bipartita has typical *Moraea* flowers with larger outer tepals with reflexed limbs, smaller, similarly oriented inner tepals and flat petaloid style branches with conspicuous crests. The flowers are pale-bluish, and have nectar guides on the outer tepals. They are relatively small in size, and this together with the two to four leaves and typically branched stems, distinguish the species.

Moraea bipartita is apparently closely allied to the widespread Karoo and eastern Cape autumn-flowering species, *M. polystachya*. The two are occasionally confused but the smaller flowers, spathes and leaves of *M. bipartita* should make misidentification infrequent. The flowers of *M. polystachya* are similarly proportioned but it is a more robust species and is larger in most features and consistently so in the floral parts. Tepals of *M. polystachya* are usually at least 4 cm long and the filaments and anthers both about 10 mm long, while the style crests are well-developed and 12–20 mm long. These dimensions are substantially larger than in *M. bipartita* in which the tepals are 2–3 cm long, the filaments and anthers about 5 mm long and the style crests seldom longer than 5–8 mm.

Moraea bipartita blooms in the spring months,

usually August to September, whereas *M. polystachya* typically blooms in the autumn from March to June, but in July and August in the Little Karoo. The two species both grow in the Little Karoo and in similar situations, but they appear to be isolated reproductively by the differences in flowering time. In the same general area, *M. bipartita* usually blooms several weeks and sometimes months later than *M. polystachya*.

Moraea bipartita is particularly variable in height and in the size of other vegetative characteristics depending on the rainfall and growing conditions each season. In dry years it may be only 10 cm high, but up to 40–50 cm high when adequate moisture is available. No significant morphological variation has been recorded for the flowers. The feature for which it was named, the bilobed stigma, is not unique or even unusual in *Moraea*, and is not taxonomically significant, as many other species as well as *M. bipartita* may have a somewhat to distinctly bilobed stigma. *Moraea bipartita* is described as having only two leaves, but one of the two specimens of the type collection actually has three leaves, the number most common in the species.

HISTORY

It is uncertain who first collected this relatively common southern Cape species. The earliest collections of *Moraea bipartita* that I have seen are those of Harry Bolus, who found it near Graaff-Reinet in the late nineteenth century, but it was also collected by William Burchell in 1812, and perhaps even earlier. Baker assigned Bolus' collection to *M. polyanthos* together with several collections of this allied species. Only in 1933 did Louisa Bolus describe *M. bipartita* for plants that she believed to be distinct from what was then and for some years later, known as *M. polyanthos*. In my revision of *Moraea* for the winter rainfall area of southern Africa (Goldblatt, 1976b) I regarded *M. bipartita* as conspecific with *M. polyanthos*. Only in 1979, when I had the opportunity to examine the Thunberg Collection at Uppsala University in Sweden, did it become clear that the type material on which this name was based was in fact the species known then as *Homeria lilacina* L. Bolus, which is essentially identical to *M. bipartita* in the vegetative state. Only when the flowers are carefully examined is it possible to see that the filaments of Thunberg's type are entirely united and the style branches are very reduced, narrow and lack crests. There is no doubt that *M. bipartita* and *M. polyanthos* are very closely allied and differ mainly in the details of the stamens and style branches. The two species can readily be crossed artificially and yield vigorous offspring that are morphologically intermediate between the parents. The similarities and relationship between *M. bipartita* and *M. polyanthos* are discussed in more detail under the treatment of the latter species.

42. MORAEA POLYANTHOS
Linnaeus fil.

Linnaeus fil., *Supplementum Plantarum* 99. 1782; Thunberg, *Dissertatio de Moraea* no. 14, 1787; Goldblatt, *Ann. Mo. bot. Gdn* **63**: 746. 1976, misapplied to *M. bipartita* L. Bolus; *Ann. Mo. bot. Gdn* **66**: 589. 1979; *Bot. Notiser* **133**: 92–93. 1980. TYPE: South Africa, Cape, 'in regione Kore rivier', Thunberg s.n. (Herb. Thunberg *1226*, UPS, lectotype designated by Goldblatt, 1979: 589; Herb. Thunberg *1227*, UPS, syntype).

SYNONYMS

Homeria lilacina L. Bolus, *Ann. Bolus Herb.* **3**: 9. 1920. TYPE: South Africa, Cape, near Matjiesfontein, Beattie & F. Bolus s.n. (BOL *15186*, holotype).

polyanthos = many-flowered, describing the numerous flowers that may be open on a single day on a robust plant.

Plants (10–)15–45 cm tall. *Corm* 10–15 mm in diameter, with black, coarsely reticulate to clawed tunics. *Cataphylls* membranous, often disintegrating when dry. *Leaves* 2–3, the lower basal and larger than the upper, linear, channelled, 3–6 mm wide, exceeding the stem. *Stem* erect, straight, branched in the upper half (occasionally unbranched), sheathing stem bracts 2–3(–5) cm long. *Spathes* herbaceous or becoming dry above, *inner* 3,5–4 mm long, *outer* slightly less than half as long as the inner. *Flowers* light to dark blue-purple, lilac or white, fragrant, with yellow nectar guides on the inner and outer tepals, claws forming a cup about 7–9 mm wide and 10–12 mm deep, including the stamens or only the filaments; *outer tepals* 23–40 mm long, claw 10–12 mm, limb 8–10 mm wide, obtuse, widest near apex, usually spreading horizontally or somewhat reflexed; *inner tepals* 18–35 mm long, 6–10 mm wide, limb also usually spreading more or less horizontally. *Filaments* united, column (5–)7–9 mm long, minutely papillate in the lower two-thirds, slender, tapering gradually from base to apex; *anthers* (4–)5–7 mm long, diverging, pollen yellow. *Ovary* 5–7 mm long, exserted from the spathes, *style branches* diverging, 4–5 mm long, reaching to or slightly below the apex of the anthers, apically forked, crests lacking. *Capsule* obovoid, 6–11 mm long; *seeds* many, angled. Chromosome number $2n = 12$.

41.

M. bipartita.

Flowering time: (May to) late August to November (to early December).

DISTRIBUTION AND HABITAT

Moraea polyanthos is a winter rainfall area species, most common in the Little Karoo, from Worcester and Robertson in the west through the Longkloof to Uitenhage. It also occurs in karroid parts of the eastern Cape, and in the southern Cape between Stormsvlei and Mossel Bay. *Moraea polyanthos* is usually found on drier rocky or shale flats, rarely on sandy substrates.

DIAGNOSIS AND RELATIONSHIPS

Moraea polyanthos has a flower typical of the genus *Homeria* with deeply-cupped tepal claws, horizontally-extended limbs and narrow, reduced style branches, no wider, and often shorter, than the anthers. Despite the similarity of the flowers to *Homeria*, there is a striking resemblance between *Moraea polyanthos* and *M. bipartita* that extends to all characteristics except the details of the tepals, stamens and style branches, and there can be no doubt that these two species are very closely related. The morphological evidence for their close affinity is supported by crossing studies which have shown that the two species can readily be crossed and a hybrid generation has been raised at the Missouri Botanical Garden. The hybrid plants are perfectly intermediate between the two species in their floral characteristics. It seems clear that *M. bipartita* is the ancestral type, for it accords well with *Moraea*, while *M. polyanthos* is specialized in its unusual and reduced style branches that lack crests and in its entirely united filaments.

Moraea polyanthos is also probably close to the ancestor that gave rise to the widespread Karoo and interior Cape mountain species, *M. crispa*, which has similarly reduced flowers with nearly equal tepals and united filaments. *Moraea crispa* is a generally smaller plant and it has smaller flowers with short tepal claws, 3–4 mm long, that form a narrow, almost tubular cup, only a single leaf, a reduced number of branches and short style branches that are 1–2 mm shorter than the anthers. There is little likelihood of confusion between these two species.

VARIATION

Like many species of arid areas and irregular annual and seasonal rainfall, *Moraea polyanthos* is very variable in height and the dimensions of its vegetative features. Plants from the same locality may, in a year of low rainfall be only 10–15 cm high and sometimes unbranched, while in years of ample rainfall individuals may be up to 45 cm or more in height with repeatedly-branched stems. The unusual degree of variation in flower colour, however, is not due to seasonal fluctuations in rainfall. A medium blue-violet flower colour is most common, but plants from sandy soils sometimes have deep violet flowers. In parts of the Little Karoo populations sometimes have flowers of an unusual pale lilac-purple shade not encountered elsewhere in this species.

A more distinctive variant is a white-flowered form from the southern Cape. Not only are the tepals white, but the flowers are somewhat smaller than in plants with blue to purple flowers. In the plants with white flowers, the tepal cup is deeper and the stamens smaller so that the stamens are more or less included. The more common situation is for only the filaments to be included in the cup. The white-flowered form was given the manuscript name var. *alba* by Louisa Bolus, who also described *Homeria lilacina*, the name by which *M. polyanthos* was long known. The white-flowered plants from populations uniform for flower colour have somewhat shorter filaments, 5–6 mm long, as compared to 7–9 mm in plants with blue to purple flowers. However, there are both populations of uniformly white-flowered plants, and some with white, pale bluish or darker blue flowers. At present it is not clear whether the white-flowered plants represent a newly evolving species, or a distinct form gradually losing its identity due to hybridization with plants with blue to purple flowers.

HISTORY

Moraea polyanthos was first described as early as 1782, by the younger Linnaeus, who based his description on the manuscripts and specimens collected by Thunberg at the Cape. The species was assigned to *Moraea* instead of to *Iris* because the flowers lacked the broad petaloid style branches that were considered characteristic of *Iris*. *Moraea polyanthos* was later confused with the vegetatively identical *M. bipartita*. J. G. Baker, for example, included both species under *M. polyanthos* in *Flora Capensis*. When plants that matched Thunberg's species were brought to Louisa Bolus in the 1920's, she thought it was new, and described it as *Homeria lilacina*.

In 1979 when I was studying the genus *Homeria* (Goldblatt, 1980b) it became clear that the three blue-flowered species at the time assigned to *Homeria* were more closely related to certain species of *Moraea* than to any *Homeria*. Other species of *Homeria* have yellow or pink to orange flowers, but share with a few scattered species of *Moraea*, a similar flower structure in which the tepals are nearly equally disposed, the filaments are united, nectar guides are present on the inner and outer tepals and the style branches are reduced in size and have vestigial, or completely lack, crests. Vegetatively, *M. polyanthos* is indistinguishable from *M. bipartita*, and the flowers differ only in the details mentioned above. However, *M. polyanthos* has a chromosome complement identical to that of *M. bipartita* and, moreover, crosses readily with this species but not with any of several species of *Homeria* that were tried in crossing experiments. Clearly *Moraea polyanthos* is closely related to *M. bipartita* and they must be placed in the same genus despite the floral details that must have evolved in parallel with *Homeria*.

The type specimens of *Moraea polyanthos* have flowers with completely united filaments, long erect anthers and reduced style branches without crests and correspond exactly to *Homeria lilacina*

42.

N. polyanthos.

(Goldblatt, 1980b) and the two species are undoubtedly conspecific.

CULTIVATION

Moraea polyanthos is not in general cultivation, but it has been grown successfully at Kirstenbosch and at the Karoo Gardens in Worcester for many years. Its floriferous habit, the ease with which it responds to garden treatment and a long flowering season recommend it highly. It is especially desirable for areas of limited rainfall where it is often difficult to find plants that require little moisture and are not fussy about soil conditions. *Moraea polyanthos* grows well as a pot plant, but it is more attractive in a natural setting, either in a rock garden or among native shrubs. At present seed can be obtained in limited quantity from the National Botanic Gardens, Kirstenbosch.

43. MORAEA CRISPA Thunberg

Thunberg, *Dissertatio de Moraea* no. 13. 1787; Goldblatt, *Bot. Notiser* **133**: 93. 1980, non *M. crispa* (Linnaeus fil.) Ker. TYPE: South Africa, Cape, 'Roggeveld,' *Thunberg s.n.* (Herb. Thunberg *1214*, UPS, holotype).

*Illustration facing page 116

SYNONYMS

Homeria rogersii L. Bolus, *Fl. Pl. Africa* **8**: sub tab. 306. 1928. TYPES: South Africa, Cape, Naauwpoort, *Rogers 12078* (BOL, lectotype designated by Goldblatt, 1980: 93; K, PRE, Z, isolectotypes); Richmond Division, Vlakplaats, *H. Bolus s.n.* (BOL *13835*; MO, Z, syntypes).

crispa = crisped, the Latin word for curled, referring to the leaf margins which, in the type specimens, are wavy to strongly curled.

Plants small, 8–20(–25) cm high. *Corm* 1–2 cm in diameter, with tough, black fibrous tunics often accumulating to form a thick layer. *Cataphyll* membranous and pale or becoming brown, sometimes broken or fibrous above, rarely accumulating. *Leaf* usually solitary (rarely 2), basal, erect to trailing, to 25 cm long, either terete and filiform to fistulose or linear and channelled, then 2–5,5 mm wide and sometimes undulate or twisted, rarely crisped. *Stem* usually branched, branches flexed below the spathes, sheathing stem bracts herbaceous, becoming dry and pale straw-coloured above, 1,5–4 cm long. *Spathes* green to entirely dry and straw-coloured, *inner* (2–)2,5–4 cm long, *outer* half to two-thirds as long as the inner. *Flowers* blue (rarely white – *Viviers 844*), with deep-yellow nectar guides near the base of the inner and outer tepals, claws short and erect, forming a tube around the base of the filament column, limbs spreading horizontally; *outer tepals* 12–21 mm long, claw 3–4 mm long, limb (4–)5–8 mm wide, widest in the upper third; *inner* 11–18 mm long, 5–6 mm wide. *Filaments* (3,5–)5–8 mm long, united below in a smooth cylindric column, free in the upper half to one-quarter, rarely free completely; *anthers* (2–)3–5 mm long, diverging, exceeding the style branches and becoming arched after anthesis with apices curving inward. Ovary globose, 3–6 mm long, usually exserted from the spathes, *style* dividing at or below the base of the anthers, *branches* diverging, appressed to the anthers, straight, 2–3 mm long, bilobed and apically stigmatic, usually reaching to about mid-anther level, crests lacking. *Capsules* globose-oblong, 6–7 mm long, 3–4 mm in diameter; *seeds* angular. Chromosome number 2n = 12, 24, 36, 48.

Flowering time: October to early December; flowers opening in the later afternoon, usually after 4 pm., and fading in the early evening.

DISTRIBUTION AND HABITAT

Moraea crispa is widespread in the Karoo and interior Cape mountains on stony clay or sandy flats and slopes. It extends from Calvinia and Nieuwoudtville in the north-west Cape to the western Orange Free State. It is especially common in the western and southern Karoo, particularly in the Roggeveld, but is apparently rare and local in the Cedarberg, Cold Bokkeveld, Witteberg, Swartberg and Baviaanskloof mountains.

DIAGNOSIS AND RELATIONSHIPS

In general appearance *Moraea crispa* resembles several smaller species of *Moraea*, having a single basal leaf (rarely two leaves) that is usually bifacial and channelled, and an aerial, branched stem bearing terminal inflorecenses of small bluish flowers. The flowers are unusual in having similar, spreading inner and outer tepals with short ascending claws that cup the lower part of the filament column. The style branches are short and narrow and not flattened, and they lack the paired erect crests regarded as typical of *Moraea*. The style branches are also shorter than the anthers.

This type of flower is characteristic of *Homeria* in general, but also occurs in several unrelated species of *Moraea* (Goldblatt, 1980b; 1986a) including *M. polyanthos* and *M. speciosa* of section *Polyanthes*. It seems likely that *M. crispa* is most closely allied to *M. polyanthos* on the basis of general morphological similarity. However, *M. crispa* differs from most species of the section in its very short tepal claws and single leaf, and it is by no means certain that *M. crispa* is most closely allied to *M.*

polyanthos and section *Polyanthes*. However, in the absence of other possibilities, this is accepted as a working hypothesis.

Until recently, *Moraea crispa* appeared to be the only species of *Moraea* with the floral characteristics outlined above, but extensive collecting in western southern Africa since 1980 has brought to light the unusual *M. pseudospicata* and *M. verecunda* from the Nieuwoudtville district of the north-west Cape, and three species from southern Namibia that have nearly identical flowers (Goldblatt, 1986a). *Moraea pseudospicata* and *M. verecunda* have slender stems with sessile lateral inflorescences and small flowers with exserted ovaries. Both have a limited range in the Nieuwoudtville area of the north-western Cape. The Namibian species are all from the extreme south-western corner of the country where they survive on winter precipitation. Of these, *M. rigidifolia* has a thick swollen leaf, sessile inflorescences and fusiform, included ovaries; *M. graniticola*, a nearly acaulescent species, has a perianth tube and long, rostrate, fusiform ovary; and *M. hexaglottis*, closely resembling *M. crispa* in general appearance, has short, deeply-divided style branches, the arms of which extend horizontally below the anthers for some distance. Only *M. pseudospicata* and *M. verecunda* seem to be allied to *M. crispa*. The Namib species have diploid chromosome numbers of $2n = 20$ in contrast to $2n = 12$ in *M. crispa*, *M. pseudospicata* and *M. verecunda*, and for this and other reasons, discussed under the appropriate species, are probably closely allied to species in section *Moraea*. The similarity in the flowers of all these species must be due to convergent evolution and they are presumably adapted to arid habitats and to similar pollinators.

VARIATION

Moraea crispa is relatively uniform over its wide range but some unusual populations stand out. While slender, channelled leaves are the norm, plants with rather broad and somewhat spreading to prostrate leaves occur in the western Karoo. In some of these western populations the leaves are slightly twisted and occasionally, as in the type, have undulate and lightly crisped margins. Plants from the Matjiesfontein district at the south-western edge of the Karoo also stand out in having terete leaves. Cultivated plants occasionally have a small second leaf but this has not been recorded in wild plants and is probably an abnormal development. An interesting white-flowered population is recorded in the Baviaanskloof mountains, and the time of flowering in this population is early evening at about 6 p.m., in contrast to late afternoon, 4–4.30 p.m., for the blue-purple flowered form. This form needs further investigation.

Moraea crispa is unusually variable cytologically. It is apparently diploid, $2n = 12$, over most of its range, or at least in the western Karoo (Goldblatt, 1986b; in press) where several populations have been counted, but a tetraploid population, $2n = 24$, is known from the Roggeveld near Sutherland. Populations in the western Cape mountains, at the edge of its range, are either hexaploid, $2n = 36$, as in the Cedarberg populations studied, or octoploid, $2n = 48$, as in one population from the Cold Bokkeveld. This degree of heteroploidy is rare in *Moraea*. The different levels of ploidy do not appear to be correlated with any morphological peculiarities except that the hexaploid and octoploid western Cape mountain plants have unusually long anthers, up to 5 mm long, whereas 3 mm is the norm.

HISTORY

Moraea crispa was discovered by Carl Peter Thunberg in the 1774 in the Roggeveld and assigned to *Moraea*, at that time a heterogeneous assemblage of species having in common slender style branches rather than the broad petal-like style branches characteristic of *Iris* in which were placed the majority of the species now regarded as belonging to *Moraea*. It remained essentially unknown for over 100 years but was recollected in the later nineteenth century and finally described as *Homeria rogersii* by H. M. L. Bolus in 1928, based on plants from the Karoo at Naauwpoort and near Richmond. The species remained in *Homeria* until 1980 when it became clear that the only three blue-flowered species of *Homeria*, *H. lilacina*, *H. speciosa* and *H. rogersii* (a later synonym for *M. crispa*) were closely related to species of *Moraea* section *Polyanthes* and not at all to the other species of *Homeria*. These three species have karyotypes closely matching those of *Moraea bipartita* and *M. polystachya* (Goldblatt, 1980), and hybrids were obtained between *M. bipartita* and *H. lilacina* and between *M. polystachya* and *H. speciosa*. Vegetative morphology was also consistent with the species of *Moraea* section *Polyanthes*. No hybrids were obtained between *M. crispa* and any species of *Homeria* or *Moraea* but it is difficult to cultivate and few crosses could be attempted. It has, however, a karyotype characteristic of *Moraea* section *Polyanthes* and it too was transferred to *Moraea* and for the first time associated with Thunberg's *M. crispa*.

The type specimens today lack flowers, and moreover have unusual leaves with undulate to crisped margins that were not present in collections of the species known in 1980. However, the evidence for associating *H. rogersii* with *M. crispa* seemed compelling and the two were united. This decision has since been justified when a population of plants closely matching Thunberg's type was discovered in the western Karoo south of Calvinia, near Bo-Downes, by Dee Snijman of the Compton Herbarium, Kirstenbosch. These plants have flowers that match in all respects *M. crispa* and they have the twisted leaves with undulate to somewhat crisped margins that are so distinctive in the Thunberg type collection, which was also found in the western Karoo.

44. MOREAEA PSEUDOSPICATA
Goldblatt

Goldblatt, *Ann. Mo. bot. Gdn* 73: in press. 1986. TYPE: South Africa, Cape, Glenlyon, east of Nieuwoudtville, dry Dwyka tillite flats, *Snijman 783* (NBG, holotype; K, MO, PRE, S, STE, WAG, isotypes).

pseudospicata = with a false spike, describing the flowering stem in which the lateral inflorescences are sessile in the upper part as compared to a true spike in which the individual flowers are sessile.

Plants slender, 15–40 cm high. *Corm* 3–5 cm in diameter, with tough, blackish fibrous tunics usually accumulating to form a thick layer and extending upwards in a neck, live corm about 1 cm in diameter. *Cataphylls* firm membranous to coriaceous, decaying to become fibrous and accumulating together with remains of previous season's leaves in a thick neck around the base. *Leaf* solitary, basal, slender, apparently terete but narrowly grooved on adaxial surface and margins tightly inrolled, straight or weakly twisted, dying back at the time of flowering. *Stem* with 1 main axis or bearing 1–2 long branches from below, with sessile inflorescences at the upper nodes, sheathing stem bracts dry, brown, to 2,5 cm long, distinctly darker on the veins. *Spathes* subequal, partly concealed by the subtending bracts, dry and straw-coloured at anthesis, also darker on the veins, *inner* 2–2,5 cm long, *outer* slightly shorter than the inner. *Flowers* pale blue-mauve with yellow nectar guides on inner and outer tepals, the claws forming a short tube around the base of the filament column, limbs spreading horizontally; *tepals* lanceolate, 11–17 mm long, claw about 2 mm, limb 3,5–4 mm wide, widest in the upper third, the inner tepals about 1 mm shorter than the outer. *Filaments* 4–6,5 mm long, united entirely or free in the upper two-thirds but contiguous, forming a slender, smooth cylindric column; *anthers* 2–4,5 mm long, erect and contiguous, pollen yellow. Ovary globose, about 2 mm long, included or exserted from the spathes, *style branches* diverging at about mid-anther level, narrow, ascending, 1–1,5 mm long, stigmatic apically, initially concealed by the anthers, reaching to the upper third or slightly exceeding the apex of the anthers, crests lacking. *Capsules* globose, 2–4 mm in diameter, membranous and semi-transparent, not loculicidal but fragmenting irregularly; *seeds* several, dark brown. *Chromosome number* $2n = 12$.

Flowering time: late November to March; flowers opening in the later afternoon after 4.30 pm. and fading in the early evening.

DISTRIBUTION AND HABITAT

Moraea pseudospicata is a local endemic of the Nieuwoudtville district of the north-west Cape. It has been recorded from the hills north of Nieuwoudtville, southwards to Lokenberg, and possibly into the dry interior valleys of the Cedarberg mountains. Good collections are needed to confirm the distribution south of Lokenburg. It grows on rocky clay flats and low hills, in karroid scrub, with the corms buried very deeply, sometimes up to 20 cm below the surface.

RELATIONSHIPS AND VARIATION

Moraea pseudospicata has strong resemblance to *M. crispa* in both flower structure and general aspect. The pale blue-mauve flowers are almost identical in their subequal tepals with short erect claws that form a short tube that includes the lower part of the filament column. The filaments and anthers are slightly shorter in *M. pseudospicata*, and the anthers are nearly erect and so conceal the narrow and short style branches. In *M. crispa* the anthers and style branches diverge strongly and although the style branches are shorter than the anthers they can easily be seen. The two species also have the same basic chromosome number, $x = 6$, and similar karyotype with acrocentric to submetacentric chromosomes that characterizes section *Polyanthes*, and it seems certain that the two are closely allied. *Moraea pseudospicata* differs mainly in its sessile lateral inflorescences and in the dry, chaffy stem bracts and spathes. Its capsules also differ from those of *M. crispa* in being slightly smaller, having almost membranous walls, and in apparently dehiscing irregularly rather than along the locule sutures as in nearly all other species of *Moraea*. *Moraea pseudospicata* is also distinctive in its flowering time, mid to late summer, in an area of summer drought, and at the time of flowering the leaf is usually dry and often broken. In the summer-dry western Karoo and adjacent Cedarberg where *M. pseudospicata* and *M. crispa* both occur, *M. crispa* blooms from October to November and rarely later into December.

The relatively few collections of *Moraea pseudospicata* indicate little variability except for the filaments which may be almost entirely united or free but contiguous in the upper half. This feature does not appear to be correlated with geographical distribution.

Moraea pseudospicata is also closely allied to *M. verecunda*, described in this monograph. The two are very alike in general appearance, both having sessile lateral inflorescences, small bluish flowers and reduced style branches. *Moraea verecunda* is known only from collections south and west of Nieuwoudtville in the sandstone part of the Bokkeveld Escarpment, and it can be distinguished from *M. pseudospicata* by its deep-violet flowers and unusual spindle-shaped capsules with a few large, light-brown seeds. These capsules are quite different from the perfectly spherical capsules of *M. pseudospicata* which contain numerous and quite small, dark-brown seeds. It seems likely that the two species have a common ancestor in the widespread and morphologically less specialized *M. crispa*.

44.

N. pseudospicata.

HISTORY

The first known collections of *Moraea pseudospicata* were made by the early nineteenth century German botanist and collector Karl Ludwig Zeyher. In 1829 Zeyher travelled to Namaqualand (Gunn & Codd, 1981) and the mouth of the Orange River 'Reise nach Kamiesberg, Boschmanland, bis zur Mündung des Garip'. Several duplicates, distributed as *Ecklon & Zeyher Irid. no. 32* have now been found in several herbaria. Of the known duplicates, only the one at the Stockholm Herbarium has detailed locality data 'Onderboksveld, Blüht December, 4 hohe'. From this it seems almost certain that the specimens were found near present-day Nieuwoudtville. This general area is still sometimes called the Lower Bokkeveld (Onderbokkeveld). Other early records of *M. pseudospicata* include plants from 'Cedarberg', collected by H. J. Thode, and from Lokenberg, south of Nieuwoudtville, collected by J. H. P. Acocks. These collections remained unidentified or were placed with either *Hexaglottis* or *M. crispa*. Then in 1980 Dierdre Snijman of the Compton Herbarium at Kirstenbosch showed me her collection of a species, possibly a *Moraea*, she had found near Nieuwoudtville. The specimens, for the first time with well-pressed flowers, struck me as unusual, both in morphology and in their flowering time. When I was later able to visit the Nieuwoudtville area at the end of summer, I found plants at two sites to the north of the town. Once this species had been identified as a new and distinctive *Moraea*, I was able to assign to it the earlier records cited above. More plants have since been found closer to Nieuwoudtville and it is clear that *Moraea pseudospicata* is not at all uncommon in the area, but it is inconspicuous and blooms at a time when few botanists visit this area of complete summer drought.

As might be expected, *Moraea pseudospicata* is not in cultivation and the small, pale-coloured flowers that last only a few hours do not recommend it to even the most enthusiastic of wild-flower growers.

45. MORAEA VERECUNDA Goldblatt, sp.nov.

TYPE: South Africa, Cape, Nieuwoudtville, rocky outcrop west of the town, *Goldblatt 7391* (MO, holotype; K, NBG, PRE, S, isotypes).

verecunda = shy or modest, alluding to the fact that the species has so rarely been seen although it grows in a well-botanized area of the north-west Cape.

Planta 15–20 cm alta, cormo 10–15 mm in diametro, folio solitario lineare canaliculato, caule ramoso infra, inflorescentibus sessilibus supra, bracteis 10–15 mm longis, spathis 1,5–2 cm longis herbaceis acutis interiore longiore quam exteriore, floribus atrocaeruleis, tepalis flavis notatis, exterioribus 10–13 mm longis unguibus ca. 1,8 mm longis adscendentibus, limbis patentibus, interioribus 9–12 mm longis etiam patentibus, filamentis 3–4 mm longis supra liberis, antheris ca. 2 mm longis apicibus stigma excedentibus, ramis styli adscendentibus 1–1,5 mm longis, sine cristis.

Plants small, 15–20 cm high, sometimes growing in clumps. *Corm* 12–15 mm in diameter, with black fibrous tunics accumulating to form a thick layer. *Cataphyll* membranous and pale, usually broken at flowering time. *Leaf* solitary, basal, erect to trailing and up to 25 cm long, linear and channelled, about 1 mm wide, the margins tightly inrolled and the leaf apparently terete, especially when dry. *Stem* sometimes with 1–2 long branches below but with 2–4 sessile lateral inflorescences above, stem bracts usually dry and pale straw-coloured at flowering time, 1,5–2 cm long. *Spathes* green below to entirely dry and straw-coloured, *inner* 1,5–2 cm long, *outer* two-thirds as long as the inner. *Flowers* violet-blue, with deep-yellow nectar guides near the base of the inner and outer tepals, claws ascending, forming a short open cup including the base of the filament column, limbs spreading horizontally; *outer tepals* 10–13 mm long, claw about 1,8 mm long, limb 4–5 mm wide, widest in the upper third; *inner* 9–12 mm long, 3 mm wide. *Filaments* 3–4 mm long, united below in a smooth cylindric column, free in the upper 1 mm; *anthers* almost 2 mm long before dehiscence, collapsing to 1,2–1,5 mm, nearly erect, exceeding the style branches. Ovary fusiform, 4,5–6 mm long, exserted from the spathes, *style branches* short, more or less erect, appressed to the anthers, 1–1,5 mm long, bilobed and apically stigmatic, reaching to about mid-anther level, crests lacking. *Capsules* fusiform, 10–12 mm long, about 2 mm in diameter, walls semi-transparent, often beaked for about 1 mm; *seeds* few, ovoid, 1,8–2 mm long, clearly visible through the capsule wall. Chromosome number $2n = 12$.

Flowering time: October to late November, flowers opening in the later afternoon, usually after 3.30 p.m., and fading in the early evening.

DISTRIBUTION AND HABITAT

Moraea verecunda is very rare and apparently restricted to the Nieuwoudtville district of the north-western Cape. It has been recorded only from west and south of the town, growing in rocky sandstone soil.

43.

45.

M. cuspa.

M. verecunda.

DIAGNOSIS AND RELATIONSHIPS

Moraea verecunda has a strong resemblance to *M. pseudospicata* and it seems likely that the two species are closely allied. It has similar small but deep blue-violet flowers, and the characteristic sessile lateral inflorescences of *M. pseudospicata*. However, the capsules are elongate and fusiform, about 12 mm long, and have a well-developed beak about 1 mm long. This is quite different to the short globose capsule of *M. pseudospicata*, which is 2–4 mm in diameter, but also membranous and semi-transparent. The flowers have filaments 3–4 mm long, and free above and the anthers are contiguous and very short, about 1,2 mm long. The ovary is about 4,5 mm long and the style branches are short as in *M. pseudospicata* and reach only to the mid part of the anthers. *Moraea verecunda* must be closely allied to *M. pseudospicata*, from which it can be distinguished mainly by different fruit characteristics including a long fusiform capsule (and ovary) and much larger seeds. In addition, the anthers are smaller and the flowers much darker in colour. The flowering time is September to November, another difference with *M. pseudospicata*, which has not been recorded in bloom earlier than late November, and usually later than this.

HISTORY

Moraea verecunda was apparently first collected by Ernest Galpin, who found it near Nieuwoudtville in late flower in November, 1930. The collection, with duplicates at the herbaria at Kew and Pretoria, remained amongst the *incertae* for many years. By the 1970s, when I began to study *Moraea* and the related genera, the Galpin specimens, which have poorly preserved flowers, came to my attention. I initially associated the collection with *M. crispa* to which it has a fair resemblance, but the very distinctive fusiform capsules remained to indicate a difference with this and other species of *Moraea*. Repeated searches in the vicinity of Nieuwoudtville, an area with a very rich and a diverse geophyte flora, failed to yield any plants matching the Galpin collection. Then in 1985, Jim Holmes, Horticulturist at the Rustenberg Estate near Stellenbosch, sent me a few pressed specimens that I immediately matched with the Galpin plants. The Holmes specimens had flowers and fruits and made it possible to confirm that this and the Galpin collection constituted a distinct species. I have now collected *M. verecunda* at two sites near Nieuwoudtville, and it seems likely that it occurs elsewhere in the district.

46. MORAEA POLYSTACHYA
(Thunberg) Ker

Ker, *Ann. Bot.* (Konig & Sims) 1: 240. 1805; Baker, *Flora Capensis* 6: 18. 1896; Sölch, *Prodromus Flora Südwestafrika* 155: 11. 1969; Goldblatt, *Ann. Mo. bot. Gdn* 60: 218–219. 1973; Vahrmeier, *Poisonous Plants Southern Africa* 58–59. 1981.

SYNONYMS

Iris polystachya Thunberg, *Dissertatio de Iride* no. 40. 1782. TYPE: South Africa, Cape, eastern Cape in the area of the Sundays and Fish Rivers, *Thunberg s.n.* (Herb. Thunberg *1154*, UPS, holotype).
?*Moraea toxicaria* Dinter, *Feddes Repert.* 19: 237. 1923, possibly, but see under *M. venenata*.

polystachya = many-branched, referring to the branched habit which contrasts very much with most of the species that Thunberg knew from the Cape.

Plants medium to large, to 80 cm high. *Corm* to 5 cm in diameter, covered with hard, dark, coarse, blackish fibres. *Cataphylls* usually 3, membranous, pale but often flushed reddish above the ground. *Leaves* 3–5, linear, channelled to almost flat, usually as long to longer than the stem, but often bent or trailing, 6–12(–20) mm wide. *Stem* erect, few to several branched, sheathing bract leaves 6–8 cm long, attenuate, herbaceous or becoming dry from above with age. *Spathes* 5–7 cm long, green or becoming dry and pale straw, the outer about two-thirds as long as the inner, sheathing part (10–)15–25 mm long. *Flowers* violet to pale blue with yellow to orange nectar guides on the outer tepals; *outer tepals* 3,6–5,5 cm long and 1,3–2,5 cm wide, claw ascending, 15–21 mm long, limb extending horizontally to reflexed; *inner tepals* 3–4,5 cm long, about 1,5 cm wide, the limb reflexed like the outer, or sometimes erect (Little Karoo). *Filaments* united for at least the lower two-thirds, sometimes to the apex, about 1 cm long; *anthers* 8–10 mm long, pollen yellow. *Ovary* nearly cylindric to narrowly obovoid, 6–10 mm long, usually with conspicuous reddish veins, exserted or sometimes included in the spathes, *style branches* diverging, about 1 cm long, crests up to 2 cm long. *Capsule* ovoid, (9–)11–16 mm long, erect, completely exserted; *seeds* angled, 1,2–1,5 mm at the longest axis. *Chromosome number* $2n = 12$.

Flowering time: mainly in the autumn and early winter (December to) March to July, occasionally in August in the south of its range.

DISTRIBUTION AND HABITAT

Moraea polystachya is widespread in dry areas of southern Africa, occurring almost throughout the

46.

Karoo and locally in the Little Karoo, extending to the eastern and northern Cape, western Orange Free State, southern Botswana, western Transvaal, and in Namibia as far north as Windhoek with outlying records from the Waterberg and Tsumkwe districts. It grows in a variety of habitats, but usually in open areas, either on stony or shale flats or on rocky slopes. In years of good rainfall it may extend over thousands of hectares, colouring the veld with a blue haze and making a glorious display.

Moraea polystachya has long been known to be poisonous to cattle and sheep (Vahrmeier, 1981) and in some parts of southern Africa it is the cause of considerable financial loss through death and debilitation of stock.

DIAGNOSIS AND RELATIONSHIPS

Moraea polystachya is the common Karoo 'bloutulp' that can be recognized by its large violet-blue flower with spreading tepals, three to five leaves and branched stems. Its flower is unspecialized and conforms to the type found in many species of subgenus *Moraea* except that it is larger than in most others. The several branches are also characteristic of many species in the subgenus, but the 3–5 leaves are somewhat unusual. *Moraea polystachya* has a wide distribution and is correspondingly variable, but over most of its range it is a tall plant. The ovary is unusual in often having fine red veins, and this feature is often helpful in identifying the plant.

Moraea polystachya is a central species in section *Polyanthes*. It is closely allied to the Little Karoo and southern Cape *M. bipartita* L. Bolus, which flowers in the spring, usually during September and October. The distribution of the two species does overlap to a limited extent, but the flowering time, while not completely distinct, serves to isolate them. *Moraea bipartita* is a generally smaller plant with usually only three narrow leaves and smaller flowers than those of *M. polystachya*. The tepals of *M. bipartita* are 20–30 mm long, and the anthers about 5 mm long compared to *M. polystachya* which has tepals 40–50 mm long and anthers not less than 10 mm long.

A second species, *Moraea carsonii* Baker, which extends from northern Namibia and Botswana across central Africa, also bears a strong resemblance to *M. polystachya*. *Moraea carsonii* has only two leaves and smaller flowers than are found in *M. polystachya*. The outer tepals of *M. carsonii* are 18–30 mm long and the anthers 4,5–5,5 mm long. The differences between *M. carsonii* and *M. polystachya* are discussed more extensively under the treatment for *M. carsonii*.

Moraea venenata is also closely allied to *M. polystachya* and the two have sometimes been regarded as conspecific (Goldblatt, 1973). *Moraea venenata* is a shorter plant with generally larger flowers, a longer ovary usually included in the spathes, and an elongate more or less cylindrical capsule, nodding at maturity. The largest flowers of *M. polystachya* have outer tepals about 5 cm long and an exserted ovary 6–10 mm long. In *M. venenata* the outer tepals may be 5–6 cm long and the ovary usually 15–20 mm long. Also characteristic of *M. venenata* are the relatively broad and short leaves, the margins of which are frequently undulate, and the clustering of the leaves at the base of the plant. The capsules of *Moraea venenata* are 16–20 mm long and they remain included in the spathes until nearly ripe. The seeds are relatively large, 2–2,5 mm at the widest diameter. In contrast, the erect capsules of *M. polystachya* are some 11–16 mm long and well exserted from the spathes, and the seeds are smaller than in *M. venenata*, 1,2–1,5 mm at the longest axis. The capsules and general habit of *M. venenata* are so different from *M. polystachya* that fruiting specimens have been associated with *M. speciosa* rather than with *M. polystachya*.

VARIATION

The most significant variant of *Moraea polystachya* is the form from the Little Karoo, along the southern edge of its range, the only area where it grows under a predominantly winter rainfall climate. Here plants have pale blue to lilac flowers rather than the deep blue violet found elsewhere. The inner tepals of many populations from the Little Karoo are also unusual in being erect rather than reflexed. These plants are also distinct in lacking the fine red venation on the ovary that is characteristic of so many other populations of *M. polystachya*. There is thus some argument for the taxonomic recognition of the Little Karoo form of *M. polystachya*. However, there are populations of plants intermediate between the typical form with blue-violet flowers, reflexed tepals and red-veined ovary and the extreme Little Karoo form. In the Laingsburg district in the southern Karoo plants have pale-blue flowers, but the inner tepals are reflexed. These populations neatly bridge the gap between the two different types. For the present I prefer to treat the two forms as a single species.

HISTORY

Moraea polystachya was first brought to the attention of science by the botanist-explorer Carl Peter Thunberg who collected it in the eastern Cape in the area of the Sundays and Fish Rivers in 1773. He described it in 1782 on his return to Sweden, assigning it, as with other species now regarded as belonging to *Moraea*, to *Iris*. The subsequent history of the species is uncomplicated. It was transferred to *Moraea* by Ker in 1805 when he formally recognized Linnaeus' genus *Moraea* for the Cape species until then usually regarded as belonging to *Iris*. The range of *M. polystachya* was extended gradually from the eastern Cape and the Karoo margins into the Great Karoo as far as the Orange Free State during the nineteenth century. At the end of the nineteenth century and in the early twentieth century *M. polystachya* was found in interior southern Namibia by Rudolf Marloth and Moritz Dinter. Later, its range was extended further into Namibia, largely though the collecting activities of J. W. Giess over a period of fifty years. In the 1930's *M. polystachya* was also recorded in Botswana and in the western Transvaal.

For a few years *Moraea venenata* Dinter and *M. toxicaria* Dinter were regarded as conspecific with *M. polystachya* (Goldblatt, 1973; 1976b).

However, my recent studies suggest that *M. venenata* is a distinct species, although closely related to *M. polystachya*. No type or authentic specimens of *M. toxicaria* have been found during my studies, and the identity of the species cannot be determined with any certainty. It remains a name known from the literature only.

CULTIVATION

Moraea polystachya is an easy and rewarding plant to grow. The individual flowers each last only for a day, but in cultivation, plants are usually robust and have many branches, each of which has a terminal inflorescence of several flowers. The flowering period may last for six to eight weeks if the plants receive light watering when they are dry. *Moraea polystachya* is fairly hardy, and tolerates the winters on the Witwatersrand without damage. Corms or seeds are difficult to obtain, but once established, *M. polystachya* is easy to maintain and it will seed itself slowly, spreading into uncared for parts of the garden. In areas of winter rainfall, *M. polystachya* appears to require little attention, and is best left alone in a corner of a rock garden where the corms will not be accidentally dug up when it is dormant in the late spring and summer.

47. MORAEA VENENATA Dinter

Dinter, *Feddes Repert.* **19**: 238. 1924. TYPE: Namibia, Bullsport flats, *Dinter 2141* (SAM, lectotype here designated).

SYNONYMS

Moraea polystachya var. *brevicaulis* Stent ex Phillips, *Mem. bot. Surv. S. Afr.* **9**: 16. 1926. TYPE: without locality, Stent & Curton, *Bull. Dept. Agric. S. Africa* 1922 (6): fig. 2. 1922 (lectotype here designated – apparently no type specimens were preserved).

Moraea toxicaria Dinter, *Feddes Repert.* **19**: 237. 1923. TYPE: Namibia, Etemba, Walthers farm, Okongue, *Dinter 3414* (location of type unknown, no authentic specimens seen).

venenata = poisonous, alluding to the very toxic nature of the plants, especially to stock, but probably also to humans.

Plants 15–25 cm high. *Corm* 2–3,5 cm in diameter, covered with accumulated layers of dark, medium to coarse fibres. *Cataphyll* membranous, dry and sometimes fibrous above. *Leaves* 3–6, at least the lower 2 basal, lanceolate or occasionally linear, channelled to flat, margins undulate below and often thickened and hyaline, falcate, (8–)10–30 mm wide, about as long to twice as long as the stem. *Stem* erect, few to many-branched, sheathing bract leaves 3–4 cm long, attenuate, sheathing part 6–8(–12) mm long, sometimes herbaceous or becoming dry and pale straw-coloured from above. *Spathes* 3,5–6 cm long, green or becoming dry and pale straw, the outer about half as long as the inner and often with an unusually short sheath 5–7(–10) mm long. *Flowers* large, blue-violet with yellow to orange nectar guides on the outer tepals; *outer tepals* (3,6–)4,5–6,5 cm long, claw about 22 mm long, limb reflexed, about 18 mm wide; *inner tepals* apparently erect, 35–50 mm long, 9–11 mm wide. *Filaments* 10–15 mm long, free in the upper third; *anthers* 8–9 mm long, yellow. Ovary nearly cylindric, (9–)11–18 mm long, rarely with coloured veins, included in the spathes, *style branches* diverging, about 12 mm long, crests up to 15 mm long. *Capsule* cylindric, 16–20 mm long, nodding when mature, exposed as the spathes dry out; *seeds* large, angled, at least 2 mm at the longest axis. *Chromosome number* not known.

Flowering time: autumn and winter, April to July (occasionally into August); flowering phenology not known.

DISTRIBUTION AND HABITAT

Moraea venenata occurs in the northern parts of the Karoo in the Kenhardt and Prieska districts, the northern Cape and in the southern half of Namibia as far north as the Rehoboth district. As far as I can judge from the available specimens, *M. venenata* grows in flat areas of alkaline to saline soil. Information given with some of the collections indicates a parent rock of black or blue limestone or chalk. Where *M. venenata* grows in the same areas as the related *M. polystachya*, for example at Bullspoort in the Rehoboth District in central Namibia, *M. venenata* grows on flats while *M. polystachya* is reported from rocky slopes.

DIAGNOSIS AND RELATIONSHIPS

Moraea venenata is a close relative of the widespread and common Karoo species *M. polystachya*. It has until now often been included in this species or it has sometimes been referred to '*M. gigantea* Klatt*'*, the type of which is *Homeria miniata* (Andrews) Sweet. *Moraea venenata* has the 3–several leaves, large blue-violet flowers and the branched habit characteristic of *M. polystachya*. However, it consistently differs in its lower stature and generally larger flower, except in poorly-grown

specimens. It has a longer ovary than *M. polystachya*, 15–20 mm long, which is usually included in the spathes, and the capsules are elongate and more or less cylindrical. The largest flowers of *M. polystachya* have outer tepals about 5 cm long and an ovary 6–10 mm long which is exserted from the spathes. In *M. venenata* the outer tepals are often 5–6 cm long. In addition, the inner tepals are apparently erect (I have not seen living plants) whereas the inner tepals of most forms of *M. polystachya*, including populations from the Karoo, northern Cape and Namibia, have spreading to reflexed inner tepals. Also characteristic of *M. venenata* are the short, basally clustered leaves, which are in many populations relatively broad and the margins are frequently undulate.

The capsules of *Moraea venenata* are also different from those of *M. polystachya*. They are nearly cylindric and 16–20 mm long, and remain included in the spathes during ripening and when mature are pendent. The seeds are relatively large, 2–2,5 mm at the widest diameter. In contrast *M. polystachya* has erect, exserted capsules some 10–16 mm long and smaller seeds 1,2–1,5 mm at the widest. The capsules and general habit are so different from *M. polystachya* that fruiting specimens have sometimes been associated with *M. speciosa* rather than with *M. polystachya*. It is possible that *M. venenata* may be more closely related to *M. speciosa* but at present there is no evidence other than gross morphology available with which to assess the detailed relationships of these species, and such questions cannot be settled with any certainty. *Moraea speciosa* has pale-bluish flowers with nectar guides on both inner and outer tepals, and a cylindrical style with terminal stigmatic lobes that lack crests in contrast to the broad petaloid style branches and long conspicuous crests that are found in *M. venenata* and *M. polystachya*.

Like the very poisonous *Moraea polystachya*, *M. venenata* is known to be toxic to stock, hence the specific name given to it by Dinter. While there are no critical studies of its toxicity, it must be considered extremely dangerous to cattle and sheep.

Moraea venenata still requires further study especially from live populations. Even some basic details of the morphology of the flowers are still incompletely known.

HISTORY

Moraea venenata has been known for many years but mostly from poorly-preserved specimens, and only recently have the substantial numbers of collections accumulated that are needed to determine the nature and limits of a species. The earliest collection of *M. venenata* appears to be the type gathering, made in 1911 by the German botanist Moritz Dinter, who collected and extensively explored the poorly-known flora of what was then German South West Africa, at the beginning of the century. As mentioned in the previous paragraphs, specimens of *M. venenata* have in the past usually been assigned to *M. polystachya*, *M. speciosa* or *M. gigantea*. The latter determination, in particular, suggests that the species was believed to be distinct from *M. polystachya*.

Moraea toxicaria Dinter is provisionally included here as a synonym of *M. venenata*. The two species were described at the same time by Dinter who considered them closely related. A diagnosis only, is provided for *M. toxicaria*, whereas there is a complete description given for *M. venenata*. No type or even authentic specimens have so far been found for *M. toxicaria*.

48. MORAEA SPECIOSA (L. Bolus) Goldblatt

Goldblatt, *Bot. Notiser* 133: 92. 1980.

SYNONYMS
 Homeria speciosa L. Bolus, *Ann. Bolus Herb.* 3: 10. 1920. TYPE: South Africa, Cape, near Prince Albert, *Krige s.n.* (BOL 13486 lectotype here designated; BOL, PRE, isolectotypes).

speciosa = beautiful, referring to the large and attractive pale-bluish flowers, usually produced in large numbers.

Plants 40–75 cm high. *Corm* large, 3–4 cm in diameter, with coarse, dark-brown fibrous tunics. *Cataphylls* pale and membranous. *Leaves* several, the lower basal, upper cauline, usually

48.

M. speciosa.

about half as long as the stem, channelled, to 4 cm wide, margins undulate, sometimes twisted towards the apex. *Stem* several-branched from the upper nodes. *Spathes* herbaceous or becoming pale and membranous to dry above, *inner* 5–7 cm long, *outer* about two-thirds as long as the inner. *Flowers* pale blue-mauve, erect or becoming pendent, nectar guides yellow, on inner and outer tepals, tepal claws forming a wide cup enclosing the filament column, limbs extending horizontally or somewhat reflexed; *outer tepals* 35–45 mm long, claw 12–15 mm long, limb to 17 mm wide; *inner tepals* about as long as the outer but slightly narrower. *Filaments* (7–)10–13 mm long, united in a slender cylindrical column, sparsely puberulous in lower half; *anthers* (8–)12–17 mm long, erect, contiguous, appressed to the style; pollen yellow. Ovary 8–12 mm long, often at least partly included in the spathes at flowering time, *style branches* dividing near or well above the apex of the anthers, 2–3(–6) mm long, not diverging, stigmas extended above the anthers, crests lacking. *Capsule* oblong, nodding to pendent, 12–22 mm long, 7–8 mm in diameter, smooth or sometimes sparsely papillate; *seeds* many, angled. *Chromosome number* 2n = 12.

Flowering time: June to September.

DISTRIBUTION AND HABITAT

Moraea speciosa occurs in dry areas on the western and southern margins of the Karoo, from Prince Albert to Calvinia. It is most common in the very arid Tanqua and Doorn River basin that lies in the rain shadow of the Cedarberg mountains, where it grows on exposed flats in a substrate composed of fragmented blackish shale.

DIAGNOSIS AND RELATIONSHIPS

The large, pale blue-mauve flower of *Moraea speciosa* has deeply-cupped tepals, with laxly spreading limbs, and is unlike all species of *Moraea* except the closely related *M. deserticola* (Goldblatt, 1986a). The stamens and style are also unusual. The filaments are united into a slender column and the long anthers are contiguous for their entire length so that the style can only be seen above the anther apex where it divides into three lobes, each with a broad transverse stigma and small obscure erect crest-like appendages. The flower has several similarities with that of *Homeria* and this is the reason that the species was at first assigned to this genus. Only after studies involving chromosome cytology and artificial hybridisation (Goldblatt, 1980b) did it become clear that *Homeria speciosa* and the few other blue- to purple-flowered species placed in *Homeria* were quite unrelated to the other species of the genus, but were probably related to species of *Moraea* section *Polyanthes*. *Moraea speciosa* was artificially crossed with *Moraea polystachya* by the Bellville native bulb grower Johan Loubser, who thus established beyond reasonable doubt its correct relationships.

The only species of *Moraea* with flowers similar to those of *M. speciosa* is the closely related *M. deserticola* from the Knersvlakte in southern Namaqualand. It has somewhat smaller flowers and a few narrow linear leaves that are quite unlike the several broad, falcate leaves with undulate margins that are characteristic of *M. speciosa*. In section *Polyanthes*, *Moraea speciosa* is almost certainly related to and derived from *M. polystachya* and *M. venenata* or their immediate allies. Despite the great morphological differences in the flowers of these species, the vegetative similarities and the fact that *M. speciosa* and *M. polystachya* can be hybridized, leaves no room to doubt their close phylogenetic relationship.

HISTORY

There are no early historical records of *Moraea speciosa* and the specimens collected by Miss A. M. Krige in 1911, near Prince Albert in the Karoo north of the Great Swartberg Mountains appear to constitute the first gathering of the species. Specimens sent to the University of Cape Town were described some ten years later by Louisa Bolus, who placed it in *Homeria*. *Moraea speciosa* has not been collected again in the Prince Albert district, but is now known to be common in the arid valley between the Cedarberg Mountains and the Roggeveld Escarpment in the western Karoo, an area sometimes referred to as the Tanqua Karoo. Despite the harsh climate there, and the very low and irregular rainfall, *Moraea speciosa* blooms nearly every year and can be found predictably along the road from Calvinia to Ceres in June, July and August.

CULTIVATION

Moraea speciosa is very rarely grown in gardens but it is well worth the effort to obtain plants and to try and flower them. Well-grown specimens such as are exhibited on the Clanwilliam Wild Flower Show in August each year are really striking and would be a wonderful addition to any spring garden display. This is a desert species and is probably less easy to grow than Moraeas from areas of wetter climate. However, it is possible to grow outdoors even in the wet winter climate of Cape Town, and the type material was grown for a few years at Kirstenbosch in the 1920s. It can also be grown in pots and I have maintained plants for ten years, in most of which they have flowered well, although the plants were much smaller than the robust specimens that grow in the wild.

49. MORAEA DESERTICOLA
Goldblatt

Goldblatt, *Ann. Mo. bot. Gdn* **73**: in press. 1986. TYPE: South Africa, Cape, Vanrhynsdorp district, Knersvlakte, farm Quaggas Kop, Zout River, *Hall 5089* (NBG, holotype; MO, isotype).

deserticola = desert-loving, referring to the extremely arid part of southern Namaqualand, the Knersvlakte, where the species is found.

Plants 33–45 cm high. *Corm* about 1 cm in diameter, with tunics of dark brown to blackish fibres. *Cataphylls* pale and membranous. *Leaves* 2–3, linear and channelled, 2–3 mm wide, about as long as the stems, margins becoming tightly inrolled when dry, the lower basal, upper cauline. *Stem* simple or 1–3 branched from the upper nodes, the branches subtended by sheathing bract leaves 2,5–4 cm long. *Spathes* herbaceous, often membranous and becoming dry above, *inner* 3,3–4 cm long, *outer* about two-thirds as long as the inner. *Flowers* pale blue or white with pale blue on the reverse of the tepals, and fading pale blue, with yellow nectar guides on the inner and outer tepals, tepal claws ascending and forming a wide cup including the filament column, limbs extended horizontally; *outer tepals* 30–36 mm long, claw about 12 mm long, limb 18–20 mm long and 10–11 mm wide; *inner tepals* slightly smaller than the outer. *Filaments* 8–10 mm long, united into a smooth, slender, cylindrical column; *anthers* 5–6,5 mm long, erect, contiguous, appressed to and initially concealing the style. *Ovary* 6–7 mm long, narrowly obconic, exserted from the spathes, with conspicuous reddish veins; *style branches* dividing just above the apex of the anthers, about 1 mm long, the stigma lobe broad, crests lacking. *Capsule* more or less obovoid, 9–10 mm long, red-veined; *seeds* many, angled. *Chromosome number* unknown.

Flowering time: June to August.

DISTRIBUTION AND HABITAT

Moraea deserticola is restricted to the Knersvlakte in southern Namaqualand between Vanrhynsdorp and Nuwerus. It grows on stony slopes and flats among the sparse succulent leaved shrubs that comprise the main vegetation of the Knersvlakte. The area is extremely arid and the exclusively winter rainfall low and irregular, so that plants grow and flower rapidly after soaking rains, often blooming as early as June, and always before the ground dries out in the spring.

DIAGNOSIS AND RELATIONSHIPS

The large and deeply-cupped flower of *Moraea deserticola* with its nearly equal tepals and long-conspicuous anthers is strongly reminiscent of *M. speciosa*, a species that grows in the drier parts of the western Karoo. It seems certain that the two are closely allied, although they differ markedly in vegetative morphology. The long style surrounded by the contiguous anthers, and short, broadly-lobed style branches held above the anthers when the stigmas are receptive are exactly the same in both species. Except for a slightly smaller size, the flowers and all floral parts of *Moraea deserticola* are apparently identical to those of *M. speciosa*. The leaves of *M. deserticola* are narrow and few, and only the lowermost is basal, while the other two or three are spaced well apart along the stem. Moreover, the leaves are straight and narrowly channelled and the stem has only a few branches towards the apex. In contrast, *M. speciosa* has a thick, fleshy well-branched stem and several relatively short and broad basal leaves that are often undulate or twisted. *Moraea deserticola* can also be distinguished by its conspicuously red- to purple-veined ovary, a feature not evident in *M. speciosa*, as well as the smaller flower and very narrow leaves.

HISTORY

The species was first discovered in 1967 by P. A. B. van Breda, a few kilometres north of Vanrhynsdorp in the Knersvlakte. Due to the limited material available and inadequate preservation, the specimen could not at first be identified although it did not seem to be any known species. Then in 1981 more plants of this species were found by Harry Hall, and two years later by Jan Vlok. *Moraea deserticola* is probably rare in the wild but as it has been found at three separate sites in the Knersvlakte it probably occurs widely in the area. Most likely the plants are scattered and inconspicuous and added to this, they probably do not flower regularly, but only when good rains have fallen in this dry semi-desert.

50. MORAEA CARSONII Baker

Baker, *Kew Bull.* 391. 1894; *Flora Tropical Africa* **7**: 341. 1898; Goldblatt, *Ann. Mo. bot. Gdn* **64**: 252–254. 1977. TYPE: Zambia, 'Fwambo' (Mbala district), *Carson s.n.* (K, holotype).

SYNONYMS

Moraea homblei De Wild., *Contr. Fl. Katanga Suppl.* **4**: 7. 1932. TYPE: Zaire, Shaba (Katanga), near Kolwezi, *Homble 1024* (BR, holotype).

carsonii = named after Alexander Carson, Scottish missionary and plant collector in central Africa in the late nineteenth century.

Plants medium in size, 20–40 cm high. *Corm* 10–15 mm in diameter, tunics of fine to medium, dark-brown fibres. *Cataphylls* membranous and pale, the upper often broken or fibrous above. *Leaves* 2 (occ. 3), linear, channelled, 2–5 mm wide, longer than the stem, but often bent and trailing, the lower basal or inserted shortly, or sometimes well above the ground, the upper in the mid part of the stem. *Stem* nearly erect, usually with a few, sometimes with several branches, these ascending, flexed below the erect spathes, sheathing bract leaves 2,5–6 cm long, herbaceous with a dry, brown, acute apex. *Spathes* herbaceous and sometimes flushed reddish, apex and margins becoming dry membranous, *inner* 3–4(–5) cm long, *outer* shorter than inner by 1 cm, frequently brown almost to the base. *Flowers* blue-violet with yellow nectar guides on the outer tepals; *outer tepals* 18–24 (–30) mm long, limb lanceolate, slightly reflexed, claw ascending, slightly shorter than the limb; *inner* 17–28 mm long, much smaller than the outer, nearly linear, the limb also reflexed. *Filaments* about 7,5 mm long, united in the lower two-thirds; *anthers* 4,5–5,5 mm long, pollen yellow. *Ovary* exserted from the spathes, 3,5–7 mm long, *style branches* 8–10 mm long, crests 7–10 mm long. *Capsule* globose, 7–9 mm long; *seeds* small, angled. *Chromosome number* $2n = 12$ (recorded only from tropical Africa).

Flowering time: February to April (also December and January in tropical Africa).

DISTRIBUTION AND HABITAT

Moraea carsonii has a wide distribution in south tropical Africa, extending from east-central and northern Namibia and central Botswana to southern Zaïre, Zambia, Malawi and the Inyanga Highlands of Zimbabwe, where a very robust form occurs. It grows in open grassland and rocky slopes.

DIAGNOSIS AND RELATIONSHIPS

Moraea carsonii differs from the several other species of section *Polyanthes* with small blue to purple flowers with spreading inner and outer tepals largely in its vegetative morphology. It is the only species that consistently has two long foliage leaves, and the lower of these is usually inserted on the stem near ground level. Occasionally, the lower leaf may be inserted higher on the stem when the undergrowth is particularly thick. As in other species with similar flowers, the filaments are united only in the lower half. In floral details it is hardly possible to distinguish *M. carsonii* from its close allies *M. elliotii*, *M. natalensis* in particular, but also from the related tropical African species *M. afro-orientale* and *M. iringensis*.

Moraea carsonii appears to stand in an intermediate position between *M. polystachya* and *M. elliotii* and *M. natalensis*. *Moraea polystachya* has 3–5 leaves arranged in the basic two-ranked condition for the genus, and the stem has several to many branches. *Moraea elliotii* and *M. natalensis* both have only a single leaf, which in the latter is inserted in the upper part of the stem, and close to the apically clustered branches. *Moraea polystachya* has the largest flowers of the group, the outer tepals usually 5–5,5 cm long, the spathes up to 6 cm long, and both the anthers and the filaments about 1 cm long. In *M. carsonii* the spathes are usually 3–4 cm (to 5 cm in robust plants from Zimbabwe), the outer tepals usually 1,8–2,4 cm long, and the anthers about 5 mm and the filaments about 7 mm long. Flower dimensions in *M. elliotii* and *M. natalensis* are similar or somewhat smaller.

HISTORY

The first records of *Moraea carsonii*, from eastern Zambia and Malawi were made in the later nineteenth century. Botanical exploration has gradually increased the known range considerably (Goldblatt, 1977). The species has, however, only recently been recognized from the southern African region. Actually, the first collection from Namibia was made in 1932 and then another in 1964, but these plants were uncritically assigned to the related and often very similar *M. polystachya*. When more recent collections from Kobe Pan in Botswana and near Steinhausen in Namibia came to my notice, it became clear that *M. carsonii* does indeed occur over a relatively wide area of interior southern Africa and that the early collections, placed in *M. polystachya* were misidentified.

Moraea carsonii is still one of the least known of the southern African species of *Moraea*, and it seems likely that more records will be made as Botswana and northern Namibia become better known botanically. Virtually nothing is known of the habitat of the species in southern Africa, but it must be assumed that it grows in seasonally wet grassland or on stony moist hill slopes as it does in tropical Africa.

51. MORAEA ELLIOTII Baker

Baker, *Handbook Irideae* 58. 1892; *Flora Capensis* 6: 23. 1896; Goldblatt, *Ann. Mo. bot. Gdn* 60: 218–220. 1973; *Ann. Mo. bot. Gdn* 64: 259–260. 1977. TYPE: South Africa, Transvaal, marshes near Lake Chrissie, *Scott-Elliot 1592* (K, holotype).

*Frontispiece

SYNONYMS

Moraea macra Schlechter, *J. Bot.* 36: 377. 1898. TYPE: South Africa, Cape, Queenstown, *Galpin 2193* (B, holotype; BOL, PRE, isotypes).

Moraea stewartae N. E. Brown, *Trans. R. Soc. S. Afr.* 37: 346. 1929. TYPE: Swaziland, Hlatikulu, *Stewart 44* (K, holotype; PRE, isotype).

Moraea violacea Baker, *Bull. Herb. Boiss.*, ser. 2. 1: 863. 1901. TYPE: South Africa, Natal, Byrne, *Wood 5220* (Z, holotype; BM, isotype).

Moraea juncifolia N. E. Brown, *Trans. R. Soc. S. Afr.* 17: 346. 1929. TYPE: South Africa, Transvaal, Saddleback, Barberton, *Galpin 859* (K, holotype; SAM, isotype).

elliotii = named after George F. Scott Elliot, Scottish botanist who collected in Africa in the later nineteenth century, and published the earliest observations on plant pollination in the southern African flora.

Plants medium in size, reaching 12–55 cm high. *Corm* 1–2 cm in diameter, tunics of dark brown, medium to coarse fibres often forming a neck extending upwards a short distance. *Cataphylls* membranous, becoming dry and brown, and eventually fragmenting irregularly. *Leaf* solitary, linear and channelled to apparently terete with the margins tightly inrolled, but adaxial groove usually present, inserted near, to well above, ground level, exceeding the inflorescence. *Stem* usually erect and unbranched or with 1–3(–8) erect branches, the sheathing bract leaves at the nodes and subtending the branches 2,5–4,5(–6) cm long, herbaceous with a dry, brown, attenuate apex. *Spathes* herbaceous, apex and margins brown and membranous to dry, inner 4–5(–6) cm long, outer shorter than the inner by about 1 cm, often brown almost to the base. *Flowers* blue-violet with yellow to orange nectar guides on the outer tepals; *outer tepals* 19–30 mm long, limb to 18 mm long, 9–12 mm wide, spreading; *inner* 15–24 mm long and 2–4 mm wide, linear-lanceolate, limb also spreading when fully open. *Filaments* 3,5–4 mm long, united in the lower 1,5–2 mm; *anthers* 5–6 mm long, pollen yellow. Ovary 6–8 mm long, partly to fully exserted from the spathes, *style branches* about 8–10 mm long, crests 5–9 mm long. *Capsule* more or less obovoid, 9–12 mm long and to 4 mm wide; *seeds* small, angled. *Chromosome number* $2n = 12, 24$.

Flowering time: September to March, usually late spring in the south and summer to autumn in the north.

DISTRIBUTION AND HABITAT

Moraea elliotii is widespread from the edge of the winter rainfall area in the southern and eastern Cape, throughout Natal and Swaziland to the eastern Transvaal. It has also been recorded from southern Malawi where it is collected in the mountains near Dedza. It often occurs in moist grassland especially in montane habitats where it grows in thin rocky soils. It has also been found in seeps and seasonal marshes.

DIAGNOSIS AND RELATIONSHIPS

Moraea elliotii has a small blue-violet flower typical of subgenus *Moraea* in which the outer and inner tepal limbs are reflexed and the style branches are broad and flat and the crests prominent. It can be recognized by this unspecialized flower and a solitary foliage leaf inserted close to or well above the ground. It appears intermediate between

M. carsonii, which always has two leaves, and the more specialized *M. stricta*. This latter species is early flowering and easily distinguished by the absence of a green leaf when it is in flower. The forms of *M. elliotii* with the leaf inserted high on the stem can also be confused with *M. natalensis*, but this is a more slender plant with very small flowers, and the leaf is inserted at the base of the inflorescence and always much shorter than in *M. elliotii*. Moraea elliotii has been confused in herbaria with *M. setacea*, which is actually a synonym for a species of *Gynandriris*, *G. setifolia*. The cause of the confusion over the identity of *M. setifolia* and its variant *M. setacea* and its application to *M. elliotii* is not clear but is probably due to superficial similarity of the two species in general habit and flower colour, but there is no doubt that the two species are quite different and unrelated.

Plants from the southern part of its range are somewhat smaller, have more branches and a basal leaf insertion, while in the north plants tend to be larger, less branched, and have a variable position of leaf insertion. However, the pattern is not consistent and an infraspecific taxonomy does not seem desirable.

HISTORY AND SYNONYMY

Moraea elliotii is treated here in a very wide sense and it includes several synonyms that seem to be minor variants. The first collections were made by the Natal botanist John Medley Wood in 1879, but *M. elliotii* was described from a later collection made by George Scott Elliot in 1890 in the eastern Transvaal Highveld near Lake Chrissie. The type material and plants from elsewhere in the Transvaal and Swaziland have a linear leaf inserted high up on the stem, but not immediately under the inflorescence as in *M. natalensis*. Specimens corresponding to *M. stewartae*, described by N. E. Brown, tend also to have a linear leaf inserted above ground level, but the position of insertion is variable even in the few specimens that comprise the type collection. A third species, *M. juncifolia*, also varies in the position of insertion of the leaf in the stem. The leaf in the latter species is terete or subterete. The three species mentioned above all occur in the Transvaal and Swaziland and generally flower from December to March.

Closely matching *Moraea juncifolia* with its terete leaf is *M. violacea*, the type from Byrne, near Richmond in Natal. Other specimens from the Natal Midlands correspond to this form, and generally have the leaf inserted near ground level. The leaf varies from terete to linear. In Natal, plants generally flower in late spring. Further south in the eastern Cape, forms of *M. elliotii* flower earlier, from September onwards. In the eastern Cape plants corresponding to *M. macra*, yet another synonym of *M. elliotii*, leaf insertion is usually basal but the leaf may either be linear or terete.

52. MORAEA EXILIFLORA Goldblatt, sp. nov.

TYPE: South Africa, Cape, Swartberg Mountains, along the path to Towerkop above Ladismith, wet south-facing rock faces in shallow pockets of soil, ca. 1 000 m, *Esterhuysen 36122* (BOL, holotype; K, MO, NBG, PRE, S, US, WAG, isotypes).

exiliflora = with very small flowers; the species has flowers that are amongst the smallest in the genus.

Planta 15–25 cm alta, cormo 5–8 mm in diametro, folio solitario canaliculato 2–3 mm lato, caule 2–5 ramoso, spathis 22–26 mm longis herbaceis, floribus albis interdum purpureo colore suffusis, tepalis exterioribus 14–15 mm longis, interioribus 13–14 mm longis et 1,5 mm latis etiam reflexis, filamentis 4,5 mm longis infra connatis, antheris ca. 3,5 mm longis, polline flavo, ramis styli ca. 5 mm longis et 2 mm latis, cristis productis ad 5 mm longis.

52.

M. exciliflora.

Plants 15–25 cm high. *Corm* globose, 5–8 mm in diameter, tunics of pale, fine, reticulate fibres. *Cataphylls* pale and membranous. *Leaf* solitary, inserted near gound level, linear, channelled, usually somewhat longer than the stem and trailing, 2–3 mm wide. *Stem* slender, erect, simple or more often 2–5 branched, sheathing stem bracts 23–25 mm long, usually dry in the upper half. *Spathes* herbaceous becoming dry and membranous apically, attenuate, *inner* 22–26 mm long, *outer* about half as long as the inner. *Flowers* white, sometimes suffused with pale purple, nectar guide speckled, yellow; *outer tepals* 14–15 mm long, claw ascending, 6–7 mm long, limb extending horizontally to reflexed up to 35°, up to 8 mm long and 4–4,5 mm wide; *inner tepals* similarly oriented, 13–14 mm long and 1,5 mm wide. *Filaments* about 4,5 mm long, united below, free in the upper half; anthers 3,5 mm long, reaching to the base of the stigmatic lobe. Ovary 2–3 mm long, exserted from the spathes, *style branches* about 5 mm long, broad, about 2 mm wide, arching towards the apex of the claw of the outer tepals, *crests* erect, to 5 mm long. *Capsules* obovoid, 5–6 mm long (mature capsules not seen); *seeds* not known. Chromosome number $2n = 12$.

Flowering time: October; flowers opening in the late afternoon, about 4 pm. and fading at dusk.

DISTRIBUTION AND HABITAT

Moraea exiliflora is known only from the slopes of Towerkop in the Klein Swartberg mountains. It grows at about 1 000–1 500 m, on seasonally moist south-facing sandstone rock faces and on thin soils among rocks. The corms are often rooted in crevices where shallow pockets of soil accumulate.

DIAGNOSIS AND RELATIONSHIPS

Moraea exiliflora has a flower typical of *Moraea* in all respects except that it is very small. The inner tepals are entire and reflexed to the same degree as the outer, and the pale yellow nectar guides are located on the outer tepals only. The filaments are united in the lower half and the style crests are well developed. The single narrow channelled leaf combined with the unspecialized flower suggests that it belongs in section *Polyanthes* close to the summer rainfall area species, *M. elliotii*. The chromosome number, $2n = 12$ and karyotype of large chromosomes with the longest pair submetacentric supports this position in the genus. It seems reasonable, in the absence of contradictory data, to treat *M. exiliflora* as a close ally of *M. elliotii* and probably a segregate of this species that evolved in isolation from the main eastern southern African range of the ancestral stock. The small plant and flower size is possibly an adaptation to the stressful, arid climate and nutrient poor soil of the Cape mountains.

HISTORY

Moraea exiliflora was discovered by Elsie Esterhuysen in the summer of 1982, on a climbing expedition to the Klein Swartberg mountains. The species is very inconspicuous and probably grows elsewhere in the Swartberg, but so far it is known from only two collections, both from Towerskop. The small, pale coloured flowers open only in the late afternoon and plants are easily overlooked unless in full bloom.

53. MORAEA NATALENSIS Baker

Baker, *Handbook Irideae* 56. 1892; *Flora Capensis* **6**: 20. 1896; Goldblatt, *Ann. Mo. bot. Gdn* **60**: 221–222. 1973; **64**: 261–262. 1977. TYPES: South Africa, Natal, *Sanderson 253* (K, lectotype designated by Goldblatt, 1973; S, isolectotype); Natal, without precise locality, *Sutherland s.n.* (K, syntype).

SYNONYMS

Moraea parviflora N. E. Brown, *Trans. R. Soc. S. Afr.* **17**: 346. 1929. TYPE: South Africa, Transvaal, Tomson's vlei, Nylstroom, *Pole-Evans 19668* (K, holotype; PRE, isotype).

Moraea erici-rosenii Fries, Wiss. Ergeb. Schwed.-Rhod.-Kongo Exped. 1911–1912, *Bot. Untersuch.* **1**: 234. 1915. TYPE: Zambia, Kalambo, *Fries 1345* (UPS, holotype; Z, isotype).

natalensis = from Natal, the province where the first collections of *M. natalensis* were made.

Plants 15–45 cm in height including leaf. *Corm* to 1,5 cm diameter, covered with tunics of dark brown to black fibres. *Cataphylls* membranous, reaching a few cm above ground. *Leaf* solitary, sometimes inconspicuous, inserted towards the top of the stem, at time of flowering shorter than or more often exceeding the spathes, to 20 cm long, narrowly channelled to apparently terete. *Stem* erect or inclined, the lowermost internode very long with the leaf at the first node, very short above the leaf, flexuously branched, the branches crowded, rarely simple, sheathing bract leaves seldom more than 2,5 cm long, usually dry, light brown. *Spathes* herbaceous with dry apex and margins, *inner* 2,5–3,5 cm long, *outer* about 1 cm shorter than the inner, often entirely dry, brown and lacerated, speckled below. *Flowers* lilac to blue-violet with yellow nectar guides ringed with dark mauve on the outer tepals; *outer tepals*

14–20 mm long, claw narrow, ascending, limb 7–14 mm long, to 10 mm wide, reflexed to about 45°; *inner tepals* linear-lanceolate, to 15 mm long, limb to 4 mm wide, also reflexed. *Filaments* 4–5 mm long, united in the lower 2–3 mm; *anthers* 4–5 mm long, pollen yellow. Ovary about 4 mm long, exserted from the spathes, *style branches* to 11 mm long including the crests. *Capsule* more or less obovoid, 4,5–10 mm long, 4–5 mm in diameter; *seeds* angled. *Chromosome number 2n = 12.*

Flowering time: summer, mainly December and January; flowers opening in the late morning and fading towards the evening.

DISTRIBUTION AND HABITAT

In southern Africa *Moraea natalensis* is found at coastal to mid-altitudes in Natal, notably between Durban and Howick, and locally at isolated sites in the central and eastern Transvaal. It extends into tropical Africa, occurring in Zimbabwe, Malawi, Zambia, north-western Mozambique and Shaba in southern Zaïre. It usually grows in seasonally wet, exposed sites along rocky stream banks, in seeps, vleis and rock outcrops.

DIAGNOSIS AND RELATIONSHIPS

Moraea natalensis is a small plant with the typical small blue-purple flowers of subgenus *Moraea*, but is distinctive in its vegetative morphology. The lower internode of the stem is elongate and the single leaf is thus inserted well above the ground. The leaf is relatively short, sometimes not exceeding the few, usually crowded spathes.

Moraea natalensis is clearly allied to *M. inclinata* which has a similar morphology with a single leaf inserted high on the stem. The overall smaller size, in flowers as well as vegetative parts, and the differences in bracts, spathes and capsules do, however, make it easy to distinguish the two. *Moraea inclinata* is a much taller plant with the stems nearly always inclined towards the ground. It has longer branches so that the spathes are less crowded, and short outer inflorescence spathes always a brownish colour. The ovary and capsules are also distinctive, being globose in contrast to the obovoid capsules of *M. natalensis*.

The type form of *Moraea natalensis* is from the Pietermaritzburg area and is represented by fairly large plants with capsules up to 10 mm long. Further north near Nylstroom in the central Transvaal, slender plants, described by N. E. Brown as *M. parviflora*, have capsules less than 8 mm long. Some plants from the area are much branched, but others resemble the Natal plants in having only a few crowded branches and *M. parviflora* is now regarded as conspecific with *M. natalensis*. Plants from eastern Zambia described as *M. erici-rosenii* by Fries in 1915 appear to be no more than a particularly small form of *M. natalensis* with a very short leaf and it is now also included in the latter (Goldblatt, 1977).

HISTORY

Moraea natalensis was first collected in the mid-nineteenth century in interior Natal, near Pietermaritzburg and further inland, by the early Natal plant collectors John Sanderson and Peter Sutherland. Their rather poor specimens were sent to Kew and later described by J. G. Baker. The related *M. inclinata* was discovered somewhat later, and specimens of this species were included in *M. natalensis* by Baker in the *Flora Capensis*. They were only separated in the 1970's (Goldblatt, 1973) when *M. inclinata* was described.

54. MORAEA INCLINATA Goldblatt

Goldblatt, *Ann. Mo. bot. Gdn* 60: 222–223. 1973. TYPE: South Africa, Natal, Cathkin Park, *Galpin 11847* (BOL, holotype; PRE, isotype).

inclinata = inclined or leaning, referring to the habit of the stem which is never erect, but leans strongly towards the ground.

Plant fairly tall, 40–90 cm long including the leaf. *Corm* 1–1,5 cm in diameter, with tunics of brown fibres, sometimes extending upwards in a neck. *Cataphylls* membranous, becoming dry with age and irregularly broken. *Leaf* solitary, inserted on the upper part of the stem just below the inflorescence, usually between 15–40 cm long, channelled, up to 3 mm wide or nearly terete with the margins tightly inrolled. *Stem* slender, glabrous or rarely woolly, usually leaning to one side, bearing a long leaf towards the apex, just below the inflorescence; usually flexed and with 2–4 branches, sheathing bract leaves 1–2 cm long, dry and light brown, or green basally. *Spathes* green to light brown below, margins and apices dry and brownish, *inner* 2,5–4 cm long, *outer* much shorter, rarely half as long as the inner. *Flowers* blue-violet with yellow nectar guides on the outer tepals; *outer tepals* 25–30 mm long, about 10 mm at the widest, both limb and claw fairly broad, limbs laxly spreading; *inner tepals* 20–25 mm long and up to 6 mm wide, limbs reflexed. *Filaments* about 5 mm long, united in the lower third; *anthers* 7 mm long. Ovary narrowly obovoid, 4–5 mm long, exserted from the spathes, *style branches* about 6 mm long, up to 3 mm wide, crests up to 5 mm long. *Capsule* rotund, 5–6 mm in diameter; *seeds* angled. Chromosome number $2n = 22$.

Flowering time: summer months, from November at lower altitudes, to February and March at high elevations.

DISTRIBUTION AND HABITAT

Moraea inclinata occurs in the Natal Midlands and the slopes and plateaus of the Drakensberg mountains in Natal and the north-eastern Transkei. It has been collected from Oliviers Hoek in the north to Engcobo in the south and grows on well-watered slopes growing in tufts of sedges and grasses.

DIAGNOSIS AND RELATIONSHIPS

Moraea inclinata is easily recognized by its long slender stem with its single leaf inserted well above the ground near the stem apex and the comparatively short outer inflorescence spathes that are typically slightly less than half the length of the inner. The leaf itself is relatively short but always longer than the few branches that are clustered above the leaf axil. Although the species is really quite distinct, it has often been confused in the past with *M. natalensis* which has a similar habit with the leaf inserted high on the stem just below the inflorescence. *Moraea natalensis* is undoubtedly closely related to *M. inclinata* but it is a smaller, more slender plant with a smaller flower and different capsules. It occurs in tropical Africa and in the Transvaal and Natal where its distribution borders on that of *M. inclinata* along the foothills of the Drakensberg. The two can easily be distinguished by the capsules, which are spherical in *M. inclinata* and ovoid in *M. natalensis*. The size of the spathes and flowers are also quite different in the two species so that there is no reason to confuse them in flower or in fruit.

HISTORY

Moraea inclinata has been known since the late nineteenth century when it was collected several times by John Medley Wood, the important early Natal botanist, and others including Harry Bolus who recorded the species in the Transkei. However, it was generally confused with its close relative *M. natalensis* and hence remained unnamed until I began to study the systematics of *Moraea* in southern Africa in the early 1970's. By that time there were sufficient collections of *M. inclinata* and *M. natalensis* available to make it quite clear that these were two separate species. Subsequent information has tended to support this conclusion. *Moraea inclinata* consistently has a different capsule which is quite globose in contrast to the obovoid capsule of *M. natalensis*. *Moraea inclinata* also has an unusual chromosome number, $2n = 22$, and is apparently a hypotetraploid. Its chromosome number, unique in *Moraea*, requires confirmation since only one population has so far been counted. *Moraea natalensis* and its allies have the common chromosome number for *Moraea* of $2n = 12$, and basic for section *Polyanthes* to which *M. inclinata* belongs.

54.

M. inclinata.

55. MORAEA STRICTA Baker

Baker, *Viert. Nat. Ges. Zürich* **49**: 178. 1904; Goldblatt, *Ann. Mo. bot. Gdn* **60**: 223–225. 1973. TYPE: South Africa, Transvaal, Schilouvane, *Junod 563* (Z, holotype; K, LD, isotypes).

SYNONYMS

Moraea tellinii Chiovenda, *Ann. Bot. (Roma)* **9**: 138. 1911. TYPE: Ethiopia, Semien, Debarek, *Chiovenda 3007* (F, lectotype designated by Goldblatt, 1977: 262).

Moraea trita N. E. Brown, *Trans. R. Soc. S. Afr.* **17**: 347. 1929; Letty, *Wild Flowers of the Transvaal* tab. 36, fig. 1. 1962. TYPE: South Africa, Transvaal, Lydenburg, *Wilms 1419* (K, holotype; P, PRE, isotypes).

Moraea parva N. E. Brown, *Trans. R. Soc. S. Afr.* **17**: 347. TYPE: South Africa, Transvaal, Woodbush, *Moss 15564* (K, holotype.)

Moraea mossii N. E. Brown, *Trans. R. Soc. S. Afr.* **17**: 347. 1929. TYPE: South Africa, Transvaal, Johannesburg, *Moss 15805* (K, holotype; PRE, isotype).

Moraea curtisae R. Foster, *Contr. Gray Herb.* **127**: 46. 1939. TYPE: Kenya, near Noyrosera, 40 miles south-east of Narok, *Curtis 676* (GH, holotype).

Moraea thomsonii Baker sensu Goldblatt, *Ann. Mo. bot. Gdn* **64**: 262. 1977. in part but excluding the type.

stricta = very straight or upright, referring to the erect stem with the lateral branches held tightly to the axis.

Plants small to medium, usually 15–25 cm high. *Corm* 1–3 cm in diameter, with tunics of medium to coarse fibres, dark brown in colour, often bearing cormlets among the fibres. *Cataphylls* dry and irregularly broken at flowering time. *Leaf* solitary, usually absent at flowering time (or dead and still attached to base of stem), rarely the new leaf emerging, eventually produced to about 60 cm or more, terete, without an adaxial groove, about 1,5 mm thick. *Stem* erect, usually bearing 3–6 branches, these held close to the main stem, sessile or on short branches concealed by the subtending bract leaves, sheathing bract leaves brown, 3–6 cm long, membranous and usually dry and pale straw-coloured, apices often lacerated. *Spathes* dry and papery, rarely green near the base, inner (2,5)3–4 cm long, apices membranous, speckled darker brown, sometimes lacerated, outer usually about two-thirds as long as the inner, sometimes shorter. *Flowers* pale lilac to blue-violet with yellow-orange spotted nectar guides on the outer tepals; outer tepals 19–24 mm long, claw ascending, narrow, slightly shorter than the limb, limb about 11–14 mm long and 5–8 mm wide, obovate to lanceolate, reflexed; inner tepals linear-lanceolate, erect or ascending, 15–18 mm long and 2–4 mm wide. *Filaments* 3–4 mm long, united in the lower third only; anthers 5–6 mm long, pollen orange. Ovary nearly cylindric, 5–6 mm long, usually exserted from the spathes, style branches 7–8 mm long, diverging about 1,5 mm above the base, crests narrow, 3–6 mm long. *Capsule* obovoid, (8–)9–11 mm long; seeds angled. *Chromosome number* 2n = 24, 36, 48 (in tropical Africa).

Flowering time: July to November.

DISTRIBUTION AND HABITAT

Moraea stricta is widespread in Africa, occurring in southern Africa from the eastern Cape near Stutterheim through Lesotho, Transkei and Natal to the central and north-eastern Transvaal and Zimbabwe. It ranges widely in tropical Africa, extending through the eastern part of the continent into northern Ethiopia. Plants are usually found in open, often stony, grassland. They flower among dry grasses usually at the end of the dry season, in southern Africa before the first summer rains begin.

DIAGNOSIS AND RELATIONSHIPS

Moraea stricta can generally be recognized by the characteristic lack of a green leaf at flowering time, together with its short to sessile lateral branches and small blue-violet flowers. The lanceolate inner tepals are often erect and the style branches have long, narrow, erect crests. The previous season's dead, dry leaf is sometimes attached to the flowering stem, and its presence often gives rise to confusion over identification, especially in the case of herbarium material. The short lateral branches hugging the main axis and the dry bracts are, however, also characteristic, and should help avoid confusion with species such as *M. elliotii* which have similar flowers.

A handful of other species are also leafless or have dry leaves at flowering time, but all except two have trifid to very reduced inner tepals and are only distantly related. However, *M. alpina*, a dwarf species of the high Drakensberg and the predominantly tropical African *M. thomsonii* are closely allied to *M. stricta* and both can be confused with it unless the flowers are carefully examined. *Moraea alpina* is smaller in all its features than *M. stricta* and is typically later flowering. The outer tepals are 12–16(–18) mm long and the anthers 3–4 mm long, consistently smaller than in *M. stricta*, in which the outer tepals are usually at least 20 mm long and the anthers 5–6 mm long. Other features are also smaller in *M. alpina*, notably the spathes but the outer tepals and the anthers are the most useful indicators of flower size.

Moraea thomsonii differs from *M. stricta* only, as far as I can tell, in flower structure; the vegetative morphology is virtually identical. In *M. thomsonii* the tepals are a pale lilac-blue, and the inner and outer tepals are similar in size and orientation, both being held horizontally and both having yellow nectar guides. The style branches are broader than in *M. stricta* and have a crennate margin and the crests are vestigial, and shorter than the stigma lobes. Also, in the excellent painting of the species in the *Botanical Magazine* tab. 7976, it is clear that the anthers are held above the tepal claws. Thus the whole aspect of the flower when alive is quite different from that of *M. stricta*. *Moraea thomsonii* is largely tropical African, apparently centred in Malawi and southern Tanzania, but it has been recorded in the Transvaal near Pilgrims Rest and more records are likely in the future.

It is probable that *Moraea alpina* and *M. thomsonii* are specialized offshoots of *M. stricta*, which has the widest distribution of the three species and is the most generalized in its morphology. The group is probably derived from an ancestor close to *M. elliotii* which has a wide range in southern Africa, and differs mainly in having a green leaf at flowering time, but also distinctly stalked lateral branches.

Moraea stricta is unusually variable cytologically. The basic chromosome number for section *Polyanthes* and for the species is $x = 6$, and most members of the section are diploid, $2n = 12$. However, *M. stricta* is polyploid and a polyploid series has been found in the handful of populations so far examined cytologically. The lowest number recorded in *M. stricta* is $2n = 24$, and $2n = 36$ has also been found in Transvaal populations. In tropical Africa an even higher level of polyploidy, $2n = 48$ has been found in a population in Malawi. No clear pattern is yet evident and more populations need to be examined.

HISTORY

The first collections of this widespread African species are apparently those of C. F. Ecklon & C. L. Zeyher, actually probably made by Zeyher alone in 1832, in the eastern Cape during their exploration of this, then botanically unknown, area. Their collections were apparently distributed unnamed and not recognized as new species, but often confused with *M. elliotii*, which until quite recently was known in many herbaria as *M. setacea* (correctly a synonym for the Cape *Gynandriris setifolia*).

The English botanist and expert on Iridaceae, J. G. Baker, first described *M. stricta* in 1904, based on plants collected by the missionary Henri Junod in the eastern Transvaal. Twenty-five years later, N. E. Brown described three new Transvaal species of *Moraea*, *M. trita*, *M. parva* and *M. mossii*, all very similar to one another and sharing the distinctive terete leaf that is dry or broken at flowering time. Brown separated these three species on the most trivial characters and there can be no doubt that they represent different collections of *M. stricta*, which Brown also recognized, regarding it as close to *M. trita*. A few years later, the American, R. C. Foster, described *M. curtisae* from Kenya and an examination of the type specimen of this species shows it to correspond closely with *M. stricta* as well as with *M. tellinii*, described by the Italian botanist Emilio Chiovenda in 1911 from Ethiopia. *Moraea stricta* is now known to occur widely in tropical Africa, where it is easily confused with the related and vegetatively similar *M. thomsonii* which I made the mistake of treating as conspecific with, and an earlier name for, *M. stricta* (Goldblatt, 1977), believing that the typical form of both represented the extremes of one variable species. I now believe that this was incorrect and that there are two quite different species involved, but identification is often difficult (or impossible) without properly pressed flowers.

56. MORAEA ALPINA Goldblatt

Goldblatt, *Ann. Mo. bot. Gdn* 60: 225–226. 1973. TYPE: South Africa, Natal, Mont aux Sources, *Galpin 10361* (PRE, holotype).

alpina = alpine, referring to the habitat at high elevations in the main Drakensberg Range.

Plants very small, 4–12 cm high. *Corm* about 0,7–1,2 cm in diameter with tunics of fine, light-brown fibres. *Cataphylls* membranous, reaching shortly above the ground. *Leaf* solitary, absent or emergent at time of flowering, but then not attached to the current flowering stem, slender, terete, 0,5 mm in diameter. *Stem* slender, simple or few-branched, the branches then congested, sheathing bract leaves dry and membranous, 5–15 mm long. *Spathes* green or becoming dry and semi-transparent, inner 2,5–3 cm long, outer about 1 cm shorter than the inner. *Flowers* dark blue to violet with yellow-orange nectar guides on the outer tepals; *outer tepals* 12–18 mm long, claw 6–8 mm long, limb 5–7 mm wide, reflexed to about 45°; *inner tepals* 11–13 mm long, lanceolate, limb apparently always reflexed. *Filaments* 3–4 mm long, joined towards the base only; *anthers* 3–4 mm long, exceeding the stigmas. Ovary nearly cylindric to narrowly obovoid, 3–4,5 mm long, *style branches* free almost to the base, 6–8 mm long, crests 2–3 mm long. *Capsule* broadly obovoid, 5–9 mm long; *seeds* angular. Chromosome number $2n = 12$.

Flowering time: mid-October to December; flowering phenology not known.

DISTRIBUTION AND HABITAT

Moraea alpina has a limited distribution along the summit plateau of the Drakensberg in Natal, Lesotho and Transkei, where it extends from Mont-aux-Sources in the north to Barkly East in the south. It occurs in open rocky sites or low mountain grassland at elevations usually above 2 500 m.

DIAGNOSIS AND RELATIONSHIPS

The relatively unspecialized flower and the terete basal leaf which is not attached to the current flowering stem, indicate a relationship with *M. stricta*, a larger flowered and taller species which has a similar terete leaf, lacking or dry at flowering time. The flowers of the two species are similar and differ mainly in size. In *M. alpina* the outer tepals are 12–16(–18) mm long, the anthers 3–4 mm long and the spathes are 2,5–3 cm long. In *M. stricta* the tepals are usually at least 20 mm long, the anthers 5 mm long, and the spathes 3–4 cm long. Other features of *M. alpina* are also smaller and indicate that it is not merely a diminutive form of *M. stricta*, but a distinct, although undoubtedly closely-related species. Populations of *M. stricta* occurring in the same area of the Drakensberg usually flower earlier than *M. alpina*, from July to September or October even at high altitudes, where *M. alpina* only begins to flower at the end of October, and has been collected in bloom into December.

HISTORY

Moraea alpina was based on a collection made in 1932 by the famous southern African plant collector and mountaineer, Ernest Galpin in the Mont-aux-Sources area of the Drakensberg. When I described it in 1973, few other collections were known. This constituted a very limited sample on which to base a new species. However, the plants seemed so different from their obviously close relative, *M. stricta*. Now, several more collections have been made, largely by the botanists Olive Hilliard and Bill Burtt, and my decision to recognize the species seems to be correct. All the collections have similar small flowers, short spathes and a low stature. The geographical distribution of *M. alpina* has been extended as a result of the new collections and the species is now known from Mont-aux-Sources to south to Barkly East.

57. MORAEA THOMSONII Baker

Baker, *Handbook Irideae* 57. 1892; *Flora Tropical Africa* 7: 341. 1898; Hemsley, *Bot. Mag.* ser. 3, **60**: tab. 7976. 1904; Goldblatt, *Ann. Mo. bot. Gdn* **64**: 262–265. 1977, in part excluding *M. stricta* and other synonyms. TYPE: Tanzania, 'plateau north of Lake Nyassa', Oct. 1880, *Thomson s.n.* (K, holotype).

thomsonii = named after Joseph Thomson, British geologist and plant collector in Central Africa.

Plants small to medium, usually 15–30 cm high. *Corm* 1–2 cm in diameter with tunics of dark brown medium to coarse fibres. *Cataphylls* membranous, usually dry and broken above at flowering time. *Leaf* solitary, usually absent at flowering time (or dead and still attached to base of stem), new leaf sometimes emerging but not attached to current flowering stem, eventually produced to 60 cm or more, terete, without an adaxial groove, about 1,5 mm thick. *Stem* erect, usually bearing 3–6 branches held close to main stem, on short peduncles or sessile, sheathing bract leaves usually dry and pale straw-coloured at flowering, 3–6 cm long, apices often lacerated. *Spathes* dry and papery, rarely green below, *inner* (2,5–)3–4 cm long, apices membranous, speckled darker brown, sometimes lacerated, *outer* usually about two-thirds as long as the inner, sometimes shorter. *Flowers* pale lilac-blue with yellow nectar guides on the inner and outer tepals; *outer tepals* 20–24 mm long, claw ascending, shorter than the limb, 9–10 mm long, limb 11–14 mm long, 5–8 mm wide, obovate to lanceolate, spreading more or less horizontally; *inner tepals* similar to the outer but somewhat narrower, about 16–18 mm long, about 7 mm wide, lanceolate, spreading like the inner. *Filaments* 3–4 mm long, united in the lower third only; *anthers* 5 mm long, pollen pale yellow. Ovary nearly cylindric, 4–5 mm long, usually exserted from the spathes, *style branches* 7–8 mm long, about twice as wide as the anthers and with crennate margins, crests vestigial, shorter than the stigma lobes. *Capsule* obovoid, (8–)9–11 mm long; *seeds* angled. Chromosome number $2n = 12$.

Flowering time: August to September in southern Africa (to November in tropical Africa); flowering phenology not known.

DISTRIBUTION AND HABITAT

In southern Africa, *Moraea thomsonii* is known only from the Pilgrims Rest area of the eastern Transvaal. It is apparently very local in well-watered mountain grassland. *Moraea thomsonii* also occurs in central Africa, and it is especially common in the highlands of southern Tanzania and adjacent northern Malawi.

DIAGNOSIS AND RELATIONSHIPS

Moraea thomsonii is recognized by the characteristic lack of a green leaf at flowering time and a pale lilac-blue flower in which the inner and outer tepals are similar and both have yellow nectar guides at the base of the limbs. The style crests are reduced and vestigial, and shorter than the stigma lobes.

It is closely related to the common *Moraea stricta* of eastern southern Africa and the two are virtually identical in vegetative morphology, both having a stiffly erect stem with the lateral branches very short or sessile and held tightly to the axis, while the basal leaf is terete, and always dead and often broken or lacking at the time of flowering. *Moraea stricta* has a more generalized and typical *Moraea* flower in which the inner tepals are smaller than the outer, lack nectar guides and the limbs are usually suberect rather than spreading. The style branches of *Moraea stricta* are also narrower and have well-developed more or less linear crests.

HISTORY

Moraea thomsonii was first collected in the Southern Highlands of Tanzania in the later nineteenth century by Joseph Thomson, and described at Kew by J. G. Baker in 1892. It has subsequently been collected many times in Central Africa. In my study of *Moraea* in tropical Africa (Goldblatt, 1977), I considered *M. thomsonii* and *M. stricta* conspecific and united the two under the earliest name, *M. thomsonii*. At this time I was more impressed by the similarity in the vegetative morphology of the two species and thus overlooked the significance of the floral differences.

However, when plants matching exactly *Moraea thomsonii* were discovered by L. E. Davidson at Mount Sheba near Pilgrims Rest in the eastern Transvaal, I began to reconsider my earlier taxonomic decision. The floral differences appear to be complete, and there are no examples of plants that are intermediate between the two species in flower structure. In addition, chromosome counts for *M. thomsonii* are diploid, $2n = 12$, like many other members of section *Polyanthes*, but not *M. stricta*, in which there is a polyploid series with tetraploid, hexaploid and octoploid races. There now appear to be sound reasons for reversing my past taxonomy and I must recognize *M. thomsonii* as distinct from *M. stricta*. As far as I can tell, *M. thomsonii* is rare in southern Africa, and I know only of the single record from here.

SUBGENUS *VIEUSSEUXIA*

SECTION *THOMASIAE*

58. MORAEA THOMASIAE Goldblatt

Goldblatt, *Ann. Mo. bot. Gdn* **63**: 20. 1976; **63**: 758–759. 1976. TYPE: South Africa, Cape, Karoo Garden, Worcester, *Goldblatt 2422* (NBG, holotype; BOL, K, MO, PRE, S, isotypes).

thomasiae = named in honour of Margaret Thomas, Cape Town botanist and horticulturist, who brought this species to my attention, and has helped me in many ways in my studies of Iridaceae.

Plants small, slender, 15–30 cm high. *Corm* about 10 mm in diameter, tunics of dark brown to black, medium to coarse fibres. *Cataphylls* membranous, dark brown. *Leaf* solitary, nearly basal, linear, 2–4(–6) mm wide, somewhat glaucous, about as long as or exceeding the inflorescence. *Stem* simple, very rarely with 1 branch, sheathing stem bracts 2,5–4 cm long, herbaceous below, pale and membranous above, attenuate. *Spathes* herbaceous with dry, light-brown attenuate apices, *inner* 3,5–6 cm long, *outer* about half as long as the inner. *Flowers* pale yellow with prominent dark veins and deep yellow nectar guides on the outer tepals; *outer tepals* 26–37 mm long, claw narrow, nearly erect, 15 mm long, limb reflexed slightly below the horizontal, 13–22 mm long; *inner tepals* narrowly lanceolate, 18–22 mm long, distinctly clawed, initially erect, the limb usually ultimately spreading. *Filaments* 4–5 mm long, free almost to the base; *anthers* about 6 mm long, pollen yellow. Ovary 8–11 mm long, exserted or partly included in the spathes, *style branches* 12–15 mm long, united in a style at the base only, crests linear, 7–10 mm long. *Capsules* elliptic, 12–15 mm long; mature *seeds* not known. Chromosome number $2n = 12$.

Flowering time: August to mid-September.

DISTRIBUTION AND HABITAT

Moraea thomasiae is a relatively poorly-known species of the interior winter rainfall area. It extends from Worcester in the south-western Cape, through the western part of the Little Karoo where it has been recorded at Touws River, Koo, Hex River Pass, Montagu and Barrydale. It grows on south-facing slopes on shale and heavy clay soils that remain relatively wet for several months during the growing season.

DIAGNOSIS AND RELATIONSHIPS

Moraea thomasiae has a single basal leaf, a simple stem and pale yellow flowers with delicate tepals distinctly dark veined. The inner tepals are lanceolate with an expanded limb, initially erect but later spreading. The filaments and style branches are unusual in being free virtually to the base, and diverging for their entire length. Despite a similar arrangement of the stamens and style branches in *M. tripetala*, the two species are probably not closely related. *Moraea tripetala* has reduced inner tepals, usually represented by small cilia. Moreover, the karyotypes of the two species are very different, although both have a diploid number of $2n = 12$. The similarity of the stamens and style branches is apparently due to convergence and does not indicate a real relationship. *Moraea thomasiae* is very like *M. angusta* (subgenus *Monocephalae*) in general appearance, but they are certainly unrelated, the species of subgenus *Monocephalae* having terete leaves, truncate to acute spathes, usually discoid seeds and $2n = 20$. *Moraea thomasiae* probably stands in a rather isolated position in subgenus *Vieusseuxia*, its slender habit, unbranched stem, and solitary leaf suggesting no close allies, and for this reason it has been placed in a section of its own.

HISTORY

Moraea thomasiae, described only in 1976, has a relatively wide range in the winter rainfall area, suggesting that the south-western Cape is, in general, not as well known botanically as might be expected for an area studied since the 1770's. No specimen is known to have been collected prior to 1945, but in the past ten years it has been found at several localities, and it is now clear that *M. thomasiae* is common in the Worcester and Montagu districts.

58.

M. thomasiae.

SECTION *VIEUSSEUXIA*

59. MORAEA ALGOENSIS Goldblatt

Goldblatt, *Ann. Mo. bot. Gdn* **60**: 226. 1973; **63**: 750–751. 1976. TYPE: South Africa, Cape, Port Elizabeth, *Batten 7* (NBG, holotype).

algoensis = from Algoa Bay, the vicinity of Port Elizabeth, where some of the first collections of the species were made.

Plants 20–40 cm high. *Corm* 1–1,5 cm in diameter, with coarse, brown, fibrous tunics often extending upward. *Cataphylls* membranous to brittle and papery, brown above the ground. *Leaf* linear, inserted near ground level, channelled, 2–3 mm wide, longer than the stem. *Stem* with up to 4 branches, these diverging from the axis, often secund, sheathing bract leaves to 4 cm long, dry and brown in the upper part with long, tapering apices. *Spathes* herbaceous with dry, brownish attenuate apices, *inner* 4–5 cm long, *outer* about half as long as the inner. *Flowers* pale to dark violet-blue with yellow nectar guides on the outer tepals; *outer tepals* 27–30 mm long, the limb about 20 mm long, to 9 mm wide, reflexed about 30° below the horizontal; *inner tepals* blue or brown, comparatively short, 6–10 mm long, reaching to about the level of the stigmas, erect, spathulate, often distinctly clawed, limb expanded, to 2,5 mm wide, entire or sometimes obscurely 3-lobed. *Filaments* 3,5–7 mm long, united below, free in the upper third to half; *anthers* 4–7 mm, not reaching the stigmas, pollen yellow-orange. Ovary about 5 mm long, typically exserted from the spathes, *style branches* 5–8 mm long, crests linear, up to 8 mm long. *Capsule* ellipsoid to obovoid, 9–12 mm long; *seeds* angled. Chromosome number $2n = 12$.

Flowering time: July to September.

DISTRIBUTION AND HABITAT

Moraea algoensis is essentially a species of the winter rainfall area. It extends from Worcester in the south-western Cape through the southern Cape to Port Elizabeth, at the edge of the summer rainfall area. It is most common in the east of its range, from the Long Kloof to Uitenhage and is known from only a few sites to the west, at Barrydale and Worcester. Plants occur at lower altitudes on both clay and sandy soils, more often the former, in renosterveld or dry fynbos.

DIAGNOSIS AND RELATIONSHIPS

Moraea algoensis has a single foliage leaf and small violet, long-lasting flowers with well-developed inner tepals, usually entire and erect. It appears to represent a link between sections *Polyanthes* and *Vieusseuxia*, with species like *M. elliotii* and *M. carsonii* of the former, possibly allied to *M. algoensis*. However, the species of section *Polyanthes* have fugacious flowers that last a single day, while *M. algoensis* has flowers that last 2–3 days – as do those of all members of section *Vieusseuxia*. The small, spathulate and sometimes somewhat 3-lobed inner tepals appear to represent an early step in the reduction of this organ to a tricuspidate or ciliate structure characteristic of section *Vieusseuxia*.

In section *Vieusseuxia*, *Moraea algoensis* seems related to the complex of species around *M. tripetala*, all of which occur in the south-western Cape. *Moraea algoensis* and *M. tripetala* grow together near Barrydale where they flower at the same time. Although superficially similar, the short, expanded inner tepals and filaments united in a short column of *M. algoensis* contrast markedly with the minute ciliate inner tepals, virtually free filaments and short style of *M. tripetala*. Careful attention to these details make confusion between the two unlikely. The recently discovered *M. worcesterensis*, which has reduced, narrow style branches without crests, long anthers and similar spreading outer and inner tepals is probably closely allied to *M. algoensis*, but the flowers of the two species are so different that they cannot be confused.

HISTORY

When first described (Goldblatt, 1973), *Moraea algoensis* was believed to occur mainly in the Port Elizabeth-Humansdorp region, with a westerly extension to the upper Long Kloof near Avontuur. It was consequently regarded as a species from the summer rainfall area of South Africa, Port Elizabeth being a borderline region. It has subsequently become clear that the Port Elizabeth populations are an easterly extension of a truly winter rainfall area species and it has been collected further west on the Wildehondekloof Pass between Barrydale and Montagu and at the Karoo Garden near Worcester. The first records of *Moraea algoensis* are apparently those of Ernest Galpin, who found it near Humansdorp in 1897, and Florence Paterson, who collected at Redhouse between Port Elizabeth and Uitenhage at the beginning of this century.

59.

M. algoensis.

60. MORAEA WORCESTERENSIS
Goldblatt

Goldblatt, *Ann. Mo. bot. Gdn* **73**: in press. 1986. TYPE: South Africa, Cape, rocky sandstone flats at Worcester West, *Goldblatt & Snijman 6977A* (NBG, holotype; K, MO, PRE, S, STE, US, isotypes).

worcesterensis = from the town of Worcester in the south-western Cape, where the only known population occurs.

Plants 12–25 cm high. *Corm* globose, 15–20 mm in diameter, tunics brown, fibrous, often heavily clawed, sometimes accumulating to form a thick covering. *Cataphylls* brown, dry at flowering time and becoming irregularly broken to fibrous and accumulating around the base in a neck. *Leaf* solitary, basal, linear, channelled, somewhat longer to about twice as long as the stem. *Stem* simple or with a single branch, erect or flexed at the upper nodes, sheathing stem bracts 3–4 cm long, dry and brown in the upper half, attenuate. *Spathes* herbaceous, dry and dark brown above, attenuate, *inner* 28–35 mm long, *outer* about half as long as the inner. *Flowers* dark violet-purple with yellow nectar guides on inner and outer tepals; *outer tepals* 15–17 mm long, claw nearly horizontal, about 3 mm long, limb laxly spreading, 12–14 mm long, to 9 mm wide; *inner tepals* similarly oriented, smaller, 13–15 mm long and 4–5 mm wide. *Filaments* 5–6 mm long, united below, free in the upper 2 mm; *anthers* 4 mm long, exceeding the style branches, pollen yellow. Ovary about 5 mm long, nearly cylindric but narrowing below, included in the spathes; *style branches* narrow, less than 1 mm wide, diverging, becoming bilobed apically and stigmatic at the ends of the lobes, *crests* lacking. *Capsules* narrowly obovoid, to 10 mm long, at least partly exserted from the spathes; *seeds* angled. Chromosome number 2n = 12.

Flowering time: September.

DISTRIBUTION AND HABITAT

Moraea worcesterensis is a narrow endemic, known only from stony flats west of Worcester in the south-western Cape. It grows in mixed fynbos and renosterveld in rocky, sandstone derived soil.

DIAGNOSIS AND RELATIONSHIPS

Moraea worcesterensis has more or less spreading tepals, both whorls of which have nectar guides, a slender filament column and very reduced, narrow style branches that are shorter than the subtending anthers and completely lack crests. It is probably closely related to the widespread southern Cape species *M. algoensis* although at first examination it seems very different. *Moraea algoensis* has a typical *Moraea* flower with large inner tepals, the claws of which touch the broad petaloid style branches to conceal the anther and stigma lobe. In *Moraea algoensis* the inner tepals are relatively broad for section *Vieusseuxia*, most species of which have tricuspidate to linear or ciliate inner tepals. The general flower colour of *M. worcesterensis* and *M. algoensis* is the same and the corms conform to the type found in many species of the section. The single and basal leaf, the flowers lasting more than one day, and the reduced number of branches are also consistent with placement in section *Vieusseuxia*.

Information from chromosome cytology and experimental hybridization support the placing of *Moraea worcesterensis* in section *Vieusseuxia*. It has a karyotype typical of the section with the largest chromosome pair metacentric and a satellite located on a long acrocentric pair. *Moraea worcesterensis* has been successfully crossed with *M. tripetala*, a representative member of section *Vieusseuxia*, but neither it nor *M. tripetala* will hybridize with *M. bipartita*, a representative species of section *Polyanthes*.

The general similarity of *Moraea worcesterensis* to *M. polyanthos* is probably due to convergence for the *Homeria* type of flower. Thus, although the flowers of the two species are similar, the vegetative structure is very different. *Moraea polyanthos* has (2–)3–5 leaves, several branches, and blackish corm tunics of a tough wiry texture, all characteristics that seem to be significant in determining the relationships of species of *Moraea*.

HISTORY

Moraea worcesterensis was first discovered in the spring of 1983, on a visit to the new and expanding suburb of Worcester West to collect and record the plants growing in this rapidly-developing urban area. The new *Moraea* was spotted immediately in local open areas around low shrubs. At the time of writing, the site where *M. worcesterensis* was found is being built over, but it seems likely there are more populations along the foothills of the Langeberg mountains where there is similar soil and vegetation.

61.

60.

M. incurva.

M. worcesterensis.

61. MORAEA INCURVA G. Lewis

Lewis, S. African Gard. **23**: 167–168. 1933; Goldblatt, Ann. Mo. bot. Gdn **63**: 756–757. 1976. TYPE: South Africa, Cape, between Wellington and Tulbagh, *Stanford s.n.* (BOL 20185, holotype).

incurva = incurved, referring to the distinctively incurving, broad limbs of the inner tepals.

Plants slender, 35–40 cm high. *Corm* about 1,5 cm in diameter, with tunics of dark-brown reticulate fibres. *Cataphylls* brown, membranous, persisting as a fibrous neck around the base. *Leaf* solitary, basal, linear 2–4 mm wide, exceeding the inflorescence. Stem simple, 3–4 internodes long, unbranched, sheathing bract leaves 5–6 cm long, dry, brown and attenuate apically. *Spathes* herbaceous, dry above, attenuate, *inner* 4–5 cm long, *outer* about 2,5 cm long. *Flowers* violet-blue with yellow nectar guides on the outer tepals; *outer tepals* about 20 mm long, lanceolate, claw erect, limb about 15 mm long, spreading to slightly reflexed; *inner tepals* entire, lanceolate, erect, about 18 mm long, to 6 mm wide, distinctly clawed, the limb curved inward in an arc. *Filaments* 10–11 mm long, united in a slender column, free near the apex; *anthers* 3 mm long, slightly exceeding the stigmas, pollen yellow-orange. Ovary to 10 mm long, exserted from the spathes, *style branches* 4 mm long, crests 2–4 mm long. *Capsule* obovoid, 15–17 mm long; *seeds* angled. *Chromosome number* not known.

Flowering time: October to November.

DISTRIBUTION AND HABITAT

Moraea incurva is a rare endemic of the south-western Cape. It is known only from the type and one other collection, made between Wellington and Tulbagh, probably at the foot of the Elandskloof mountains. It may well be extinct in this now intensively farmed area. There is no record of the habitat but it seems likely to have grown in clay soil in renosterveld.

DIAGNOSIS AND RELATIONSHIPS

Moraea incurva has a strong resemblance in its vegetative appearance to *M. tripetala* and its close allies in its slender form, single narrow channelled leaf and small flowers. It differs from most other species of this alliance in its large, entire inner tepals, and it is also unusual in having long filaments that are almost entirely united into a column. The obvious general relationship to the *M. tripetala* complex places *M. incurva* in section *Vieusseuxia* even though it has entire inner tepals. This feature is unusual but not unknown in the section. Entire tepals also occur in the Cedarberg species, *M. barkerae*, which may be closely related to *M. incurva*, as well as in *M. amissa*, *M. insolens*, *M. thomasiae* and forms of *M. neopavonia* and *M. lurida*. Only *M. barkerae* has a comparable flower with a long filament column, but it can readily be distinguished from *M. incurva* by its larger, pale-pink flowers and the filaments, 14–16 mm long, exceeding the tepal claws and free in the upper third.

HISTORY

Moraea incurva was first collected by the early nineteenth-century Cape collectors, C. F. Ecklon and C. L. Zeyher. Their collection, with the general locality 'Tulbagh', is undoubtedly *M. incurva*, and has remained confused in herbaria until today with *M. tripetala*. It was recollected, although apparently a new discovery, in 1932 by K. C. Stanford, a pioneer in growing and promoting the cultivation of wild flowers in South Africa. The illustration here is based on the type specimen and an unpublished painting by G. J. Lewis, made from living plants at the time she drew up the description.

62. MORAEA BARKERAE Goldblatt

Goldblatt, Ann. Mo. bot. Gdn **63**: 757–758. 1976; Fl. Pl. Africa **44**: tab. 1747. 1977. TYPE: South Africa, Cape, Cedarberg Mountains, 1 400 m, above Algeria on the trail to Middelberg, *Goldblatt 3245* (MO holotype; K, NBG, PRE, S, isotypes).

barkerae = named in honour of W. F. Barker, past Curator of the Compton Herbarium at Kirstenbosch, who was one of the first to collect this species.

Plants 15–40 cm high, occasionally branched. *Corm* to 1,5 cm in diameter, tunics of coarse light-brown fibres. *Cataphyll* pale and membranous. *Leaf* solitary, basal, linear, channelled, glabrous, longer than the inflorescence but often bent and trailing.

62.

M. barkerae.

Stem smooth, usually simple or with one branch, sheathing stem bracts 2,5–4 cm long, with dry, brown attenuate apices. *Spathes* herbaceous with dry, dark-brown, attenuate apices, inner 5,5–7 cm long, outer 3–4,5 cm long. *Flowers* pale pink to almost white, with whitish nectar guides outlined in purple on the outer tepals; *outer tepals* about 30 mm long, lanceolate, the claw 10–14 mm long, lightly bearded, the limb spreading, about 10 mm wide; *inner tepals* about 25 mm long, erect or curving outwards in the upper part, to 6 mm at the widest point, the apex produced as a long slender cusp, usually entire, occasionally trilobed. *Filaments* 14–16 mm long, exceeding the tepal claws, united below in a slender column, free in the upper third; *anthers* 4–5 mm long, apiculate, extending beyond the claw of the outer tepal, pollen whitish. Ovary usually at least partly included in the spathes, *style branches* 8–10 mm long, crests lanceolate, to 10 mm long. *Capsule* and *seeds* not known. *Chromosome number* $2n = 12$.

Flowering time: late September to mid-November.

DISTRIBUTION AND HABITAT

Moraea barkerae is restricted to the higher mountains of the western Cape. It occurs at middle to upper elevations in the Cedarberg and Cold Bokkeveld Mountains in stony, sandstone soils. *Moraea barkerae* has been collected at only a few isolated localities between the Middelberg at Algeria and Elands Kloof, east of Citrusdal, but it is probably more common than the present record indicates. It flowers well only in the years following veld fires which largely explains the few collections. Plants flower in September at lower altitudes and well into December on the higher peaks.

DIAGNOSIS AND RELATIONSHIPS

Moraea barkerae has pale-pinkish flowers of an unusual shade for *Moraea* and the inner tepals have a distinctive erect, attenuate incurved limb, usually entire and lanceolate but occasionally obscurely 3-lobed with two small obtuse lateral projections formed at the base of the central cusp. The filaments are 14–16 mm long, slightly exceeding the tepal claws and united in the lower two-thirds in a slender column. The long filaments raise the anthers above the outer tepal claws, a feature that is not common in section *Vieusseuxia*. The slender form and lack of branching suggest affinities with *M. tripetala* and *M. unguiculata* as well as *M. incurva*, and it is to this species that *M. barkerae* is probably most closely related. *Moraea incurva* is a poorly known endemic of the mountains north of Wellington in the south-western Cape. It has dark-blue flowers with erect, distinctively incurved, entire inner tepal limbs and a long filament column similar to that of *M. barkerae*, but somewhat shorter and with the filaments united almost entirely.

HISTORY

Moraea barkerae has been known for some sixty years since it was discovered by M. A. Pocock in the 1920s. Despite it obviously being a distinct new species, it was described only in 1976 (Goldblatt, 1976b). *Moraea barkerae* is one of the loveliest species of *Moraea*, with the slender stems bearing delicate pale-salmon to shell-pink flowers marked with pale nectar guides outlined in purple. It is unfortunately not in cultivation and I suspect that it would be difficult to grow with any degree of success. There is at present no source of seed or corms.

63. MORAEA DEBILIS Goldblatt

Goldblatt, *Ann. Mo. bot. Gdn* **63**: 21. 1976; **63**: 755–756. 1976. TYPE: South Africa, Cape, clay slopes SW of Caledon, *Goldblatt 673* (BOL, holotype; K, MO, PRE, S, isotypes).

debilis = slender, referring to the graceful habit of the plant.

Plants slender, 15–40 cm high, usually branched. *Corm* 8–12 mm in diameter, with pale, finely-fibrous tunics. *Cataphylls* light brown, membranous, becoming fibrous and persisting as a fine reticulum around the base. *Leaf* solitary, basal, linear, pubescent on the outer surface or only ciliate on the margins, exceeding the inflorescence and usually dry and trailing in the upper half. *Stem* laxly branched, rarely simple, sheathing bract leaves 4,5–6 cm long, attenuate, dry throughout when in flower. *Spathes* herbaceous, or dry above, the apices attenuate or lacerated, inner 4–5,5 cm long, outer about half as long as the inner. *Flowers* purple, fading to pale mauve and becoming lightly speckled, with white nectar guides on the outer tepals; *outer tepals* to 20 mm long, claw slender, bearded, limb to 10 mm long, lanceolate, spreading to slightly reflexed; *inner tepals* to 10 mm long, erect, filiform, usually tricuspidate with the central cusp much exceeding the laterals. *Filaments* about 4 mm long, joined in the lower half; *anthers* about 5 mm long, pollen pale yellow. Ovary 6–8 mm long, exserted from the spathes, *style branches* about 7 mm long, crests lanceolate, to 3 mm long. *Capsule* narrowly obovoid to elliptic; *seeds* angled. *Chromosome number* $2n = 12$.

Flowering time: September to October.

DISTRIBUTION AND HABITAT

Moraea debilis has a limited distribution in the south-western Cape where it is restricted to the Caledon district. It ranges from the foot of Houw Hoek Pass to Bredasdorp, and was once common on the predominantly clay and shale soils of the area. *Moraea debilis* is typically late flowering, blooming at a time when the surrounding vegetation is usually quite dry and brown.

63.

N. debilis.

DIAGNOSIS AND RELATIONSHIPS

Moraea debilis is a slender, delicate plant with a pubescent basal leaf, small blue-purple flowers and filiform, usually tricuspidate inner tepals. The tepals are dark violet-blue on opening but fade gradually, becoming speckled on a light mauve background. The filaments are about 4 mm long and united for half their length. At first glance, *M. debilis* is easily mistaken for one of the many forms of *M. tripetala* but it is distinct from this species in the short filaments that are united in the lower half and in the filiform and typically tricuspidate inner tepals. It is obviously allied to *M. tripetala* which can be distinguished by longer filaments being free almost to the base and short ciliate (to sometimes filiform and tricuspidate) inner tepals.

HISTORY

Moraea debilis was collected by several of the early botanists at the Cape, including Carl Pappe, first Colonial Botanist at the Cape, and Rudolf Schlechter. Their collections were generally identified as *M. tripetala* which *M. debilis* resembles in all but the details of the flower. Only when I saw living plants did it become clear that it was indeed distinct from *M. tripetala*, and represented an undescribed species (Goldblatt, 1976a).

64. MORAEA LONGIARISTATA
Goldblatt

Goldblatt, *Ann. Mo. bot. Gdn* **69**: 361–362. 1982. TYPE: South Africa, Cape, Caledon Zwartberg above the Gardens, *Goldblatt 5883* (MO, holotype; C, E, K, NBG, PRE, S, US, WAG, isotypes).

longiaristata = with a long cusp, referring to the remarkable long filiform erect inner tepals unique to this species.

Plants slender, rarely exceeding 25 cm in height. *Corm* 9–12 mm in diameter; tunics light brown, coarsely fibrous. *Cataphylls* membranous to papery, brown, darker above the ground. *Leaf* solitary, linear, narrowly channelled, usually exceeding the inflorescence, 4–8 mm wide, smooth. *Stem* usually simple or occasionally with one branch, bearing 2 sheathing bract leaves 2,5–4 cm long. *Spathes* herbaceous, dry and brown above, acuminate, *inner* 4,5–6 cm long, *outer* about half as long as the inner. *Flowers* cream to white, speckled blue towards the base of the tepal limbs, nectar guides whitish, usually outlined in blue; *outer tepals* 23–30 mm long, the claw usually slightly longer than the limb, limb spreading to slightly reflexed, 11–16 mm wide, the margins undulate; *inner tepals* 13–15 mm long, filiform, erect, reaching the anthers, curving inwards apically. *Filaments* 12–15 mm long, united in the lower half; *anthers* oblong, 3–4 mm long, pollen red. *Ovary* 8–10 mm long, partly to completely included in the spathes, *style branches* about 10 mm long, crests erect, about 5 mm long, lanceolate. *Capsule* and *seeds* unknown. *Chromosome number* unkown.
 Flowering time: September to mid-October.

DISTRIBUTION AND HABITAT

Moraea longiaristata has a very limited distribution, occurring only on the Zwartberg above the south-western Cape town of Caledon, where it is relatively common. It is found at lower to middle altitudes, in stony, mountain soil. Like many geophytic plants of the nutrient-poor sandstone soils of the Cape, it flowers best after fires or when the veld has been cleared.

DIAGNOSIS AND RELATIONSHIPS

Moraea longiaristata can be recognized immediately by its white flower with large outer tepals and long filiform erect inner tepals. The tepal claws are also unusual in being disproportionately long, usually slightly exceeding the limbs. The filaments are almost as long as the claws, so that the bright-red anthers are displayed above the tepal limbs. In general aspect, *M. longiaristata* resembles any of several of the more slender species of section *Vieusseuxia*, and the flowers must be examined with care especially when dry to ensure correct identification.

It seems likely that *Moraea longiaristata* is most closely related to another localized endemic of the Caledon area, *M. barnardii* and the flower colour and the rather undulate edges of the tepal limbs are very similar. The differences between the two species are entirely in the flowers. *Moraea barnardii* lacks inner tepals and the tepal claws and filaments are relatively short, the filaments being united only at their bases for about 2 mm.

HISTORY

Moraea longiaristata was apparently first collected by Harry Bolus in the late nineteenth century and it was subsequently found by several other botanists. However, it was usually simply regarded as a variant of *M. tripetala*, despite its several very striking differences to that species. It was only in

64.

M. longiaristata.

1978, when I saw live plants at the Caledon Wild Flower Show that I realized that it was undescribed. *Moraea longiaristata* was subsequently found to be common on the lower slopes of the mountain above Caledon immediately above the Caledon Gardens. Since this discovery, it has been located at other sites on the Zwartberg and it is clear that *M. longiaristata* is by no means rare although its distribution is very limited.

The species is attractive but the flowers are small and it is probably difficult to grow. So far I have failed to establish plants in cultivation.

65. MORAEA BARNARDII L. Bolus

L. Bolus, *J. Bot.* **71**: 22. 1933; Goldblatt, *Ann. Mo. bot. Gdn* **63**: 756. 1976. TYPE: South Africa, Cape, top of Shaws Pass, *Barnard s.n.* (BOL 20067, holotype).

barnardii = named in honour of T. T. Barnard, anthropologist and amateur botanist who made a special study of Cape Iridaceae, especially *Gladiolus* and *Moraea* over many years and generously helped many younger botanists, including myself, with his fund of knowledge and experience of Cape plants.

Plants small, slender, rarely exceeding 20 cm in height. *Corm* about 1 cm in diameter, with light-brown tunics of coarse, often claw-like fibres. *Cataphylls* membranous to papery, brown, darker above the ground. *Leaf* solitary, linear, channelled, usually exceeding the inflorescence, about 1,5 mm wide, smooth. *Stem* usually simple or occasionally with one branch, sheathing bract leaves 2, dry and reddish above, 3-4 cm long, attenuate. *Spathes* herbaceous, dry and brown above, often flushed red, attenuate, inner about 4,5 cm long, outer about half as long as the inner. *Flowers* white marked with blue-purple veins and nectar guides, usually speckled on the tepal limbs; *outer tepals* about 20 mm long, the limb somewhat longer than the claw, to 13 mm long, the margins undulate; *inner tepals* lacking. *Filaments* 8-9 mm long, united at the base for at least 2 mm; *anthers* oblong, 3-4 mm long, pollen red. Ovary exserted from the spathes, red, 7-9 mm long, *style branches* to 6 mm long, crests 6-7 mm long, lanceolate. *Capsule* narrowly obovoid, about 10 mm long; *seeds* angled. Chromosome number $2n = 12$.

Flowering time: late September to October.

DISTRIBUTION AND HABITAT

Moraea barnardii has a limited distribution in the mountains south of Caledon in the south-western Cape. It is most well-known from Shaws Pass between Caledon and Hermanus, but it has also been recorded near Gansbaai. *Moraea barnardii* grows in coarse, stony, Cape mountain soil. Its flowering is stimulated by fire but plants can be found in bloom almost every year, in places where they are not shaded by the surrounding fynbos.

DIAGNOSIS AND RELATIONSHIPS

Moraea barnardii is a diminutive species, the plants seldom exceeding 20 cm high, with a single narrow basal leaf and a usually unbranched stem. The white flowers are small and speckled with dark-blue spots, and the limbs of the outer tepals are broad and distinctively undulate. The inner tepals are completely lacking and the filaments, 8-9 mm long, are united in the lower third. It is almost certainly closely related to *M. longiaristata* which is restricted to the Caledon Zwartberg, a short distance to the north of the range of *M. barnardii*. The two species are superficially similar and have flowers of the same colour and markings. However, *M. longiaristata* has long filiform inner tepals, unusually long outer tepal claws and a long filament column, with the filaments 12-15 mm long and united for half their length. *Moraea barnardii* has short outer tepal claws, lacks inner tepals entirely and has much shorter filaments. A close examination of the floral details will prevent any confusion between these two species.

Moraea barnardii and *M. longiaristata* are allied to the *M. tripetala* complex, but they are unlikely to be confused with any other species. The flower colour and blue speckling are not known in other species of *Moraea*, and the floral details of both species are distinctive. *Moraea tripetala* sometimes lacks inner tepals but these are more often represented by small cilia. It also has the filaments free and diverging almost from the base, a feature that sets it well apart from *M. barnardii* and *M. longiaristata*.

HISTORY

Moraea barnardii was discovered by T. T. Barnard in the 1930's on Shaws Pass south of Caledon, and it was described shortly afterwards by Louisa Bolus. It is extremely rare, being well-known only from the type locality, where it has been recollected frequently.

Its rarity and attractive flowers have tempted several people to try and grow it. Few have succeeded, but it can be flowered in pots if the soil conditions are duplicated and the corms are left undisturbed for some years.

65.

M. barnardii.

66. MORAEA TRIPETALA (Linnaeus fil.) Ker

Ker, *Bot. Mag.* **19**: tab. 702. 1802; Baker, *Flora Capensis* **6**: 23. 1896, incl. var.; Lewis, *Flora Cape Peninsula* 230. 1950; Goldblatt, *Ann. Mo. bot. Gdn* **63**: 751–755. 1976.

SYNONYMS
Iris tripetala Linnaeus fil., *Supplementum Plantarum* 97. 1782. TYPE: South Africa, Cape, hills near Cape Town, near Piketberg, etc., *Thunberg s.n.* (Herb. Thunb. *1186*, UPS, lectotype designated by Goldblatt, 1976b).

Vieusseuxia tripetala (Linnaeus fil.) Klatt, Durand & Schinz, *Conspectus Flora Africae* **5**: 155. 1895.

Vieusseuxia tripetaloides DC., *Ann. Mus. Natl. Hist. Nat.* **2**: 138. 1803; nom. illeg., superfl. pro *Iris tripetala* Linnaeus fil.

Moraea tripetala var. *jacquinii* Schlechter ex Lewis, *Jl. S. Afr. Bot.* **7**: 54. 1941. TYPE: South Africa, Cape, Constantiaberg, *Wolley Dod 1919* (BOL, lectotype designated by Goldblatt, 1976b).

Iris mutila Lichtenstein ex Roemer & Schultes, *Systema Vegetabilium* **1**: 477. 1817. TYPE: South Africa, Cape, Lions Head, *Lichtenstein s.n.* (location of specimen unknown, probably originally at B, and destroyed in World War II).

Moraea tripetala var. *mutila* (Lichtenstein ex Roemer & Schultes) Baker, *Flora Capensis* **6**: 23. 1896.

Vieusseuxia pulchra Ecklon, *Topographisches Verzeichniss* 13. 1827. TYPE: South Africa, Hottentotskloof, *Ecklon & Zeyher s.n.* (S, lectotype designated by Goldblatt, 1976b).

Vieusseuxia mutila C. H. Berg ex Ecklon, *Topographisches Verzeichniss* 12. 1827. TYPE: South Africa, Cape, Camps Bay, *Berg s.n.* (S, lectotype designated by Goldblatt, 1976b).

Moraea punctata Baker, *Bull. Herb. Boissier*, ser. 2, **4**: 1003. 1904. TYPE: South Africa, Cape, Gouda (as Piketberg Road), *Schlechter 4851* (K, lectotype designated by Goldblatt, 1976b; B, PRE, isolectotypes).

Moraea monophylla Baker, *Kew Bull.* 1906: 24. 1906. TYPE: South Africa, Cape, Olifants Rivier, *Penther 685* (K, lectotype designated by Goldblatt, 1976b), *Penther 626* (K, syntype).

Moraea amabilis Diels, *Bot. Jahrb. Syst.* **44**: 118. 1910. TYPE: South Africa, Cape, Bokkeveld, Oorlogs Kloof, Calvinia, *Diels s.n.* (B, lectotype designated by Goldblatt, 1976b).

tripetala = with three petals, referring to the three prominent outer tepals and the apparently absent but actually very reduced inner tepals.

Plants 10–50 cm high, sometimes with 1 or more branches. *Corm* 1–2 cm in diameter, tunics variable, pale straw to dark grey, fine to coarsely fibrous. *Cataphylls* pale and membranous. *Leaf* solitary or rarely 2, basal, channelled, linear or nearly lanceolate, sometimes pubescent, usually longer than the stem but bent and trailing, occasionally stiffly erect and shorter than the stem. *Stem* simple or with one to few diverging branches. *Spathes* herbaceous, with dark-brown attenuate apices, *inner* 3,5–7 cm long, *outer* about half as long as the inner. *Flower* pale to dark blue to purple, occasionally pale pink or yellow, with white or yellow nectar guides on the outer tepals; *outer tepals* lanceolate, 2–3,5 cm long, the claw to 1,5 cm long, bearded and often darkly spotted, the limb spreading to reflexed to 45°; *inner tepals* very reduced, inconspicuous, occasionally tricuspidate with a longer central cusp, usually filiform or ciliate, occasionally absent. *Filaments* 4–6 mm long, joined at the base only or apparently free; *anthers* 4–8 mm long, the pollen usually red. Ovary exserted from the spathes, *style branches* united into the style only at the very base, 7–10 mm long, crests 5–15 mm long, linear-lanceolate. *Capsule* ellipsoid, 1,3–1,6 cm long; *seeds* medium to small, angular. Chromosome number $2n = 12$.

Flowering time: August to December, latest at high altitudes.

DISTRIBUTION AND HABITAT
Moraea tripetala has a wide range in the winter rainfall area. It extends from Loeriesfontein and Calvinia in the western Karoo to the Cape Peninsula, and eastwards through the Langeberg and Outeniqua mountains to Humansdorp. Unlike most Cape species, it is tolerant of a wide range of conditions, and it seems equally successful in the well-watered Cape mountains and in the semi-arid western Karoo, where it is relatively common in years of good rainfall. In the Karoo it has been recorded all along the Roggeveld escarpment, and between Laingsburg and Touws River. *Moraea tripetala* occurs both on clay and sandy soils and in the western and south-western Cape, and it ranges from low elevations near the coast to the higher Cape mountains. It has a scattered distribution in the southern Cape east of the Caledon district, and occurs only at isolated sites through the Langeberg mountains to George and Humansdorp.

DIAGNOSIS AND RELATIONSHIPS
Moraea tripetala resembles several other members of section *Vieusseuxia* in its general habit and vegetative morphology but it can always be recognized by its flowers with very reduced and typically ciliate inner tepals, nearly free filaments and a vestigial style. The inner tepals are variable. They are usually reduced to small cusps but may be completely absent or occasionally filiform but elongate and rarely even trifid. However, the virtually free filaments that diverge from the base and the style branches that unite close to the ovary do not vary.

66.

M. tripetala.

Only the yellow-flowered *M. thomasiae* has comparable filaments and style branches, but it can always be distinguished by its erect inner tepals with an expanded flat surface.

Moraea tripetala is allied to a number of southwestern Cape species, amongst which are the late flowering *M. debilis* which has the filaments united for half their length; *M. incurva* also with partly united filaments and entire flat inner tepals; and possibly *M. barnardii* which lacks inner tepals and has white flowers with undulate to crisped tepal margins. The relationships of the species of section *Vieusseuxia* are uncertain and appear complex and reticulate so that it is difficult to single out one particularly close relative of *M. tripetala*. The species of section *Vieusseuxia* are apparently interfertile and *M. tripetala* has successfully been crossed with a range of different species such as *M. villosa*, *M. tulbaghensis*, *M. unguiculata* and *M. worcesterensis*. A natural hybrid with *M. unguiculata* has once been found in the wild. *Moraea tripetala*, with its reduced inner tepals and unusual, nearly free stamens and style branches, appears to be a very specialized and isolated species that represents the climax of one line of evolution within the section. Unlike most members of section *Vieusseuxia*, it is common in a variety of habitats over a wide area and it must be considered one of the most successful species of the genus.

VARIATION

Moraea tripetala is unusually variable (Goldblatt, 1976b) and the variation patterns are no more clear now in 1985 than they were ten years ago when I first began to study the species. All populations so far counted have a diploid chromosome number of $2n = 12$. The karyotypes vary only in minor details such as the proportions of chromosome arms and satellite location, indicating a degree of cytological differentiation that may in the future be correlated with the morphological variation.

The variation is largely floral, including colour, size and form, notably the structure of the inner tepals, described above. The colour and texture of the corm tunics is also unusually variable and is evidently linked to the wide range of soils on which the species grows. Plants from sandy areas with adequate moisture tend to have small corms with dark tunics, while plants in drier sandy soils have larger corms with coarse dark fibres. In general, plants on clay soils in dry areas have large corms with pale tunics which have fine inner fibres but quite coarse outer layers. This pattern has exceptions and small dark corms may be encountered among plants growing on clay.

The most important colour variants are the populations with yellow or sometimes pinkish flowers from the mountain valleys near Worcester. This form is very attractive and is an unusual example of intraspecific variation for flower colour. These populations also have pubescent leaves, a feature found sporadically in *M. tripetala*, especially in populations from the more arid parts of its range. There seems no merit in giving taxonomic recognition to either the major colour variants or to the plants with pubescent leaves. The latter feature probably represents a frequently recurring mutation.

A more significant variant is a form with two nearly-equal basal leaves that has been collected at a few sites in the western part of the Little Karoo. Near Barrydale, both this and the more common single-leafed form grow close together and differ also in height and floral features and obviously represent distinct races of *M. tripetala*.

The following major forms can be distinguished.

a. A relatively small-flowered form occurring on sandy soils in the Caledon, Worcester and Cape Town districts. The leaf in this, taken to represent the typical form, is slender, longer than the stem and without pubescence.
b. A tall, often branched, pale blue to purple-flowered form from the Clanwilliam, Calvinia and Vanrhynsdorp districts (matching the type specimens of *M. amabilis*). The claws of the tepals are pale with dark spots.
c. Short, small, dark purple-flowered plants found on clay soils in the Ceres district and in the adjacent western end of the little Karoo. Some of the populations in the Little Karoo comprise plants with two basal leaves, but these appear to differ in no other way from the Ceres plants.
d. Early flowering plants with relatively large flowers, either pale blue or whitish, and a short and fairly broad pubescent leaf, in the western Cape lowlands between Cape Town and Piketberg (perhaps corresponding to *M. tripetala* var. *mutila*).
e. Very late blooming (November–January), small-flowered plants from higher altitudes in the south-western Cape, usually on sandy soils (*M. tripetala* var. *jacquinii*).

HISTORY

Moraea tripetala has been known to botanists since the later seventeenth century when illustrations of excellent quality were printed in several Codices of Cape plants, copies of which are in a few libraries in South Africa and Holland. However, it was apparently not known to Linnaeus who described so many of the more common Cape species, and was only described after his death by his son in 1782. The specimens on which the name was based were collected by Thunberg during his four years of exploration at the Cape and the type material probably came from the Cape Peninsula, although Thunberg mentions the species (or at least his collections) from Piketberg, the Peninsula and 'elsewhere'.

The later history of *Moraea tripetala* is less confusing than most Cape Moraeas that were known as early as the eighteenth century, perhaps because it is so distinctive. It was transferred to *Moraea* by Ker in 1802 when it became clear that the Cape species referred to *Iris* by Linnaeus fil., Thunberg and others, actually belonged to a different genus. Curiously, the great French botanist A. P. de Candolle renamed the species *tripetaloides* when he transferred it to *Vieusseuxia* in 1803 at a time when it was uncertain whether *Moraea* and *Vieusseuxia* should be treated as the same genus or not. Then in

1817, a form with a pubescent leaf was described as *Iris mutila*, which J. G. Baker continued to recognize as a distinct variety in *Flora Capensis*. Other names applied to the species include *Vieusseuxia pulchra* Ecklon and *M. punctata* and *M. monophylla*, both described by Baker after the publication of *Flora Capensis* in 1896. The German, Friedrich Diels, who collected in the north-western Cape, considered the beautiful pale-bluish form of *M. tripetala* from the Nieuwoudtville plateau to be a distinct species which he named *M. amabilis* in 1910. All these species were united under *M. tripetala* with no infraspecific variants recognized in the last revision of *Moraea* for the winter rainfall area (Goldblatt, 1976b).

67. MORAEA UNGUICULATA Ker

Ker, *Bot. Mag.* **16**: tab. 593. 1802; Baker, *Flora Capensis* **6**: 24–25. 1896; Goldblatt, *Ann. Mo. bot. Gdn* **63**: 759–761. 1976. TYPE: South Africa, without precise locality, illustration in *Bot. Mag.* tab. 593.

SYNONYMS
Vieusseuxia unguiculata (Ker) Roemer & Schultes, *Systema Vegetabilium* **1**: 491. 1917.
Iris tricuspis var. *minor* Jacquin, *Icones Plantarum Rariorum* **2**: tab. 222. 1792. TYPE: South Africa, without precise locality, illustration in Jacquin, *Icones Plantarum Rariorum* tab. 222. 1792.
Moraea tenuis Ker, *Bot. Mag.* **26**: tab. 1047. 1807; Baker, *Flora Capensis* **6**: 25. 1896. TYPE: South Africa, without precise locality, illustration in *Bot. Mag.* tab. 1047.
Vieusseuxia tenuis (Ker) Roemer & Schultes, *Systema Vegetabilium* **1**: 491. 1817.
Moraea violacea L. Bolus, *S. African Gard.* **28**: 116. 1928, hom. illeg. non *M. violacea* Baker (1901) (= *M. elliotii* Baker). TYPE: South Africa, Cape, Ceres, *Cook s.n.* (BOL *17020*).
Moraea ceresiana Lewis, *Jl S. Afr. Bot.* **7**: 57. 1941, nom. nov. pro *M. violacea* L. Bolus.

unguiculata = clawed, referring to the pronounced long slender claw (lower part) of the tepals.

Plants 15–60 cm high, simple, or few branched. *Corm* 1–2 cm in diameter; tunics pale to dark grey, fine to coarsely fibrous. *Cataphylls* membranous, becoming dry above with age and sometimes accumulating around the base in a neck. *Leaf* solitary, basal, linear, channelled, usually exceeding the stem and trailing. *Stem* simple or more often branched. *Spathes* herbaceous, becoming dry above, attenuate, dark brown, inner 3–5 cm long, outer about half as long as the inner. *Flowers* white, cream, yellow, brown or pale to deep blue or violet, with white to cream or yellow nectar guides on the outer tepals; *outer tepals* lanceolate, 12–22 mm long, the claw strongly ascending, about as long as the limb, villous, the limb reflexed from 45° to 90°; *inner tepals* erect, 7–12 mm long, tricuspidate with a long, central, incurved and often coiled cusp and 2 short obtuse lateral lobes. *Filaments* 4–6 mm long, joined almost to the apex; *anthers* 3–4 mm long, apiculate, pollen usually yellow. *Ovary* nearly cylindric, 6–8 mm long, exserted from the spathes, *style branches* about 5 mm long, crests erect, 2,5–4 mm long. *Capsule* obovoid, 13–15 mm long; *seeds* small, angular. *Chromosome number* $2n = 12$.

Flowering time: (August to) late September to November, and to early December at higher elevations.

DISTRIBUTION AND HABITAT
Moraea unguiculata is widespread throughout the winter rainfall region. It extends from Steinkopf in northern Namaqualand in the north-west to the Humansdorp district in the south-east. Populations are also scattered through the mountainous areas of the Karoo between Sutherland and Queenstown. It grows on a variety of soils and in different vegetation types, ranging from sandy Cape mountain soils and fynbos vegetation to dry shales and low renosterbosveld. Curiously, it is absent from the Cape Peninsula and the Port Elizabeth district, but elsewhere it is often common.

DIAGNOSIS AND RELATIONSHIPS
Moraea unguiculata is a slender plant with a single channelled leaf and small flowers with distinctive tricuspidate inner tepals, the outer lobes of which are short and obtuse and the inner slender and coiled inwards. The filaments are united in a slender column and the anthers and style branches diverge strongly. It is probably most closely related to *M. bellendenni* and *M. tricuspidata*, but can readily be distinguished from these by its small flowers. Both the last mentioned have broad outer tepals and tricuspidate inner tepals, the inner cusp of which is short and twisted obliquely to one side.

The summer rainfall *Moraea trifida* is closely allied to *M. unguiculata* and probably derived from it. Apart from its different distribution, *M. trifida* can be distinguished by the leaf inserted above the

ground and typically relatively short, often not as long as the stem which is hardly ever branched. In addition, the outer tepals are always fully reflexed and the central cusp of the inner tepal is more or less erect.

VARIATION

The relatively small flowers are usually a dull white to cream but in the mountains of the western Cape they vary in colour from white or deep blue-violet to shades of brown, dull yellow and even pale pink, the last two forms being very inconspicuous. The blue-violet flowered form, restricted to the Ceres district, was described as *M. violacea* by Louisa Bolus. This is an illegitimate homonym, renamed *M. ceresianus* by G. J. Lewis. A distinct form of *Moraea unguiculata* with dull brown flowers and completely reflexed tepals grows in the southern Cape on clay soils between Worcester and Riversdale. The latter, as well as a more typical mountain form from Hermanus, are illustrated here. The long central cusp of the inner tepal is typically coiled inwards, but in plants from the Karoo mountains the cusp may be loosely erect or barely incurved. The corm tunics vary depending on the soil type. Dark, coarsely fibrous to claw-like tunics are usual on soils derived from Cape sandstone, whereas plants growing on clay and granite-derived soils have pale tunics often with finer fibres.

Moraea tricuspidata is diploid, $2n = 12$, and no chromosomal variation has been recorded from the several populations that have been examined from a substantial part of its range. The karyotype is indistinguishable from those of several other species of section *Vieusseuxia*.

HISTORY AND SYNONYMS

Moraea unguiculata was, until my revision of the winter rainfall area species of *Moraea* (Goldblatt, 1976b), treated as distinct from *M. tenuis* and the two were distinguished in *Flora Capensis* by differences in the relative length of the tepal claw and blade, those of *M. tenuis* being half as long as the blade while in *M. unguiculata* the claw and blade were equal. However, with so many more collections available to me, it became clear that there was no consistent difference between the two extremes and it seemed better to treat the two species under *M. unguiculata*, the earlier name by five years. Both were described by Ker and are typified by plates in *Curtis's Botanical Magazine*. *Moraea tenuis*, described in 1807, is readily identified with the brown-flowered form of *M. unguiculata*. The typical form, dating from 1802, has a white flower, speckled with blue. The colouring is unusual and more difficult to match with living populations, but it corresponds reasonably with plants from the dry hills between Worcester and Villiersdorp which have white flowers irregularly speckled with purple and yellow.

There is no record of the source of the plants that were figured in the *Botanical Magazine* but even before the species was grown and named in England, *Moraea unguiculata* was figured in Austria by Nicholas Jacquin in 1792, who called it *Iris tricuspis* var. *minor*. In view of this early figure published by Jacquin, it seems that the honour of first introducing *M. unguiculata* to Europe must go to Franz Boos and Georg Scholl who, in the 1780s, collected so many of the Cape plants described and illustrated by Jacquin (Gunn & Codd, 1981).

68. MORAEA TRIFIDA Foster

Foster, *Contr. Gray Herb.* 114: 49. 1936 as nom. nov. pro *M. rogersii* N. E. Brown; Goldblatt, *Ann. Mo. bot. Gdn* 60: 233–235. 1973. TYPE: as for *M. rogersii* N. E. Brown (below).

SYNONYMS

Moraea rogersii N. E. Brown, *Trans. R. Soc. S. Afr.* 17: 348. 1929, hom. illeg. non Baker (1892) (= *Gynandriris setifolia* (Linnaeus fil.) Klatt). TYPE: South Africa, Transvaal, Pilgrims Rest, *Rogers s.n.* (K, holotype).

Moraea culmea Killick, *Bothalia* 6: 436. 1954. TYPE: South Africa, Natal, Cathedral Peak, *Killick 1558* (PRE, holotype; BOL, K, LD, NBG, NU, P, isotypes).

trifida = referring to the three-lobed inner tepals of the flower.

Plants small to medium, sometimes to 55 cm high. *Corm* 1–2 cm in diameter, with tunics of straw-coloured fibres. *Cataphylls* light brown, reaching shortly above the ground. *Leaf* inserted on the stem some distance above the ground, erect and channelled, 3–4 mm wide, 20–60 cm long, varying in degree of development at flowering and sometimes short. *Stem* erect, simple or rarely branched, sheathing bract leaves 1–2(–3), herbaceous with a dry, brown apex, 5–6 cm long. *Spathes* herbaceous with dry brown apices, 3,5–7 cm long, outer spathe 1–2 cm shorter than the inner. *Flowers* creamy yellow, with brown to green markings; *outer tepals* 15–20 mm long, claw erect, slightly shorter than the limb, limb spreading to slightly reflexed, lanceolate, 6–10 mm wide; *inner tepals* about 15 mm high, erect, trifid with short obtuse outer lobes and a long,

61.

M. unguiculata.

slender, more or less erect, inner cusp to 7 mm long. *Filaments* 8–9 mm long, free in the upper 1,5 mm; *anthers* about 4 mm long, often extending beyond the stigma in old flowers. Ovary nearly cylindric, 7–10 mm long, usually included in the spathes, *style branches* about 4 mm long, crests slender, to 4 mm long. *Capsule* barrel-shaped, 12–20 mm long, about 5 mm wide. *Chromosome number* $2n = 12$.

Flowering time: late spring to autumn – November to March, rarely later.

DISTRIBUTION AND HABITAT

Moraea trifida occurs in the well-watered higher areas of eastern southern Africa. It extends from the interior Transkei and Lesotho, through Natal to the south-eastern Transvaal where it is apparently rare. It is most common in the Natal Drakensberg, but this area is also the most well-collected, whereas Lesotho, the Transkei and even the Transvaal are less well known botanically. *Moraea trifida* grows in moist grassland, often along seeps and stream banks.

DIAGNOSIS AND RELATIONSHIPS

Moraea trifida has a single foliage leaf, usually shorter than the stem and inserted above the ground, and differs from other eastern southern African species by its small cream to dull-yellow flower with unusual trilobed inner tepals. The central lobe is long and slender, and usually more or less erect, and the lateral lobes are much smaller and obtuse. In other summer rainfall area species with trilobed inner tepals, either the tepal itself is very small, or the lateral lobes are as long or longer than the inner. The flower of *M. trifida* is very similar to that of the winter rainfall area species, *M. unguiculata*, and there is no doubt that these two species are closely allied. In fact, it is often difficult to distinguish them when geographical origin is not known. One important difference is that in *M. unguiculata* the leaf is always basal, appreciably longer than the stem, and usually trailing distally. In addition, the inner cusp of the inner tepals is distinctive in typically coiling inwards and the stem is often branched. In *M. trifida* the leaf is often inserted above the ground and is usually relatively short, often not as long as the stem, and the stem is branched only in exceptional specimens. These differences taken together are usually sufficient to separate the two species despite their close resemblance.

HISTORY

This species was first described by N. E. Brown in 1929, to accommodate a number of collections from Natal that had until then been placed in *M. tenuis* (now *M. unguiculata*). However, the name he selected, *Moraea rogersii*, was a later homonym, having already been used by Baker for a different species, and now regarded as conspecific with the common Cape *Gynandriris*, *G. setifolia*. Foster provided the necessary new name *M. trifida* in 1936, by which this eastern mountain species is currently known. *Moraea culmea*, described by D. J. B. Killick in 1954 is conspecific with *M. trifida* and was reduced to synonymy in my revision of *Moraea* for the summer rainfall area of southern Africa. There are no significant differences between the type specimens of *M. trifida* and *M. culmea* and the structure of the flowers is identical. *Moraea culmea* is smaller and has only a single sheathing bract leaf, while the taller, more robust *M. trifida* has two. The size and number of the sheathing bract leaves, however, appear to have no taxonomic significance. In general, early flowering plants are smaller, have a short leaf, and have one bract leaf, while the later flowering plants are taller, have a longer leaf, and have two or even three bract leaves. In spite of this loose correlation, some plants from the same collection may have one or two bract leaves and vary considerably in height and in length of the produced leaf.

69. MORAEA MARIONAE
N. E. Brown

Brown, *Trans. R. Soc. S. Afr.* **17**: 347. 1929; Goldblatt, *Ann. Mo. bot. Gdn* **60**: 235–236. 1973. TYPE: South Africa, Transvaal, Woodbush, *Blenkiron sub Moss 15565* (K, holotype).

SYNONYMS
Moraea exilis N. E. Brown, *Trans. R. Soc. S. Afr.* **17**: 348. 1929. TYPE: South Africa, Transvaal, Saddleback, Barberton, *Galpin 467* (K, holotype; PRE, isotype).

marionae = named in honour of Marion Blenkiron, teacher and lecturer in Botany, who made the type collection.

Plants small, rarely reaching 30 cm in height. *Corm* about 1 cm in diameter, with tunics of pale straw-coloured fibres. *Cataphylls* pale and membranous, sometimes persisting around the base in a neck. *Leaf* solitary, absent in flowering specimens, produced after flowering, linear, channelled, 3–4 mm wide. *Stem* erect, slender, simple, sheathing bract leaves usually 2, the lower inserted near the ground, 2,4–4,5 cm long, herbaceous, dry, brown and attenuate apically. *Spathes* herbaceous with brown attenuate apices, *inner* to 5 cm long, *outer* about two-thirds as long as the inner. *Flowers* white to pale blue, marked with lilac veins; *outer tepals* 15–20 mm long, claw nearly erect, about as long as the limb, limb spreading to somewhat reflexed; *inner tepals* 10–12 mm long, erect, tricuspidate, with short obtuse lateral lobes and a long slender central cusp. *Filaments* about 5 mm long, united in a column, free apically; *anthers* to 4 mm long, extending shortly above the stigmas in older flowers, pollen apparently white. *Ovary* about 8 mm long, usually exserted from the spathes, *style branches* about 4 mm long, crests slender, to 3 mm long. *Capsule* more or less elliptic, to 10 mm long; *seeds* angular. Chromosome number $2n = 12$.

Flowering time: August to October.

DISTRIBUTION AND HABITAT
Moraea marionae occurs over a wide area of eastern southern Africa, extending from Eshowe in Zululand, through Swaziland to Haenertsburg in the eastern Transvaal. Records are few and scattered over this great distance and the species needs further study. It grows in open, low grassland, flowering at the end of the dry season when the short stems extend above the dry ground cover.

DIAGNOSIS AND RELATIONSHIPS
Moraea marionae has small white to pale-bluish flowers that are distinctive in having the inner tepals tricuspidate, with short obtuse lateral lobes and a long central cusp. Except in minor details of coloration, the flowers match very closely those of another summer rainfall area species, *M. trifida*, and there can be no doubt that they are closely allied. They differ mainly in the presence or absence of the foliage leaf at flowering time. All the collections of *M. marionae* lack a leaf, and a recent collection from Mount Sheba near Pilgrims Rest in the eastern Transvaal confirms that the leaf is, in fact, produced after the end of flowering. In *M. trifida*, a generally taller species, the leaf is borne on the flowering stem and is often relatively short. *Moraea trifida* grows in wet grassland, often along streams or seeps, and flowers later in the season than *M. marionae*, from November to January. Thus the two species seem separated on leaf characteristics as well as habitat and flowering time.

The absence of the foliage leaf at flowering time is also known in a few species of section *Polyanthes*, the best known of which is *Moraea stricta*, but these species have a terete leaf and quite different flowers, and they are certainly not closely related to *M. marionae*.

HISTORY
The first collection of *Moraea marionae* was made by Ernest Galpin in 1890 on the slopes of the Saddleback mountains in the Barberton area of the south-eastern Transvaal. Then many years later, in 1927, it was found by Marion Blenkiron east of Pietersburg in the mountains around Haenertsburg. N. E. Brown treated the two collections as separate species in his study of the *Moraea* species of the Transvaal (Brown, 1929), naming the Galpin collection *M. exilis*. There appear to be no differences of any significance between the two and they were united under the name *M. marionae* (Goldblatt, 1973). The species is still poorly known and needs further study.

70. MORAEA PUBIFLORA
N. E. Brown

Brown, *Trans. R. Soc. S. Afr.* **17**: 348. 1929; Goldblatt, *Ann. Mo. bot. Gdn* **60**: 227–229. 1973; TYPE: Swaziland, Hlatikulu, *Stewart s.n.* (K, holotype; PRE, isotype).

Plants medium to tall, 45–75 cm high. *Corm* 1,5–2 cm in diameter, covered with tunics of dark-brown, netted fibres, sometimes forming a neck. *Cataphylls* pale to dark brown, ribbed below. *Leaf* solitary, inserted near the base, usually just above ground level, linear, channelled, 3–4 mm wide and up to 60 cm long. *Stem* usually several-branched, the branches often all held to one side, sheathing bract leaves 2–3, green, with dry, brown apices, 6–8 cm long. *Spathes* herbaceous with dry apices, inner 6–8 cm long, outer about half as long as the inner. *Flowers* white, sometimes flushed pale blue-lilac, darker and scabrid on the reverse of the outer tepals, speckled green to brown on the inner tepals and claws and nectar guides of the outer tepals; *outer tepals* 25–30 mm long, limb and claw more or less equal, limb lanceolate, spreading to slightly reflexed, claw bearded on inner surface, pubescent to scabrid on the reverse; *inner tepals* 15–18 mm long, green spotted with brown, tricuspidate, the lateral cusps slender, 5–7 mm long, erect, expanded above and obtuse, central cusp linear, acute, curving outwards, 5–6 mm long. *Filaments* 13–15 mm long, free in the upper 2 mm; *anthers* 5–6 mm long, extending beyond the stigmas, pollen white. Ovary more or less cylindric, 6–8 mm long, exserted from the spathes, *style branches* 4 mm long, crests linear, 4–5 mm long. *Capsule* ovoid-elliptic, to 10 mm long; *seeds* angular. Chromosome number unknown.

Flowering time: summer months from December to March.

DISTRIBUTION AND HABITAT

Moraea pubiflora occurs in the eastern Transvaal and Swaziland, ranging from Pilgrims Rest in the north to Wakkerstroom in the south. It is one of the few species of *Moraea* endemic to the eastern Transvaal-Swaziland part of the eastern escarpment where it grows in well-watered, stony, mountain grassland, often amongst a rich herbaceous flora.

DIAGNOSIS AND RELATIONSHIPS

Moraea pubiflora has large pale flowers marked brown and greenish on the claws of the outer tepals and on the very unusual tricuspidate inner tepals, which are divided into three subequal slender lobes, the outer two being expanded at the apex and obtuse, and the inner slender with an acute apex. The outer tepals are peculiar in being scabrid to pubescent on the reverse and the very long filaments are united in a slender column, about 13 mm long, and are free in the upper 2 mm. Similar inner tepals are also found in *M. brevistyla* and *M. dracomontana*, related species from the Drakensberg and coastal Natal. In *M. brevistyla* the flowers are smaller and the tepal claws, style and filament column much shorter, so that although the flowers of this and *M. pubiflora* are in general similar, there is no likelihood of their being confused. In my study of *Moraea* in eastern southern Africa, I treated *M. pubiflora* as comprising two subspecies: the northern and typical form with a robust habit, large flowers with a markedly scabrid outer surface on the claw of the outer petals and a long style and filament column; and the southern, with smaller flowers, little or no scabridity and a short style and filament column. The differences between the two, however, now seem too great and I feel compelled to regard them as separate species. The reasons for this are presented in more detail under the discussion of *M. brevistyla*.

HISTORY

Moraea pubiflora was discovered by Rudolf Schlechter in 1893 near Belfast in the eastern Transvaal. This very distinctive species was recollected by Harry Bolus a few years later, and then in 1911 by Mabel Stewart who first recorded it in Swaziland. It was the latter collection that caught the attention of N. E. Brown, who described it in 1929 together with several more new Moraeas from the Transvaal (Brown, 1929).

Moraea pubiflora has a comparatively large and very attractive flower, and although not as far as I know ever introduced into cultivation, its strangely structured flower would make the effort to obtain and establish it very worthwhile. I suspect that it would do very well as a garden subject throughout the summer rainfall area, except perhaps along the coast where it is probably too hot.

70.

M. pubiflora.

71. MORAEA BREVISTYLA (Goldblatt) Goldblatt, stat. nov.

SYNONYMS

Moraea pubiflora subsp. *brevistyla* Goldblatt, *Ann. Mo. bot. Gdn* 60: 229-230. TYPE: South Africa, Natal, Cathkin Park, *Galpin s.n.* (BOL *30823*, holotype).

brevistyla = with a short style, referring to the major difference between this and the allied *M. pubiflora*.

Plants medium 15-35(-60) cm high. *Corm* about 15 mm in diameter, covered with tunics of dark-brown, fine reticulate fibres. *Cataphylls* pale to dark brown, usually dry above at flowering time, sometimes becoming fibrous and persisting around the base. Leaf solitary, inserted near the base, usually just above ground level, linear, channelled, 3-4 mm wide and up to 60 cm long. *Stem* usually several-branched, the branches often all held to one side, sheathing bract leaves 2-3, green, with dry, brown apices, 5-7 cm long. *Spathes* herbaceous with dry, brown apices, *inner* 4-5 cm long, *outer* about half as long as the inner. *Flowers* white, sometimes flushed pale blue-lilac, grey to purple on the reverse, inner tepals and claws and nectar guides of the outer tepals yellow, with brown spots; *outer tepals* about 20 mm long, limb and claw more or less equal, limb lanceolate, spreading to slightly reflexed, claw bearded on inner surface, lightly pubescent to smooth on the reverse; *inner tepals* 8-10 mm long, tricuspidate, with slender, erect obtuse lateral lobes, 3-4 mm long, central cusp linear, acute, curving outwards, to 4 mm long, pollen yellowish. *Filaments* 6-7 mm long, free in the upper 1 mm; *anthers* 4-5 mm long extending beyond the stigmas. Ovary more or less cylindric, 5-6 mm long, exserted from the spathes, *style branches* about 4 mm long, crests linear, 2-3 mm long. *Capsule* obovoid, mature ones not seen; *seeds* probably angled. Chromosome number unknown.

Flowering time: summer months from late November to March.

DISTRIBUTION AND HABITAT

Moraea brevistyla has its centre of distribution in the Drakensberg of Natal and Lesotho and extends into the south-eastern Orange Free State and to Wakkerstroom at the southern edge of the Transvaal, while a disjunct population has been recorded in the Katberg in the eastern Cape. It grows in grassland, often near streams or seeps.

DIAGNOSIS AND RELATIONSHIPS

Moraea brevistyla is distinguished from the allied eastern southern African species of section *Vieusseuxia* by its comparatively small pale-coloured flower, and from its immediate relative, the eastern Transvaal and Swaziland *M. pubiflora*, by a much shorter style and filament column. The outer tepals are white to cream and spread horizontally, whereas the peculiar inner tepals are upright with the long lateral cusps obtuse and erect and the slender acute central cusp curving outwards in a wide arc.

It seems fairly certain that *Moraea brevistyla* is most closely related to *M. pubiflora* as the structure of the flowers of the two species is very similar, and the inner tepals are so distinctive. *Moraea pubiflora* has a much larger flower and it differs particularly in having longer tepal claws, style and filament column, the latter reaching 15 mm long in comparison to 5-7 mm in *M. brevistyla*. *Moraea pubiflora* is also peculiar in having the reverse of the large outer tepals scabrid to pubescent in texture, a feature as far as I know unique in *Moraea*. However, as already mentioned, the general flower structure of these two species is similar, and I originally treated *M. brevistyla* as a subspecies of *M. pubiflora* (Goldblatt, 1973). The differences between the two are sharp and discontinuous and remain consistent over a wide range and there is no possibility of confusing them. The differences in fact, seem greater than between several other related species pairs and warrant the raising of *M. brevistyla* to specific rank. A collection from the Wakkerstroom area of the south-eastern Transvaal (Goldblatt, 1973) appears to comprise both species or hybrids between them, but this is the only place where there can be any confusion between the two.

The distinctive inner tepals of *Moraea brevistyla*

and *M. pubiflora* are also found in *M. dracomontana*, a presumably allied species from the higher Drakensberg. The inner tepals are uniformly purple in this species, rather than yellow, mottled brownish to green. Differences between *M. dracomontana* and *M. brevistyla* besides the flower colour, include the semi-terete leaf with inrolled margins and an unbranched stem, and they are unlikely to be confused despite their evident close relationship.

HISTORY

The first collection of *Moraea brevistyla* was apparently made by the English plant collector, Thomas Cooper, who botanized the eastern Cape in 1860–1861. His specimens, preserved at Kew, appear to have largely been overlooked, but there seems to be no doubt that the identification is correct and that Cooper found *M. brevistyla* in the Queenstown district, and probably in the Katberg Mountains where until recently it had not been recollected. Later *M. brevistyla* was found in Natal where it is more common, the first records from here being made by the Natal botanist, John Medley Wood, who collected extensively in the colony in the later nineteenth and early twentieth centuries. His collections of *M. brevistyla* are known from several localities, and were initially regarded simply as forms of *M. tricuspis* (now *M. tricuspidata*), a strictly winter-rainfall area species. Early collections of *M. brevistyla* were made in lowland Natal, around population centers, but more recently it has been collected in northern Natal, Zululand and throughout the Drakensberg. It is apparently absent from the Transkei, but occurs in the Katberg mountains of the eastern Cape, an unusually large disjunction in the range. Further plant exploration in the Transkei will show whether the break in distribution is real or the result of incomplete collecting.

Moraea brevistyla is not known to have ever been grown in gardens but its floriferous habit would certainly make it an interesting subject. Mature fruit and seeds are still required to complete the description, and a chromosome number is not yet known for the species or its relative *M. pubiflora*.

72. MORAEA ALBICUSPA Goldblatt

Goldblatt, *Ann. Mo. bot. Gdn* **64**: 230–231. 1973. TYPE: South Africa, Natal, source of the Tina River, summit of the Drakensberg, *Galpin 6846* (BOL, holotype; PRE, SAM, isotypes).

albicuspa = with a white cusp, referring to the reduced inner tepals which are white and represented by a short, usually simple, slender cusp.

Plants tall, to 60 cm high. *Corm* 12–20 mm in diameter, with tunics of brown fibres. *Cataphylls* brown, irregularly broken and somewhat fibrous, accumulating with the decayed leaf bases in a neck around the base. *Leaf* channelled, linear, usually much longer than the stem, often dry and broken distally. *Stem* erect, simple or with 1–2 branches, sheathing bract leaves 2–4, herbaceous with dry, brown apices, 4–6 cm long, attenuate. *Spathes* herbaceous, apically dry and brown, inner 5–7 cm long, outer about two-thirds as long as the inner. *Flowers* white to cream, with yellow nectar guides, dark-spotted on the outer tepal claws and the edges of the nectar guides; outer tepals 30–35 mm long, claw strongly ascending, slightly longer than the limb, limb 14–18 mm long, 11–15 mm wide, spreading horizontally; inner tepals reduced and cusp-like, undivided or slightly 3-lobed apically, 5–7 mm long, acute. *Filaments* 7–8 mm long, united in a cylindrical column, free apically for less than 0,5 mm; anthers 5–6 mm long, not reaching the stigma lobes, pollen white. Ovary more or less cylindric, about 10 mm long, usually exserted from the spathes, *style branches* to 7 mm long, crests slender, to 8 mm long. *Capsules* and *seeds* not known. *Chromosome number* not known.

Flowering time: January to March.

DISTRIBUTION AND HABITAT

Moraea albicuspa occurs in the southern Drakensberg mountains from Giants Castle through the Sani Pass and Bushmans Nek areas to Engcobo in the Transkei. It grows in well-watered mountain grassland, usually among rocks or in thick clumps of grass or sedge.

DIAGNOSIS AND RELATIONSHIPS

Moraea albicuspa is quite unlike any other *Moraea* from the summer rainfall area in its comparatively large cream to white flower which is distinctive in having the inner tepals reduced to slender needle-like cusps some 7–8 mm long. The inner tepals are usually linear, but occasionally there is a suggestion of the development of a trilobed structure towards the apex. The outer tepals are about 35 mm long and have a horizontally-spreading limb and a long sub-erect claw that completely conceals the stamens and most of the style branches. The filaments are comparatively short so that the anthers are completely concealed by the tepal claws. *Moraea albicuspa* is probably most closely allied to

M. brevistyla which has much smaller flowers and spotted tricuspidate inner tepals. The reduced size of the inner tepals of *M. albicuspa* and their typically needle-like structure makes the species easily to recognize, and it is unlikely to be confused with any other species.

HISTORY

Moraea albicuspa was discovered by Harry Bolus in the late nineteenth century at Engcobo and Maclear in what was then the north-eastern Cape, but the species remained unnamed until 1973 when I revised the eastern southern African species of the genus. By that time, several more collections had been discovered and it was quite clear that this was a very distinct species with an apparently limited distribution in the southern Drakensberg along the Transkei–Lesotho–Natal border. Since 1973, several more specimens have been collected, filling out the geographical range, and *M. albicuspa* is now much better known. The most recent collections are from Sehlabathebe National Park in south-eastern Lesotho, an area from which it was not previously known. Further collecting in Lesotho will almost certainly add to the known range of *M. albicuspa*.

73. MORAEA DRACOMONTANA
Goldblatt

Goldblatt, *Ann. Mo. bot. Gdn* 60: 231–232. 1973. TYPE: South Africa, Natal, Langabalela Pass, Giants Castle, *Trauseld 500* (PRE, holotype; CPF, NU, isotypes).

dracomontana = from the Drakensberg mountains, where the species is endemic.

Plants small, reaching to 30 cm high. *Corm* about 10 mm in diameter, with tunics of fine, light-brown fibres. *Cataphylls* brown, irregularly broken, extending well above the ground, accumulating with the fibrous remains of the decayed leaves in a neck around the base. *Leaf* apparently terete, with a narrow adaxial groove and tightly inrolled margins, about as long as the stem, often broken above. *Stem* erect, rarely branched, sheathing stem bracts 2, green with dry, brown apices, 3,5–5,5 cm long. *Spathes* green, with dry, brown apices, attenuate, *inner* 4,5–6 cm long, *outer* slightly more than half as long as the inner. *Flowers* blue-purple with yellow nectar guides on the outer tepals; *outer tepals* 25–30 mm long, limb to 18 mm long; *inner tepals* 3–6(–10) mm long, tricuspidate, with the outer lobes linear, expanded and obtuse apically, central cusp slender, acute, shorter to about as long as, or occasionally longer than, the lateral lobes. *Filaments* 3–5(–6) mm long, united in the lower half to two-thirds; *anthers* 4,5–6 mm long, mauve, not reaching the stigmas, pollen orange. Ovary nearly cylindric, 6–9 mm long, usually at least partly included in the spathes, *style branches* about 8 mm long, crests, lanceolate, to 6 mm long. *Capsule unknown. Chromosome number* unknown.

Flowering time: November to January.

DISTRIBUTION AND HABITAT

Moraea dracomontana is restricted to the higher parts of the Drakensberg where it occurs between Witsieshoek in the extreme eastern Orange Free State, and Bushmans Nek near the Natal–Lesotho–Cape border. It grows in damp grassland at elevations above 2 200 mm.

DIAGNOSIS AND RELATIONSHIPS

Moraea dracomontana is allied to *M. brevistyla* and *M. modesta* but seems intermediate between the two. The characteristic three-lobed inner tepals with the long, obtuse, lateral and acute central cusps remind one of *M. brevistyla* and its close relative *M. pubiflora*, but the purple colour of the flowers and the unbranched stems are distinctive and make *M. dracomontana* easy to recognize in the field. When dry, however, *M. dracomontana* may be confused with *M. modesta*, which has similar, but white to pale bluish flowers, and tiny inner tepals either linear or trifid, but then the central cusp is usually longer than the laterals. *Moraea dracomontana* is still not sufficiently known and details about the leaf are needed. The frequency of plants collected without leaves indicate that the plants may, at least sometimes, be leafless at flowering time or have dry leaves attached to the stem base. This condition is typical for *M. modesta*, which is closely related to, and perhaps derived from, *M. dracomontana*. *Moraea modesta* usually flowers earlier than *M. dracomontana* but they are sympatric over part of their range, and have been collected in flower at the same time and place but in different habitats. *Moraea dracomontana* grows in wetter sites such as streamside grassland, while *M. modesta* grows among rocks or in open well-drained grassland.

HISTORY

When it was first described in 1973, *Moraea dracomontana* was known from only three collections, all from high elevations in the Drakensberg, close to the Natal–Lesotho border. Subsequent collecting in the area by the botanists, Olive Hilliard and Bill

72.

M. albicuspa.

Burtt, who have explored the Drakensberg flora extensively in the last fifteen years, has added substantially to the record of this species which is now known from several more localities, all in the higher Drakensberg. The additional collections confirm the unusual features of the species, in particular, the distinctive inner tepals which are short and trifid with three slender cusps, the outer apically expanded and obtuse, and the inner acute and usually shorter than the laterals. Collections from the southern part of the range have shorter inner tepals and filaments, only 3–4 mm long and united in the lower half, while in the north the filaments are about 6 mm long and free only in the upper third.

74. MORAEA MODESTA Killick

Killick, *Bothalia* **6**: 437; 1954 Goldblatt, *Ann. Mo. bot. Gdn* **60**: 232–233. 1973; TYPE: South Africa, Natal, Cathedral Peak Forest Station, *Killick 1028* (PRE, holotype).

modesta = modest in size, referring to the low stature as well as the small and inconspicuous flowers.

Plants small, usually 10–20 cm high, without a living leaf at flowering time. *Corm* globose, about 10 mm in diameter, the tunics of fine, usually brownish, reticulate fibres. *Cataphylls* membranous, sheathing the stem base, often broken and fibrous above. *Leaf* dry or lacking at flowering time, solitary, terete, with a narrow adaxial groove; sometimes the new season's leaf present but not fully developed. *Stem* slender, erect, rarely branched, sheathing stem bracts 2(–3), attenuate, green with a dry, brown apex, 3,5–5 cm long. *Spathes* attenuate, green with dry, brown apices, *inner* 3–4,5 cm long, *outer* half to two-thirds as long as the inner. *Flowers* white to pale blue-mauve, veined or flushed with purple on the reverse, and inner tepals and style crests usually dark purple, nectar guides yellow, sometimes edged with bluish spots; *outer tepals* 20–27 mm long, claw nearly erect, slightly shorter than the limb, limb 12–15 mm long, narrowly to broadly obovate, 8–15 mm wide; *inner tepals* minute, 2–6 mm long, linear or trifid with the central cusp larger and up to 1 mm long. *Filaments* (3–)4–6 mm long, usually united for about half their length, occasionally free in the upper two-thirds or almost entirely; *anthers* (3–)4–5,5 mm long, usually slightly shorter than the filaments, pollen pale yellow. Ovary nearly cylindric, 7–10 mm long, partly to fully exserted from the spathes, *style branches* 7–10 mm long, narrow, crest linear, 4–6 mm long. *Capsule* narrowly obovoid, 10–12 mm long, fully exserted; *seeds* angled. *Chromosome number* not known.

Flowering time: spring to early summer, from late September to the end of November.

DISTRIBUTION AND HABITAT

Moraea modesta occurs in the mountains of eastern southern Africa, extending from the southern Drakensberg of the Transkei, Natal and Lesotho to the south-eastern Transvaal. It has been recorded from Kokstad in the south to Wakkerstroom and Schoonwater near Machadodorp in the north. *Moraea modesta* grows in mountain grassland at elevations between 1 800–3 000 m where it normally flowers early in the growing season when the grass is dry and short.

RELATIONSHIPS

Moraea modesta is one of the smallest and most inconspicuous members of section *Vieusseuxia*, and it appears to be one of the most specialized in having the inner tepals reduced to tiny trifid or linear cusps 3–6 mm long. It also stands out in flowering very early in the season for the summer rainfall area, in spring, often before the first rains have fallen. The flowering stem is actually produced at the end of its growing season and is formed in the axil of a leaf produced during the previous summer and autumn. During the dry and cold winter, the leaf gradually dies back so that flowering plants are typical leafless or have a dead leaf attached to the stem base. Sometimes the new season's leaf is present at flowering time, but then it is usually small and it is not attached to the flowering stem. A similar adaptation for flowering after the end of the growing season when the leaf had died is found in *M. thomsonii*, *M. alpia* and *M. marionae*. However, *M. modesta* is not directly related to these species but rather to the rare high Drakensberg species *M. dracomontana* with which it may be confused. *Moraea dracomontana* has a larger flower with deep blue-purple tepals and a living leaf is usually attached to the flowering stem. The pale-coloured flower of *M. modesta* is very different. In the field the two species cannot be confused, but in the herbarium where the natural colour is lost, correct identification may be more difficult. The inner tepals of *M. modesta* are smaller than those of *M. dracomontana* and can be used reliably to separate the species. In *M. modesta* the inner tepals are 2–6 mm long and linear to trifid, and then with the central cusp longer than the laterals, whereas in *M. dracomontana* the inner tepals are 3–10 mm

long and always tricuspidate, with the lateral lobes apically expanded and obtuse and the central usually shorter and acute.

The most northerly record, from Schoonwater, in the mountains near Machadodorp in the eastern Transvaal, is interesting as it has the unusual feature of nearly free filaments and style branches free almost to the base. The anthers are also unusual in being longer than the filaments, whereas the reverse is usual for the *M. modesta*. Further collections from the Transvaal are needed to determine the significance of this variation.

HISTORY

This small species was first described in 1954 by D. J. B. Killick, of the Botanical Research Institute, Pretoria, who collected it on grassy slopes in the Drakensberg at altitudes of between 2 000 and 3 000 m. More material, since examined, confirms this general observation of its habitat, and the geographical range has been extended considerably by subsequent collecting and the discovery of some older collections in herbaria.

75. MORAEA TRICUSPIDATA
(Linnaeus fil.) G. Lewis

Lewis, *Jl S. Afr. Bot.* **14**: 89. 1948, name misapplied to *M. aristata* (as *M. glaucopis*); Goldblatt, *Ann. Mo. bot. Gdn* **63**: 765–767. 1976.

SYNONYMS

Iris tricuspidata Linnaeus fil., *Supplementum Plantarum* 98. 1782. TYPE: South Africa, Cape, probably foothills of Devils Peak, Cape Peninsula, *Thunberg s.n.* (Herb. Thunberg *1183*, UPS, lectotype designated by Goldblatt, 1976b).

Iris tricuspis Thunberg, *Dissertatio de Iride* no. 15. 1782. TYPE: As for *Iris tricuspidata* Linnaeus fil.

Vieusseuxia tricuspis (Thunberg) Sprengel, *Systema Vegetabilium* **1**: 165. 1825.

Moraea tricuspis (Thunberg) Ker, *Bot. Mag.* **16**: tab. 696. 1803; Baker, *Flora Capensis* **6**: 25. 1896, in part.

Moraea confusa G. Lewis, *Jl S. Afr. Bot.* **14**: 89. 1948. TYPE: Illustration in *Bot. Mag.* **16**: tab. 696. 1803.

Moraea bellendenii subsp. *cormifera* Goldblatt, *Ann. Mo. bot. Gdn* **61**: 236. 1973. TYPE: South Africa, Cape, Atherstone area, Albany, *Jacot-Guillarmod 6706* (GRA, holotype; RUH, isotype).

tricuspidata = three-cusped, alluding to the three-lobed inner tepals.

Plants 25–60 cm high, usually several-branched. *Corms* 1–2 cm in diameter, with pale to dark-brown tunics of medium to coarse fibres. *Cataphylls* membranous and pale to dark brown, often irregularly broken above. *Leaf* solitary, basal, glabrous, 4–7 mm wide, exceeding the inflorescence and often trailing. *Stem* simple or more often branching from the upper nodes, the branches slender, diverging from the axis, sheathing stem bracts 5–7 cm long, dry and attenuate above. *Spathes* herba-

ceous, occasionally brown above, apices attenuate, *inner* 4–7 mm long, *outer* about half as long as the inner. *Flowers* white to cream, speckled-brownish at the centre, with yellow- to brown-speckled nectar guides on the outer tepals; *outer tepals* 26–30 mm long, claw nearly erect, slightly shorter than the limb, 3–5 mm wide at the midpoint, pubescent, limb about 15 mm wide, spreading more or less horizontally; *inner tepals* tricuspidate, to 12 mm long excluding the central cusp, to 4 mm wide below the point of forking, the lateral lobes obtuse, inner slender and coiled obliquely inwards, 3–5 mm long. *Filaments* 6–7 mm long, united in the lower half; *anthers* about 5 mm long, pollen whitish. Ovary 8–12 mm long, exserted from the spathes, *style branches* 6–7 mm long, crests usually 5–7 mm long. *Capsule* obovoid, 15–22 mm long; *seeds* angled. *Chromosome number* $2n = 12, 24$.

Flowering time: (September to) October to mid-November.

DISTRIBUTION AND HABITAT

Moraea tricuspidata is a winter rainfall area species with a wide distribution extending from the Cedarberg mountains in the west, to the Cape Peninsula, and eastwards as far as Grahamstown in the eastern Cape. It is rare in the western Cape mountains but common on the Cape Peninsula. *Moraea tricuspidata* grows at mid to lower elevations in the mountains, and less often on flats near the coast. Plants have been found on both clay and sandy soils, but more often on heavier soils. It is most common after fires, but does flower even when undisturbed at some sites.

DIAGNOSIS AND RELATIONSHIPS

Moraea tricuspidata has large white to cream flowers with dark tepal claws and small tricuspidate inner tepals, the latter peculiar in their short, obtuse lateral lobes and slender, obliquely coiled inner cusp. It is closely allied to *M. bellendenii* and barely distinguishable from it without knowledge of flower colour; the flowers of *M. bellendenii* are clear yellow in contrast to white to cream in *M. tricuspidata*. When alive the flowers can be distinguished by their shape. The tepals of *M. bellendenii* curve upwards giving the flower a cupped appearance, while the tepals of *M. tricuspidata* spread horizontally. When pressed, slight but apparently consistent differences in size of floral parts can usually be relied upon to give a correct determination. The filaments are 5–6 mm long in *M. tricuspidata* and 3–4 mm long in *M. bellendenii*. The two species have different habitat preferences. *Moraea tricuspidata* always blooms slightly earlier and typically grows on clay slopes, while *M. bellendenii*, often taller and more branched, prefers sandy situations. Occasionally the two grow near one another as at some sites on the Cape Peninsula, and hybrids have been reported. These are intermediate in height and the flowers are a pale creamy yellow.

It is also occasionally difficult to distinguish *Moraea tricuspidata* from the white-flowered forms of *M. lurida* such as are found on Houw Hoek Pass, but these are usually shorter, have blackish corm tunics and invariably occur in sandy mountain soils. Particularly robust forms of *M. unguiculata*, like those from northern Namaqualand may also be confused with *M. tricuspidata*. These two species are no doubt closely related, but *M. unguiculata* can be distinguished by its generally smaller flowers with lanceolate and reflexed outer tepal limbs and a symmetrically incurving to coiled central cusp of the inner tepal.

A form of *Moraea tricuspidata* with red-brown markings from the extreme east of its range between Humansdorp and Grahamstown was recognized as a distinct subspecies (Goldblatt, 1973) and was assigned to *M. bellendenii* as subsp. *cormifera*. Though somewhat different from forms occurring further west, it is not given taxonomic recognition here and thus is reduced to synonymy.

Moraea tricuspidata is heteroploid. Populations in the east of its range, at Humansdorp and Grahamstown, and the Cedarberg population are tetraploid, $2n = 24$, while those on the Cape Peninsula are diploid, $2n = 12$. More counts are necessary from populations over the entire range before the significance of this can be assessed.

HISTORY

This comparatively widespread species is common on the Cape Peninsula, and it was here that Carl Peter Thunberg first collected it in the 1770's. His plants and manuscripts formed the basis for the younger Linnaeus' (1782) *Iris tricuspidata*. In Thunberg's amplified description, published later the same year, the name is changed slightly to *I. tricuspis*. Typification of *Moraea tricuspidata* has presented several problems, for Thunberg, in addition to a detailed description, cites several varieties and three localities. The several specimens annotated "tricuspis" in the Thunberg collection at Uppsala comprise *M. tricuspidata*, *M. villosa*, *M. aristata* and probably *M. bellendenii* (Goldblatt, 1976b). Thunberg's detailed description clearly refers to a white-flowered species with tricuspidate inner tepals. The outer tepals are described as having a yellow, black-spotted claw and suborbicular, white limb, while the inner tepals are spotted brown, and trilobed, with the inner lobe somewhat longer than the outer ones. This description can only match the specimen now designated the lectotype. G. J. Lewis' interpretation of *M. tricuspidata* as conspecific with *M. aristata* (which she called *M. glaucopis*) was based on a different understanding of the original description and typification, and as a result, she had to rename what is here *M. tricuspidata*, calling it *M. confusa*, alluding to the nomenclatural confusion relating to the plant.

75.

N. tricuspidata

76. MORAEA BELLENDENII (Sweet) N. E. Brown

Brown, *Kew Bull.* 1929: 139. 1929; Goldblatt, *Ann. Mo. bot. Gdn* 63: 767–769. 1976.

SYNONYMS

Vieusseuxia bellendenii Sweet, *Hortus Britannicus*, ed. 1. 395. 1827. TYPE: South Africa, without precise locality, illustration in *Bot. Mag.* 20: tab. 772. 1804.

Moraea tricuspis (Thunberg) Ker var. *lutea* Ker, *Bot. Mag.* 20: tab. 772. 1804. TYPE: South Africa, Cape, without precise locality, illustration in *Bot. Mag.* tab. 772. 1804.

Moraea pavonia (Linnaeus fil.) Ker var. *lutea* (Ker) Baker, *Flora Capensis* 6: 24. 1896.

Vieusseuxia spiralis de la Roche, *Descriptiones Plantarum Aliquot Novarum* 31. 1766. TYPE: South Africa, Cape, without precise locality, illustration in De la Roche, *Descriptiones Plantarum* tab. 5 1766.

bellendenii = named in honour of John Bellenden Ker (*née* John Gawler), nineteenth-century English botanist and expert in Iridaceae.

Plants slender, 50–100 cm high, usually several-branched. *Corms* 1,5–2 cm in diameter, with light-brown tunics of medium to coarse fibres, *Cataphylls* pale and membranous. *Leaf* solitary, basal, linear, glabrous, to 1 cm wide, exceeding the inflorescence but trailing. *Stem* more or less erect or inclined above, branching at the upper nodes, branches slender, diverging little from the main axis, sheathing stem bracts 6–10 cm long, herbaceous, dry and straw-coloured above, attenuate. *Spathes* herbaceous, brown above, attenuate, *inner* 5–7 cm long, *outer* about half as long as the inner. *Flowers* yellow, speckled in the centre, the nectar guides deeper yellow, indistinct; *outer tepals* 22–33 mm long, claw 9–13 mm long, broad, darkly-veined and speckled, limb 14–18 mm wide, about as wide as long, somewhat ascending and the margins curving upwards; *inner tepals* tricuspidate, 8–10 mm long excluding the inner cusp, usually to 4 mm wide at the point of forking, lateral lobes short and obtuse, the inner slender, 2–4 mm long and coiled obliquely inward. *Filaments* 3–5 mm long, free for the upper 1 mm; *anthers* 4–5 mm long, pollen pale yellow. *Ovary* 8–10 mm long, exserted from the spathes, *style branches* 6 mm long, crests 3–5(–8) mm long, narrowly triangular. *Capsule* narrowly obovoid, to 15 mm long; *seeds* many, angular. *Chromosome number* $2n = 12$.

Flowering time: October to November.

DISTRIBUTION AND HABITAT

Moraea bellendenii is a common species along the Cape coast from the vicinity of Darling in the west to Knysna and Plettenberg Bay in the east. It is usually found on sandy slopes and flats, especially in the western part of its range, but is also recorded on heavy clay soils. It is generally late blooming when the pale flowers are not easy to see amongst the dry, brown, late-spring vegetation.

DIAGNOSIS AND RELATIONSHIPS

Moraea bellendenii is a tall slender plant, often somewhat willowy in appearance, with yellow flowers, distinctive in their broad ascending, slightly cupped outer tepal limbs. The inner tepals are tricuspidate with short obtuse lateral lobes and a slender central cusp obliquely curved inwards. It is very closely allied to *M. tricuspidata*, from which it is often difficult to distinguish when preserved, as flower colour and tepal orientation are important differences between them. The flowers of *M. tricuspidata* are white to cream, and the outer tepals more or less horizontally extended to slightly reflexed in contrast to the ascending, yellow outer tepal limbs of *M. bellendenii*. Small differences in the size of floral parts can be used as an aid to identification, especially the style branches and stamens which are shorter in *M. bellendenii*. It has filaments 3–5 mm long, compared with 5–6 mm long in *M. tricuspidata*. *Moraea tricuspidata* has the same general distribution as *M. bellendenii*, but it extends further inland and also further east, as far as Grahamstown, and is found predominantly on clay soils. Naturally occurring hybrids between the two are discussed under *M. tricuspidata*.

HISTORY

Moraea bellendenii was one of the first species of *Moraea* to be described, when in 1766, Daniel de la Roche called it *Vieusseuxia spiralis*. The existence of *M. spiralis* Linnaeus fil. (= *Aristea spiralis*), however, prevents the transfer of *V. spiralis* to *Moraea*. Carl Peter Thunberg collected *M. bellendenii* on the Cape Peninsula in the 1770s and included it in *Iris tricuspidata*, as *I. tricuspis* var. *corolla lutea*. Later Ker (1804) transferred it to *Moraea* as *M. tricuspis* var. *lutea*, and it was only in 1827 that it was described as a separate species, but assigned to *Vieusseuxia*, by the English botanist Robert Sweet. It was again treated as a variety in the *Flora Capensis* where J. G. Baker (1896) called it *M. pavonia* var. *lutea*. Only in 1929 did *M. bellendenii* come to rest in *Moraea*.

A subspecies, *Moraea bellendenii* subsp. *cormifera*, which I described in 1973 from the Grahamstown area, is misplaced under this species and is now referred to *M. tricuspidata*.

CULTIVATION

Moraea bellendenii is not in cultivation but has been grown occasionally at Kirstenbosch, where it does well in garden conditions. It is unsuitable for pot culture because of its height, but would be an excellent plant for naturalizing among native shrubs. The long-lasting and quite large flowers also make an interesting cut flower. *Moraea bellendenii* has excellent potential for garden display.

76.

M. bellendenii.

77. MORAEA ATROPUNCTATA Goldblatt

Goldblatt, *Ann. Mo. bot. Gdn* **69**: 362–364. 1982. TYPE: South Africa, Cape, Caledon district, Vleitjies Farm, Eseljacht Mountains, *Goldblatt 5635* (MO, holotype; K, NBG, PRE, S, US, isotypes).

atropunctata = darkly spotted, referring to the speckled markings on the outer tepals.

Plants 15–20 cm high. *Corm* 9–12 mm in diameter, with tunics of light-brown reticulate fibres. *Cataphyll* membranous, often conspicuous and dark brown above. *Leaf* solitary, basal, linear, channelled, margins heavily ciliate-pubescent, 4–8 mm at the widest point, usually erect, slightly longer to about twice as long as the stem. *Stem* erect, simple or 1-branched, glabrous, sheathing stem bracts 2,5–4 cm long, attenuate, brown and dry apically. *Spathes* herbaceous, attenuate, brown above, *inner* 4,5–6,5 cm long, *outer* about half as long as the inner. *Flower* cream, red-brown on the reverse, nectar guides yellow, densely spotted dark-brown or blue on the claws and near the base of the outer tepal limbs; *outer tepals* 20–24 mm long, claw 5–7 mm, dark-coloured and bearded, limb 17–25 mm wide, spreading horizontally; *inner tepals* 9–15 mm long, tricuspidate, central cusp longest, acute, straight or twisted, lateral lobes short, obtuse, yellow, speckled brown, and darker below. *Filaments* about 5 mm long, united, free in the upper 0,5 mm; *anthers* about 4 mm long, pollen orange. Ovary 10–14 mm long, usually exserted from the spathes, *style branches* 4–5 mm long, *crests* to 4 mm long. *Capsule* oblong to cylindric, 2,5–3,5 cm long, somewhat inflated; *seeds* not seen. Chromosome number $2n = 12$.

Flowering time: mid-August to September.

DISTRIBUTION AND HABITAT

Moraea atropunctata is a local endemic of the Caledon district in the south-western Cape where it is known only from a small area on the southern slopes of the Eseljacht mountains north of Caledon. It grows on fertile clay soil, and is now restricted to the edge of farm tracks and the margins of wheatlands where the soil is thin and rocky and unsuitable for cultivation. It seems likely that the former range was larger, but *M. atropunctata* may never have extended beyond the limits of the farm where it now occurs.

DIAGNOSIS AND RELATIONSHIPS

Moraea atropunctata is unusual both in flower and vegetative morphology. It has a single, relatively broad, short leaf with conspicuously pubescent margins. The flowers are a dull off-white colour, and red-brown on the reverse, and the tepal claws and the edge of the nectar guides are marked with dark spots. While it is probably related to *M. tricuspidata* and to the *M. unguiculata* group in general, it is unusual in this alliance. Pubescence is unknown in other species of the *M. unguiculata* alliance but common in the related *M. villosa* group of species. The large, somewhat inflated cylindric capsule, to 3,5 cm long, is also a characteristic of the *M. villosa* group. The flower, however, is more consistent with the *M. unguiculata* alliance in its dull colour and the relatively short and often somewhat twisted central cusp of the inner tepals. The chromosome number is $2n = 12$, and the karyotype is consistent with those described for *M. unguiculata* and its allies.

HISTORY

Moraea atropunctata first came to my attention in 1978 when it was exhibited at the Caledon Wild Flower Show. The following year, specimens again appeared at the Show, and Ion Williams, the Hermanus botanist, obtained several specimens for preservation. Williams also established that the plants came from the farm Vleitjies, on the slopes of the Eseljacht mountains, where it was later recollected and described (Goldblatt, 1982). A painting preserved in the Bolus Herbarium, University of Cape Town, attests to an earlier record of *M. atropunctata*, when it was also exhibited at the Caledon Wild Flower Show.

77.

M. atropunctata.

78. MORAEA LURIDA Ker

Ker, *Edward's Bot. Reg.* **4**: tab. 312. 1818; Baker, *Flora Capensis* **6**: 14. 1896; Goldblatt, *Ann. Mo. bot. Gdn* **63**: 762–763. 1976. TYPE: South Africa, Cape, without precise locality, illustration in *Bot. Reg.* tab. 312.

SYNONYMS

Vieusseuxia lurida (Ker) Sweet, *Hortus Britannicus*, ed. 1. 395. 1825.

Phaianthes lurida (Ker) Rafinesque, *Flora Telluriana* **4**: 30. 1838.

Moraea montana Schlechter, *Bot. Jahrb. Syst.* **27**: 92. 1900. TYPE: South Africa, Cape, Onrus River mouth, *Schlechter 9494* (B, lectotype designated by Goldblatt, 1976b; BOL, GRA, K, PRE, isolectotypes).

Moraea fusca Baker, *Kew Bull.* 1906: 42. 1906. TYPE: South Africa, Cape, Caledon, *Penther 762* (K, holotype; BOL, isotype).

lurida = lurid or dark-red, referring to the most common flower colour.

Plants 20–30 cm high, often branched. *Corm* 1–1,5 cm in diameter with tunics of coarse, often woody, claw-like fibres. *Cataphylls* membranous and pale, dark above ground, sometimes accumulating as a fibrous neck around the base. *Leaf* solitary, basal, linear, glabrous, exceeding the inflorescence, often trailing above, 3–5 mm wide. *Stem* glabrous, usually branched, the branches diverging from the axis, sheathing stem bracts 4–5 cm long, attenuate, dry apically. *Spathes* herbaceous with dry attenuate apices, *inner* (3,5–)4–5,5(–7,0) cm long, *outer* about half as long as the inner. *Flowers* often a dark red-maroon, or partly to entirely yellow to cream, usually foul smelling, with or without nectar guides on the outer tepals; *outer tepals* 22–30 mm long, claw 13–17 mm long, the claw broadest below the knee and narrowed at the apex, lightly papillate, limb to 1 cm wide, spreading to reflexed; *inner tepals* either entire, becoming apiculate, or somewhat 3-lobed at the apex, 12–15 mm long, claw distinct, broad, limb spreading. *Filaments* 5–6 mm long, united almost to the apex; *anthers* 4–6(–8) mm long, apiculate, pollen blackish, red or yellow. Ovary 8–9 mm long, usually exserted from the spathes, *style branches* to 6 mm long, about 2 mm wide, crests 2–3 mm long, triangular. *Capsule* obovoid to elliptic, to 1,5 cm long; *seeds* many, angular. Chromosome number $2n = 12$.

Flowering time: October to November.

DISTRIBUTION AND HABITAT

Moraea lurida is restricted to the Caledon district of the south-western Cape. It occurs on stony, sandstone flats and mountain slopes, from Sir Lowrys Pass to Bredasdorp, and is especially common in the Klein River mountains between Hermanus and Stanford. Plants seldom flower except a year or two after a fire, when they sometimes appear in thousands for a few weeks on exposed, burnt veld.

DIAGNOSIS AND RELATIONSHIPS

Moraea lurida has a single, channelled leaf, a branched stem and unusual flowers with broad inner and outer tepal claws that form a wide cup that includes the stamens and style branches. The tepal limbs are shorter than the claws and extend more or less horizontally. The inner tepals may be similar to the outer, although smaller, or the limbs may be trilobed to tricuspidate. *Moraea lurida* is unusual also in its extremely variable flower colour. In the type and most common form, the flower is dark maroon, and smells faintly of rotten meat. Other colours range from red marked with yellow, through orange, violet, brown, to cream and white. The lighter coloured forms do not seem to smell, yet are equally attractive to flies which visit *M. lurida* in large numbers and are probably the principal pollinators. Individual populations are usually relatively uniform in colour, but almost the whole range of known colours can be seen in some places. The shape of the inner tepals varies from fairly broad and entire to truly tricuspidate with a fairly long coiled central cusp.

Moraea lurida is allied to *M. insolens*, a rare and local species occuring near Caledon, and to the widespread, white-flowered *M. tricuspidata*. *Moraea insolens* has tepals spreading from the base, and distinctive large anthers that exceed the style branches, and it cannot be mistaken for *M. lurida*. Confusion is, however, likely between the white-to cream-flowered forms of *M. lurida* and *M. tricuspidata*. *Moraea tricuspidata* has narrower tepal claws and the inner tepals are tricuspidate with an acute, obliquely incurved central cusp. This species also has pale corm tunics and usually grows on clay soils. This contrasts with the grey to blackish corm tunics of *M. lurida*, which always grows in sandy to rocky ground.

HISTORY

There is no record of who first collected *Moraea lurida* in the wild. The plants described by Ker in 1818, in *Curtis's Botanical Magazine*, together with a good illustration, were introduced from the Cape by a Mr Griffin, who flowered the species in London. Corms or seeds must have been collected a few years earlier at the Cape. Because of its very peculiar flower, *M. lurida* was placed in its own genus *Phaianthes* by the Italian-American botanist Constantin Rafinesque. In 1900, Rudolf Schlechter described *M. montana* from plants with sulphur-coloured flowers that he had collected at Onrus River mouth near Hermanus, apparently overlooking Ker's species, named almost 100 years earlier, or considering his colour form distinct from it. J. G. Baker's new species, *M. fusca*, described in 1906, matches *M. lurida* closely and they are undoubtedly conspecific.

78.

M. lurida.

79. MORAEA INSOLENS Goldblatt

Goldblatt, *Fl. Pl. Africa.* **41**: tab. 1639. 1971; *Ann. Mo. bot. Gdn* **63**: 763–765. 1976. TYPE: South Africa, Cape, Caledon district, Drayton siding, *Goldblatt 570* (BOL, holotype; K, PRE, isotypes).

SYNONYMS

Homeria maculata Klatt, *Linnaea* **34**: 628. 1863, pro parte. TYPE: South Africa, Cape, Caledon district, Boontjieskraal near Zwartberg, *Ecklon & Zeyher Irid. 259 (55.8)* (B, lectotype designated by Goldblatt, 1976b; S, isolectotype); Caledon district, 'Langehoogde', *Ecklon & Zeyher Irid. 38* (B, syntype) = *Homeria* sp.

insolens = radiant or sun-like, referring to the very bright orange, open radiate flowers.

Plants medium tall, to 35 cm high, growing in small clumps. *Corm* 10–14 mm in diameter, with tunics of coarse, brown fibres. *Cataphylls* brown, membranous, becoming fibrous and accumulating around the base in a neck. *Leaf* solitary, linear, channelled, usually exceeding the stem, 2–4 mm wide. *Stem* slender, usually branched, sheathing stem bracts 4–5,5 cm long. *Spathes* herbaceous with dry, brown attenuate apices, *inner* 5–6 cm long, *outer* 3–4 cm long. *Flowers* either bright orange or creamy yellow, with the tepal claws and nectar guides dark brown, the claws spreading from the base and poorly differentiated from the limbs; *outer tepals* 26–30 mm long, claw shorter than the limb, weakly differentiated, limb spreading to slightly reflexed, to 20 mm wide; *inner tepals* similar to the outer but smaller, to 25 mm long, 15 mm wide. *Filaments* 4–5 mm long, united in a column, free apically for less than 0,5 mm; *anthers* about 8 mm long, exceeding the style crests, pollen orange. *Ovary* about 10 mm long, exserted from the spathes, *style branches* 4 mm long, narrow, the crests short, 1–2 mm long, triangular. *Capsule* narrowly obovate to elliptic; *seeds* angled, small. Chromosome number $2n = 12$.

Flowering time: late September and October.

DISTRIBUTION AND HABITAT

Moraea insolens is restricted to the lower southern slopes of the Caledon Zwartberg and is today known from only a single site. It grows on a mixed sandy clay soil that becomes waterlogged in the winter and bakes hard during the dry summer. Like its close ally *M. lurida*, it flowers well only after a fire or when the surrounding vegetation has been cleared. The robust many-branched plants produced in the first season after a fire give way subsequently to smaller, fewer-branched plants in the following years, and by the fourth season few if any plants flower.

At the present only one small population is known and is under protection in a reserve set aside to conserve the species.

DIAGNOSIS AND RELATIONSHIPS

Moraea insolens has most unusual flowers in which the tepal claws are much shorter than the limbs and spread outwards from the base. The claws are broad and hardly differentiated from the limbs. The flower is thus more open than most species of *Moraea*. The style branches are relatively short and the crests only about 2 mm long, and the large anthers exceed and partly conceal them. Despite their very different flowers, *M. insolens* is probably most closely related to *M. lurida*, which has broad, ascending tepal claws forming a cup enclosing the stamens and style branches, and relatively short tepal limbs. The very distinctive long anthers of *M. insolens*, exceeding the stigma lobes, are known in several other species, notably *M. gigandra*. This character has arisen independently in *Moraea*, and species sharing it are not necessarily related.

The type population has orange flowers, but earlier records, from nearer the town of Caledon, have greenish-cream flowers. This form has not been seen for over fifty years and may be extinct.

HISTORY

Moraea insolens was described only in 1971, from plants that were discovered by the late T. T. Barnard east of Caledon. At first this seemed to be the first record of a new species, but paintings of the cream-flowered form, made by Louise Guthrie, were subsequently found in the Bolus Herbarium, University of Cape Town. Apparently, *M. insolens* was displayed at the Caledon Wild Flower Show many years ago, and it was also recorded by Guthrie as growing at the western edge of Caledon.

Only after *Moraea insolens* had been described did I learn that there was an earlier name for the species, *Homeria maculata* Klatt. The description is of an orange-flowered plant with ovate-rotund outer tepals 'green at the base'. All known forms of *M. insolens* have brown markings, but the colour cannot be taken at face value since Klatt was describing dry plants collected forty years before. The name had been applied at times to *H. elegans* (Jacquin) Sweet or to *H. comptonii* L. Bolus, and is typified by collections made by C. F. Ecklon and C. L. Zeyher in the 1820's from two localities near Caledon. One of these, from the farm Boontjieskraal, is undoubtedly *M. insolens*. Specimens matching Klatt's description, and bearing Ecklon & Zehher's manuscript name, *Vieusseuxia aurantiaca* at the Riksmuseum in Stockholm and at the Berlin Herbarium are undoubtedly *M. insolens*, and the Berlin collection has been designated the lectotype (Goldblatt, 1976b). As *M. maculata* Sesse and Moçino (= *Tigridia* sp.) blocks the transfer of Klatt's species to *Moraea*, no change is required to the nomenclature.

79.

M. insolens.

80. MORAEA CAECA Barnard ex Goldblatt

Goldblatt, *Ann. Mo. bot. Gdn* **63**: 21. 1976. TYPE: South Africa, Cape, top of Dasklip Pass near Porterville, *Goldblatt 678* (BOL, holotype; K, MO, PRE, S, isotypes).

caeca = blind, referring to the small, sometimes entirely black nectar guides or 'eyes' at the base of the tepal limbs.

Plants slender, 20–40 cm high. *Corm* about 10 mm in diameter, with tunics of brown fibres. *Cataphylls* dry and scarious, brown, usually broken above and sometimes persisting in a neck around the base. *Leaf* solitary, linear, glabrous, exceeding the inflorescence, channelled, to 3 mm wide. *Stem* usually glabrous, rarely pubescent, occasionally 1-branched, the branch held close to the axis, sheathing stem bracts 4–5 cm long, dry and brown above, attenuate. *Spathes* herbaceous or dry above with brown attenuate apices, *inner* about 5 cm long, *outer* about half as long as the inner. *Flowers* lilac-purple with small, yellow or black nectar guides on the outer tepals, and the outer tepal claws yellow; *outer tepals* 23–28 mm long, claw 8–12 mm long, erect, pubescent, limb wider than long, 18–22 mm wide, spreading horizontally; *inner tepals* tricuspidate, the central cusp 5–8 mm long, spreading, the laterals to 2 mm long. *Filaments* 2–3 mm long, united at least in the lower half to nearly completely; *anthers* 5–7 mm long, dark blue, pollen yellow. Ovary about 10 mm long, exserted from the spathes, *style branches* about 5 mm long, crests acute to obtuse, to 7 mm long. *Capsule* oblong-ellipsoid, to 15 mm; *seeds* angular. Chromosome number $2n = 12$.

Flowering time: late September and October.

DISTRIBUTION AND HABITAT

Moraea caeca has a restricted range in the southwestern Cape where it occurs on the Olifants River mountains between Porterville and Piekenierskloof Pass, and on the Piketberg. It is typically late flowering, and grows in rocky, open sites in sandstone derived soil.

DIAGNOSIS AND RELATIONSHIPS

Moraea caeca is related to the 'peacock' alliance, the group of species allied to *M. villosa*, with broad outer tepal limbs and conspicuous eye-like nectar guides. It has the characteristic broad outer tepal limbs, but lacks the large nectar guides found in other species of the group. Instead of the usual dark crescent surrounding a yellow eye, the nectar guide is a small yellow or solid black dot. The tepals are also less brightly-coloured than other species in the group, being a pale lilac-purple. *Moraea caeca* is the only species in the alliance that has a strictly montane distribution.

Typically the stem and leaves are quite glabrous, but a collection from the Groot Winterhoek (*Haynes 858*) is conspicuously villous. The flowers of this collection are somewhat larger than the usual, but otherwise conform in colour and markings to other populations. *Moraea caeca* is probably most closely related to *M. villosa* and the rare and almost extinct *M. aristata*, both of which occur in lowland areas of the western Cape.

HISTORY

Moraea caeca was first collected in the 1930's by T. T. Barnard and N. S. Pillans in the Piketberg mountains. The early collections attracted little attention from botanists but more recent gatherings from the mountains above Porterville have the manuscript name *M. purpurea* in Joyce Lewis's hand. However, it was not until 1976 that the species was formally described (Goldblatt, 1976a). *Moraea caeca* was then thought to also occur on the Karbonkelberg on the Cape Peninsula, but examination of live plants from the area has made it clear that the identification was incorrect. The Cape Peninsula plants are an unusual purple-flowered form of *M. tricuspidata* (Goldblatt, 1982).

CULTIVATION

Moraea caeca has recently been brought into cultivation, and is at present being grown with success by Jim Holmes at Rustenberg near Stellenbosch. It seems to be an easy subject and flowers well in a sandy soil in open beds. The plants illustrated here were obtained from Holmes' stock. In a few years, seed should be available on a limited basis.

80.

M. caeca.

81. MORAEA AMISSA Goldblatt

Goldblatt, *Ann. Mo. bot. Gdn* **63**: 774–775. 1976. TYPE: South Africa, Cape, Malmesbury district, 10 km NW of Malmesbury, *Acocks 20739* (PRE, holotype)

amissa = lost or missing, alluding to the rarity of the species, which was thought at one time to be extinct.

Plants slender, about 30 cm high. *Corm* about 15 mm in diameter, tunics dark brown, with coarse reticulate to somewhat claw-like fibres, extending shortly upward. *Cataphylls* dry and brown, persisting and accumulating around the base in a neck. *Leaf* solitary, basal, linear, channelled, glabrous, much exceeding the inflorescence and trailing, 1,5–2 mm wide, the margins becoming tightly inrolled. *Stem* erect, glabrous, unbranched, sheathing stem bracts 35–40 mm long, dry in the upper half, dark brown apically and attenuate. *Spathes* herbaceous with dry upper margins, the apices attenuate, dark brown, *inner* 4–4,5 cm long, *outer* about half as long as the inner. *Flowers* violet with white nectar guides outlined in dark purple, the tepal claws blackish; *outer tepals* 17–20 mm long, the claw 7–8 mm, ascending, limb spreading horizontally, 10–13 mm wide; *inner tepals* either entire and lanceolate or becoming tricuspidate, to 15 mm long. *Filaments* 3–4 mm long, free near the apex only, pubescent at the base; *anthers* 4–5 mm long, pollen yellow. Ovary about 7 mm long, exserted from the spathes, *style branches* about 5 mm long, crests 2–4 mm long. *Capsule* ovoid-elliptic, to 12 mm long; *seeds* unknown. Chromosome number unknown.

Flowering time: early to late October.

DISTRIBUTION AND HABITAT

Moraea amissa has a very restricted distribution in the western Cape, where it is limited to a few hectares of undisturbed natural vegetation northwest of Malmesbury. The plants grow in sandy granitic soil, often in rock outcrops, among degraded fynbos or renosterveld vegetation.

DIAGNOSIS AND RELATIONSHIPS

Moraea amissa has a single narrow trailing leaf and a slender, unbranched stem bearing small, violet-blue flowers with white nectar guides. The short filaments are almost completely united, and the inner tepals are lanceolate to obscurely three-lobed. It appears intermediate between the distantly related *M. incurva* and *M. villosa* and its immediate relationships are not apparent. It resembles *M. villosa* in the general aspect of the flowers, with short united filaments and broad outer tepals, although the flower is much smaller, and unlike *M. villosa*, the leaf and stem are smooth, not villous. The inner tepals are either entire or imperfectly tricuspidate and thus seem rather like those of *M. incurva*. *Moraea amissa* is placed here in section *Vieusseuxia* close to the beginning of the peacock alliance where the small flower, glabrous stem and leaf, and distinctive inner tepals distinguish it.

HISTORY

Moraea amissa was first collected in 1959 by the South African, J. H. P. Acocks, famous for his vegetation survey of southern Africa. The collection was overlooked for some time, or only examined superficially and it was not until the 1970's, during my research on *Moraea*, that it was found to be an undescribed species. It was for a time thought to be extinct, but C. J. Burgers of the Cape Department of Nature Conservation has recently relocated small populations on farms north of Malmesbury where it was first discovered. The figure here was drawn from the plants that Burgers found in 1981.

81.

N. anissa.

82. MORAEA ARISTATA (de la Roche) Ascherson & Graebner

Ascherson & Graebner, *Synopsis Mitteleuropaischen Flora* **3**: 518. 1906; Goldblatt & Barnard, *Jl S. Afr. Bot.* **36**: 313–314. 1970; *Ann. Mo. bot. Gdn* **63**: 773–774. 1976.

SYNONYMS

Vieusseuxia aristata de la Roche, *Descriptiones Planatarum Aliquot Novarum* 33. 1766. TYPE: South Africa, Cape, exact locality unknown (cult. Europe), *van Royen s.n.* (Herb. van Royen, L, lectotype designated by Goldblatt, 1970).

Vieusseuxia glaucopis de Candolle in Redoute, *Les Liliacées* **1**: tab. 42. 1803; *Ann. Mus. Natl. Hist. Nat.* **2**: 141, tab. 42. 1803. TYPE: South Africa, without precise locality, illustration in Redoute, *Les Liliacées* tab. 42.

Moraea glaucopis (de Candolle) Drapiez, *Dict, Class. Sci. Nat.* **7**: 478. 1841; Baker, *Flora Capensis* **6**: 23. 1896.

Moraea candida Baker, *Handbook Irideae* 59. 1892, nom. nov. pro *Vieusseuxia fugax* de la Roche.

Ferraria ocellaris Salisbury, *Prodromus Stirpium* 41. 1796, nom. nov. pro *Iris pavonia* var. TYPE: South Africa, precise locality unknown, illustration in *Bot. Mag.* tab. 168. 1791.

Moraea tricuspis (Thunberg) Ker var. *ocellata* D. Don, *Br. Fl. Gard.* ser 2, **3**: tab. 249. 1834. TYPE: South Africa, without precise locality, illustration in *Br. Fl. Gard.*, ser 2. tab. 249.

Moraea tricuspidata (Linnaeus fil.) G. Lewis sensu Lewis, *Flora Cape Peninsula* 231. 1950. excluding the type.

aristata = with an arista or cusp, describing the long central lobe of the inner tepal.

Plants 25–35 cm high. *Corms* 10–15 mm in diameter, with tunics of pale fibres. *Cataphylls* pale and membranous. *Leaf* solitary, linear, glabrous, basal, exceeding the inflorescence, to 5 mm wide. *Stem* glabrous, occasionally 1-branched, sheathing stem bracts 4–5 cm long, dry and brown above, attenuate. *Spathes* herbaceous, dry above with dark-brown, attenuate apices, *inner* 5–7 cm long, *outer* about half as long as the inner. *Flowers* white with prominent nectar guide variously marked with concentric crescents of black, blue-violet, or green on the outer tepals; *outer tepals* 30–35 mm long, claw to 12 mm long, nearly erect, heavily bearded, limb spreading horizontally, about 20 mm long, wider than long, to 25 mm wide; *inner tepals* 15–20 mm long, tricuspidate, the lateral lobes short, obtuse, the central cusp long, spreading. *Filaments* 3–4 mm long, united in a column, free apically; *anthers* about 5 mm long, pollen whitish. Ovary to 10 mm long, exserted from the spathes, *style branches* 7–8 mm long, crests 6–7 mm long, triangular. *Capsule* obovoid, 1,5–2 mm long; *seeds* angled, with a spongy testa. *Chromosome number* $2n = 12$.

Flowering time: September.

DISTRIBUTION AND HABITAT

Moraea aristata is known only from the Royal Observatory grounds on the Liesbeek River, Cape Town. It was probably more common in the past in the vicinity of Cape Town, but did not apparently ever grow elsewhere. The early records indicate that it grew on clay slopes and flats in the northern Cape Peninsula, between Cape Town and Rondebosch, where there is little open land left. Too few individuals remain to constitute a viable population. Not many plants flower and little seed is produced to ensure long-term survival. It is thus on the verge of extinction in the wild, if its present habitat can be described as wild. Its survival is ensured in the short-term through cultivation at Kirstenbosch and in gardens in Europe, Australia and elsewhere.

DIAGNOSIS AND RELATIONSHIPS

Moraea aristata is a striking plant with large, white flowers with conspicuous pale and deep-blue nectar guides or 'eyes' on the broad outer tepals. The inner tepals are tricuspidate with short lateral lobes and a long central cusp. Like other members of the peacock group of species, *M. aristata* has a single basal leaf. It appears to be closely related to *Moraea villosa*, from which it can be distinguished by its glabrous leaf and stem, and by the white flower colour. *Moraea villosa* usually has blue to purple flowers, or sometimes pink or orange, but white is rare and only occurs in a few individuals in any population. *Moraea aristata* is diploid with $2n = 12$, in contrast to *M. villosa* which is polyploid over most of its range, but has a diploid subspecies.

HISTORY

There is no record of how *Moraea aristata* reached Europe, but it was already in cultivation in Holland by the mid-eighteenth century. It was first described in 1766 by Daniel de la Roche, pupil of the Dutch botanist David van Royen, who assigned it to his new genus *Vieusseuxia*. A printer's error, placing the epithets of *V. aristata* and a second species *V. fugax* opposite the wrong descriptions in De la Roche's published dissertation, *Descriptiones Plantarum Aliquot Novarum* (Goldblatt & Barnard, 1970), subsequently led to considerable confusion, and caused botanists to reject both species. *Moraea aristata* was collected some years later by Carl Peter Thunberg, in the 1770's, and his specimens in the Thunberg Herbarium in Uppsala bear the epithet 'tricuspis'. These are probably Thunberg's *Iris tricuspis* var. α (Thunberg, 1782). *Iris tricuspis*

82.

M. aristata.

is a synonym of *M. tricuspidata* (Linnaeus fil.) Lewis. Lewis (1948), rejected *M. aristata* on grounds of nomenclatural confusion, and used the name *M. tricuspidata*, for the species (see discussion under *M. tricuspidata*).

Later in the eighteenth century all the so-called 'peacock' Moraeas were treated as *Moraea* (or *Vieusseuxia*) *pavonia*, under which name *M. aristata* appears in the *Botanical Magazine*. R. A. Salisbury recognized the white-flowered plant illustrated here as different from *M. pavonia*, and he named it *Ferraria ocellaris*. Yet another name was given to *M. aristata*, by A. P. de Candolle, in 1803, who called it *Vieusseuxia glaucopis*, and it is widely known today as *M. glaucopis* in Europe, where it is sometimes grown in gardens.

CULTIVATION

Moraea aristata has been grown and flowered successfully in gardens in Europe for over 200 years but it is seldom seen in South Africa. It can still be found in nursery catalogues, usually under the name *M. glaucopis*. It is hardy to light frost and can be grown in most parts of southern Africa. Over the years it has been grown at Kirstenbosch, lost and reintroduced, but it has never captured the imagination of gardeners in its native land. Nevertheless, it is easy to grow and to maintain in the open ground or in pots. The large flowers last three days and several are produced over a period of up to three weeks. In my opinion it is a superb plant and deserves to be in every wild-flower garden in the country.

83. MORAEA VILLOSA (Ker) Ker

Ker, *Ann. Bot.* (Konig & Sims) 1: 240. 1805; Turrill, *Bot. Mag.* **165**: new series tab. 112. 1950: Goldblatt, *Ann. Mo. bot. Gdn* **63**: 775–776. 1976; *Ann. Mo. bot. Gdn* **69**: 366–368. 1982.

SYNONYMS

Iris villosa Ker, *Bot. Mag.* **16**: tab. 571. 1802. TYPE: South Africa, Cape, without precise locality, illustration in *Bot. Mag.* tab. 571 (lectotype here designated).

Vieusseuxia villosa (Ker) Sprengel, *Systema Vegetabile* 1: 165. 1825.

Moraea pavonia (Linnaeus fil.) Ker var. *villosa* (Ker) Baker, *Flora Capensis* 6: 24. 1896.

Iris tricuspis Linnaeus fil. var. *corolla purpurea* Thunberg, *Dissertatio de Iride* no. 15. 1782. TYPE: South Africa, Cape, without precise locality, *Thunberg s.n.* (Herb. Thunberg, UPS) nom inval, polynom.

For additional synonyms see under subsp. *elandsmontana*

villosa = villous or pubescent, referring to the characteristic hairy leaves and stems.

Plants (15–)20–40 cm high. *Corm* 1–1,5 cm in diameter, tunics of fine to coarse pale straw fibres. *Cataphylls* membranous, brown, sometimes accumulating as a fibrous neck around the base. *Leaf* solitary, linear, channelled, basal, pubescent on the outer surface, occasionally only on the margins and veins, as long as or more often exceeding the stem. *Stem* villous, simple or 1–2 branched, sheathing stem bracts attenuate, brown-tipped, 3–5 cm long. *Spathes* herbaceous or dry above, with dry brown attenuate apices, *inner* 4–6 cm long, *outer* 2,5–4 cm long. *Flowers* various shades of purple, lilac, or sometimes pink or orange (rarely cream to white), with yellow nectar guides on the outer tepals outlined in 1–2 broad bands of dark colour; *outer tepals* 28–40 mm long, claw 8–12 mm long, suberect, limb nearly circular, 20–28 mm long, about as wide as long, spreading horizontally to slightly reflexed; *inner tepals* 16–30 mm long, tricuspidate, with 2 short obtuse lateral lobes and a long, slender, more or less spreading central cusp. *Filaments* 4–5 mm long, united almost to the apex; *anthers* 6–10 mm long, reaching, or occasionally slightly exceeding the stigma lobe. *Ovary* 7–10 mm long, cylindric, usually exserted from the bracts, style branches 5–7 mm long, to 8 mm wide, crests (2,5–)5–8 mm long, erect, sometimes inconspicuous. *Capsules* cylindric, 2–3 cm long; *seeds* angular, with an inflated spongy testa. *Chromosome number* $2n = 12$ (subsp. *elandsmontana*); 24 (subsp. *villosa*).

Flowering time: August to September.

DISTRIBUTION

Moraea villosa was once common on the flats and lower mountain slopes of the western Cape between False Bay and the Olifants River mountains. Farming activities have greatly decreased its range, but it is still to be found in large colonies in undisturbed areas below Gydo Pass north of Ceres, in the Tulbagh valley, and on the Piketberg mountains. It blooms well after fires or when the surrounding vegetation has been well grazed or partly cleared. *Moraea villosa* prefers heavier soils, and is more often found on clays or decomposed granites, but it does also grow on sandy or stony Cape mountain soil.

83a.

M. villosa. subsp. villosa.

DIAGNOSIS AND RELATIONSHIPS

A typical member of section *Vieusseuxia*, *Moraea villosa* has long-lasting flowers with tricuspidate inner tepals. It can readily be distinguished from most species of the section by its pubescent stem, villous leaves and large, broad outer tepals. The nectar guides are conspicuous, consisting of a central yellow eye surrounded by 1–2 broad concentric bands of dark blackish, purple, blue or green. The illustration here shows some of the variation in the colour of the tepals and nectar guides encountered in *M. villosa*.

Moraea villosa is regarded as comprising two subspecies (Goldblatt, 1982). Subsp. *elandsmontana*, described in 1982, can readily be distinguished from subsp. *villosa* by its orange flowers with somewhat ascending, cupped outer tepals. The flowers are otherwise very like those of subsp. *villosa*, although in size they fall in the lower part of the range for the latter. Thus the outer tepals of subsp. *elandsmontana* are 28–31 mm long and the anthers about 7 mm, compared with outer tepals 28–40 mm long and anthers 6–10 mm in subsp. *villosa*. An important factor in deciding to recognize subsp. *elandsmontana* was the chromosome number $2n = 12$, in contrast to subsp. *villosa*, the several counts for which are all polyploid, $2n = 24$.

Moraea villosa is the central species of the peacock alliance, members of which have orbicular outer tepal limbs with conspicuous dark-edged nectar guides. It may be confused particularly with the orange-flowered species, *M. tulbaghensis* and *M. neopavonia*. *Moraea tulbaghensis* has somewhat smaller flowers with ascending, more or less cupped outer tepals and nectar guides edged in peacock-green. It also has long anthers that always exceed the style branches. *Moraea neopavonia* has more open flowers with widely-cupped tepal claws held away from the style branches and spreading tepal limbs. Its style branches are smaller than those of *M. villosa* and the long anthers exceed the short crests, only 1–2 mm long. The orange-flowered subsp. *elandsmontana* is most easily confused with *M. tulbaghensis* because of its similar flower colour and somewhat cupped outer tepals. The dark-blue nectar guides and large style branches with prominent crests, and the short anthers that reach only to the base of the stigma lobes adequately distinguish the subspecies.

HISTORY

Moraea villosa was probably recorded first by Carl Peter Thunberg during his four years of exploration at the Cape from 1772 to 1775. Thunberg included it in his broadly circumscribed *Iris tricuspis* (now *Moraea tricuspidata*) as var. *corolla purpurea*. John Bellenden Ker was the first to recognize it as a separate species, and he treated it first as *Iris villosa* in 1802, and then a few years later transferred it to *Moraea*. In the *Flora Capensis*, J. G. Baker treated it as a variety of *Moraea pavonia* (1896), but *M. villosa* was subsequently always regarded as a separate species. The distinctive bright orange-flowered subsp. *elandsmontana* was discovered in 1979 near Gouda, on the private Elandsberg Nature Reserve, by Fay Anderson, who immediately completed the painting reproduced here.

CULTIVATION

Moraea villosa has been in cultivation for many years to a limited extent, both in South Africa and elsewhere. It makes a very attractive subject for the small garden and can be grown with ease. Corms should ideally be lifted at the end of spring to prevent insect damage or rotting through over-watering, but given the right conditions, the corms will survive for many years in the ground, and flower well year after year. Sources of corms are limited, but seed can be obtained nearly every year from Kirstenbosch. Some of the more striking colour forms, such as the bright purple flowers with blue-edged nectar guides from north of Piketberg, and the orange-flowered subsp. *elandsmontana* are not available either in trade or through botanical sources.

KEY TO THE SUBSPECIES

1. Flowers shades of blue to purple, cream or pink; outer tepals 30–40 mm long, limb spreading to horizontal subsp. **villosa**
1'. Flowers orange (rarely white) with nectar guide edged in navy blue; outer tepals 28–31 mm long; limbs ascending, somewhat cupped . subsp. **elandsmontana**

83a. Subsp. villosa

Stem usually branched. *Flowers* shades of blue to purple, pink or rarely cream or greenish, nectar guides heavily edged in a dark colour, often deep blue; *outer tepals* 30–40 mm long, claw 8–12 mm long, limb spreading to usually somewhat reflexed, the margins horizontal to curving downwards; *inner tepals* 16–30 mm long. *Filaments* about 5 mm long; *anthers* 6–10 mm long. *Chromosome number* $2n = 24$.

DISTRIBUTION AND HABITAT

Subsp. *villosa* has a relatively wide range in the western Cape. It extends from False Bay to the upper Olifants River valley. The habitat is as described for the species.

83B. Subsp. elandsmontana Goldblatt

Goldblatt, *Ann. Mo. bot. Gdn* **69**: 366–368. Type: South Africa, Cape, Elandsberg Nature Reserve, foot of the Elandskloof Mountains, *Goldblatt 6202* (MO, holotype; K, NBG, PRE, S, isotypes).

Stem usually unbranched. *Flower* bright orange with nectar guides heavily edged with navy blue (rarely white with brownish nectar guides); *outer tepals* 28–31 mm long, claw 8–11 mm long, limb ascending, the margins curving upwards; *inner tepals* about 21 mm long. *Filaments* 4–5 mm long; *anthers* about 7 mm long. *Chromosome number* $2n = 12$.

DISTRIBUTION AND HABITAT

Subsp. *elandsmontana* has a very limited range, occurring at the foot of the Elandskloof mountains south of Voëlvlei Dam in the western Cape. It is known only from the private Elandsberg Nature Reserve where it grows at the foot of the mountains in very stony ground.

83b

M. villosa subsp. *elandsmontana*.

84. MORAEA CALCICOLA Goldblatt

Goldblatt, *Ann. Mo. bot. Gdn* **69**: 364–366. 1982. TYPE: South Africa, Cape, hill tops above Saldanha Bay, *Goldblatt 4118* (MO, holotype; BR, E, K, NBG, PRE, S, US, WAG, isotypes).

calcicola = lime-loving, referring to the rocky, white limestone soil in which it grows.

Plants slender, 30–40 cm high. *Corm* 9–12 mm in diameter, with light brown reticulate tunics. *Leaf* solitary, basal, linear, channelled, exceeding the stem, villous on the outer surface, 3–5 mm at the widest, often bent and trailing. *Stem* erect or inclined, simple or 1-branched, puberulous, sheathing stem bracts 5–6 cm long, attenuate and dry above. *Spathes* herbaceous, becoming dry from apex, attenuate, *inner* 5–7 cm long, *outer* about two-thirds as long as the inner. *Flowers* clear blue, becoming paler with age, weakly scented, with small triangular dark-blue nectar guides on the outer tepals; *outer tepals* 25–35 mm long, limb 15–25 mm long and up to 32 mm wide, spreading horizontally, claw 8–10 mm long, sub-erect, heavily bearded with dark blue hairs; *inner tepals* 14–22 mm long, tricuspidate, with a long, slender, spreading central cusp, and short, obtuse, erect lateral lobes. *Filaments* 2–3 mm long, united in a column, free in the upper 0,5 mm; *anthers* 5,5–6,5 mm long, pollen yellow. Ovary 10–15 mm long, usually exserted from the spathes, *style branches* 6–8 mm long, about 6 mm at the widest, just exceeding the anthers, *crests* about 4 mm long, margins irregularly incised. *Capsule* and *seeds* unknown. Chromosome number $2n = 12$.

Flowering time: September.

DISTRIBUTION AND HABITAT

Moraea calcicola is a rare local endemic of the western Cape. It is known only from the coast near Saldanha Bay where it occurs on the low hills above the town. *Moraea calcicola* grows among low shrubs and other geophytic plants in rocky, white limestone soil.

DIAGNOSIS AND RELATIONSHIPS

Moraea calcicola is related to *Moraea villosa* and its immediate allies, species characterized by having large, brightly-coloured and very broad outer tepals, often with conspicuous nectar guides in contrasting pale and dark bands, and tricuspidate inner tepals. Several of the species of the group, including *M. villosa* itself, have puberulous stems and villous leaves and it is to these species than *M. calcicola* is most closely related. *Moraea calcicola* differs from *M. villosa* in its clear, blue flower with inconspicuous small, blackish nectar guides. Apart from colour differences, it is more slender than *M. villosa* and has closer set outer tepals with darkly bearded claws, 8(–10) mm long, and relatively short filaments 2–3 mm long. *Moraea villosa* has purple, rarely pink, orange or cream flowers with large nectar guides, usually yellow-edged in bands of dark colour, contrasting yellow tepal claws 8–12 mm long, and longer filaments 4–5 mm long.

The dark beard on the outer tepal claws of *Moraea calcicola* is reminiscent of *M. loubseri* (Goldblatt, 1976b), which has outer tepals with a heavy beard covering the tepal claws and part of the limb as well. This similarity may indicate a close relationship between these two species. Both *M. calcicola* and *M. loubseri* are diploid, $2n = 12$, and have very restricted ranges along the western Cape coast in the Saldanha Bay district, *M. loubseri* known only from a single granite hill near Langebaan, a short distance to the south of Saldanha Bay. *Moraea villosa* is a much more widespread western Cape species. It occurs on flats and mountain slopes between Piketberg in the north to Gordons Bay in the south, and extends inland to Gydo Pass near Ceres. The several populations of subsp. *villosa* examined cytologically are polyploid, $2n = 24$, while the local subsp. *elandsmontanta*, is like *M. calcicola*, diploid.

HISTORY

Moraea calcicola was brought to my attention by the amateur botanist and native bulb grower, J. W. Loubser, in 1976, and there seem to be no records of the plant before this time.

84

M. calcicola.

85. MORAEA LOUBSERI Goldblatt

Goldblatt, *Ann. Mo. bot. Gdn* **63**: 778–779; *Fl. Pl. Africa* **42**: tab. 1724. 1977. TYPE: South Africa, Cape, Olifants Kop, Langebaan, *Goldblatt 2076* (MO, holotype; K, NBG, PRE, S, isotypes).

loubseri = named in honour of Johan Loubser, amateur botanist who has studied and grown native South African bulbous plants for many years, and who discovered this species.

Plants 15–20 cm high, usually 1-branched. *Corm* about 1 cm in diameter, with tunics of greyish, fairly coarse claw-like fibres. *Cataphylls* pale and membranous, becoming broken and netted above. *Leaf* solitary, basal, linear, channelled, pubescent on the outer surface, usually exceeding the inflorescence, 2–3 mm wide. *Stem* minutely pubescent, usually bearing a single branch, sheathing stem bracts 4–5 cm long, attenuate and dry above. *Spathes* herbaceous with brown, attenuate apices, *inner* 4–5 cm long, *outer* about 3–4 cm long. *Flowers* blue-violet with a black pubescent centre and deep-blue nectar guides on the outer tepals; *outer tepals* 20–24 mm long, claw broad, ascending to horizontal distally, to 10 mm long, completely bearded with black hairs, the limb slightly reflexed, 14–20 mm at the widest point; *inner tepals* 15–20 mm long, tricuspidate, with 2 short lateral lobes and a long, spreading to slightly reflexed central cusp. *Filaments* about 4 mm long, free in the upper third; *anthers* 5 mm long, pollen yellow-orange. Ovary about 8 mm long, exserted from the spathes, *style branches* about 6 mm long, crests 1–2 mm long, triangular. *Capsule* cylindric to clavate, to 2 cm long; *seeds* angular, testa somewhat inflated. *Chromosome number* $2n = 12$.

Flowering time: late August to September.

DISTRIBUTION AND HABITAT

Moraea loubseri is known only from one site, the summit of Olifants Kop near Langebaan in the south-western Cape. This is one of several granite outcrops in the western Cape coastal lowlands that rise out of the surrounding sandy plains. The nearby hills and granite outcrops have been searched for *M. loubseri* without success, and it almost certainly does not grow anywhere else.

DIAGNOSIS AND RELATIONSHIPS

Moraea loubseri has striking violet-blue flowers with the outer tepal claws and limb bases densely bearded with black hairs. The flowers have such an extraordinary appearance that one is reminded of some strange insect, which in fact it may mimic so as to attract a specific pollinator. The inner tepals are long and tricuspidate with a long acute central cusp and small obtuse lateral lobes. The structure of the inner tepals, the broad outer tepal limbs and pubescent leaf and stem suggest that it is related to *M. villosa* and the other peacock species of section *Vieusseuxia*. The violet-blue flower with its remarkable black beard covering the claw and part of the limb of the outer tepals is so distinctive that confusion with any other species seems unlikely.

HISTORY

Moraea loubseri is one of several examples of species with extremely localized ranges in the south-western Cape. Its discovery was entirely fortuitous. It was first recorded in 1973, when Olifants Kop was visited by Johan Loubser just before quarrying was scheduled to begin at this site (Goldblatt, 1977). The hill has subsequently been partially excavated and at one time it seemed likely that the natural habitat and only known population of *M. loubseri* would be entirely destroyed within a few years of its discovery. Fortunately, quarrying has been stopped and the hilltop is, at least temporarily, being preserved from further disturbance.

Moraea loubseri has also been introduced to horticulture. Plants have been grown and propagated for several years at Kirstenbosch and seed is available to anyone who wants to grow the plant. It now seems certain that although very rare and severely threatened in the wild, it may, through its beauty and relative ease of cultivation, become an established garden favourite.

85.

M. loubseri.

86. MORAEA TULBAGHENSIS
L. Bolus

L. Bolus, *S. African Gard.* **22**: 276. 1932; Goldblatt, *Ann. Mo. bot. Gdn* **63**: 777–778. 1976. TYPE: South Africa, Cape, Saron, Tulbagh districts. *L. Bolus s.n.* (BOL *16738*).

tulbaghensis = from the town of Tulbagh in the south-western Cape.

Plants 25–35 cm high, occasionally branched. *Corm* 1–1,5 cm in diameter, with tunics of pale, thick, often claw-like, fibres. *Cataphylls* pale to brownish, often broken above. *Leaf* solitary, linear, basal, pubescent on the outer surface, usually exceeding the inflorescence, channelled, to 4 mm wide. *Stem* villous, simple or 1-branched, sheathing stem bracts attenuate, dry and brown apically. *Spathes* herbaceous to dry above with dark-brown attenuate apices, *inner* 5–7 cm long, *outer* about half as long as the inner. *Flowers* bright orange, with orange-yellow nectar guides, broadly edged with peacock-green on the outer tepals, these ascending and somewhat cupped; *outer tepals* 20–24 mm long, the claw about 10 mm long, ascending, bearded and speckled, the limb ascending, about as wide as long, 15–20 mm wide; *inner tepals* 15–18 mm long, tricuspidate with 2 short lateral lobes and a long central cusp. *Filaments* 4–5 mm long, free near the apex for less than 1 mm; *anthers* 7–10 mm long, shortly exceeding the style branches, sometimes reaching the apex of the crests, pollen yellow. *Ovary* 10–12 mm long, exserted from the spathes, rapidly elongating after fertilization, *style branches* about 7 mm long, to 3 mm wide, crests triangular, to 2 mm long, inconspicuous. *Capsule* cylindrical, to 2 cm long; *seeds* large, angular, with a spongy testa. *Chromosome number* $2n = 24$.

Flowering time: early to late September.

DISTRIBUTION AND HABITAT

Moraea tulbaghensis has a restricted distribution in the south-western Cape where it occurs in the upper Tulbagh valley between Tulbagh and Tulbagh Kloof, and to the west between Saron, Gouda and Wellington. It grows in light, often stony, clay soils on flats and lower slopes in renosterveld.

DIAGNOSIS AND RELATIONSHIPS

Moraea tulbaghensis is one of the peacock group of species and it has the pubescent leaf and stem and the broad outer tepals characteristic of the alliance. It can be distinguished by its deep-orange flowers with intense peacock-green edged nectar guides that in general form, but not in colour, resemble those of the related *M. villosa*. The flowers of *M. tulbaghensis* are always smaller, and the broad outer tepals, 20–24 mm long, are ascending and thus broadly cupped, unlike those of most forms of *M. villosa*, in which the outer tepals are 28–40 mm long and outspread to reflexed. The flowers of *M. tulbaghensis* are also distinctive in having short style crests to 2 mm long, and anthers as long as to slightly longer than the style branches which they partly conceal. The only form of *M. villosa* that is likely to be confused with *M. tulbaghensis* is subsp. *elandsmontana*, which also has orange flowers, but the nectar guides are edged in navy blue and the anthers are shorter than the style branches, while the style crests are well developed and 3–6 mm long.

There is also the possibility of confusion between *Moraea tulbaghensis* and *M. neopavonia* which is one of the few other species of *Moraea* with orange flowers. *Moraea neopavonia* usually has entire, elliptic, but sometimes tricuspidate inner tepals and is otherwise similar in general appearance to *M. tulbaghensis*. In *M. neopavonia* the outer tepals have either speckled or solid, deep-blue nectar guides in contrast to the bright green in *M. tulbaghensis*, and the anthers are 10–12 mm long, well exceeding the narrow style branches and short crests.

Moraea tulbaghensis is one of the few polyploid species of *Moraea* with $2n = 24$ (Goldblatt, 1976a). In view of the morphological similarities with both *M. villosa* ($2n = 12$ and 24) and *M. neopavonia* ($2n = 12$), it may be an allotetraploid species derived from these ancestors.

HISTORY

Moraea tulbaghensis was for many years confused with *M. villosa*, and only in 1932 did Louisa Bolus recognize it as a distinct species. It is poorly known and seldom seen, and its range has in recent years been considerably reduced by agricultural activities. It still persists at the foot of the mountains in the Tulbagh and Wellington districts where the soil is too poor or stony to be ploughed. The first collections of *M. tulbaghensis* were made in the 1820's by the important early collectors C. F. Ecklon and C. L. Zeyher, and it was apparently not recollected for over 100 years, when it was found by C. L. Leipoldt, Louisa Bolus and others.

86.

M. tulbaghensis.

87. MORAEA NEOPAVONIA
R. Foster

R. Foster, *Contr. Gray Herb.* **165**: 107. 1947, nom. nov. pro *M. pavonia* (Linnaeus fil.) Ker nom. illeg. TYPE: as for *Iris pavonia* Linnaeus fil. (see below).

SYNONYMS

Iris pavonia Linnaeus fil., *Supplementum Plantarum* 98. 1782. TYPE: South Africa, Cape, Swartland hills, *Thunberg s.n.* (Herb. Thunberg *1148A*, UPS, lectotype designated by Goldblatt, 1976b).

Moraea pavonia (Linneaus fil.) Ker, *Ann. Bot.* (Konig & Sims) **1**: 240. 1805; Baker, *Flora Capensis* **6**: 23. 1896, excl. varieties., hom. illeg. non *M. pavonia* (Linnaeus fil.) Thunberg, 1787 (= *Trigridia pavonia* (Linnaeus fil.) de Candolle).

Viesseuxia pavonia (Linnaeus fil.) de Candolle, *Ann. Mus. Hist. Nat. Paris* **2**: 139. 1803.

neopavonia = the new peacock, so named because the original name *Iris pavonia* could not be transferred to *Moraea* where the name had already been used for another species, now *Tigridia pavonia*: pavonia, Latin for peacock, alludes to the markings on the outer tepals that resemble the 'eyes' on peacock feathers.

Plants slender, 30–60 cm high. *Corms* about 10 mm in diameter, with light-brown tunics with coarsely fibrous outer and finer inner layers. *Cataphylls* light to dark brown, membranous, becoming dry and irregularly broken, sometimes persisting around the base in a neck. *Leaf* solitary, basal, linear, sparsely pubescent on the outer surface, exceeding the inflorescence, channelled, 3–5 mm wide. *Stem* finely pubescent, simple or 1-branched, sheathing stem bracts 6–7,5 cm long, attenuate, dry and brown apically. *Spathes* herbaceous below, dry above with long, dark brown, attenuate apices, *inner* 4,5–7(–8) cm long, *outer* about two-thirds as long as the inner. *Flowers* pale to deep orange, rarely reddish, with speckled or solid, navy-blue nectar guides on the outer tepals, the claws speckled deep blue; *outer tepals* 22–40 mm long, claw 10–12 mm long, ascending, limb 20–28 mm long, spreading, lanceolate to about as wide as long, 12–18 mm wide; *inner tepals* entire and narrowly lanceolate or weakly to distinctly trifid with 2 small obtuse lateral lobes and a long central cusp. *Filaments* 4–5 mm long, united except in the upper 1 mm; *anthers* 9–12 mm long, exceeding the style branches and crests. Ovary 10–14 mm long, exserted from the spathes, *style branches* 5–8 mm long, the crests 1–2 mm long, broadly triangular, obscured by the anthers. *Capsule* cylindrical, 2–4 cm long; *seeds* angled, with spongy testa. *Chromosome number* $2n = 12$.

Flowering time: mid to late September.

DISTRIBUTION AND HABITAT

Moraea neopavonia occurs in the western Cape lowlands, between Paarl and Piketberg in the valley of the Berg River. It grows on gravelly clay among sparse stunted bushes. It is rare today but probably once grew in profusion on the flats between Piketberg and Porterville, now largely under wheat and vine cultivation. *Moraea neopavonia* is now confined to isolated banks and slopes that are unsuitable for cultivation. In view of its great beauty and potential for horticulture, the species should be protected from further extension of agriculture into its remaining habitats.

DIAGNOSIS AND HABITAT

Moraea neopavonia has unusual orange flowers with large outer tepals and entire, elliptic to tricuspidate inner tepals. The nectar guides are variable with some plants in a population having broad, navy-blue markings and others, a zone of dark-blue spots at the base of the tepal limbs. In both forms the ascending tepal claws are speckled blue. The anthers are very long, 9–12 mm, and exceed and partly conceal, the style branches and very short style crests. The distinctive flower, together with the solitary and pubescent leaf, and the pubescent stem mark the species as related to *Moraea villosa* and *M. tulbaghensis*, with both of which it may be easily confused. The long anthers, exceeding the style branches and crests, immediately separate it from *M. villosa*, which has anthers shorter than the style branches, but it is more difficult to distinguish from *M. tulbaghensis*. The latter has smaller flowers with the outer tepals 20–24 mm long and ascending and somewhat cupped, and the nectar guide outlined in a band of brilliant green, while the anthers exceed the style branches but seldom overtop the crests.

HISTORY

The first record of this lovely plant in the scientific literature is the description published in 1782 by the younger Linnaeus as *Iris pavonia*. His species was based on the notes and specimens of his compatriot Carl Peter Thunberg who must have collected it in 1773 or 1774 somewhere north of Cape Town. Thunberg describes the locality as *'in Swartland collibus et alibi inter frutices rariores'* which seems to indicate that *Moraea neopavonia* grew in the Swartland, that is north of Paarl, scattered among low shrubs. He may well have collected his specimens on the banks of the Berg River near Piketberg where the early travellers crossed by a ford when journeying into the interior. A relict population can still be found near the site of the ford.

In *Flora Capensis*, *Moraea neopavonia* (as *M. pavonia*) was treated by J. G. Baker (1896) as including at least two other species with similar broad outer tepals and tricuspidate inner tepals, and both *M. villosa* and the more distantly related *M. bellendenii* are regarded as conspecific. Only in the 1930's, when extensive collecting was undertaken north of

87.

M. neopavonia

Cape Town, were these species re-collected and they then became better understood. The technical correcting of the specific epithet in *Moraea* from *pavonia* to *neopavonia* was made by the American botanist R. C. Foster in 1947 when it became clear that the name *M. pavonia* had already been used in early botanical literature for what is now considered *Tigridia pavonia*.

CULTIVATION

Moraea neopavonia is hardly known in horticulture and it deserves more attention. The flowers of the choicest forms are as large as those of *M. villosa*, some 6–8 cm in diameter, and the bright orange colour with contrasting navy blue is most unusual in the genus and very lovely. It is as easy to grow as most other Moraeas, and makes a good pot or rock garden subject. Seed is occasionally offered by Kirstenbosch. A major effort should be undertaken to locate populations of *M. neopavonia* and to secure seed of the best forms to propagate to increase stocks for introduction and improvement.

88. MORAEA GIGANDRA L. Bolus

Bolus, *S. African Gard.* **17**: 418. 1927; Turrill, *Bot. Mag.* **169**: new ser. tab. 188. 1952; Goldblatt, *Ann. Mo. bot. Gdn* **63**: 771–772. 1976. TYPE: South Africa, Cape, precise locality unknown, *Metelerkamp s.n.* (BOL, holotype).

gigandra = with very large anthers, referring to the anthers which much exceed, and all but conceal, the style branches.

Plants 20–40 cm high, usually unbranched. *Corms* 10–15 mm in diameter, with tunics of fine inner and coarse, woody, outer fibres. *Cataphylls* pale and membranous. *Leaf* solitary, basal, linear, sparsely pubescent or glabrous, as long as or longer than the stem. *Stem* finely pubescent, simple or bearing 1 branch, sheathing bract leaves 5–7 cm long, dry and brown above, attenuate. *Spathes* herbaceous below, dry and dark brown above, attenuate, inner 5–8 cm long, outer about two-thirds as long as the inner. *Flowers* large, usually blue-purple, rarely white or orange, with dark-blue nectar guides in a narrow band across the base of the outer tepals; outer tepals 30–45 mm long, claw about 6 mm long, weakly ascending, limb spreading horizontally, about as wide as long, to 35 mm wide; inner tepals 9–15 mm long, tricuspidate with 2 short lateral lobes and a long, slender, spreading central cusp. *Filaments* 2–4 mm long, united in a column, apically free for less than 0,5 mm; anthers very large, 13–15 mm long, much exceeding the style crests. *Ovary* 18–22 mm long, usually exserted from the spathes, style branches to 6 mm long, 2 mm wide, the crests short, barely exceeding the large stigma lobes. *Capsule* 2–3 cm long, cylindrical; seeds unknown. *Chromosome number* $2n = 12$.

Flowering time: late September to mid October.

DISTRIBUTION AND HABITAT

Moraea gigandra is native to the flats and lower slopes of the Swartland between Piketberg and Porterville. It favours damper sites, and grows on south-trending low slopes and banks or around vleis and moist depressions, and is apparently restricted to heavy clay soils. Once common north of the Berg River in the broad valley between the Piketberg and Olifants River mountains, *M. gigandra* is now on the verge of extinction, as the area is almost entirely given over to grain cultivation. It survives in only a few isolated places, too steep or stony to plough.

DIAGNOSIS AND RELATIONSHIPS

Moraea gigandra has a single basal leaf, pubescent stem and one of the largest and most striking flowers in the genus. The flowers are usually deep blue-purple, with brilliant blue nectar guides outlined in white, but white and orange forms with different coloured nectar guides are also known. The large outer tepals are as long as 45 mm, making *M. gigandra* one of the largest flowered species in the genus. The flowers are distinctive not only in size, but also for their extraordinarily long anthers which reach 15 mm in length, much exceeding the style branches and stigmas. The style crests are barely developed and are about as long as the stigmatic lobes, to which they are appressed. *Moraea gigandra* is allied to the *M. villosa* species group, and is perhaps most closely related to *M. neopavonia* which also has long anthers that exceed the style branches. *Moraea neopavonia* has bright-orange flowers and short style branches topped by short but distinct erect crests.

HISTORY

This strikingly beautiful plant was only brought to the attention of science in 1927, though it was evidently known in Europe in the eighteenth century. A manuscript description in the hand of Daniel de la Roche, who described the genus *Vieusseuxia*, attests to this little known fact (Goldblatt & Barnard, 1970). Today, *M. gigandra* is in limited cultivation in South Africa and also in New Zealand and Australia where it thrives. *Moraea gigandra* is fairly easy go grow, and seed is often offered by Kirstenbosch, when stocks are available from the plants maintained in their nursery.

88.

M. gigandra.

SUBGENUS *GRANDIFLORA*

89. MORAEA MUDDII N. E. Brown

Brown, *Trans. R. Soc. S. Afr.* **27**: 346. 1929; Goldblatt, *Ann. Mo. bot. Gdn* **60**: 239–241. 1973; **64**: 271–272. 1977. TYPE: South Africa, Transvaal, Mac Mac Creek, *Mudd s.n.* (K, holotype).

muddii = named in honour of Christopher Mudd, English horticulturist and plant collector, who travelled across the Transvaal in 1877, from Delagoa Bay over the escarpment to Pretoria, at a time when the Transvaal flora was hardly known.

Plants 15–70 cm but usually about 35 cm high, solitary. *Corm* 10–15 mm in diameter, with tunics of pale, straw-coloured fibres. *Cataphylls* brown, usually broken vertically into irregular strips. *Leaf* solitary, linear, channelled, 3–6 mm wide, usually overtopping the stem. *Stem* erect, unbranched, sheathing bract leaves 2–3(–4), herbaceous, dry and brown apically, 8–12 cm long. *Spathes* herbaceous, dry and brown apically, *inner* 7–9(–12) cm long, *outer* slightly shorter than the inner. *Flowers* cream to yellow with deeper-yellow nectar guides on the outer tepals; *outer tepals* lanceolate, 35–50 mm long, claw 15–20 mm long, limb slightly reflexed, 12–20 mm wide; *inner tepals* erect, lanceolate, to 35 mm long, to 7 mm wide. *Filaments* to 10 mm long, united in the lower two-thirds; *anthers* to 9 mm long, not reaching the stigma. Ovary oblong, about 15 mm long, exserted from the spathes, *style branches* to 13 mm, crests about 10 mm long. *Capsules* cylindric, to 2 cm long; *seeds* flattened, discoid. *Chromosome number* not known.

Flowering time: mid-September to December, rarely later.

DISTRIBUTION AND HABITAT

Moraea muddii has a scattered distribution in the mountains of eastern southern Africa. It extends from the Chimanimani mountains of Mozambique and eastern Zimbabwe, through the eastern Transvaal to the Amatola mountains of the eastern Cape. It is most common in the eastern Transvaal, where the majority of the collections have been made, and it is apparently absent from Swaziland and the main Drakensberg range in Natal. This break in the distribution pattern is unusual, but there seems little doubt that *M. muddii* does not occur in the well-collected Natal Drakensberg. *Moraea muddii* grows in open grassland, in peaty or stony ground, at elevations usually above 2 000 m.

DIAGNOSIS AND RELATIONSHIPS

Moraea muddii is one of the smallest species of subgenus *Grandiflora* but it conforms with the basic morphology of the alliance in its single basal leaf and unbranched stem. Its distinguishing characters are mostly those of size, the plant and its flowers being comparatively small. The soft-textured, brown, and irregularly broken cataphylls and the finely-fibrous corm tunics are perhaps its most characteristic features. Its small size and solitary habit distinguish it from the widespread and common *M. spathulata*; its slender leaf, comparatively soft cataphylls and early flowering period from *M. moggii*; and its 2–4 sheathing bract leaves from *M. unibracteata*. This last mentioned species is probably very closely allied to *M. muddii*, but differs consistently from it in having a single sheathing bract leaf inserted near the base of the spathes and in having a leaf clasping the lower part of the stem.

HISTORY

Moraea muddii was discovered by the English horticulturist, Christopher Mudd, who was sent on a plant-collecting expedition to South Africa in 1877. He accomplished little on his trip, but was one of the earliest to collect the rich flora of the eastern Transvaal. Mudd found this *Moraea* in the vicinity of Mac Mac Falls, near Sabie. His collection was not cited by J. G. Baker in *Flora Capensis*, and it was only in 1929 that N. E. Brown described *M. muddii*, based on the collections of Mudd and others, who had by then also collected it.

90. MORAEA INYANGANI Goldblatt

Goldblatt, *Ann. Mo. bot. Gdn* **64**: 271–272. 1977. TYPE: Zimbabwe, vlei on Mount Inyangani, 8 000 ft, *Wild 5519* (SRGH, holotype; K, LISC, M, PRE, isotypes).

inyangani = named after the only known locality, Mount Inyangani, highest mountain in the Inyanga Highlands in eastern Zimbabwe.

Plants 15–30 cm high, solitary. *Corm* to 10 mm in diameter, with tunics of fine pale straw-coloured fibres. *Cataphylls* brown, usually irregularly broken. *Leaf* solitary, linear, channelled, about 3 mm wide, longer than the stem. *Stem* erect, unbranched, sheathing bract leaves 3(–4), herbaceous, overlapping, 5–8 cm long. *Spathes* herbaceous, dry apically, *inner* 5–8 cm long, *outer* slightly shorter than the inner. *Flowers* pale yellow with deeper yellow nectar guides on the outer tepals; *outer tepals* lanceolate, to 25 mm long, claw about 10 mm long, limb slightly reflexed, 15 mm long; *inner tepals* erect, lanceolate, 15–20 mm long. *Filaments* 4 mm long, united in the lower two-thirds; *anthers* about 6 mm long, not reaching the stigma. Ovary oblong, about 14 mm long, exserted from the spathes, *style branches* 8–9 mm, crests about 4–8 mm long. Capsules and seeds unknown. Chromosome number not known.

Flowering time: September to October (also in April).

DISTRIBUTION AND HABITAT

Moreaea inyangani is restricted to the higher altitudes of Mount Inyangani in the Inyanga Highlands of eastern Zimbabwe. It occurs in seeps, marshy sites and along streams at an elevation of about 2 500 m.

DIAGNOSIS AND RELATIONSHIPS

Moraea inyangani is the smallest species of subgenus *Grandiflora* but it conforms with the basic morphology of the alliance in its single basal leaf, unbranched stem and large overlapping bract leaves. Its distinguishing characters are mostly those of size, the plant and its flowers being unusually small for the subgenus, only 15–30 cm high with outer tepals about 25 mm long. The leaf is very narrow and the margins tightly inrolled so that, at least when dry, it appears to be terete. The soft-textured, brown, and irregularly broken cataphylls and the finely-fibrous corm tunics are similar to those of *M. muddii*, to which it is probably most closely related, and in fact it appears to be a geographically isolated segregate of its more widespread relative.

Moraea muddii extends from the eastern Cape through the eastern Transvaal to the Chimanimani mountains of eastern Zimbabwe. Throughout its range plants have widely channelled leaves and relatively large flowers with outer tepals 35–50 mm long and it is thus easy to distinguish from *M. inyangani*. The small size of the plants and the flowers of *M. inyangani* and its solitary habit also distinguish it from the widespread and common *M. spathulata* which also occurs in the Inyanga Highlands.

HISTORY

The first collection of *Moraea inyangani* was made by the Zimbabwean botanist H. D. L. Corby, in 1955. A few more collections were made in the following decade but the species remains poorly known and under-collected. It was only described in 1977 (Goldblatt, 1977).

91. MORAEA UNIBRACTEATA
Goldblatt

Goldblatt, *Ann. Mo. bot. Gdn* 60: 241–242. 1973. TYPE: South Africa, Natal, Nottingham Road, *Galpin 9457* (PRE, holotype, CPF, NU, isotypes).

unibracteata = with a single bract, referring to the solitary sheathing bract on the flowering stem.

Plants small, 20–35 cm high, solitary. *Corm* 8–12 mm in diameter, with tunics of fine, pale fibres. *Cataphylls* brown, entire or more usually broken irregularly, sometimes accumulating around the base. *Leaf* solitary, stiffly erect, somewhat longer than the stem, 2–10 mm wide, channelled, clasping the stem in the lower half. *Stem* erect, simple, sheathing bract leaf solitary, inserted near the base of the inflorescence and overlapping the spathes. *Spathes* herbaceous, sometimes dry and brown apically, *inner* 6–8 cm long, *outer* 1–2 cm shorter than the inner. *Flowers* pale yellow, veined with green (drying pale blue occasionally), with deep-yellow nectar guides on the outer tepals; *outer tepals* 30–45 mm long, lanceolate, claw suberect, about 15 mm long, shorter than the limb, limb slightly reflexed; *inner tepals* 27–40 mm long, erect, narrowly lanceolate. *Filaments* 6–8 mm long, united in the lower half; *anthers* 7–9 mm long, pollen yellow. *Ovary* 10–14 mm long, rapidly elongating after fertilization, exserted from the spathes; *style branches* about 10 mm long, crests 8–13 mm long. *Capsule* and *seeds* unknown. *Chromosome number* unknown.

Flowering time: October to November.

DISTRIBUTION AND HABITAT
Moraea unibracteata occurs in the Natal Midlands and at lower elevations in the central Drakensberg. It has been recorded from Mooi River and Giants Castle Nature Reserve in the north, to Inanda, near Durban in the south. It grows in mountain grassland, usually on steep slopes.

DIAGNOSIS AND RELATIONSHIPS
Moraea unibracteata is one of the smaller flowered species of subgenus *Grandiflora*, and perhaps the smallest species of the subgenus in South Africa. The plants are only 20–30 cm high and the flowers have tepals in the 30–40 mm long range. In its height and small flower size, *M. unibracteata* resembles most closely *M. muddii*, a species with a wider distribution from eastern Zimbabwe to the Transkei and eastern Cape. *Moraea unibracteata* is distinguished by the single sheathing bract leaf inserted just below the inflorescence spathes and the relatively short leaf that clasps the lower part of the stem. Its finely-fibrous corm tunics are similar to those of *M. muddii*, to which it is perhaps most closely related.

HISTORY
Moraea unibracteata was discovered by the early Natal botanist, John Medley Wood, near the turn of the century. Only a handful of more collections have been made since, and it was not until 1973 that this distinctive member of subgenus *Grandiflora* was described (Goldblatt, 1973).

92. MORAEA CARNEA Goldblatt

Goldblatt, *Ann. Mo. bot. Gdn* 60: 242–243. 1973; Trauseld, *Wild Flowers of the Natal Drakensberg* 37, fig. 418. 1969. TYPE: South Africa, Natal, Giants Castle, *Trauseld 481* (PRE, holotype; CPF, NU, isotype).

carnea = pale pink or flesh-coloured, alluding to the colour of the style crests.

Plants medium in size, up to 50 cm high, solitary. *Corm* to 15 mm in diameter, with tunics of fine, reticulate fibres. *Cataphylls* brown, usually irregularly broken vertically. *Leaf* solitary, linear, exceeding the stem, channelled, 3–6 mm wide. *stem* erect, unbranched, sheathing bract leaves 3–4, herbaceous, dry apically and acuminate, 4–8 cm long. *Spathes* herbaceous, dry apically, *inner* 7–10 cm long, *outer* 2–3 cm shorter than the inner. Flowers creamy-yellow to pinkish, marked with pink to brown veins, purple on the reverse, the style crests uniformly red-brown, with large, deep-yellow nectar guides on the outer tepals; *outer tepals* to 60 mm long, claw suberect, limb 30–35 mm long, 20–25 mm wide, reflexed; *inner tepals* 45–50 mm long, erect, about 10 mm wide. *Filaments* 10–12 mm long, united in the lower two-thirds; *anthers* 9–

10 mm long, slightly shorter than the filaments, not reaching the stigmas. Ovary about 2 cm long, included or partly exserted from the spathes, *style branches* 15–17 mm long, crests to 15 mm long. *Capsule* cylindric, beaked; *seeds* not known. *Chromosome number* not known.

Flowering time: November to December.

DISTRIBUTION AND HABITAT

Moraea carnea is restricted to higher elevations in the Drakensberg of Natal and the south-eastern Orange Free State (and probably also Lesotho) above 2 000 m, where it occurs between Harrismith in the north and Bushmans Nek in the south. It grows in well drained open grassland, usually on steep moist slopes.

DIAGNOSIS AND RELATIONSHIPS

Moraea carnea and the following species, *M. ardesiaca*, are closely related, and both allied to *M. muddii* and may, in fact, replace this species in the Natal Drakensberg. *Moraea carnea* and *M. ardesiaca* are the only members of subgenus *Grandiflora* in South Africa that do not have yellow to white flowers. The colour difference in a group where yellow so predominates is one of the prime reasons for recognizing these as distinct species, although there are other characters of importance. *Moraea ardesiaca* has slate-blue to mauve flowers, a longer, broader leaf and distinctly broader tepals.

The colour is by far the easiest way to recognizing the two, but unfortunately in old material, without colour notes, or with poorly-pressed flowers, this is of little use, and then less obvious features such as the cataphylls must be relied upon. In the absence of these and without well-preserved flowers, identification is very difficult.

Moraea carnea has cream tepals, veined and flushed purple to flesh pink. In most individuals the inner tepals and especially the style crests are dark reddish-brown. The key character, whether the anthers are longer (in *M. ardesiaca*) or shorter (in *M. carnea*) than the filaments, appears to be useful and separates all the specimens that I have seen. Apart from the floral characters, it is mainly the stouter stems and firmer leaf that distinguish this species from *M. muddii*. *Moraea carnea* and *M. ardesiaca* occur in the Natal Drakensberg but are not found together, the former occupying habitats above 2 200 m and the latter usually below this. As can be expected, some overlap does occur, but, nevertheless, it seems that they occupy different ecological niches.

HISTORY

The earliest record of *Moraea carnea* that I have been able to trace is a collection from 'Harrismith' (? district) in the Orange Free State by an English forester, H. J. Sankey, who worked in South Africa for a short time at the beginning of the century. All later collections are from the Natal Drakensberg and were made after World War I. *Moraea carnea* was recognized as a distinct species only in 1973 (Goldblatt, 1973).

93. MORAEA ARDESIACA Goldblatt

Goldblatt, *Ann. Mo. bot. Gdn* 60: 243–244. 1973; Trauseld, *Wild Flowers of the Natal Drakensberg* 37, fig. 84. 1969. TYPE: South Africa, Natal, Royal Natal National Park, *Trauseld 84* (PRE, holotype).

ardesiaca = slate-coloured, referring to the dull, slate-blue flower colour.

Plants medium to large, to 70 cm high, usually solitary. *Corm* to 15 mm in diameter, with tunics of pale, membranous, unbroken layers, similar to the cataphylls. *Cataphylls* pale below, light-brown above ground level, to 15 cm long, irregularly broken above. *Leaf* erect below, trailing distally, channelled, usually exceeding the stem, 5–10(–25) mm wide. *Stem* erect, unbranched, sheathing bract leaves 2, rarely 3, about 10 cm long, inserted on the upper part of the stem, often naked below. *Spathes* herbaceous, dry apically, inner 9–14 cm long, outer 2–4 cm shorter than the inner. *Flowers* slate-blue to purple, often brown on the reverse, with narrow, yellow nectar guides on the outer tepals; outer tepals to 75 mm long, claw suberect, limb to 50 mm long, 25–35 mm wide; inner tepals more or less erect, 50–60 mm long. *Filaments* 8–12 mm long, joined united in the lower third; anthers to 12 mm long, about as long or longer than the filaments, not reaching the stigmas. Ovary about 20 mm long, usually included in the spathes, style branches to 15 mm long, crests 15–20 mm long. *Capsule* beaked, not known when mature; seeds unknown. Chromosome number unknown.

Flowering time: November to January.

DISTRIBUTION AND HABITAT

Moraea ardesiaca is found at middle elevations in the Natal Drakensberg, where it has been recorded between Van Reenen in the north and Garden Castle Forest Reserve in the south. It appears to prefer wetter situations and grows in stream valleys, along streams and in seeps among rocks, at elevations between 1 800 and 2 200 m.

DIAGNOSIS AND RELATIONSHIPS

Moraea ardesiaca is typical of subgenus *Grandiflora* in its solitary, long leaf and unbranched stem, but unusual among the southern African species of the subgenus in having slate-blue to mauve flowers, the feature by which it can easily be recognized. The flowers are large and have rather flaccid, initially erect, inner tepals. The outer tepals are about 75 mm long and have characteristically narrow, pale-yellow nectar guides, while the filaments are usually slightly shorter, to as long as the anthers, the latter about 12 mm long. The leaves are usually comparatively narrow, 5–10 mm wide, but may reach 25 mm, thus the plants are relatively slender. *Moraea ardesiaca* is probably closely related to *M. carnea*, another Drakensberg endemic that occurs at somewhat higher elevations on steep grassy slopes. *Moraea carnea* has cream to buff flowers flushed with pink and distinctive dark red-brown style crests. In dried plants colour is often lost, and then it is often difficult to distinguish the two species. *Moraea ardesiaca* is generally the larger plant with longer and wider tepals, the outer 75 mm × 25–35 mm, compared with *M. carnea* with outer tepals about 60 mm × 20–25 mm.

As discussed at greater length under *Moraea carnea*, this species and *M. ardesiaca* appear to be closely allied to *M. muddii*, which they perhaps replace in the Drakensberg.

HISTORY

The first records of *Moraea ardesiaca* were made by John Medley Wood towards the end of the nineteenth century in the Van Reenen area of northern Natal. One of his collections was cited by J. G. Baker in *Flora Capensis* under *M. spathacea* (i.e. *M. spathulata*) var. *natalensis*. The variety was briefly and inadequately described, and at least *M. ardesiaca*, *M. moggii*, and probably forms of *M. spathulata* were included in var. *natalensis*, so that it is impossible to identify it with any one currently-recognized species. The recent extensive collecting activity of Olive Hilliard and B. L. Burtt in the Drakensberg has resulted in the discovery of several more localities for *M. ardesiaca*, and the species has now become much better understood than it was when first described in 1973.

94. MORAEA GRAMINICOLA
Obermeyer

Obermeyer, *Fl. Pl. Africa.* **39**: tab. 1526. 1969; Goldblatt, *Ann. Mo. bot. Gdn* **60**: 244–246. 1973. TYPE: South Africa, Natal, Clovelly farm near Mooi River, *Mauve 4466* (PRE, holotype; BOL, isotype).

For synonyms see under subsp. *robusta*.

graminicola = favouring grassland, referring to the habitat, open grassveld, where it blooms early in the season.

Plants 25–60 cm at flowering time, solitary. *Corm* to 15 mm in diameter, with brown, reticulate tunics sometimes extending upwards a short distance. *Cataphylls* 3–4, innermost rarely more than 10 cm, pale, submembranous, entire or frayed or broken at the apex. *Leaf* basal, linear, erect, channelled, usually exceeding the stem at flowering time, 7–25 mm wide. *Stem* erect, simple (rarely branched in subsp. *notata*), sheathing bract leaves 1–3, herbaceous, often overlapping, to 15 cm long, long and tapering apically. *Spathes* entirely herbaceous or with a dry, brown apex, inner 14–18 cm long, outer several cm shorter than the inner. *Flower* pale-yellow to grey, veined with mauve, especially on the crests, self-coloured or distinctly blotched with mauve at the base of the crests; *outer tepals* 60–75 mm long, claw suberect, limb ovate, to 45 mm long, to 30 mm wide; *inner tepals* lanceolate, 40–50 mm long, erect, to 15 mm at the widest. *Filaments* 8–12 mm long, united in the lower half; *anthers* about 13 mm long. Ovary about 2 cm long, exserted from the spathes, *style branches* to 20 mm long, crests 10–15 mm, flushed with mauve. *Capsule* cylindric, to 3 cm long; *seeds* flattenned, discoid. *Chromosome number* 2n = 12 (subsp. *graminicola*).

Flowering time: August to November.

DISTRIBUTION AND HABITAT

Moraea graminicola occurs in northern and central Natal between Ngome and Nottingham Road, and in the Transkei between Port St. Johns and East London. It grows in open grassland, where it typically flowers early in the season, often before the first summer rains have fallen. Plants are presumably poisonous to stock, as are many other species of *Moraea*, and are avoided by grazing animals.

DIAGNOSIS AND RELATIONSHIPS

Moraea graminicola can be recognized by its short basal leaf at flowering time, and by its characteristic pale, membranous cataphylls which are either unbroken or frayed above. Two subspecies are recognized, the typical subsp. *graminicola* from Natal and flowering early in the season, often before the spring rains, and a second, occurring to the south in the Transkei, where plants are generally taller and tend to flower later. Both subspecies are found in open grassland and are solitary.

Moraea graminicola needs more investigation; subsp. *graminicola* is fairly well known in a limited area of Natal, but it probably occurs outside this area. Southern Natal and Pondoland particularly, should be surveyed for this species, and it is possible that forms intermediate between the two subspecies will be found in this intervening area between the known ranges for each. Subsp. *notata* is not well known.

HISTORY

Although it was first collected in 1928 by Ernest Galpin, *Moraea graminicola* was only described 40 years later by the Pretoria botanist Mrs Amelia Mauve (née Obermeyer). She collected it on the farm Clovelly, near Mooi River, no great distance from where Galpin first recorded the species near Lions River (Obermeyer, 1969). It is known to be poisonous to stock.

KEY TO THE SUBSPECIES

1. Sheathing bract leaves 1 or 2; style crests not darkly blotched at base; occurring in Natal 94A. subsp. **graminicola**
1'. Sheathing bract leaves 3; crests darkly blotched at base; occurring in the Transkei 94B. subsp. **notata**

94A. Subsp. graminicola

Plants seldom exceeding 45 cm. *Stem* unbranched, bearing 1 or 2 overlapping sheathing bract leaves. *Flowers* pale yellow to grey, veined with mauve; style crests sometimes flushed a pale mauve, but not darkly marked at the base.

Flowering time: August to November.

DISTRIBUTION, HABITAT AND DIAGNOSIS

Subsp. *graminicola* extends from Ngome in northern Natal to Nottingham Road in the south. It flowers early in the season, typically before the first summer rains.

This subspecies is fairly well known and has been fully described, with ecological observations, in *Flowering Plants of Africa* (Obermeyer, 1969), where there is a good illustration. It can be distinguished from subsp. *notata* by having darkly-veined but otherwise uniformly-coloured style crests, a shorter stem, and 1–2 sheathing bract leaves on the stem, while subsp. *notata* has 3 sheathing bract leaves.

94B. Subsp. notata Goldblatt

Goldblatt, *Ann. Mo. bot. Gdn* **60**: 245–246. 1973. TYPE: Transkei, east of Libode, *Codd 10691* (BOL, holotype; PRE, isotype).

Plants 40–60 cm high, usually larger than subsp. *graminicola*. *Stem* very occasionally branched, sheathing stem bracts 3. *Flowers* pale-yellow to cream; style crests marked at base a dark-brown to mauve colour.

Flowering time: September to January.

DISTRIBUTION, HABITAT AND DIAGNOSIS

Subsp. *notata* has been recorded along the coast and near interior Transkei between Port St. Johns in the north and East London in the south.

Subsp. *notata* has the distinctive pale, rather truncate, submembranous cataphylls found in subsp. *graminicola*, and resembles it in overall appearance and solitary growth form. It can be distinguished by a generally more robust habit and the characteristic dark markings at the base of the style crests. The latter feature is otherwise known only in *M. huttonii*, a plant that grows in large clumps along streams or in other moist situations. Subsp. *notata* has been recorded in bloom from September to January and is thus usually later-flowering than subsp. *graminicola*.

95. MORAEA HIEMALIS Goldblatt

Goldblatt, *Ann. Mo. bot. Gdn* **60**: 248–249. 1973. TYPE: South Africa, Natal, Lions River, *Obermeyer s.n.* (PRE *33562*, holotype).

hiemalis = of the winter, referring to the midwinter flowering season.

Plants to 25–45 cm high, solitary. *Corm* 10–15 mm in diameter, with dark-brown reticulate tunics. *Cataphylls* brown, brittle, entire, or irregularly broken, ribbed and silver and purplish below. *Leaf* solitary, longer than the stem, often dying back at flowering time, margins tightly inrolled and apparently terete, but with a narrow adaxial groove, 4–6 mm in diameter. *Stem* erect, simple, sheathing bract leaves (3–)4–5, overlapping, to 14 cm long, attenuate, brown apically. *Spathes* herbaceous, with dry, light-brown apices, attenuate, *inner* 8–14 cm long, *outer* equal or slightly shorter than the inner. *Flowers* yellow with dark veins and deep-yellow nectar guides on the outer tepals; *outer tepals* to 50 mm long, limb to 35 mm long, 18–24 mm wide, slightly reflexed; *inner tepals* erect, lanceolate, 35–40 mm long and 12–15 mm wide. *Filaments* 6–8 mm long, united in the lower half to two-thirds; *anthers* 6–10 mm long. *Ovary* 14–18 mm long, exserted from the spathes, *style branches* 11–13 mm long, crests about 10 mm long. *Capsule* cylindric, 20–25 mm long, about 10 mm wide; *seeds* flat and discoid. *Chromosome number* not known.

Flowering time: July to August (occasionally in September).

DISTRIBUTION AND HABITAT

Moraea hiemalis is restricted to central Natal, in the area around Pietermaritzburg and Richmond, extending north to the Kamberg near Estcourt. It grows in open grassland at altitudes ranging from 1 000–2 000 m.

DIAGNOSIS AND RELATIONSHIPS

Moraea hiemalis is a solitary-growing species with the single leaf apparently terete, with the margins tightly inrolled so that the adaxial groove is no more than a narrow slit. The leaf is produced long before the flowers, and by flowering time it has usually begun to die back, and is sometimes green only in the lower third. Plants are generally quite low in stature, seldom exceeding 40 cm, and the stem is sheathed with 3–5 overlapping sheathing bract leaves. The flowers are yellow and large, and typical of subgenus *Grandiflora* in having erect inner tepals, and broad style branches with conspicuous crests. Its immediate relationships within the subgenus are uncertain. *Moraea hiemalis* is isolated from other representatives of the subgenus *Grandiflora* by its early flowering time, July and August.

HISTORY

The first collections of *Moraea hiemalis* were made by Rudolf Schlechter near Mooi River, in September 1893. Since then it has been recorded sporadically from the Natal Midlands, but it was only recognized as a distinct species in 1973, being regarded in the intervening years as a form of *M. spathulata*.

96. MORAEA MOGGII N. E. Brown

Brown, *Trans. R. Soc. S. Africa* 17: 346. 1929; Sealy, *Bot. Mag.* new ser. 175: tab. 469. 1965; Letty, *Wild Flowers Transvaal* tab. 36, fig. 2. 1962; Goldblatt, *Ann. Mo. bot. Gdn* 60: 237–239. 1973. TYPE: South Africa, Transvaal, Struben's farm, *Mogg s.n.* (PRE *15652*, holotype).

For synonyms see under subsp. *albescens*.

moggii = named after A. O. D. Mogg, South African botanist, who collected extensively in the Transvaal and Mozambique in the early and middle part of this century.

Plants medium to tall, usually slender, to 70 cm high, always solitary. *Corm* to 20 mm in diameter, with unbroken, pale, coriaceous tunics, frequently covered by matted fibres of previous season's decayed leaf bases. *Cataphylls* dark-brown to purplish below, firm, entire or irregularly broken, not fibrous above. *Leaf* solitary, linear, channelled at least below, often flat above, longer than the stem, to 15 mm wide. *Stem* erect, simple, sheathing bract leaves (2–)3(–4), herbaceous, with dry, brown apices, generally not overlapping. *Spathes* herbaceous, inner 9–16 cm long, outer slightly shorter than the inner. *Flowers* yellow, cream or white, with large, bright yellow nectar guides edged with purple veins on the outer tepals; *outer tepals* broadly lanceolate, obtuse, 40–75 mm long, limb to 50 cm long, to 33 mm wide, reflexed to 45°; *inner tepals* erect, broadly lanceolate with tapering base, obtuse to retuse, to 60 mm long, 20–25 mm wide. *Filaments* about 10 mm long, united for about half their length; *anthers* about 10 mm long, not reaching the stigma. Ovary linear 2–3 cm long, exserted from the spathes, *style branches* to 20 mm long, crests 10–20 mm long. *Capsule* cylindric, to 4 cm long; *seeds* flattened, discoid. *Chromosome number* 2n = 12 (subsp. *moggii*).

Flowering time: December to May.

DISTRIBUTION AND HABITAT

Moraea moggii extends along the eastern Transvaal escarpment from Magoebas Kloof and Haenertsburg in the north, to north-eastern Natal in the south. It grows in open grassland in exposed well-drained sites.

DIAGNOSIS AND RELATIONSHIPS

Moraea moggii is a typical member of subgenus *Grandiflora* and difficult to distinguish from several other species of the alliance. It is solitary in habit, relatively slender, with a long stem and long, usually trailing, channelled leaf and a large pale-yellow to white flower. It is most easily confused with *M. spathulata*, some forms of which are very similar, but the two can usually be distinguished by the solitary habit of *M. moggii* compared with *M. spathulata*, which typically, but not always, grows in clumps, combined with a narrow, grey leaf and, at least in subsp. *moggii*, in the late flowering season. *Moraea spathulata* flowers in winter in the south, to early summer in the northern part of its range, and has broad, pale- to deep-green leaves.

Moraea moggii is regarded as comprising two subspecies, occurring in different parts of the summer rainfall area. They have in common the solitary habit, similar basal sheathing cataphylls and slender channelled leaf, combined with fairly large size, and grow in open, short grassland, usually in montane areas. There is some doubt, still to be resolved, concerning the relationships of the subspecies.

HISTORY

The first record of *Moraea moggii* is the type collection made by A. O. D. Mogg early this century, and the species was described by the English botanist N. E. Brown, in 1928, based only on this one collection. The locality given for the specimen is Struben's Farm, Pretoria, an area where *M. moggii* does not grow. When asked about the problem, Dr Mogg suggested that the plant originally came from Haenertsburg, where his family once farmed. He was not positve, but it seems likely, for the species is very common around Haenertsburg. A photograph accompanying the type specimen adds confusion, as this is of a small-flowered species, probably *M. stricta*. There is, however, no reason to reject the name because Brown indicated quite clearly the type specimen, and this can readily be matched with wild plants from Haenertsburg.

CULTIVATION

Moraea moggii makes a very attractive garden plant, and it is easy to grow and maintain in the summer rainfall area. It looks best in a natural setting, perhaps among rocks interplanted with low native shrubs. The flowers are produced in large numbers, and as the plants become established, they increase, forming small clumps and several flowering stems. The flowers are large and striking, and they last three days. *Moraea moggii* extends the flowering season of the large-flowered summer rainfall area Moraeas into April. The corms are best left in the ground when dormant in the winter, but care must be taken not to dig them up.

KEY TO THE SUBSPECIES

1. Flowering from late February to April; flowers yellow; occurring in the eastern Transvaal and Swaziland 96A. subsp. **moggii**
1'. Flowering in December or January, occasionally later; flowers usually white, sometimes yellow; occurring in Zululand, northern Natal and the Wakkerstroom area of the Transvaal . 96B. subsp. **albescens**

96A. Subsp. moggii

Cataphylls firm, dark-brown above, paler and veined below, inner rarely less than 15 cm long. *Leaf* grey-green, glaucous, 4–10 mm wide, not ribbed when fresh. *Flowers* yellow, veined purple-brown.

Flowering time: late February to April.

DISTRIBUTION, HABITAT AND DIAGNOSIS

Subsp. *moggii* extends from Haenertsburg in the northern Transvaal to Mbabane in Swaziland. The habitat is as described for the species, short grassveld on open mountain slopes.

Subsp. *moggii* can be distinguished from subsp. *albescens* by its glaucous leaf, well-developed cataphylls and otherwise by its distribution in the eastern Transvaal and Swaziland. It is typically autumn-flowering, but has been found in flower as early as February and as late as May.

96B. Subsp. **albescens** Goldblatt

Goldblatt, *Ann. Mo. bot. Gdn* 60: 238–239. 1973; *Fl. Pl. Africa* 44: tab. 1726. 1977. TYPE: South Africa, Transvaal, Tafelkop near Wakkerstroom, *Mauve & Tölken 4524* (PRE, holotype; BOL, isotype)

albescens = pale or whitish, referring to the colour of the flowers in the most common form of the subspecies.

Cataphylls firm to submembranous, light-brown, inner seldom reaching more than 15 cm in length, usually less than 10 cm. *Leaf* to 15 mm wide, light-green or somewhat glaucous, veins occasionally prominent even in fresh material. *Flowers* white, cream or sometimes yellow, veined green, purple or brown; *style branches* and crests often suffused with purple.

Flowering time: December to February, occasionally extending to late autumn.

DISTRIBUTION, HABITAT AND DIAGNOSIS

Subsp. *albescens* occurs in Zululand and westwards to the Utrecht distict of northern Natal, and locally in the Wakkerstroom area of the southern Transvaal. It grows in open grassland.

Subsp. *albescens* differs from subsp. *moggii* in having white to pale-yellow flowers and shorter, light-brown cataphylls. It flowers earlier in the season than the typical subspecies, from December to February. It appears at first to be a very distinct taxon, but when the whole range of material from areas surrounding the type locality are examined, plants are found to vary in colour and time of flowering, and it becomes increasingly difficult to distinguish it from subsp. *moggii*. It may be that subspecific rank is unwarranted, but in the absence of intermediates in the intervening areas of the Transvaal and southern Swaziland, it remains as a separate subspecies.

97. MORAEA SPATHULATA
(Linnaeus fil.) Klatt

Klatt, Durand & Schinz, *Conspectus Florae Africae* **5**: 152. 1895; Goldblatt, *Ann. Mo. bot. Gdn* **60**: 250–255. 1973; **64**: 265–268. 1977.

SYNONYMS
Iris spathulata Linnaeus fil., *Supplementum Plantarum* 99. 1782. TYPE: South Arica, Cape, Langkloof, Wolwekraal, *Thunberg s.n.* (Herb. Thunberg *1172*, UPS, holotype).

Iris spathacea Thunberg, *Dissertatio de Iride* no. 23. 1782. TYPE: as for *I. spathulata* Linnaeus fil.

Moraea spathacea (Thunberg) Ker, *Bot. Mag.* **28**: sub tab. 1103. 1808, non Thunberg, 1787 (= *Bobartia indica* Linnaeus); Baker, *Flora Capensis* **6**: 14. 1896. excluding var. *natalensis* and var. *galpinii*.

Moraea longispatha Klatt, *Linnaea* **34**: 560. 1866. TYPE: South Africa, Cape, Transkei, banks of Kei River ("Tambikuland"), *Ecklon & Zeyher Irid. 3* (MO, lectotype designated by Goldblatt, 1973).

Moraea spathulata subsp. *transvaalensis* Goldblatt, *Ann. Mo. bot. Gdn* **60**: 253. 1973. TYPE: South Africa, Transvaal, near Sabie, *Goldblatt 610* (BOL, holotype; MO, isotype).

Moraea spathulata subsp. *saxosa* Goldblatt, *Ann. Mo. bot. Gdn* **60**: 254. 1973. TYPE: South Africa, Transvaal, summit of Long Tom Pass, *Goldblatt 612* (BOL, holotype; PRE, isotype).

M. spathulata subsp. *antumnalis* Goldblatt, *Ann. Mo. bot. Gdn* **60**: 254. 1973. TYPE: South Africa, Cape, Transkei, Nyameni Mouth, Port Edward district, *Strey 8619* (PRE, holotype; NH, isotype).

spathulata = spathulate or spatula-like, referring to the shape of the inner tepals, broadest near the apices.

Plants large, 50–90 cm high, solitary or in small clumps. *Corm* 1,5–2 cm in diameter, with tunics of brown, fine to coarse fibres. *Cataphylls* prominent, brown to pale, firm in texture, brittle, dry, entire or irregularly broken, or frayed at the apex. *Leaf* solitary, flat or channelled, to 1,5 cm wide. *Stem* simple, rarely bearing one branch, sheathing bract leaves 2–3, often dry and brown, to 15 cm long, rarely overlapping. *Spathes* herbaceous, or becoming dry and brown from the apex, attenuate, inner 10–14 cm long, outer about three-quarters as long as the inner. *Flowers* yellow with deep-yellow nectar guides on the outer tepals; *outer tepals* 35–50 mm long, the limb 20–35 mm, spreading to reflexed; *inner tepals* 30–40 mm long, erect. *Filaments* 8–12 mm long, free in the upper half to one-third; *anthers* 8–12 mm long. Ovary 2–3 cm long, exserted from the spathes, *style branches* 12–18 mm long, the crests to 10 mm long. *Capsule* cylindric, 3,5–5,5 cm long; *seeds* flattenned, discoid. *Chromosome number* $2n = 12$.

Flowering time: May to November in the south, November to February in Natal and the Transvaal, and into early April in Zimbabwe and Mozambique.

DISTRIBUTION AND HABITAT
Moraea spathulata is one of the most common and widespread of the summer rainfall area species of *Moraea*. It extends from George in the southern Cape through Lesotho and Transkei to Swaziland and the eastern Transvaal, and north of the Limpopo in the Inyanga, Vumba and Chimanimani highlands of Zimbabwe and Mozambique, with outlying populations in the Gorongosa mountains to the east. *Moraea spathulata* occurs along the coast as well as in mountainous areas in the south, but is restricted to well-watered highlands from Natal northwards. It grows in open grassland or at the edge of forest or thickets, and often among rocks.

DIAGNOSIS AND RELATIONSHIPS
Moraea spathulata has large, yellow flowers and a broad basal leaf usually much exceeding the stem, and more or less flat above. The plants almost always grow in large clumps, each corm producing its own leaf and stem. The cataphylls are usually dark-brown and often unbroken, or they may become irregularly fragmented from the apex.

It is unusually variable, and I initially (Goldblatt, 1973) recognized four subspecies in southern Africa. Subsequent field observations and examination of more herbarium material has made it seem less useful to subdivide *M. spathulata*, as the subspecies did not accurately reflect the variation found in the species (Goldblatt, 1977). Subsp. *autumnalis* from the Transkei is merely a very early-blooming coastal form and must be included in the typical form. *Moraea spathulata* in the southern part of its range in the Knysna district of the Cape Province blooms from July to September but not unusually in June or even May, thus the March to May blooming subsp. *autumnalis* is not particularly unusual. The remaining two subspecies, subsp. *transvaalensis* and subsp. *saxosa*, both from the Transvaal and Swaziland, differ from one another mainly in that the lower altitude subsp. *transvaalensis* forms large clumps, while the higher altitude subsp. *saxosa* is often solitary in habit and has a slightly longer ovary and capsule. However, when the entire pattern of variation in *M. spathulata* is considered, both the tendency to solitary habit, and the longer ovary of subsp. *saxosa* and the features of subsp. *transvaalensis* now seem altogether too insignificant to make taxonomic recognition worthwhile. It seems far more useful to recognize *M. spathulata* as a single variable species.

North of the Limpopo River the largest forms of *Moraea spathulata* occur in the Inyanga Highlands in Zimbabwe and Mozambique, some plants even bearing branches. A rather smaller form occurs in the Chimanimanis. Differences between the two forms appear significant but the few collections from the intervening highland areas in Mozambique are intermediate in all characteristics.

HISTORY

Moraea spathulata was first collected by the Swedish botanist, Carl Peter Thunberg, probably in 1772, during his first expedition through the southern Cape. Thunberg records the species from the Outeniqua mountains and the Longkloof near the Keurbooms River. It was described by the younger Linnaeus in 1782, as *Iris spathulata*, based on Thunberg's specimens and manuscript notes. Later the same year Thunberg redescribed the plant, calling it *Iris spathacea*, and it was by this specific epithet that the species was transferred to *Moraea* (Ker, 1808), where it is an illegitimate homonym for *Bobartia spathacea*, now *B. indica* Linnaeus. Nevertheless, it remained known as *M. spathacea* throughout the eighteenth century, and was so treated in *Flora Capensis* by J. G. Baker in 1896. The transfer of the slightly earlier epithet *spathulata* to *Moraea* was made by F. W. Klatt in 1895. Until recently *M. spathulata* included several different large, yellow-flowered species of subgenus *Grandiflora*. The only synonym of *M. spathulata* is *M. longispatha*, described by Klatt in 1866, from specimens collected in 1832 on the banks of the Kei River by C. F. Ecklon and C. L. Zeyher.

CULTIVATION

Moraea spathulata is an excellent garden subject. It seems to be easy to grow in the open ground, and it is hardy almost throughout southern Africa. It needs good watering in the summer and autumn, and it will flower for years if left undisturbed and given a sunny position. The large yellow flowers each last three days, and the flowering season lasts for about six weeks. The long arching strap-like leaves are also attractive so that plants are useful even after flowering. *Moraea spathulata* has been grown successfully in large tubs at Kirstenbosch, but it does not do well in smaller pots, and is much better suited to open ground.

97.

M. spathulata.

98. MORAEA ALTICOLA Goldblatt

Goldblatt, *Ann. Mo. bot. Gdn* **60**: 255–256. 1973; Pearse, *Mountain Splendour* 75. 1978. TYPE: South Africa, Natal, Mont aux Sources, *Schweickerdt s.n.* (PRE 28588, holotype; NH, isotype).

alticola = from high altitudes, referring to the distribution in the high Drakensberg.

Plants large, to 1 m high, in large clumps. *Corm* about 2 cm in diameter, with coarsely-fibrous tunics covered by the matted fibres of previous season's decayed leaves and cataphylls. *Cataphylls* brown, broken irregularly but forming a pale, well-developed, fibrous network above the ground, sheathing the lower part of the leaf, usually accumulating to form a thick neck around the base. *Leaf* solitary, basal, exceeding the stem, broad and flat becoming channelled below, 15–30 mm wide, margins often conspicuously thickened and straw-coloured to pale yellow. *Stem* erect, simple or rarely branched, sheathing bract leaves 3–5, overlapping, to 18 cm long, apices brown. *Spathes* herbaceous, becoming dry and brownish above, *inner* 12–15 cm long, *outer* nearly as long to somewhat shorter than the inner. *Flower* pale-yellow with darker-yellow nectar guides on the outer tepals; *outer tepals* to 88 mm long, limb to 50 mm long, 30–40 mm wide; *inner tepals* to 70 mm long, erect, to 25 mm wide. *Filaments* to 20 mm long, united in the lower half; *anthers* about 15 mm long, not reaching the stigma. Ovary 20–30 mm long, exserted from the spathes, *style branches* to 20 mm long, crests about 15 mm long. *Capsule* cylindric, about 4,5 cm long; *seeds* flattenned and discoid. Chromosome number $2n = 12$.

Flowering time: mainly December to February, but occasionally from October to March.

DISTRIBUTION AND HABITAT

Moraea alticola is restricted to the higher parts of the Drakenberg Mountains and the plateau of Lesotho. It extends from Mont-aux-Sources in the north to Naudes Nek near the southern Lesotho border in the south, almost always at altitudes above 2 200 m.

DIAGNOSIS AND RELATIONSHIPS

Moraea alticola, undoubtedly closely allied to *M. spathulata*, has been accorded specific rank, due in part to several distinct and easily recognizable features, and to its spatial and ecological isolation from the various forms of *M. spathulata*. In spite of its occurring in the alpine summit plateau of the Drakensberg, it is easily the largest, most robust species in the genus. While size alone makes *M. alticola* easy to distinguish, it can also be recognized by its inner cataphyll which forms an extensive pale network around the base of the stem and leaf. This is sometimes found in other allies of *M. spathulata* but, except in the eastern Cape, solitary growing *M. reticulata* never achieves the same degree of development and is often present only in some individuals of a population.

HISTORY

The energetic South African mountain climber and plant collector Ernest Galpin was probably the first to record *Moraea alticola* but it is relatively common and has been collected repeatedly in recent years as the high Drakensberg has become more accessible to botanists. All early collections of *M. alticola* were assigned to *M. spathulata*, and it was only recognized as a separate species in 1973.

98.

I. allicola.

99. MORAEA RETICULATA Goldblatt

Brown, *Trans. R. Soc. S. Afr.* **17**: 348. 1929; 1973. TYPE: South Africa, Cape, top of Katberg Pass, Goldblatt 682 (BOL, holotype; MO, PRE, isotypes).

reticulata = reticulate or netted, referring to the upper part of the cataphyll that sheaths the lower part of the plant.

Plants solitary, rarely in small clumps. *Corm* to 20 mm in diameter, with unbroken, pale, coriaceous tunics, frequently covered by matted fibres of previous season's decayed leaf bases. *Cataphylls* fibrous, reticulate, inner produced to 20 cm above ground in a network, sheathing leaf and scape. *Leaf* solitary, channelled (conduplicate when dry), to 15 mm wide, exceeding the stem. *Stem* 45–70 cm long, erect, simple, sheathing bract leaves 3–4, green, becoming membranous late in the season, to 15 cm long. *Spathes* herbacious, *inner* to 15 cm long, *outer* slightly shorter than the inner. *Flowers* bright-yellow with orange nectar guides on the outer tepals; *outer tepals* to 70 mm long, about 25 mm wide, limb reflexed; *inner tepals* 50–60 mm, to 15 mm wide, erect. *Filaments* to 13 mm long, united in the lower half; *anthers* linear, to 15 mm long, pollen white. Ovary linear, 2–3 cm long, exserted from the spathes, *style branches* about 20 mm long, crests somewhat shorter. *Capsule* to 4 cm long; *seeds* flattened, discoid. Chromosome number $2n = 12$.

Flowering time: March to May.

DISTRIBUTION AND HABITAT

Moraea reticulata has a limited distribution in the mountains south of Queenstown in the eastern Cape, where it extends from Bedford to Cathcart. It has been collected most frequently on the Hogsback and Katberg. Plants grow on steep grassy slopes.

DIAGNOSIS AND RELATIONSHIPS

The flowers of *Moraea reticulata* are similar to those of *M. spathulata*, but the plants themselves differ in being almost invariably solitary. *Moraea spathulata* has been recorded from the same area as *M. reticulata* where it blooms in late spring or summer, while *M. reticulata* flowers in autumn, from March to May.

Moraea reticulata can always be recognized by its very characteristic cataphylls, the inner of which extends upwards well above the ground and forms a grey or brown fibrous network around the leaf and stem base. This type of cataphyll is occasionally found in *M. spathulata* but is never as stongly developed, and is also present in the high Drakensberg species, *M. alticola*. In the latter, the reticulate cataphyll is conspicuous and straw-coloured to pale-yellow. *Moraea reticulata* can be easily distinguished from *M. alticola* which grows in clumps and has broad, flat leaves in contrast to the solitary habit and channelled leaves of *M. reticulata*.

Moraea reticulata is a segregate of the *M. spathulata* complex and the decision to accord its specific rank is based partly on the solitary habit, and partly because it flowers at a different season from the forms of *M. spathulata* that occur in the same area.

HISTORY

Moraea reticulata was described in 1973 from a number of collections made in the Hogsback and Katberg mountains north of Grahamstown, in the 1950's and 1960's. It was apparently not recorded by early botanists who collected in the eastern Cape.

100. MORAEA GALPINII (Baker) N. E. Brown

Brown, *Trans. R. Soc. S. Afr.* **18**: 2346. 1929; Obermeyer, *Fl. Pl. Africa* **40**: tab. 1582. 1970; Goldblatt, *Ann. Mo. bot. Gdn* **60**: 204-259. 1973, excl. subsp. *robusta* Goldblatt (= *M. robusta*).

SYNONYMS
Moraea spathacea var. *galpinii* Baker, *Flora Capensis* **6**: 14. 1896. TYPE: South Africa, Transvaal, Saddleback Range, *Galpin 459* (K, holotype; PRE, BOL, isotypes).

galpinii = named in honour Ernest Galpin, amateur botanist and important early twentieth-century collector of southern African flora.

Plants reaching to 30 cm above ground, solitary or in small clumps. *Corm* to 1,8 cm in diameter, covered by fibrous remains of tunics of previous seasons. *Cataphylls* dark brown to black, comprising rigid, vertical fibres often reaching above the ground, accumulating with those of past seasons to form a thick neck around the base. *Leaf* solitary, present or absent at flowering time, eventually exceeding the inflorescence; subterete with a narrow adaxial groove, to 2,5 mm wide. *Stem* erect, unbranched, sheathing bract leaves 6-8 cm long, usually 3, rarely 2 or 4, overlapping. *Spathes* herbaceous, *inner* to 11 cm long, outer to 7 cm long. *Flowers* bright-yellow with slightly darker yellow nectar guides outlined with dark spots on the outer tepals; *outer tepals* 4-5 cm long, limb to 3,5 cm long and 2,2 cm wide, obtuse to retuse; *inner tepals* lanceolate, to 5 cm long and about 1 cm wide, obtuse to retuse. *Filaments* to 8 mm long, united in the lower two-thirds; *anthers* to 9 mm long, pollen yellow. Ovary initially about 10 mm long, rapidly elongating after fertilization to 20-25 mm, exserted from the spathes, *style branches* to 13 mm, crests 10-13 mm long. *Capsules* and *seeds* unknown. *Chromosome number* $2n = 12$.

Flowering time: August to early October.

DISTRIBUTION AND HABITAT
Moraea galpinii occurs in the eastern and south-eastern Transvaal and adjacent Swaziland. It extends from Mount Sheba near Pilgrims Rest in the north through the Barberton mountains to Forbes Reef in Swaziland. Plants bloom early in spring, often before the first rains, and sometimes the flowers appear before the leaf is evident. This may be due to veld burning, which destroys the apex of the emergent leaf, or perhaps it develops late in some seasons. *Moraea galpinii* grows in open low grassland, sometimes in rock outcrops, and has also been recorded among rocks along stream banks.

DIAGNOSIS AND RELATIONSHIPS
Moraea galpinii is one of the smaller-flowered members of subgenus *Grandiflora* and can be recognized by its slender subterete leaf, about 2,5 mm in diameter, and distinctive, firm, blackish cataphylls, which are divided into fairly thick vertical fibres. These persist, forming a dense layer around the base of the plant. Immature plants have quite different, soft, pale, membranous cataphylls. The flowers are deep-yellow, and the nectar guides are about the same colour, but ringed by a border of minute dark dots.

Moraea galpinii is apparently closely related to *M. robusta* which until recently (Goldblatt, 1982) was treated as a subspecies of *M. galpinii*. *Moraea robusta* has pale yellow flowers with darker yellow nectar guides, and is distinctive in subgenus *Grandiflora* in having spreading inner tepals. It is thus easy to distinguish from *M. galpinii* when living flowers are available, despite a striking vegetative similarity. When dry, *M. robusta* can be distinguished by its somewhat thicker leaf, 4-10 mm wide, with less tightly inrolled margins, and taller stem, to 40 cm high.

HISTORY
Moraea galpinii was discovered by the South African collector and amateur botanist, Ernest Galpin, during the period 1890-1892, when he was living in Barberton in the south-eastern Transvaal. Specimens sent to Kew were described by the English botanist J. G. Baker as variety *galpinii* of *M. spathulata* (which Baker called *M. spathacea*),

and it was only elevated to specific rank by N. E. Brown in 1929. Although at first it was known only from very limited material, it has now become clear that it is fairly common in the eastern Transvaal escarpment area. A painting of *M. galpinii* has been published in *Flowering Plants of Africa* with the accompanying text by Mrs A. A. Mauve (Amelia Obermeyer) (1970).

101. MORAEA ROBUSTA (Goldblatt) Goldblatt

Goldblatt, *Ann. Mo. bot. Gdn* **69**: 368–369. 1982.

SYNONYMS
Moraea galpinii (Baker) N. E. Brown subsp. *robusta* Goldblatt, *Ann. Mo. bot. Gdn* **60**: 248. 1973. TYPE: South Africa, Transvaal, Naauwhoek, Utrecht district, *Devenish 109* (PRE, holotype).

robusta = robust referring to the generally large size of the leaves and flowers, particularly in comparison to the apparently closely related *M. galpinii*.

Plants 30–40 cm high. *Corm* 12–20 mm in diameter, covered with tunics of densely-matted, blackish fibres. *Cataphylls* dark brown to black, comprising rigid, vertical fibres often reaching above the ground, accumulating with those of past seasons to form a thick neck around the base. *Leaf* solitary, channelled to subterete with tightly inrolled margins, sometimes short at flowering time but ultimately exceeding the stem, 4–10 mm wide, often dry and withered distally. *Stem* unbranched, sheathing bract leaves 3, imbricate, 7–10 cm long. *Spathes* herbaceous, *inner* 10–11 cm long, *outer* about two-thirds as long as the inner. *Flowers* pale yellow, to whitish, tepal claws weakly ascending, limbs spreading more or less horizontally; *outer tepals* 55–65 mm long, limb about 40 mm long, to 26 mm wide; *inner tepals* 55–57 mm long. *Filaments* 10–11 mm long, united in the lower half; *anthers* about 10 mm long, pollen pale-yellow. Ovary to 15 mm long at anthesis, exserted from the spathes, *style branches* to 15 mm long, crests about 15 mm long. *Capsules* and *seeds* unknown. *Chromosome number* unknown.
 Flowering time: (? August, September to) October to November.

DISTRIBUTION AND HABITAT
Moraea robusta has a wide range in the summer rainfall area, extending from the south-eastern Transvaal, near Machadodorp, and northern Natal, through the eastern Orange Free State to the northern Transkei. It grows in mountain grassland, mainly at altitudes of 2 000–2 500 m. It is apparently absent from the main range of the Drakensberg in Natal, but has been recorded from Sehlabathebe National Park in south-eastern Lesotho.

DIAGNOSIS AND RELATIONSHIPS

Moraea robusta is a fairly typical member of subgenus *Grandiflora*, and it has a long basal leaf and large, yellow flower. The flower is distinctive in its pale to whitish colour and in having the limbs of the outer tepals spreading rather than erect as in the other species of the group. Plants are fairly robust, and have fibrous corm tunics and accumulating cataphylls exactly like those of the eastern Transvaal–Swaziland species *M. galpinii*, to which it is presumably closely related. It can be distinguished from *M. galpinii* by its larger and very pale-yellow flower and channelled to subterete leaf, 4–10 mm in diameter, compared to 2,5 mm in *M. galpinii*.

HISTORY

Moraea robusta was for a long time confused with *M. galpinii*, in which it was included as a separate subspecies in my treatment of *Moraea* for the summer rainfall area of southern Africa (Goldblatt, 1973). Only when the botanists, O. M. Hilliard and B. L. Burtt, showed me pictures of the subspecies which they had found flowering in the Wakkerstroom area of the southern Transvaal, did I realize that there were fundamental differences between the two. *Moraea robusta* was raised from subspecific to species rank in 1982 (Goldblatt, 1982).

102. MORAEA HUTTONII
(Baker) Obermeyer

Obermeyer, *Fl. Pl. Africa* **40**: tab. 1581. 1970; Goldblatt, *Ann. Mo. bot. Gdn* **60**: 256–258. 1973.

SYNONYMS

Dietes huttonii Baker, *Bot. Mag.* **101**: tab. 6174. 1875. TYPE: South Africa, Eastern Cape, *Hutton s.n.* (K, holotype).

Moraea baurii Baker, *Handbook Irideae* 50. 1892; *Flora Capensis* **6**: 14. 1896. TYPE: Transkei, Baziya, along streams, *Baur 247* (K, holotype).

Moraea rivularis Schlechter, *Bot. Jahrb. Syst.* **40**: 90. 1908. TYPE: South Africa, Natal, Ifafa, *Rudatis 100* (B, holotype).

huttonii = named in honour of Henry Hutton, amateur botanist who collected extensively in the eastern Cape in the mid-nineteenth century.

Plants large, to 1 m in height, growing in clumps. *Corm* about 1,5–2 cm in diameter, with membranous pale tunics covered by the cataphylls. *Cataphylls* brown, innermost longest, to 20 cm, entire or irregularly broken, rarely fibrous and then forming a weakly-developed reticulum above. *Leaf* linear, usually longer than the stem, 5–25 mm wide, more or less flat or channelled with the margins incurved, rarely subterete. *Stem* erect, rarely bearing 1–2 short to subsessile erect branches concealed by the bracts, sheathing bract leaves 5–6, sheathing the stem, often overlapping, herbaceous with dry apices. *Spathes* herbaceous with dry apices, *inner* 8–14 cm, *outer* 2–3 cm shorter than the inner. *Flowers* sweetly-scented, yellow, with large, deeper yellow nectar guides on the outer tepals and a dark, brown to purple blotch on each style crest; *outer tepals* oblanceolate, to 5,5 cm long, limb to 3,5 cm long, spreading, to 2 cm wide; *inner tepals* erect, lanceolate, to 4,5 cm long. *Filaments* to 13 mm long, joined in the lower half; *anthers* 7–9 mm long, pollen yellow. Ovary to 15 mm long, cylindric, *style branches* about 15 mm long, to 8 mm broad, crests 10–13 mm long. *Capsule* 12–30 mm long; *seeds* depressed, triangular to discoid. *Chromosome number* 2n = 12.

Flowering time: spring to early summer, sometimes as early as July, and usually October to early December.

DISTRIBUTION AND HABITAT

Moraea huttonii has wide range in eastern southern Africa, extending from the Katberg and Hogsback in the south through the mountains of Transkei, Lesotho and Natal to the south-eastern Transvaal where it is apparently restricted to the Wakkerstroom area. An isolated population has recently been recorded on the Boschberg near Somerset East, extending the range westwards to the borders of the Karoo. *Moraea huttonii* grows in or close to water, and is most often found at the edges of mountain streams and rivers.

DIAGNOSIS AND RELATIONSHIPS

Moraea huttonii is easily confused with other tall species of subgenus *Grandiflora*, such as *M. spathulata*, and it has the long, strap-like leaf and large, yellow flowers with erect inner tepals that characterize the alliance. It can easily be identified by its semi-aquatic habitat and the conspicuous violet to brown marks on the style crests. *Moraea huttonii* is the only species in the subgenus in which branches are regularly produced. These are often overlooked as they are short, and both the branch and the

spathes of the lateral inflorescences are concealed by the sheathing bract leaves, so that only the flowers and capsules are visible. The cataphylls are typically dark brown and fairly large, covering the lower part of the stem and leaf. The cataphylls are very similar to those of *M. spathulata*, to which *M. huttonii* is probably closely related.

HISTORY

In spite of its wide distribution and frequency, *Moraea huttonii* has remained poorly understood for many years. It was first described by J. G. Baker from plants grown at Kew, and originally collected by Henry Hutton in the eastern Cape. Baker placed it in *Dietes*, a genus which has a rhizome rather than a corm, and presumably he misunderstood the nature of the rootstock. In later works, Baker (1892; 1896) ignored *M. huttonii* altogether and included specimens of the species under *M. spathulata* (as *M. spathacea*) and *M. baurii*, which he described 1892, from specimens from Baziya in the Transkei. Brown (1929) also included *M. huttonii* in *M. spathulata*. In 1970 Mrs A. A. Mauve (Amelia Obermeyer), the Pretoria botanist, revived Baker's species, transferring it to *Moraea* (Obermeyer, 1970).

Moraea rivularis, described in 1808 by Rudolf Schlechter, and based on plants collected by the German horticulturist A. G. Rudatis at Ifafa in Natal, has also been included in *M. huttonii*, as there is no doubt it is the same species. *Moraea baurii* presents more of a problem (Goldblatt, 1973). The type specimens are incomplete, lacking leaves or corms, and the flowers do not have dark marks on the style crests. The identification is based mainly on habitat information provided by the collector, the Rev. Leopold Baur, who indicated that the plants grew along streams.

103. MORAEA SCHIMPERI (Hochstetter) Pichi-Sermolli

Pichi-Sermolli, *Webbia.* **7**: 349. 1950; Goldblatt, *Ann. Mo. bot. Gdn* **64**: 268–270. 1977.

SYNONYMS

Hymenostigma schimperi Hochstetter, *Flora* **27**: 24. 1844. TYPE: Ethiopia, Begemdir and Simen, 'Enschedcap', *Schimper 1173* (B, holotype; BM, F, K, M, MO, P, S, isotypes).

Vieusseuxia schimperi (Hochstetter) A. Richard, *Tentamen Florae Ethiopiae* **2**: 305. 1850.

Hymenostigma tridentatum Hochstetter, *Flora* **27**: 25. 1844. TYPE: Ethiopia, Begemdir and Simen, Barnam, Mt. Bachit, *Schimper 1296* (K, lectotype designated by Goldblatt, 1977).

Vieusseuxia tridentata (Hochstetter) A. Richard, *Tentamen Florae Ethiopiae* **2**: 305. 1850.

Xiphion diversifolium Steudel ex Klatt, *Linnaea* **34**: 572. 1866 nom. illeg. superfl. pro *Hymenostigma schimperi* Hochstetter.

Moraea diversifolia (Steudel ex Klatt) Baker, *J. Linn. Soc. Bot.* **16**: 130. 1877. nom. illeg. bas. illeg.

Moraea welwitschii Baker, *Trans. Linn. Soc. London Bot.* ser. 2, **1**: 270. 1877. TYPE: Angola, Huila, Lopollo River, *Welwitsch 1548* (BM, holotype; K, LISU, P, isotypes).

Moraea zambeziaca Baker, *J. Linn. Soc.* **16**: 130. 1878 nom. nud; *Handbk. Irideae* 51. 1892. TYPE: Zambia, Manganja Hills, *Meller s.n.* (K, lectotype here designated).

Moraea hockii De Wildeman, *Feddes Rep.* **11**: 540. 1913. TYPE: Zaire, Shaba, between Buggege and Lukoni, *Hock s.n.* (BR, holotype).

schimperi = named in honour of Wilhelm Schimper, explorer and plant collector, well-known for his travels in Ethiopia in the 1840's.

Plants medium to large, 20–50 cm high, solitary or sometimes growing in clumps. *Corm* about 1,5–2 cm in diameter, with brown, firm-textured tunics covered by the cataphylls. *Cataphylls* dark brown, innermost longest, initially unbroken, but often persisting and then becoming fragmented. *Leaf* solitary, linear, initially shorter than the stem, 9–15 mm wide, chan-

102.

M. huttonii.

nelled below, flat above, eventually much exceeding the stem. *Stem* erect, unbranched, sheathing bract leaves dry, often dark-brown, 1 or more, concealing the stem and overlapping the spathes. *Spathes* dry and often brown, attenuate, *inner* (6-)7-10(-12) cm long, *outer* 2-3 cm shorter than the inner. *Flowers* blue-purple with yellow nectar guides on the outer tepals; *outer tepals* lanceolate, 4-6,5 cm long, limb about as long to slightly longer than the claws, spreading to slightly reflexed; *inner tepals* erect, lanceolate, 3,5-4,5 cm long. *Filaments* 9-15 mm long, joined in the lower half; *anthers* 8-12 mm long, pollen white. Ovary to 15-20 mm long, cylindric, *style branches* 15-20 mm long, crests 10-20 mm long. *Capsule* 25-35 mm long, cylindric; *seeds* flattened, triangular to discoid. *Chromosome number* $2n = 12$

Flowering time: spring to early summer, sometimes as early as July, and usually October to early December south of the equator; November to May and as late as July in Ethiopia and West Africa.

DISTRIBUTION AND HABITAT

Moraea schimperi has the widest range of any species of *Moraea*. It extends from Zimbabwe and the highlands of Angola in the south through Zambia, Mozambique and Malawi to Ethiopia in the north and to Cameroun and Nigeria in the west. *Moraea schimperi* usually grows in vleis or marshy places where it flowers at the end of the dry season. However, it also occurs in more or less open grassland in well-drained sites.

DIAGNOSIS AND RELATIONSHIPS

Moraea schimperi is typical in many ways of the taller species of subgenus *Grandiflora* such as *M. spathulata*, and it has the long strap-like leaf and large flowers with erect inner tepals that characterise the alliance. Unlike most species, however, it has blue-purple flowers, rather than the more common yellow colour. Flowers in shades of blue to purple occur in the Drakensberg species, *M. ardesiaca*, and in three tropical African species, *M. macrantha*, *M. ventricosa* and *M. textilis*. *Moraea schimperi* can be recognized by its large brownish cataphylls that sheath the lower part of the plant, and at the beginning of the flowering season are often more prominent than the emerging leaves. The sheathing bract leaves and spathes are dry at flowering time and are often brownish and thus very like the cataphylls. *Moraea schimperi* blooms early in the season, the stems elongating before the leaves are produced, and the leaf only emerges as the first flowers open. Later in the season, the leaf becomes much longer than the stem. The cataphylls are very similar to those of *M. spathulata* and *M. huttonii*, to which *M. schimperi* is probably closely related.

HISTORY

Moraea schimperi was first collected in the extreme north of its range in Ethiopia by the notable German explorer Wilhelm Schimper in the late 1830's. Schimper's specimens were placed in a new genus *Hymenostigma* by the German botanist C. F. Hochstetter and described as *H. schimperi* and *H. tridentata*, the latter matching in every important respect *M. schimperi*. Before it was realized by the botanical community that *Hymenostigma* was conspecific with *Moraea*, plants matching *H. schimperi* were collected in the 1850s by another early tropical plant collector, Friedrich Welwitsch in Angola. Welwitsch's plants were neglected for some years, but J. G. Baker described several new species of *Moraea* based on the collections in 1877, of which *M. welwitschii* is now regarded as conspecific with *M. schimperi*. However, it was by a third name, *M. zambeziaca*, described by Baker in 1892, that the species was known until 1950, when Schimper's collections were found to be conspecific with *M. zambeziaca*, and the combination *M. schimperi* was made by the Italian botanist Rodolfo Pichi-Sermolli.

CULTIVATION

Moraea schimperi is a most desirable garden plant for southern African gardens. Despite coming from a nearly tropical climate, it is perfectly hardy in almost all parts of South Africa and of course in its native Zimbabwe, as well as elsewhere in tropical Africa. It grows best in areas that receive appreciable summer rains, and must be kept moist during the growing season, beginning in the late spring in about October. The corms should be left undisturbed during the winter when they are dormant and they may be left dry or be watered occasionally. During the early summer plants flower prolifically and the large, blue flowers make a fine display for several weeks.

Excluded taxa

1. *Moraea balenii* Stent. The identity of this species is uncertain. The type specimen matches best *M. galpinii*, which is not known from the Katberg, where the type of *M. balenii* was apparently collected (Goldblatt, 1973).

2. *Moraea capensis* (Burman fil.) Klatt. This is *Iris xiphium* Linnaeus, apparently cultivated at the Cape before 1766 (Goldblatt, 1976b: 780).

3. *Moraea gigantea* Klatt = *Homeria miniata* (Andrews) Sweet (Goldblatt, 1981a).

4. *Moraea gracilis* (Lichtenstein ex Roemer & Schultes) Dietrich. The type was probably destroyed when the Berlin Herbarium was damaged during World War II and the species cannot be identified from the description alone (Goldblatt, 1976b).

5. *Moraea juncea* Linnaeus. Known only from the description, the species remains unidentified (Barnard & Goldblatt, 1975; Goldblatt, 1976b).

6. *Moraea minuta* (Linnaeus fil.) Ker. The type, in the Thunberg Herbarium, is in too poor a condition to be identified. It is either *M. ciliata* or *M. tricolor*.

7. *Moraea pritzeliana* Diels = *Gynandriris pritzeliana* (Diels) Goldblatt (Goldblatt, 1979).

8. *Moraea spathulata* var. *natalensis* Baker. Specimens cited under this variety belong to *M. ardesiaca, M. moggii*, and *M. spathulata*. The diagnosis is too brief to make it possible to decide on which of the specimens it was based.

9. *Moraea trita* var. *foliata* N. E. Brown. The type of this taxon, which is in the Kew Herbarium, is *M. stricta* with a dead leaf attached to the stem (*Wilms 1418*, Devils Knuckles, February, 1888). The specimen is identical to the type of *M. trita* (= *M. stricta*), also at Kew (*Wilms 1419*, Lydenburg, September 1895). Material examined at Paris indicates a possible error. *Wilms 1418* (also labelled Devils Knuckles, February 1888) in this collection is *Moraea elliotii*, common here in summer (Goldblatt, 1973).

10. *Moraea zeyheri* Lehmann. No type has been located and the species cannot be identified from the description (Goldblatt, 1976b: 781).

Bibliography

BAKER, J. G. 1878. Systema Iridacearum. *J. Linn. Soc. Bot.* **16**: 61–180.

———, 1892. *Handbook of the Irideae*. London: George Bell & Sons.

———, 1896. Irideae. In: W. T. Thiselton-Dyer (editor) *Flora Capensis* **6**: 7–71. Ashford, Kent; Reeve & Co.

———, 1898. Irideae. In: W. T. Thiselton-Dyer (editor) *Flora of Tropical Africa* **7**: 337–376. London: Lovell Reeve & Co.

———, 1906. In: Diagnoses Africanae. *Kew Bull.* 1906: 15–30.

BARNARD, K. H. 1947. A description of the Codex Witsenii in the South African Museum. *Jl S. Afr. Bot.* **13**: 1–52.

BARNARD, T. T. & P. GOLDBLATT. 1975. A reappraisal of the application of the specific epithets of the type species of *Moraea* and *Dietes* (Iridaceae). *Taxon* **24**: 125–131.

BREYNE, J. 1739. *Prodromus Fasciculi Rariorum Plantarum . . .* Danzig: Schreiber.

BROWN, N. E. 1929. Contributions to a knowledge of the Transvaal Iridaceae. *Trans. R. Soc. S. Afr.* **17**: 341–352.

BURMAN, J. 1738–39. *Rariorum Africanorum Plantarum*. Amsterdam: Boussiere.

DE LA ROCHE, D. 1766. *Descriptiones Plantarum Aliquot Novarum*. Leiden: Verbeek.

DE VOS, M. P. 1979. The African genus *Ferraria*. *Jl S. Afr. Bot.* **45**: 295–375.

ECKLON, C. F. 1827. *Topographisches Verzeichniss der Pflanzensammlung von C. F. Ecklon*. Esslingen: Reise Verein.

GOLDBLATT, P. 1971. Cytological and morphological studies in the southern African Iridaceae. *Jl S. Afr. Bot.* **37**: 317–460.

———, 1973. Contributions to the knowledge of *Moraea* (Iridaceae) in the summer rainfall region of South Africa. *Ann. Mo. bot. Gdn* **60**: 204–259.

———, 1976a. Evolution, cytology and subgeneric classification in *Moraea* (Iridaceae). *Ann. Mo. bot. Gdn* **63**: 1–23.

———, 1976b. The genus *Moraea* in the winter rainfall area of Southern Africa. *Ann. Mo. bot. Gdn* **63**: 657–786.

———, 1976c. *Barnardiella*: a new genus of the Iridaceae and its relationship to *Gynandriris* and *Moraea*. *Ann. Mo. bot. Gdn* **63**: 309–313.

———, 1977. Systematics of *Moraea* (Iridaceae) in tropical Africa. *Ann. Mo. bot. Gdn* **64**: 243–295.

———, 1979a. Chromosome cytology and karyotype change in *Galaxia* (Iridaceae). *Plant Syst. Evol.* **133**: 161–169.

———, 1979b. Biology and systematics of *Galaxia* (Iridaceae). *Jl S. Afr. Bot.* **45**: 385–423.

———, 1980a. *Gynandriris* (Iridaceae) a southern African-Mediterranean disjunct. *Bot. Notiser* **133**: 239–260.

———, 1980b. Redefinition of *Homeria* and *Moraea* (Iridaceae) in the light of biosystematic data, with *Rheome* gen. nov. *Bot. Notiser* **133**: 85–95.

———, 1981a. Systematics and biology of *Homeria* (Iridaceae). *Ann. Mo. bot. Gdn* **68**: 413–503.

———, 1981b. Systematics, phylogeny and evolution of *Dietes* (Iridaceae). *Ann. Mo. bot. Gdn* **68**: 132–153.

———, 1981c. *Moraeas* – one lost, one saved. *Veld & Flora* **67** (1): 19–21.

———, 1982. A synopsis of *Moraea* (Iridaceae) with new taxa, transfers and notes. *Ann. Mo. bot. Gdn* **69**: 351–369.

———, 1984a. New Species of *Galaxia* (Iridaceae) and notes on cytology and evolution in the genus. *Ann. Mo. bot. Gdn* **71**: 1082–1087.

———, 1984b. New taxa and notes on southern African *Gladiolus* (Iridaceae). *Jl S. Afr. Bot.* **50**: 449–459.

———, 1986a. Convergent evolution of the *Homeria* flower type in six new species of *Moraea* (Iridaceae – Irideae) in southern Africa. *Ann. Mo. bot. Gdn* **73**: in press.

———, 1986b. Cytology and systematics of the *Moraea fugax* complex (Iridaceae). *Ann. Mo. bot. Gdn* **73**: in press.

———, & T. T. BARNARD. 1970. The Iridaceae of Daniel de la Roche. *Jl S. Afr. Bot.* **36**: 291–318.

GUNN, M. & L. E. CODD. 1981. *Botanical Exploration of Southern Africa*. Cape Town: A. A. Balkema.

HOUTTUYN, M. 1780. *Natuurlyke Historie* ser. 2, 12. Amsterdam: Erven van F. Houttuyn.

JACQUIN, N. 1776. *Hortus Botanicus Vindobonensis* 3. Vienna: Kaliwoda.

JESSOP, J. P. 1966. A volume of early water-colours in the library of the Botanical Research Institute, Pretoria. *Jl S. Afr. Biol. Soc* **6**: 38–52.

KER, J. B. 1803. *Moraea edulis*. Long-leaved *Moraea*. *Bot. Mag.* **17**: tab. 613.

———, 1804. *Moraea tricuspis* var. γ *Lutea*. Yellow trident-petalled *Moraea*. *Bot. Mag.* **20**: tab. 772.

———, 1805. Ensatorum Ordo. *Konig & Sim's Ann. Bot.* **1**: 219–247.

———, 1807. *Moraea ciliata* (γ). Ciliate-leaved *Moraea*. *Bot. Mag.* **25**: tab. 1012.

———, 1808. *Moraea collina* (γ). Straw-coloured equal-flowered *Moraea*. *Bot. Mag.* **28**: tab. 1103.

———, 1827. *Iridearum Genera*. Brussels: De Mat.

KLATT, F. W. 1866. Revisio Iridearum (Conclusio). *Linnaea* **34**: 537–689.

———, 1882. Erganzungen und Berichtigungen zu Baker's Systema Iridacearum. *Abh. Naturf. Ges. Halle* **15**: 337–404.

———, 1895. Irideae. In: Th. Durand & H. Schinz (editors) *Conspectus Florae Africae* **5**: 143–230.

LEWIS, G. J. 1941. Iridaceae. New genera and species and miscellaneous notes. *Jl S. Afr. Bot.* **7**: 19–59.

———, 1948. Some changes in nomenclature – V. Part 3. *Jl S. Afr. Bot.* **14**: 85–89.

———, 1949. *Moraea angusta* (Thunb.) Ker and allied species. *Jl S. Afr. Bot.* **15**: 116–120.

———, 1950. Iridaceae. In: R. S. Adamson & T. M. Salter (editors) *Flora of the Cape Peninsula* 217–264. Cape Town: Juta & Co.

———, 1954. Some aspects of the morphology, phylogeny and taxonomy of the South African Iridaceae. *Ann. S. Afr. Mus.* **40**: 15–113.

LINNAEUS, C. 1762. *Species Plantarum* ed. 2. Stockholm: Salvius.

———, 1767. *Systema Naturae* ed. 12. Stockholm: Salvius.

LINNAEUS, C. (fil.). 1782. *Supplementum Plantarum*. Braunschweig: Orphanotropheus.

MACNAE, M. M. & L. E. DAVIDSON. 1969. The volume 'Icones Plantarum et Animalium' in the Africana Museum, Johannesburg, and its relationship to the Codex Witsenii quoted by Jan Burman in his 'Decades Rariorum Africanum Plantarum.' *Jl S. Afr. Bot.* **35**: 65–82.

MILLER, P. 1759. *Figures of Plants* **2**. London: Philip Miller.

———, 1768. *The Gardeners Dictionary* edition 8. London: Philip Miller.

OBERMEYER, A. 1969. *Moraea graminicola*. *Fl. Pl. Africa* **39**: tab. 1526.

———, 1970a. *Moraea huttonii*. *Flower. Pl. Africa*. **40**: tab. 1581.

———, 1970b. *Moraea galpinii*. *Flower. Pl. Africa*. **40**: tab. 1582.

SCOTT ELLIOT, G. F. 1891. Notes on the fertilisation of South African and Madagascar flowering plants. *Ann. Bot.* **19**: 331–404.

SEALY, J. R. 1965. *Moraea moggii*. *Bot. Mag.* **175**: new ser. tab. 469.

SOLCH, A. 1969. Iridaceae. In: H. Merxmüller (editor) *Prodromus einer Flora von Südwest-afrika* **155**: 1–12. Lehre: J. Cramer.

SWEET, R. 1830. *Hortus Britannicus* ed. 2. London: Ridgeway.

THUNBERG, C. P. 1782. *Dissertatio de Iride*. Uppsala: O. J. Eckman.

———, 1787. *Dissertatio de Moraea*. Uppsala: O. J. Eckman.

VAHRMEIJER, J. 1981. *Poisonous Plants of Southern Africa*. Cape Town: Tafelberg.

VOGEL, S. 1954. Blutenbiologische Typen als Elemente der Sippengliederung. *Bot. Studien* **1**: 1–388.

VOSS, E. G. 1983. *International Code of Botanical Nomenclature*. Regnum Vegetabile **111**: 1–472.

Taxonomic Index

Names of *Moraea* species currently recognized are in bold type.

Dietes
 huttonii Baker 215
Ferraria
 lugubris Salisbury 66
 ocellaris Salisbury 182
 tristis (Linnaeus fil.) 54
Freuchenia Ecklon 20
 bulbifera Ecklon 46
Galaxia
 peduncularis Beguinot 77
Gynandriris
 apetala (L. Bolus) Foster 102
 longiflora (Ker) Foster 104
 pritzeliana (Diels) Goldblatt 219
 stenocarpa (Schlechter) Foster 102
Helixyra Salisbury ex N. E. Brown 20
 flava Salisbury 104
 longiflora (Ker) N. E. Brown 104
Homeria
 lilacina L. Bolus 108
 maculata Klatt 176
 miniata (Andrews) Sweet 219
 rogersii L. Bolus 112
 simulans Baker 32
 speciosa L. Bolus 122
Hymenostigma Hochstetter 20
 schimperi Hochstetter 216
 tridentatum Hochstetter 216
Iris
 angusta Thunberg 40
 bituminosa Linnaeus fil. 30
 ciliata Linnaeus fil. 79
 crispa (Linnaeus fil.) Ker 52
 edulis Linnaeus fil. 98
 fugax Persoon 84
 hirsuta Lichtenstein ex Roemer & Schultes 62
 longifolia Schneevogt 98
 mutila Lichtenstein ex Roemer & Schultes 152
 papilionacea Linnaeus fil. 62
 pavonia Linnaeus fil. 194
 plumaria Thunberg 66
 polystachya Thunberg 118
 ramosa Thunberg 46
 ramosissima Linnaeus fil. 46
 spathacea Thunberg 207
 spathulata Linnaeus fil. 207
 tricuspidata Linnaeus fil. 167
 tricuspis Thunberg 167
 var. minor Jacquin 155
 tripetala Linnaeus fil. 152
 tristis Linnaeus fil. 54
 villosa Ker 184
 viscaria Linnaeus fil. 34
 xiphium Linnaeus 219
Moraea Miller 20
 section Acaules 77
 section Deserticola 86
 section Flexuosa 106
 section Polyanthes 107
 section Subracemosae 94
 section Thomasiae 138
 section Tubiflora 102
 section Vieusseuxia 140
 subgenus Grandiflora 198
 subgenus Monocephalae 38
 subgenus Moraea 46
 subgenus Vieusseuxia 138
 subgenus Visciramosa 28
 albicuspa Goldblatt 163
 algoensis Goldblatt 140
 alpina Goldblatt 136
 alticola Goldblatt 210
 amabilis Diels 152
 amissa Goldblatt 180
 angusta (Thunberg) Ker 40
 anomala Lewis 42
 apetala L. Bolus 102
 ardesiaca Goldblatt 202
 arenaria Baker 69
 aristata (de la Roche) Ascherson & Graebner 182
 atropunctata Goldblatt 172
 balenii Stent 219
 barbigera Salisb. 84
 barkerae Goldblatt 144
 barnardii L. Bolus 150
 baurii Baker 215
 bellendenii (Sweet) N. E. Brown 170
 subsp. cormifera Goldblatt 167
 bipartita 107
 bituminosa (Linnaeus fil.) Ker 30
 bolusii Baker 88
 brevistyla (Goldblatt) Goldblatt 162
 bubalina Goldblatt 28
 bulbifera Jacquin 46
 caeca Barnard ex Goldblatt 178
 calcicola Goldblatt 188
 candida Baker 182
 capensis (Burman fil.) Klatt 219
 carnea Goldblatt 200
 carsonii Baker 126
 ceresiana G. Lewis 155
 ciliata (Linnaeus fil.) Ker 79
 var. tricolor (Andrews) Baker 84
 var. barbigera (Salisbury) Baker 84
 confusa G. Lewis 167
 cooperi Baker 102
 corniculata Lamarck 98
 crispa (Linnaeus fil.) Ker 52
 crispa Thunberg 112
 var. rectifolia Baker 52
 culmea Killick 156
 curtisae R. Foster 134
 debilis Goldblatt 146
 decussata Klatt 52
 deserticola Goldblatt 125
 diphylla Baker 101
 diversifolia (Steudel ex Klatt) Baker 216
 dracomontana Goldblatt 164
 duthieana L. Bolus 84
 edulis (Linnaeus fil.) Ker 98
 var. gracilis Baker 94
 elliotii Baker 127
 elsiae Goldblatt 32
 erici-rosenii Fries 130
 exiliflora Goldblatt 128
 exilis N. E. Brown 159
 falcifolia Klatt 77
 fasciculata Klatt 77
 fergusoniae L. Bolus 64
 filicaulis Baker 101
 fimbriata Klatt 64
 flexuosa Goldblatt 106
 framesii L. Bolus 69
 fugax (de la Roche) Jacquin 98
 fusca Baker 174
 galaxioides Baker 77
 galpinii (Baker) N. E. Brown 213
 subsp. robusta Goldblatt 214
 garipensis Goldblatt 48
 gawleri Sprengel 52
 gigandra L. Bolus 196
 gigantea Klatt 219
 glaucopis (de Candolle) Drapiez 182
 gracilenta Goldblatt 94
 gracilis Lichtenstein ex Roemer & Schultes 219
 graminicola Obermeyer 203
 graniticola Goldblatt 76
 hantamensis Klatt 79
 hexaglottis Goldblatt 74
 hiemalis Goldblatt 204

hirsuta Lichtenstein ex Roemer & Schultes 62
hockii De Wildeman 216
homblei De Wildeman 126
huttonii (Baker) Obermeyer 215
inclinata Goldblatt 132
inconspicua Goldblatt 36
incurva G. Lewis 144
indecora Goldblatt 57
insolens Goldblatt 176
inyangani Goldblatt 199
iriopetala Linnaeus fil. 54, 66
juncea Linnaeus 219
juncea Linnaeus sensu N. E. Brown 54
juncifolia N. E. Brown 127
linderi Goldblatt 58
longiaristata Goldblatt 145
longiflora Ker 104
longifolia (Schneevogt) Sweet 96
longispatha Klatt 207
loubseri Goldblatt 190
lugubris (Salisbury) Goldblatt 66
lurida Ker 174
macgregorii Goldblatt 93
macra Schlechter 127
macrocarpa Goldblatt 96
macrochlamys Baker 79
macronyx G. Lewis 82
margaretae Goldblatt 60
marionae N. E. Brown 159
minuta (Linnaeus fil.) Ker 219
mira Klatt 66
modesta Killick 166
moggii N. E. Brown 205
monophylla Baker 152
montana Schlechter 174
mossii N. E. Brown 134
muddii N. E. Brown 198
namaquamontana Goldblatt 50
namibensis Goldblatt 90
natalensis Baker 130
neglecta G. Lewis 44
neopavonia R. Foster 194
nubigena Goldblatt 68
obtusa N. E. Brown 40
odora Salisbury 98
odorata Lewis 34
papilionacea (Linnaeus fil.) Ker 62
 var. maythamiae Lewis 62
parva N. E. Brown 134
parviflora N. E. Brown 130
pavonia (Linnaeus fil.) Ker 194
 var. lutea (Ker) Baker 170
 var. villosa (Ker) Baker 184
pilosa Wendland 62
plumaria Thunberg 66
polyanthos Linnaeus fil. 108
polyanthos Linnaeus fil. sensu Baker 107
polystachya (Thunberg) Ker 118
 var. brevicaulis Stent ex Phillips 121
pritzeliana Diels 219
pseudospicata Goldblatt 114
pubiflora N. E. Brown 160
 subsp. brevistyla Goldblatt 162
punctata Baker 152
ramosa (Thunberg) Ker 46
ramosissima (Linnaeus fil.) Druce 46
reticulata Goldblatt 212
rigidifolia Goldblatt 75
rivularis Schlechter 215
robusta (Goldblatt) Goldblatt 214
rogersii N. E. Brown 156
saxicola Goldblatt 86
schimperi (Hochstetter) Pichi-Sermolli 216
serpentina Baker 69
sordescens Jacquin 54
spathacea (Thunberg) Ker 207
 var. galpinii Baker 213
spathulata (Linnaeus fil.) Klatt 207
 var. natalensis Baker 219

 subsp. autumnalis Goldblatt 207
 subsp. saxosa Goldblatt 207
 subsp. transvaalensis Goldblatt 207
speciosa (L. Bolus) Goldblatt 122
stenocarpa Schlechter 102
stewartae N. E. Brown 127
stricta Baker 134
sulphurea Baker 52
tellinii Chiovenda 134
tenuis Ker 155
thomasiae Goldblatt 138
thomsonii Baker 137
thomsonii Baker sensu Goldblatt 134
tortilis Goldblatt 72
?toxicaria Dinter 118, 121
tricolor Andrews 84
tricuspidata (Linnaeus fil.) G. Lewis 167
tricuspidata (Linnaeus fil.) G. Lewis sensu Lewis 182
tricuspis (Thunberg) Ker 167
 var. lutea Ker 170
 var. ocellata D. Don 182
trifida Foster 156
tripetala (Linnaeus fil.) Ker 152
 var. mutila (Lichtenstein ex Roemer & Schultes) Baker 152
 var. jacquinii Schlechter ex Lewis 152
tristis (Linnaeus fil.) Ker 54
trita N. E. Brown 134
 var. foliata N. E. Brown 219
tulbaghensis L. Bolus 192
undulata Ker 52
unguiculata Ker 155
unibracteata Goldblatt 200
vallisavium Goldblatt 38
vegeta Linnaeus 54
venenata Dinter 121
verecunda Goldblatt 116
villosa (Ker) Ker 184
violacea Baker 127
violacea L. Bolus 155
viscaria (Linnaeus fil.) Ker 34
 var. bituminosa (Linnaeus fil.) Baker 30
viscaria sensu Ker 36
welwitschii Baker 216
worcesterensis Goldblatt 142
zambeziaca Baker 216
zeyheri Lehmann 219
Phaianthes Rafinesque 20
 lurida (Ker) Rafinesque 174
Vieusseuxia de la Roche 20
 angustifolia Ecklon 52
 aristata de la Roche 182
 bellendenii Sweet 170
 bituminosa (Linnaeus fil.) Ecklon 30
 brehmii Ecklon 52
 edulis (Linnaeus fil.) Link 98
 freuchenia (Ecklon) Steudel 46
 fugax de la Roche 98
 geniculata Ecklon 66
 glaucopis (de Candolle) in Redoute 182
 graminifolia Ecklon 54
 intermedia Ecklon 62
 lurida (Ker) Sweet 174
 mutila C. E. Berg ex Ecklon 152
 nervosa Ecklon 62
 pavonia (Linnaeus fil.) de Candolle 194
 pulchra Ecklon 152
 rivularis Ecklon 54
 schimperi (Hochstetter) A. Richard 216
 spiralis de la Roche 170
 tenuis (Ker) Roemer & Schultes 155
 tricuspis (Thunberg) Sprengel 167
 tridentata (Hochstetter) A. Richard 216
 tripetala (Linnaeus fil.) Klatt 152
 tripetaloides DC. 152
 unguiculata (Ker) Roemer & Schultes 155
 villosa (Ker) Sprengel 184
 viscaria (Linnaeus fil.) Ecklon 34
Xiphion
 diversifolium Steudel ex Klatt 216